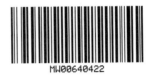

Philippe Grandrieux

ex:centrics

Series Editors:
Greg Hainge and Paul Hegarty

Philippe Grandrieux

Sonic Cinema

Greg Hainge

Bloomsbury Academic
An imprint of Bloomsbury Publishing Inc

B L O O M S B U R Y
NEW YORK • LONDON • OXFORD • NEW DELHI • SYDNEY

Bloomsbury Academic

An imprint of Bloomsbury Publishing Inc

1385 Broadway	50 Bedford Square
New York	London
NY 10018	WC1B 3DP
USA	UK

www.bloomsbury.com

**BLOOMSBURY and the Diana logo are trademarks
of Bloomsbury Publishing Plc**

First published 2017

© Greg Hainge, 2017

Library of Congress Cataloging-in-Publication Data

A catalog record for this book is available from the Library of Congress.

ISBN: HB: 978-1-6289-2313-1
PB: 978-1-6289-2312-4
ePDF: 978-1-6289-2314-8
ePub: 978-1-6289-2315-5

Series: ex:centrics

Cover image © Meurtrière © Epileptic

Typeset by Deanta Global Publishing Services, Chennai, India
Printed and bound in the United States of America

CONTENTS

LIST OF
ILLUSTRATIONS

ACKNOWLEDGEMENTS

To thank the subject of the book one is writing could easily seem either a little too affected for comfort or else invoke the spectre of a troubling conflict of interest that points towards a lack of proper critical distance. The simple fact of the matter is, however, that this book would not exist were it not for the fact that the work of Philippe Grandrieux has been so personally inspiring to me and it is only right and fitting that I should acknowledge this and express my sincere appreciation and deep admiration for this. That a body of work such as this should continue to be produced today seems at times somehow miraculous and yet the very fact that it does keeps the embers of hope burning bright.

I must acknowledge also, however, that this work could never have been what it is without the direct assistance of Philippe Grandrieux and his close family, friends and collaborators. Work that takes place on the fringes of mainstream cultural production, as Grandrieux's work so often has, can easily slip between the cracks of archival preservation, whether this is inscribed in the cultural imaginary of an epoch (for the mainstream), in institutional structures (for those products deemed worthy of the status of cultural heritage), or in the rarefied circuits of fandom and fetishism (for the underground). I am therefore indebted to and deeply grateful for the unprecedented access to certain archival and preparatory materials that have been granted to me by Philippe Grandrieux and Corinne Thevenon-Grandrieux. Annick Lemonnier, the producer of some of Grandrieux's non-feature-length works produced for Epileptic, has also been an invaluable source of information and resources. I am, in addition, grateful to Boris Gobille for access to a deeply personal interview archive that never managed to see the light of day and to Nicole Brenez and Adrian Martin for putting things in front of me that I would not have found otherwise.

The dangers of a too close relationship to one's source material is best tempered by a second opinion, and for this reason I am especially grateful to Nicole Brenez, Jenny Chamarette, John Edmond, Paul Hegarty, Richard Iveson and Adrian Martin, all of whom read the manuscript and provided encouragement and a keen critical eye.

Over the years that this work has been in preparation, my energy has been sustained and my neurones fired by the support and exchange of ideas with very many people, too numerous to mention here, but some of whom need to be namechecked nonetheless for their specific contributions: Amelia Barikin, Raymond Bellour, Jo Connah, Mathieu Copeland, Lucio Crispino, Jose Da Silva, Gregory Flaxman, Emilia Giudicelli, Ferdinand Grandrieux, Randolph Jordan, Manuela Morgaine, James Philips, Vilma Pitrinaite, Phil Powrie, Hélène Rocheteau, Robert Sinnerbrink, Elizabeth Stephens, Lisa Trahair, Saige Walton, Kathryn Weir, Francesca Ziviani, thanks to you all. It is truly wonderful to have had the support of so many people who believe in the kind of work that Grandrieux does and who understand why we must fight to ensure its continued existence.

There is no way that this book could have been completed without the time afforded to me by a Faculty Fellowship in the Institute of Advanced Studies in the Humanities of the University of Queensland. This environment provided not only the time that a project like this demands, but also the intellectual environment needed to make work such as this much better and richer than it would have been otherwise; in saying this I have one name in particular in mind, and even though I have already thanked him for reading the manuscript, I need to acknowledge him again, because on so many occasions when I was babbling excitedly after a bout of writing frenzy, Richard Iveson's reading recommendations were always spot on.

I also want to thank Ally Jane Grossan who originally had the vision, energy and conviction to sign up the series that Paul and I proposed to her when she was working at Bloomsbury and for following our logic when we argued that a book on a film-maker was the ideal first volume in this new sound studies series. Since Ally Jane moved on to fresh pastures, Leah Babb-Rosenfeld has more than capably filled some very big boots and provided wonderful

continuity and an incredible level of support and trust in what we
are trying to achieve with this series.

The staff of l'Institut national de l'audiovisuel (l'INA) provided
invaluable assistance in tracking down some of the works for
television that were buried deep in their archives.

I am grateful for the copyright holders for permission to
reproduce the images contained herein. Images from *Via la vidéo*,
Une Génération, *Retour à Sarajevo*, *L'Arrière-saison* and *Met* are
reproduced with the permission of Philippe Grandrieux. Images
from *Sombre*, *La Vie nouvelle*, *Un lac* and *Malgré la nuit* are
reproduced with the permission of Mandrake Films. Images from *Il
se peut que la beauté ait renforcé notre résolution – Masao Adachi*,
White Epilepsy and *Meurtrière* are reproduced with the permission
of Epileptic.

And finally, I want to thank Jo, Elize, James and Juliette for
supporting me always and completely, for understanding that
when doing a project like this there are times when I need to be in
lockdown, and for always being there when I emerge again.

Introduction

In Shanghai Village Dumpling Restaurant, down an alley in Melbourne's China Town, between mouthfuls of xiao long bao, our conversation turned to Bacon or, to be more precise, Gilles Deleuze's book on Bacon, *Logic of Sensation* (2003b). 'That's the one,' said Philippe Grandrieux excitedly, stabbing the air with his chopsticks. 'That's the book where he [Deleuze] talks about the cinema more than any other.' This statement puzzled me for a long time; how, I wondered, could a book on a painter be considered more relevant to the cinema than, most obviously, the two-volume work that Deleuze had penned about the cinema, titled, appropriately, *Cinema* (1986b and 1989)? The answer to this question only really became apparent to me years later, in Le Havre, where I found myself to see the latest performance directed by Grandrieux, *Meurtrière* [*Murderess*], and this book is, in many respects, an attempt to unpack that answer more fully through a consideration of Grandrieux's entire artistic output to date.[1]

Philippe Grandrieux is, when he is known at all, known predominantly for his work as a film-maker, no doubt because of the acclaim that his films have received in some quarters and the success they have enjoyed at some major international film festivals, on the one hand, and the outrage and condemnation that they have sometimes elicited on the other. To think of Grandrieux as simply a film-maker, however, is misleading if for no other reason than that he has spent more years working in television (as a producer and director), video (as a practitioner) and photography than making feature-length films. What is striking in his approach across all of these different media, however, is the singularity of his vision, the consistent prosecution of a core understanding of the way in which art comes to be, of the conditions necessary for art to take place and of the way in which it reaches out to us.

What is at stake in Grandrieux's project has to do not only with the eternally vexed question of what the cinema is – as posed by

Eisenstein (1998), Bazin (2005), Andrew (2010) and many more besides – but also of what we are, for his is an artistic project in which the boundaries between different media, forms and identities no longer obey the axiomatics that would normally keep everything in its right place, a project which in many respects, then, operates in a mode to which our auditory sense is more habituated and attuned than our visual sense, to which Grandrieux's work would seem to appeal most forcefully – even if he claims that 'sound is much more important than everything else ... For me most of the images are coming from the sound, the sound brings me to the images' (Grandrieux and Baldassari n.d.). To consider the work of Grandrieux from a perspective more attuned to a mode of aesthetic expression that is characterized by a formal and material resistance to containment is perhaps necessary here not only in order to mark the ways in which Grandrieux seems always to contravene or transgress the axiomatics of all of the media forms that he works across, however, but also because so much of his work can only be apprehended in what we might call, for want of a better term, a musical mode. With regard to his feature-length films, for instance, there is arguably little point retelling their major plot lines when discussing them because those elements of his films that might normally coalesce into something that we would call a plot resist doing so, always remaining mobile, relating to each other on a constantly shifting ground that prevents us from fixing them into place, but also because to do so would be so tragically insufficient to the task of accounting, even partially, for what we see projected on the screen and hear resonating in the room. This, one might argue, is the case with every film, but it is all the more so in the films of Grandrieux where the story is arguably as relevant to an engagement with the artistic expression as it is when one listens to a symphony.

 It would be easy to surmise from this that Grandrieux is an inheritor of the French Impressionist film-makers working in France in the period following the Great War (such as Germaine Dulac, Jean Epstein, Abel Gance and Jean Renoir). Impressionist film of this time, indeed, shared some commonalities with more abstract cinematic forms from this same period that distanced themselves from reality to head towards pure visual expression (Delons 1928, 11) while simultaneously conceptualizing of the cinema as a 'musical space' since for them the cinema could only

be conceptualized as 'a living rhythm repeated across the film's duration' (Faure 1964, 25). David Bordwell has convincingly critiqued this assumption of Impressionist film theory, namely that 'filmic construction should be based not on narrative but on rhythmic relations between images' (1980a, 125) to contend, rather, that 'Impressionist film style enriches the narrative by increasing the film-maker's commentative role or, more often, our awareness of the character's inner states' (215). While there is perhaps then some resonance between Grandrieux and the Impressionists, there is ultimately more difference than similarity between them since the relationship between narrative content and filmic form in his work is far more complex than what Bordwell identifies in the work of the Impressionists both in regard to the relationship between the two and the philosophical affordances of this relationship. Indeed, what is at stake in the interplay of form and content in Grandrieux's films has to do ultimately not just with the cinema and our relationship to it but, rather, life itself. As Marc Mercier writes, this is a cinema that escapes the subject/object binary and goes to the very essence of things, not so much filming life as *being* life itself (2005, 55).

To make this claim is to argue that the cinema, for Grandrieux, is not simply a means to tell a story and that its potential extends far beyond this. 'The triviality of cinema is adamant', he has said, 'yet its apparatus is so powerful that we must not abandon it entirely to laborious narration and the feeble psychology of characters' (Grandrieux and Copeland 2015, 121). This is not to say that Grandrieux's films have no story or plot, even if he himself explicitly rejects a primarily narrative-driven model of film-making, saying in an earlier interview:

> I don't write a script that goes 'interior, kitchen, daytime', that's so depressing, I'd shoot myself if I had to write like that. I write little fragments, notes, I look for a certain rhythm in phrases too. I also take a lot of notes on the actors, the light, the sound. (Renaud, Rioux and Rutigliano 1999; all translations from the original French are my own unless stated otherwise in the reference list)

While it is evident from the sentiment expressed here that Grandrieux does not predetermine every aspect of the narrative or even aesthetic progression of his films in advance, he does,

nonetheless, write extensive notes and texts in preparation for each of his film projects and later performance pieces. What is striking when one reads these texts, however, is the extent to which they do not resemble the final product, how little correlation there can (oftentimes) be between the written texts and the final product. Once again, this can be said of any film to a certain extent simply because there is a transformation that takes place in the translation of a written screenplay into an audiovisual form, but this logic is carried far further than this in the case of Grandrieux. In saying this I am not simply suggesting that his written texts serve a function more akin to a musical score whose complexity could never be fully apprehended outside of the act of translation into musical form, although this idea certainly takes us closer to the operation that we find here. Rather, I am suggesting that the base texts serve as a kind of abstract diagram, that they do not so much map out a narrative or formal structure as lay down a series of constraints, principles, codes and ideas from within which aesthetic expression emerges through a semi-improvised choreography that instigates semi-determined relations between all of the various components of the text in creation – be these the actors, crew, technologies, locations, sound or light environments, plot fragments or source texts. If there is in this approach something that comes close to a musical mode, this is because, in spite of the base text that operates somewhat like a score, this creative process resembles more than anything else a collaborative work of improvisation. And yet perhaps, as Grandrieux suggested to me in Melbourne, there is here also something incredibly painterly.

Back to Bacon

In his analysis of the paintings of Bacon, *Francis Bacon: The Logic of Sensation*, Gilles Deleuze describes what he considers to be the fundamental process in play in Bacon's paintings. This is a process in which – through a variety of different means, including the interplay of different chromatic zones and the inscription on the canvas of geometric lines indicating the flow of forces within the frame – the figure that appears in the painting is isolated in such a way that, from within the space in which that figure finds itself,

something happens within the Figure, a movement or sensation that takes the Figure beyond itself. For Deleuze, this process and the instigation of this movement are intimately linked to the birth of an aesthetic mode that distances painting from representation and narrative; yet this does not necessarily mean that painting falls back into abstraction – even if this is one of the possible paths open to it. As he writes in a passage that is worth quoting at length:

> Painting has neither a model to represent nor a story to narrate. It thus has two possible ways of escaping the figurative: toward pure form, through abstraction; or toward the purely figural, through extraction or isolation. If the painter keeps to the Figure, if he or she opts for the second path, it will be to oppose the 'figural' to the figurative. Isolating the Figure will be the primary requirement. The figurative (representation) implies the relationship of an image to an object that it is supposed to illustrate; but it also implies the relationship of an image to other images in a composite whole that assigns a specific object to each of them. Narration is the correlate of illustration. A story always slips into, or tends to slip into, the space between two figures in order to animate the illustrated whole. Isolation is thus the simplest means, necessary though not sufficient, to break with representation, to disrupt narration, to escape illustration, to liberate the Figure: to stick to the fact. (Deleuze 2003b, 6)

We are here, I want to suggest, very close to Grandrieux's attitude towards narrative, and an understanding of the opposing centrifugal and centripetal forces that bring about the isolation of the Figure and then a movement that takes the Figure beyond the boundaries of itself will be crucial for an understanding of the forces and modes at work in his artistic output. Indeed, what I hope to show in the chapters to follow is that the various figures and characters that move through Grandrieux's universe are subjected to precisely this kind of isolation in order to enable within them an entirely new mode of relation to the world, to enable them to live (to modulate the title of one of Grandrieux's films) a new life. What is more, this same movement is one to which we, the audience who find ourselves in front of Grandrieux's work, are subjected also. In making this

claim, I do not wish to fall into the kinds of exercises in rhetorical excess that characterize most of the work in the area of applied affect studies or post-phenomenological film criticism critiqued by Eugenie Brinkema (2014, xiii). Rather, I will contend that we are subject to these same processes in very specific ways that vary in degree and kind depending on the particularities of the medium and situation in which we find ourselves.

Yet this is only half true or, rather, not true in the way one might imagine. For while I will carry out a close textual analysis of what we actually see and hear in Grandrieux's work and stick closely to the works themselves, it will undoubtedly be necessary in what follows also to approach his work from the side, via a route that may at times seem precisely *not* to attend to the specificities of the text. In saying this, I am recalling once again my prior contention that we need to engage with Grandrieux's work in what might be considered a musical mode due to its consistent resistance to containment. More than this, however, I am suggesting that in order to engage fully with his work we need, firstly, to understand how certain tropes and ideas have been reiterated differently across his career and across the different media he has worked in. In addition, I wish to propose that to approach his work in this way is to begin to understand his own method and way of working or, rather, the way in which his work comes to be.

This slight modulation in my last sentence should hopefully indicate already that this approach is absolutely not taken in a desire to write an *auteurist* study that would fall prey not only to the traps presented by the intentional fallacy but all of those other missteps that have been so roundly critiqued by scholars since the emergence of *auteur* theory in France and the birth of the *Nouvelle vague* – a movement which undoubtedly had a big impact on Grandrieux nonetheless. Indeed, if *auteur* theory has been considered problematic in more recent times, it is in large part because the cinema cannot be authored by one person alone but is necessarily the product of a technological and industrial complex, which is to say, as suggested of Grandrieux's work above, that it is born of a choreography that instigates semi-determined relations between its various components. In Grandrieux's work, this principle is pushed to its most extreme point, to the point that the distinction between form and process is eradicated entirely, a statement that needs to be applied not only to the creation of the

text but to its transmission also insofar as the forces generated by the work act upon the Figure of the spectator, problematizing her various bodies: bodies of knowledge and her corporeal being. To suggest this is not merely to reiterate a somewhat banal point since Barthes, Foucault and many more besides them declared the author to be dead; it is rather to say that in front of Grandrieux's work we are forced or asked to construct something new out of something that is in many respects entirely alien yet, at the same time, somehow strangely and deeply familiar, something that we are tempted to reject or abject in spite of – or perhaps because of – the fact that on some level it seems to speak to a part of us that has been so profoundly and thoroughly repressed or simply forgotten that it no longer seems possible that it once formed a part of us.

The mechanics of Grandrieux's aesthetic achieve this via a number of different means (psychological alienation, narrative estrangement, visual or sonic confusion ...) that have the effect of isolating us not only from our ambient reality but also from any anthropological or sensory reflex that we might use to try and orient ourselves within unfamiliar spaces, destabilizing what we take to be fixed forms in a desire to perdure within a knowable identity. The viewer of Grandrieux's work, indeed, like the characters she sees before her, is stripped back to a post-identitarian state – or perhaps, as becomes clearer in the latter part of Grandrieux's career, a pre-identitarian state – and forced to move beyond the bounds of the prior identity now lying in shards around her. Subjected to the same kinds of forces and figural processes enacted within the work itself, what is in play here is the conversion and subsequent transmission of perception, affection and meaning into, respectively, percept, affect and sensation that Deleuze and Guattari find in those forms of art that seek to undo form (1994, 174–7). For Deleuze and Guattari, the very aim of art is 'to wrest the percept from perceptions of objects and the states of a perceiving subject, to wrest the affect from affections as the transition from one state to another: to extract a bloc of sensations, a pure being of sensations' (167). This is the vocabulary that has been used most often in scholarly work dealing with the work of Grandrieux and, indeed, by Grandrieux himself when talking about his own work. To talk about sensation and affect in such general terms, however, and not via a close textual analysis of the specific mechanics that I am claiming to be in operation in Grandrieux's work, leaves one open to the charge

levelled by Eugenie Brinkema against scholars deploying affect
theory – and Deleuzians, in particular. She writes:

> There is a formula for work on affect, and it turns on a set of shared
> terms: speed, violence, agitation, pressures, forces, intensities.
> In other words, and against much of the spirit of Deleuze's
> philosophy, which celebrated the minor, the changeable, and the
> multiple, Deleuzian theories of affect offer all repetition with no
> difference. When affect is taken as a synonym for violence or
> force (or intensity or sensation), one can only speak of its most
> abstract agitations instead of any particular textual workings.
> (2014, xiii)

If this mode can be found in much of the scholarly literature
published on Grandrieux that seeks to engage or evoke the 'sensation'
of his work, however, the shortcomings of this work result (as
intimated by Brinkema) from the ways in which Deleuze's ideas have
been used rather than anything inherent to his philosophy. Indeed,
the passage from *What is Philosophy?* quoted above continues: 'A
method is needed, and this varies with every artist and forms part
of the work' (167). It is this method that the chapters to follow will
attempt to unpack through a close examination of Grandrieux's
work across all of the media in which he has worked from the very
start of his artistic career up until the present day.

At this point some may object that if the artist himself uses the
very lexicon that I am to employ in talking about his work, there is
little point in carrying out such an analysis, that the work should
speak for itself. Leaving aside the difficulty of seeing much of the
work that will be described in the pages to follow, this is perhaps a
valid point and far from the only tension that arises in a book such
as this. Indeed, others may protest that in offering a close textual
analysis intended to shed some light on a body of work which is not
known by many yet loved by those who know it arguably because of
its darkness, a darkness both literal and figurative that seems to resist
being brought into the light, I am spectacularly missing the point
of what Grandrieux's work is all about and, to boot, attempting to
account for its operations via a mode that is not its own and that
can only then remain at a distance from it. To a certain extent this is
true, for as Daniel W. Smith notes in his translator's preface to *Logic
of Sensation* (in a comment that is equally applicable to all of the

artistic forms to be analysed herein), to talk about painting was, for Bacon, necessarily 'only an approximation, as painting is its own language and is not translatable into words'.[2] As Smith also notes, this is a tension present in Deleuze's own work and method when writing *The Logic of Sensation* for which he used reproductions of the paintings and Bacon's interviews with Sylvester as source materials. As Smith puts it, 'How does one talk in one medium (concepts) about the practices of another (percepts)?' (2003, xi). For Deleuze – who did not believe that this tension required the philosopher to abandon the attempt to talk about different kinds of expression – the way out of this apparent contradiction was to use Bacon's interviews not as 'definitive statements on Bacon's part but rather as the starting point for his own conceptual inventions' (Smith 2003, xi). This explains why Deleuze's readings of his philosophical forebears are often so controversial in the eyes of the inner circle of serious scholars who dedicate themselves purely to the thought of those philosophers to whom Deleuze turned his attention, for in each case his interest lay precisely not in explicating a pre-existing conceptual framework but in employing that framework in order to advance his own conceptual meanderings down paths he would not have discovered by himself.

For my part here, even though I shall, in the course of this book, formulate the concept of sonic cinema which is intended as an alternative or perhaps corrective to the idea of haptic cinema that has gained so much traction in recent work in film studies, I am not so vainglorious as to claim that this study treats Grandrieux's work with a similar aim in mind. My explicit intention, indeed, is to remain as close as possible to his work, to account for his percepts with concepts, and while there is necessarily an irreducible tension in the attempt to do this, I believe that his works call for this move to be made. Indeed, just as some form of concept, generated oftentimes from a written text, is vital for the genesis of Grandrieux's works, so, I believe, is a critical engagement with the work ex post facto a vital component of the way in which the work of art comes to be in the world – which is in part to say that while we are dealing here with affect and sensation, Grandrieux's work necessarily brings into the fray a political and ethical dimension.

In saying this I am expressing an idea not dissimilar to that proposed by Andrew Benjamin in his work *Disclosing Spaces: On Painting*. Commenting on painting understood not as a

representational practice in which the work of art would always be beholden to a mimetic function, in thrall to an external reality that would always pre-exist it but, rather, as an expressive form capable of generating something new and specific to it, Benjamin writes:

> Moving beyond the hold of exemplarity necessitates that it is the painting's work that figures. Work for the painting, because those moments in which what is displayed cannot be separated from its presence as the effect of painting, involves the painting's materiality. A materiality continually marked by an immaterial presence. Figures effected by the painting's work are – as a consequence – able to figure. (2004, 46)

Far from leaving the artwork subservient to the world in which it is situated, art's potential is, on the contrary, the capacity to interrupt that world, to intervene in the present moment – the political and ethical dimension talked of above. In order for this work of the artwork to be put into effect, however, something else is required. Benjamin writes:

> Even though this potential is part of the definition of art, it still does not follow that art works on its own. The capacity is released. (This is what the presence of potential entails.) The moment of release occurs as the act of criticism. (2004, 3)

For Grandrieux this idea is modulated slightly and can be best understood not via Benjamin but, instead, through Proust's preface to his three-hundred-page essay *Contre Sainte-Beuve* [*Against Sainte-Beuve*] (1987), a text that Grandrieux has stated to be seminal for his own work.[3] This text is like an early blueprint for the kind of chance sensory encounter triggering an involuntary memory that would later become the hallmark of his writing thanks to *In Search of Time Lost*'s madeleine episode. What we find both in this earlier text and *In Search of Time Lost* is an example of a specific configuration of elements that coalesce in such a way as to bring about in the subject who stands at the centre of this constellation an expression that is beyond both intelligence or the intellect and all intentionality. If the intellect is here left behind, however, it returns ex post facto in an effort to try and make some

kind of sense from this lived experience and, what is more, to attempt to comprehend those aspects of reality that such experience reveals. Indeed, intelligence and intention are here seen to cast a veil over reality, to cloak it in an image in which its every element would interrelate according to a schema at least partially (if not wholly) determined by what we think we know to be true. The potential of the kind of sensory encounter recounted by Proust is then that it permits access to a more direct form of encounter with the world that is not preconditioned by the biases, prejudices and habituated modes of a subject but in which, rather, the subject is conjugated as but one element of an assemblage that arises through a direct sensory contact with the world and its objects. The role of art is to give form to this encounter such that it might subsequently be transmissible to others, albeit in a modulated form – and this is precisely what would be referred to by Deleuze as a percept. For Proust, however, this is not all that is in operation in the work of art, for both in the primary creation of the work of art and, we can suggest going beyond Proust, in the activation of the potential of the work of art that enacts its work of figuration (which is to say in the act of interpretation, criticism or even just reception), intelligence returns. It does this, however, not in order to assert its own superiority once again and to reinstate the world order that has been disturbed and interrupted by the work of art but, rather, to realize its own insufficiency and incapacity fully to recuperate this lived experience. While this may then seem a somewhat futile exercise, a superfluous step, it is for Proust in fact vital since it is only the intellect that is capable of asserting that it is itself secondary and instinct primary. As Proust writes at the end of this preface:

Throughout the pages to come [we will] touch on some very important intellectual questions, perhaps the most important there are for an artist, which have to do with the inferiority of the intellect that I have talked about at the start of this text. Yet this inferiority of the intellect needs to be established by the intellect. Because if the intellect does not merit the crowning glory, it is only the intellect that is capable of discerning this. And if in the hierarchy of virtues it occupies only second place, it is nonetheless only the intellect that is capable of proclaiming that the instinct must take first place. (1987, 50)

Taking my lead from Deleuze's insistence that we listen more closely to what artists have to say (see Deleuze 2003a), I want to contend that this short preface by Proust is of great importance for an understanding of Grandrieux's artistic output and our engagement with it. Indeed, as will be seen in the chapters to follow, there is in Grandrieux's work across all of the different media in which he works a remarkably coherent conceptual approach that is meticulously formulated. What this conceptual framework is used to produce is the very kind of constellation of elements found in Proust's text, a situation in which there is no primary element, no superior intellect but merely a dynamic space within which the artwork comes to be. Conceptualized in this way, as an entirely heterogenetic process, Grandrieux thrusts us, the subsequent receivers of these works, into a space in which all of our prior codes, moral, cultural, anthropological and aesthetic, find themselves in crisis, unable to account for this experience or to reconcile what seem to be, from within an already established hermeneutic framework, contradictory forces.

To put this another way, what we are faced with in Grandrieux's work is an entirely immersive and immanent environment in which the events taking place are produced out of a logic entirely internal to the text itself. It is in part because of this immersive nature of the work that the term 'sonic cinema' is appropriate, since sound is an immersive medium that, what is more, stubbornly transgresses borders and attempted containment. In the spirit of taking seriously what artists themselves say about their own work, however, the term 'sonic cinema' is also particularly apposite for the work of Grandrieux since the director himself so often conceptualizes his own work in terms of sonic phenomena and/or states that the sound design of a film is oftentimes the most important or primary element. Having said that, it is important to note that in using the term 'sonic cinema', the intention is not simply to talk about sound in the cinema. This has been done very capably by many critics before me and there are now whole journals dedicated solely to cinematic sound or the soundtrack. The very term 'sonic cinema' has been used by Philip Brophy over a prolonged period to describe a strand of his own approach to film studies or, rather, 'audiovisuality' as he terms it. Like much work in this area, Brophy's approach explicitly focuses on the sonic in its most literal instantiation and sets out to engage with the cinema first and foremost through the soundtrack (2004).[4]

Another notable critic who has, across an entire career, argued for the importance of close attention to the role that sound plays in the cinema (precisely because it is so often forgotten) is Michel Chion (see for instance 2009), and another recent study whose title would seem to indicate that it has much in common with the present volume is Andy Birtwistle's *Cinesonica: Sounding Film and Video* (2010). Birtwistle's work undertakes a complex interdisciplinary analysis of the necessarily imbricated relation between image and sound in film and video and in doing so goes beyond the remit of much work in cinematic sound studies, yet ultimately does not, as here, attempt a reconfiguration of those realms through this relation, seeking rather to map a structural equivalence between the materiality of sound (arising from duration, development and rhythm) and the materiality of the relationship between sound and image more broadly (2010, 17).

In setting out to complicate the relationship between sound and image more than this, the use of the term 'sonic' here extends it beyond the realm of sound. The methodology employed thus approaches the cinema through concepts and vocabularies that originate in the realm of the sonic yet are by no means constrained by the sonic narrowly defined. Consequently, we will here analyse the cinematic image using terms such as 'accompaniment', 'harmony', 'resonance', and ultimately describe its geometry in rhythmic terms, arguing that it is only by doing so that we can describe something defined primarily by movement in time. This is done in part, as mentioned, because of the specificities of Grandrieux's work and the ways in which he himself conceptualizes his work, but also because of a sense that different kinds of approaches towards the cinema are required, approaches that do not take it for granted that the long-habituated sensory hierarchy of our own embodied selves can be unproblematically mapped onto the ways in which the cinema operates, given that it is constructed very differently – hence of course its attractiveness to Deleuze as a medium through which we might view the world outside of the very limited and situated scope of human consciousness or perception (see 1986b and 1989). In this regard, the approach taken here has much in common with recent work in film studies that seeks to analyse the notion of 'affect' in the cinema and, more specifically, work that attempts to undo this sensory hierarchy through the concept of the haptic. If here I use the term 'sonic cinema' rather than a pre-existing term such

as 'haptic cinema', however, this is in large part because of a desire to remain very close to the text, close to the cinema, to recognize that even though the cinema may be constructed very differently to us, its spectators, it remains nonetheless an audiovisual form that is problematically accounted for in terms of other sensory inputs.

What this means, of course, is that the idea of a 'sonic cinema' that is deployed throughout this book and explicitly unpacked in the intermezzo and afterword is one that could be mapped onto a consideration of any filmic text; it is though particularly appropriate for a consideration of the work of Grandrieux since, apart from all of the reasons already mentioned, the theory itself enacts the kind of reconfiguration that I have claimed is an essential component of Grandrieux's work. Indeed, if the very idea of the sonic invokes the spectre of an immersive medium that cannot be contained within the parameters of previously constituted forms, a space that is defined not by the sum total of the discrete objects within it but only by the events taking place within it, then we are very close to Deleuze's analysis of the forces in Bacon's paintings that instigate a movement in the figure that carry it beyond the bounds of the unitary, of a singular known or knowable identity, to create instead a dynamic zone of intensities, affects and lines of flight.

It is precisely such a space that is created in Grandrieux's universe in which we find ourselves face-to-face with situations that resist containment within the petrified limits of knowledge. These situations demand of us a different kind of engagement that is not premised on understanding and yet which, by the same token, brings intelligence back into the fray by making us interrogate the limits of knowledge or what it is possible to know. Given all of this, this book sets sail on its journey in the full knowledge of its own insufficiency in the face of its chosen objects of study and yet its concomitant necessity in relation to them.

1

In the beginning

Via la vidéo [*Via Video*] (1975)

While it may seem somewhat counter-intuitive or even perverse to begin this survey of Philippe Grandrieux's career by talking about somebody else, this is in fact what we must do in order to understand his first video installation piece from 1975, *Via la vidéo*, a work that significantly and counter-intuitively once again also requires us to think about a time-based audiovisual media form via painting. In this piece, Grandrieux films the creation of a work by Claude Viallat and, subsequently, the work itself, the creation of his own video documentation being in turn filmed by another camera. But before we turn our attention to the three screen installation work that this methodology produced, let us briefly consider the work of the artist who figures in this work.

Claude Viallat was one of the founding members of an artistic movement called Support(s)- Surface(s) – 'support' being the French word for an artistic medium or format. The movement took its lead in many respects from the short-lived Groupe BMPT, a group of artists comprising Daniel Buren, Olivier Mosset, Michel Parmentier and Niele Toroni who wished to present paintings that would not elicit any emotional response from the viewer and would express only the brute fact of their own existence. To this end, each artist took a simple motif and painted it onto an unstretched canvas, caring little for pictorial perfection. Buren painted vertical stripes, Parmentier horizontal ones, Mosset painted a black circle and Toroni a repeated pattern of dots. The group displayed its works in 1967 at the Young Painter's Salon, but then dissolved within a year. The basic principles of Groupe BMPT were taken up, however,

by the artists of Support(s)-Surface(s), the main members of whom were André-Pierre Arnal, Vincent Bioulès, Louis Cane, Marc Devade, Daniel Dezeuze, Noël Dolla, Toni Grand, Bernard Pagès, Jean-Pierre Pincemin, Patrick Saytour, André Valensi and Claude Viallat. All of these artists were similarly united by a common goal to create paintings and sculptures that were, as far as possible, eviscerated of any form of subject or subjectivity, that referred not to the psychology or characteristics of either that which was figured in the artwork or that of the artist but, rather, only to the work of art itself, which is to say the way in which the work comes to be as a particular constellation of pictorial or sculptural elements within its given medium. As some of the members of the group wrote in the catalogue for an exhibition entitled *Painting in Question* that took place in Le Havre in 1969, an exhibition that was to lay the foundations of the movement to come:

> The object of painting is painting itself and the canvases on display relate only to themselves. They do not call out to an 'elsewhere' (the personality of the artist, his biography, the history of art, for instance). They offer no escape route, because the surface, through the ruptures created by forms and colours that are put into effect on it, prohibits the spectator's mental projections or dreamlike wanderings. Painting is a thing in and of itself and it is on its own terms that we must engage with it. This is not a question of a return to its origins, nor of a quest for an originary purity, but simply of a laying bare of the pictorial elements that constitute painting itself. (Bioulès et al. 1969)

While these principles remained an important aspect of the group's work as it gradually morphed into the Support(s)-Surface(s) movement a year later, a name adopted for a major exhibition in the Autumn of 1970 in l'ARC-Animation/Recherche/Confrontation (a research and exhibition space in Paris' Museum of Modern Art dedicated to contemporary artistic creation), it was the physical components of painting as a medium that were to become increasingly important. In different ways, each member of the group set out to reconfigure painting as a material practice, often dissecting the very material elements that lay behind the layers of paint generally considered to form what is termed a painting in order to perform a radical reconfiguration of the work of art, of what a painting was or

could be. For the group this was, after Barthes, an attempt to attain the 'degree zero of painting', a desire that led to various attempts to treat painting not so much as a representational practice but, rather, as a specific set of materials and gestural practices. As a result, Dezeuze would take apart his canvas' stretching frames and turn them into ladders or other quasi-sculptural objects; Saytour would fold and crease his canvases before applying pigment to them in this state; and Viallat would use a stencil to paint the same abstract form on an unstretched canvas, sheet or tarpaulin over and over again, the different material properties of the canvas and paints, dyes or pigments used producing different end results. As Viallat himself sums up these different approaches: 'Dezeuze painted frames with no canvas, I painted canvases with no frames, and Saytour painted the image of the frame on the canvas.'[1]

As well as wishing to reengineer precisely how a painting is constituted as a material object, the group also wanted to reconfigure the ways in which the painting as an object might connect with its viewers, as both a material and ideological object. Indeed, the practice of the group was deliberately low-tech and artisanal, an approach that tied into their anti-elitist, Marxist stance towards culture and the art market. Their exhibitions, meanwhile, contained works made of rope or stretcher frames that did not hang obediently flat against the wall but extended into the gallery space in unruly ways, forcing viewers to relate to them not as passive scenes to be contemplated via the gaze but, rather, as material obstacles to be navigated. Ideological obstacles eventually brought about the demise of the group when Viallat resigned from it in 1971 in protest at what he saw to be an overly politicized agenda, however, the whole movement then being dissolved in 1972 after a second collective exhibition in Strasbourg.

While the Support(s)-Surface(s) group was no longer in existence by the time Philippe Grandrieux made his own video work featuring Viallat, an understanding of the agenda and method of this group is crucial for a full appreciation of *Via la vidéo*, Grandrieux's first video work which, what is more, prefigures many aspects of his subsequent work across all of the different media he has worked in. Viallat's method had not changed much by 1975 (indeed, the working method employed for making his works has remained consistent well into the new millennium) as can be seen in one of the three black and white video segments of *Via la vidéo*. In this

we see Viallat creating one of his hallmark 'bean' canvases, laying out a large sheet-like canvas on the ground, carefully placing a broad-bean-shaped cut-out stencil onto the canvas, then using what resembles a wallpaper paste brush more than an artist's brush to apply a liquid dye or pigment to the canvas through the stencil. We then see Viallat repeating this gesture again and again until the canvas is filled with the bean shapes, roughly applied yet gridded in a strict geometric arrangement. We then watch Viallat apply a lighter shade of pigment to the white, undyed areas of canvas between the bean shapes with the same brush and then, once the painting phase of the work is complete, carefully tear an inch-wide strip of canvas from the entire perimeter of the work before tearing this remainder in half again and again until it forms a long rope.

Throughout this entire sequence, we see only Viallat's hands and feet as he crouches on the canvas and works its surface to create the work via a semi-automated procedure seemingly devoid of artistic control if not intent. Indeed, we do not have the impression of witnessing 'the artist' at work here (as is the case with documentary footage of Jackson Pollock at work, for instance) and rarely if ever catch a glimpse of the artist's face. Rather, true to the agenda of the Support(s)-Surface(s) movement, we are witness simply to the coming into being of an image via a specific material configuration and repeated set of gestures. This decision to elide the identity of the artist to focus on the creation of the work from within is deliberate and consistent with Grandrieux's understanding of Viallat's method. Indeed, Grandrieux sees in the use of a stencil to produce an image constructed from the repetition of a single shape an attempt to empty the work of intentionality, to create the necessary conditions for the work to generate itself from the inside without the hand of the artist imposing any other form on it[2] – this being in some ways an extension of the chance operations and internal forces out of which Bacon's paintings are generated. It is important to note also, however, that Viallat's work here also comes into being within a constraint imposed on him by Grandrieux, namely to create a painting in an hour (a constraint we will see him impose on other artists for a film project later in his career), a requirement that undoubtedly imposed a certain concentration of activity and made image creation the sole object of attention.

If in this first segment we then see the production of a work via a set of repeated gestures and material practices, the second segment

of Grandrieux's work shows us, in effect, this very same thing, for in it we see Grandrieux himself filming a collection of Viallat's canvases (including, we suppose, the one whose creation we have witnessed) hanging in an exhibition space (see Figure 1). Filmed by a mounted camera that pans only slightly to follow Grandrieux's movements and zooms in on him even less, maintaining a medium long shot for the vast majority of the segment, we watch Grandrieux and two assistants (one holding a microphone on a boom close to Grandrieux's face even though he does not say a word, the other shining a portable spotlight on Viallat's paintings) as they slowly walk around the gallery space to film different works, all the while stepping over one of Viallat's rope works laid out on the floor. Each time the group moves, we see Grandrieux stoop to pick up the heavy reel-to-reel video tape case and then slip the strap over his shoulder before placing it back on the ground as they come to a rest again, filming all the while. While we do not actually see the work materialize before our eyes as we do with the first segment, here also we are effectively witness only to the gestures required to

FIGURE 1 *Screenshot from* Via la vidéo. *Courtesy Philippe Grandrieux.*

produce a work of art via a specific technological configuration, this time, of course, *Via la vidéo*.

In the third segment of the work, we see the work itself whose creation we have just witnessed or, rather, we see the works whose creation we have just witnessed, for we see the video that was shot through Grandrieux's camera during the second segment, a video showing close-ups of Viallat's painting that we watched come into being in the first segment. Yet if one were to ask if, ultimately, what we see here is Viallat's work or Grandrieux's, one would have to answer that it is the latter's because what we attend to in this segment is not so much the abstract shapes and shades of Viallat's painting but, rather, changes in light, texture and shade and the various forms of movement in the image created by the shake of a handheld camera, pans, zooms and (as we know from segment two) dips as Grandrieux bends to set his equipment down. Even this answer is only partially correct, however, for it should not be thought that segments one and two (as labelled here) are simply the 'making of' portion of a work constituted by segment three alone. There is really no strict chronology or hierarchy between these video segments, and while it is of course possible to reconstitute a linear narrative across them, this is confounded by their actual presentation in the gallery space. For *Via la vidéo* is not simply a video work comprising these three video segments but an installation piece that was exhibited in the Galerie Albert Baronian in Brussels that consisted of three television monitors, each of which played one of the three segments in a continuous loop and, at the fourth apex of the square formed by these elements, the actual canvas created by Viallat in segment one. Finally, in a move consistent with the Support(s)-Surface(s) group's desire to reconfigure the space in which the work of art is exhibited and the viewer's relationship with that space, the visitor entering into the space between *Via la vidéo*'s constituent elements would find herself walking through and thereby leaving a repeated pattern of identical shapes (à la Viallat) traced in this work's last element, white chalk powder sprinkled over the floor.

In pointing out the confluence between many aspects of Viallat's work and Grandrieux's approach and suggesting that this work could be said in many respects to perform an enactment of the core principles of the Support(s)-Surface(s) group via the medium of video rather than painting, there is no intention to claim that Grandrieux's work is derivative in the extreme. Rather, it is my

intention simply to suggest that in choosing to film Viallat and to use one of Viallat's art objects as the subject matter for his own work, it is undoubtedly the case that Viallat's approach is one that resonated strongly with Grandrieux. In spite of this confluence and resonance, however, what we ultimately witness in *Via la vidéo* goes beyond the principles laid down by the Support(s)-Surface(s) movement and Viallat, for this is a work in which there is not only a medium-specific operation and gesture that draws our attention to the materialities and material practices of the work of art, but also an intensification of the material and immaterial relations that are involved in the creation and reception (which is to say re-creation) of the work of art in a multisensory temporal art form. Indeed, in *Via la vidéo* we are invited to attend to the relations instigated between the original source text (Viallat's painting) and Grandrieux's final work, the relations between the members of the film crew and the subsequent interplay of light and movement produced out of their slow-motion ballet. We are invited to attend to the relational dialogue between light and recording technologies as different levels of lighting wash out the image in a brilliant overexposure or bathe areas of the image in darkness as the light moves away, or create brilliant points of white intensity that burn into zones of underexposed gloom when the camera faces into the light, leaving flares and halos in its wake. We are invited to attend to the relations between various segments of sequences that may seem to gesture towards some kind of pre-established narrative trajectory or teleology; yet, ultimately, they refuse containment within anything so facile, remaining constantly mobile in relation to each other. And we are invited to attend, finally, to our own embodied relation to the work of art we find ourselves faced with.

It is precisely these kinds of relations that we will be invited to attend to again and again throughout Grandrieux's career. This is not to say that he has spent his entire career making the same work over and over again, à la Viallat; on the contrary, this relational logic has played itself out in very different ways across Grandrieux's career as he has turned his hand (and eye and body) to different situations, different contexts, different media, different formats. In every case the work in question is produced out of a series of relations that is never reducible to Grandrieux alone but is rather the result of an active collaboration between source text, context, ambient conditions, technology, time, light, crew, actors

and audience. It is for this reason that in what follows I will not
indulge in a lengthy biographical exposition and introduce scant
biographical detail only when it is relevant to the genesis of the work
under consideration. Somewhat perversely, we might then suggest
that while ostensibly a book about Philippe Grandrieux, this book
is resolutely not about Philippe Grandrieux, and in saying this we
would, of course, remain true to the post-identitarian politics that
we find in some of his mature works.

2

The television years

It is perhaps unsurprising that Grandrieux's career is characterized by a truly collaborative mode of creation given his beginnings in the television industry. Indeed, even though the notion of *auteur* cinema is one that has been highly problematized since the time that the original manifestos were written by the *Cahiers du cinéma* critics who were to form the New Wave of French cinema in the 1960s and 1970s, what is certain is that the figure of the omnipotent authorial figure whose personal vision infuses every aspect of his or her creative output is one that holds even less water in the TV industry than it ever did in the world of the cinema. This does not mean that we should in all cases leave aside the work carried out by Grandrieux during the twenty or so years that he worked in television, although in some cases it actually does. This is so in particular in relation to the twenty-six-part historical documentary series *Le Siècle des hommes* [*The Century of Man*] in spite of the fact that Grandrieux is credited as the director. Every episode of this series is very standard fare for TV programmes of this kind – consisting of newsreel footage with original dialogues and a narrative voiceover intercut with interview footage of commentators and people who witnessed the events in question – and should be considered nothing more than a commissioned work with a brief so precise that Grandrieux was left no room to place his personal stamp on any aspect of it. This is by no means the case for the majority of the programmes that he directed, however, even when they resulted from commissions, and there is much in his work for this medium that resonates strongly with the themes and formal experimentation that we find in his cinematic, photographic, installation and performance works later on. Indeed, looking back through Grandrieux's televisual output, one is left with the strong impression that, firstly, this work introduced him

to more texts and figures that only took further the kinds of ideas about image creation that we find in *Via la vidéo* and, secondly, that from within this relatively regulated and regimented sphere in which creative control is often anything but absolute, Grandrieux was nonetheless able to use this space as a kind of laboratory for early experiments that would find their full expression in other kinds of works later in his career.[1]

This desire to conceptualize the industrial sphere of television production as a space in which to enable new audiovisual grammars and modes of expression to emerge is signalled nowhere more explicitly than with Grandrieux's creation, in 1990, of a curated series of films-cum-research lab called 'Live' that produced for La Sept and FR3 fourteen-hour-long unedited sequences directed by renowned visual artists and film-makers including Robert Frank, Steve Dwoskin, Robert Kramer, Thierry Kuntzel and Ken Kobland, all of whom were given two constraints by Grandrieux, namely, to produce a one-hour film in one take. While Grandrieux never imposed this same constraint upon himself outside of the film he himself shot for this series – even if this is not dissimilar to the methodology that he employed in filming the video segments of *Via la vidéo* – much of the work that he directed and shot for television can similarly be understood as an attempt to work within the constraints of a medium and situation in order to find ways for those centripetal forces to produce an image that would exceed the habitual forms and modes of expression of that medium and situation, producing a centrifugal force within that image that would take it beyond that to which generic conventions would ordinarily restrict it.

In saying this we are here very close to Deleuze's analysis of the lines of force and figural movements of Bacon's paintings that has been said to be so seminal for Grandrieux's thinking about the cinema. If we go right back to the start of his career in television, however, we can see very similar ideas play out through a different art historical referent.

La Peinture cubiste [*Cubist Painting*] (1981)

Co-produced by l'INA and TF1 and commissioned for the French television series *Regards entendus* [*Looks heard*], *La Peinture*

cubiste is a 49-minute film co-directed by Philippe Grandrieux and Thierry Kuntzel. It is wonderfully described in the online catalogue of Electronic Arts Intermix, an online resource for the creation, exhibition, distribution and preservation of media art, as follows:

A multilayered, elusive investigation of the perception of reality and representation through cinema, painting and video. Unfolding as an evocative, implied fictional narrative, this work was suggested by a Jean Paulhan text in which a man experiences and perceives everyday life as though in the multifaceted space of a Cubist painting. Alternating between film and video, Kuntzel and Grandrieux explore physical and psychical perception, constructing an analogy between the way video transforms conventional filmic representation and the way Cubism fractured the perspectival codes of classical pictorial space. Shifting between abstraction and materiality, the real and the imaginary, this work suggests passages between painting, cinema and video.[2]

While in many respects an excellent account of what we find in this work, it is nonetheless important, I believe, to resist the idea posited here that the different modes of representation that we find in Grandrieux and Kuntzel's work are intended to portray, alternately, 'the real and the imaginary'. *La Peinture cubiste* is, far more simply, an attempt to translate into audiovisual form Jean Paulhan's text of the same name and to do so not only by creating sequences that would in some way illustrate the events and commentaries of the voiceover – composed of extracts from Paulhan's text *La Peinture cubiste* (1990) – but also by exemplifying the radical break with prior modes of representation that Cubism represents for Paulhan. In breaking with realist representation as this term had been understood until the end of the nineteenth century, however, we do not automatically break away from the real and enter a purely imaginary realm. On the contrary, Paulhan's claim is rather that the prior modes of representation he kicks against were in many respects divorced from the real and that Cubism actually brought us into contact with the real for the first time.

The problem, as posed by Paulhan, is firstly that the classical mode of representation wishes to transmit a certain truth about the world that it represents, taking as its subject matter lofty

metaphysical categories such as 'Justice, Vengeance or Crime' (1990, 46). This leads to a somewhat petrified vision of reality in which everything is 'stuck, monotonous, regular; fixed in place once and for all' rather than 'transforming itself before our eyes with every passing moment' as does reality (46–7). According to Paulhan, for the cubist painter who reacts against this model, 'ideas tend to cut us off from things, they form a kind of self-sufficient, closed-off world, separated from reality' (47). This problem is exacerbated further still for Paulhan by the *trompe-l'œil* aspirations of classical still-life painting that is amusing if it manages to trick a monkey into thinking that a painting of an insect is indeed an insect, yet little more than amusing (86). Leaving monkeys aside, Paulhan goes on to argue that this school of (particularly still-life) painting is doubly separated from the real because it is not able to take every object in the real world as its subject matter due to issues of scale (86–7) but also, and most importantly, because it is dependent on the laws of perspective. These laws reduce the world to an artificially fixed point of view abstracted from an actual, constantly mobile point of view that would correspond to how reality is actually perceived (just as such paintings strive to render invisible all signs of the *painter*) and in the process imbue the idea with a primary ontological status. In a 'realistic' painting that obeys the laws of perspective, this is to say, all objects need to be represented from one single point of view and this representation is in turn observed from a fixed, immobile point of view, all objects being treated as though they were 'contained in a cube or rather a regular parallelepiped' (91) and lit by a single light source (92). This intransigent prescription has, for Paulhan, a possible advantage, namely that it makes us believe that 'we live in a simple world, where events take place in the right order, according to axioms and demonstrations, without any unfortunate surprises'. But here also lies perspectival art's fundamental failing, namely, 'That it is not realistic. It does not resemble the world in the slightest …, our everyday spaces with all of their difference and chaos' (104). In sum, as he writes, 'The major fault of perspectival paintings is that they do not show us the world so much as a collection of takes on the world, less the objects themselves than our idea of the objects' (106).

Paulhan's text, however, should not be thought of as simply a diatribe against the dogma of classical realist painting; his reflections on this subject, indeed, are prompted by his desire to understand the

motivations behind the work of the modern or, more specifically, cubist painters that his work addresses primarily. As he writes in a text quoted in the voiceover of Grandrieux and Kuntzel's film:

It is not enough simply to say that modern painting is different from classical painting. It occupies within us a different place. It awakens new feelings; unexpected desires and sometimes disgust; we know not what stance to adopt, what desperate love it invokes with its fear and mystery. It would appear, ostensibly, that it aims not so much to please as to inflict itself upon us. And it is as though through these forms man had discovered – or perhaps rediscovered – an emotion as different from the aesthetic pleasures of old as love is from greed or the sacred from the profane. What emotion? It is not easy to say. Yet it must be one that evades clear reason, that is on the side of all that is hidden and secret rather than on open display. (32–3)

More than this, however, for Paulhan modern painting does not only create a different emotional response, it brings into being an entirely different sensory mode of reception. In another passage quoted in the film, Paulhan suggests:

It would then seem that in modern paintings the sense of touch takes precedence over the sense of sight, and tactile space over visual space. It is as though our gaze were nothing more than an extension of our fingers, an antenna on our forehead. (28–9)

As Paulhan explains in the third chapter of his book, his insights into the new sensory and spatial configurations brought to life in cubist paintings came about, in part, thanks to 'A small adventure in the middle of the night' – this being the title he gives to this chapter. The story goes, as recounted by Paulhan in his text and in words and images in Grandrieux and Kuntzel's film, that Paulhan returned home late one night to find that the table lamp he would normally have used to find his way to the sofa on which he would sleep after late-night outings was broken. Not wanting to wake his wife who was already asleep, Paulhan decided to flick the switch of the main room light on and off quickly enough as to not wake his wife yet sufficiently to let his eyes register all of the obstacles that lay in his path (61–2). With this brief flash of images burnt into his retina,

Paulhan proceeded to traverse this space, feeling his way through it, using his hands as a substitute for his eyes which were no longer able to recognize the identity of things, only the residue of their forms. He writes:

> You will say that I couldn't see anything. On the contrary, I had seen each of the obstacles before me perfectly, I had never seen them so completely, I had almost seen them too much in this blinding light – as though they had never been there before; as though they had just been created; as though they had just created themselves! ... One might even say that I could see them from all sides at once. Because, indeed, I was able to register the back and sides of things as well, or as badly, as I could the front and the underside of the table was no less familiar to me than the tabletop. (64–5)

The effect of this on Paulhan is revelatory. As he explains, 'At the very moment that a third clock started to ring two o'clock, a curious feeling came over me, namely that I had crossed through the space of a modern painting' (64). As should be clear by now, for Paulhan this transport into the universe of modern painting is resolutely not a derealization, a journey into a fictional realm divorced from the real. On the contrary, it marks a passage into a space in which he is able to experience reality more directly than ever before, a space in which the sensory and perspectival hierarchies that had previously held him apart from reality are reconfigured and dissolved. He writes:

> It was the opposite of a dream, on the other side of thought; not one of those fluid spaces that gets gradually deeper; no, this space was perfectly opaque and voluminous; and I was no less voluminous nor opaque. Two of a kind. (68)

At this point you may well be tempted to ask what all of this has to do with Grandrieux, since it is undoubtedly not necessary to have such an in-depth analysis of Paulhan's text to be able to appreciate the use to which it is put by Grandrieux and Kuntzel in their film. If I have paused to reflect on this text for so long, however, it is because I believe this to be another one of those foundational texts that is crucial for an understanding of Grandrieux's work

across his entire career. If his early installation piece dealing with the method of Viallat revealed to us a fascination with how an image comes into being, *La Peinture cubiste* carries this interest further and supplements it with an extended reflection on not only the production of the image but, further, its reception. Indeed, if Grandrieux and Kuntzel chose to adapt this text for the screen, it is undoubtedly because it resonated so strongly with them and the approach that they would adopt towards their own work across their careers. Here, of course, I must limit myself to talking about Grandrieux, so let me suggest that if Paulhan's text is so significant for Grandrieux, it is because in it we find an extended reflection on the capacity of the work of art to instigate a different, more direct form of relation between itself and the viewer via formal innovation and a search for new modes of presentation that do not obey the representational precepts of old that operate via a principle of assumed direct equivalence. This, for Paulhan, in a phrase that resonates strongly with much of Grandrieux's work, is a procedure akin to that of the fairy tale, yet no less real for being so. Paulhan writes: 'Fairy tales, even religions, were invented, I imagine, to make us understand an event far stranger than a mere tale, yet real' (58). When art achieves this goal and makes us see the real anew, what opens up before us is, for Paulhan, in another phrase that will become extremely significant later in Grandrieux's career, nothing less than a new life ['il s'ouvre à nous une vie nouvelle' (59)].

As rigorous as it is in its prosecution of Paulhan's text, Grandrieux and Kuntzel's film is anything but a dry, theoretical treatise that lays out principles to be followed elsewhere. It is rather already an attempt to put these principles into action via formal means. The film itself consists of a monologue made up of excerpts from Paulhan's text read by Constantin Jelenski that serves as a voiceover to images of the scene recounted: Paulhan feeling his way across his apartment, the objects around him, Paulhan flicking through books of cubist paintings, flicking the lights of his studio on and off as he returns home, his wife Marguérite asleep. These scenes are not presented in any kind of logical order, following no strict, linear chronology that would be determined by the narrative logic of the adventure recounted by Paulhan – and even though the film's monologue seems very coherent, much the same can be said in relation to its treatment of the original text since the excerpts selected by no means appear in the sequence of the original but

are, rather, radically reorganized. This reorganization does not in any way affect the film's adherence to the theoretical content of Paulhan's text, however, and this can be said in relation to both the voiceover and the image. The film is made up of alternating sequences shot on film and video, and it seems at first as though these are intended to correspond to the classical model of painting critiqued by Paulhan and the cubist mode of representation that he favours respectively. It is easy to see why: the sequences shot on celluloid, often from a subjective point of view, show us the world around Paulhan with all of the clarity, impression of depth and indexical qualities that we have come to expect analogue photography to provide us with. The video sequences, however, are markedly different. These video sequences are, firstly, shot on the kind of camera favoured by Kuntzel for much of his video work, namely a Paluche camera, a very small cylindrical camera that outputs a black and white signal. This type of camera could not be more suited to the use it is put to here: just as Paulhan's text evokes an apprehension of the world taking place in a tactile rather than visual mode, through an immanent, sensory contact with the real rather than via the fixed perspective of vision that holds the world at a distance, so the Paluche camera is, for Kuntzel, more of an extension of the hand rather than the eye – precisely as in Paulhan's text.[3] The video images in the film differ even more markedly from the 35 mm images, however, because they are presented not in their raw, black and white form but, rather, altered in post-production with a video synthesizer that assigns different colours to varying levels of luminescence. The result is an image that is removed from the realistic reproduction of reality by 35 mm film not only thanks to its highly artificial colouration but also to the total absence of depth, the perspectival regress of the image flattened into a two-dimensional space by the conversion of degrees of light into different zones of colour. This is an image produced, as per the tenets of Paulhan's text, not from a point of remove but, rather, via an active reconfiguration of the real in the very act of representation, such that the image becomes a far truer reflection of the real since it expresses our embodied relation with it.

While what I am describing here is entirely consistent with things that I will say about much of Grandrieux's later work – and it is tempting indeed to see a direct correlation between the video sequences of this film and Grandrieux's use of a thermal camera

in *La Vie nouvelle* [*A New Life*], both because of the appearance
of the image and the way in which the image is produced – a note
of caution is required nonetheless. Why? Because, quite simply, the
division of labour on this film was such that the video sequences
were shot by Kuntzel and the 35 mm sequences by Grandrieux. While
the work is in many respects a collaborative one, then, and while
it is undoubtedly the case that the Paulhan text resonated strongly
with both Grandrieux and Kuntzel, it would be inappropriate to
see these video sequences as precursors of Grandrieux's approach
later in his career – all the more so since while they are similar in
many respects to certain aspects of Grandrieux's later work, they
are entirely consistent with other work by Kuntzel from around
this period. This does not mean in an absolute sense that the
35 mm sequences of *La Peinture cubiste* should be looked over as
an important element of the aesthetic development of Grandrieux's
approach to film-making, however, in spite of the fact that the
sequences he filmed are, for the most part, intended to correspond
to the classical representation of perspectival space that would then
display none of the radical moves effected by cubist painting and
Kuntzel's segments. Indeed, just as in Paulhan's text the subject's
view of *all* reality is forever more reconfigured by the radical new
relation to the real instigated by cubist painting ('a new life opens
up before us'), so it is necessary for some of the 35 mm sequences
to break with the conventions that they establish and find a way to
record reality otherwise.

This is done, firstly, by establishing serial relations between the
objects in Paulhan's apartment that are filmed in both the video and
35 mm sequences including, significantly, shots of a hand touching
various objects, turning them over, reaching through air for solid
matter via which to orient the subject in space. For Raymond Bellour,
continuity is established across the film's different segments also by
the voiceover that floats above all of them indiscriminately, often
(although not always) caring little for the precise content of the
Paulhan text (2013, 200). Most significantly, however, Grandrieux's
filmed sequences seek to emulate something akin to what we find
in Kuntzel's segments via the use of repetition, alterations to the
rhythm of cuts and subtle changes in the lighting of recurring
images. Raymond Bellour has carried out a close analysis of two
such sequences in an essay contained in his volume *Between-the-
Images* (2013) and he concludes this analysis by suggesting that

what is produced out of the relation between the film's different segments is an indiscernibility between the two formats used. He writes:

A turnabout is performed between these two segments, following a variable curve, until the identical emerges, between surfaces (or thicknesses) and depths: between cinema and video. In what they represent, both materially and historically, the paintings presented here serve as physical supports and as metaphors for this undertaking, which allows the film image to be confronted with the video image that doubles and transforms it. (2013, 204)

While Bellour's specific interest here lies in the transformation of the film image by the video image that offers up new possibilities of synthetic treatment and thus feeds back into the hermeneutic frameworks through which all images are read, at stake in his analysis more fundamentally is a core question, namely, 'how, in a work of fiction (in cinema or video, cinema and video), can reality be treated, varied or transformed on the level of the body itself, on the level of the surroundings that frame it?' (2013, 199). To put this another way, how is it possible for the image to avoid 'the problem that has haunted cinema', to stop the image always being sublated into a psychic or symbolic scene or reduced to 'a value or fantasy that can be isolated in the figure', instead to allow the image to transform bodies 'into a pure vibration of colors, lines, and light' (2013, 199)? It is for this reason that we must consider *La Peinture cubiste* to be of interest to Grandrieux's career in relation to both the aesthetic questions broached by Bellour here and the politics of the image that subtends his analysis. Indeed, the 'problem that has haunted cinema' for Bellour is, in many respects, the very problem that Grandrieux will struggle against later in his career when making fictional works for the cinema. What is more, the treatment of light and intense and careful attention to the materiality of the image in *La Peinture cubiste* analysed by Bellour are elements that will only become more pronounced as Grandrieux's career progresses. These elements, indeed, head towards a possible solution to the problem of cinema Bellour identifies and are worked through by Grandrieux in his later work without recourse to the more obvious synthetic treatment of the video image we find in Kuntzel's work. In saying this, the theoretical import of Paulhan's text becomes all

the more striking, because what is being claimed, in effect, is that Grandrieux will strive throughout his career to forge the kind of space described by Paulhan. To do this, he will, like Paulhan, need to break through the invisible wall erected between the spectator and the world by the classical perspectival stance to create a space in which – as per Paulhan and, indeed, Bacon – the relations between background and foreground, spectator and image, light and matter become entirely liminal such that each term in any of these dichotomous pairs becomes, like Paulhan himself, 'perfectly opaque and voluminous, ... two of a kind' (68).

Juste une image [*Just an Image*] (1982) and *Une Génération* [*A Generation*] (1982)

Much of Grandrieux's work in television in the early 1980s saw him in the role of producer more often than that of director. This work is not entirely without interest for the present study, however, since his role as producer often involved him in the conceptualization of television programmes and, in some cases, their curation. In 1982 he was the co-producer (with Thierry Garrel and Louisette Neil) of a series of nine 55-minute programmes entitled *Juste une image* [*Just an Image*]. Broadcast monthly on France 2, this programme was essentially a series of (often experimental) short films united by their interrogation of the ways in which an image comes into being or is transmitted and received. Showcasing work from around the world in multiple formats (TV, cinema, video, digital image production, photography), the series, as indicated by its title, set out to engage its audience in a reflection on the image itself rather than the content or meaning carried by that image. Given the nature of the format, there is little point commenting on any of the individual pieces by other artists – although it is interesting, given Grandrieux's fondness much later in his career for creating installation pieces filmed in a vertical rather than horizontal aspect ratio, to note that one episode contained an excerpt from Brian Eno's *Mistaken Memories of Medieval Manhattan* series (1980–1) in which we see a section of the Manhattan skyline filmed from Eno's apartment by a camcorder left on its side, producing an image that thus needs to be viewed in a vertical aspect and was intended to

be shown on a television turned on its side, as we see clearly in the presentation of this work as shown on *Juste une image*.

Grandrieux himself directed one segment for this show, *Petits écrans du Caire* [*The Small Screens of Cairo*]. In this short film, we witness various wide shots of different settings in Cairo – a workshop, a barber shop, a café, etc. – in each of which can be found a television. In each of these successive shots, the only moving image is to be found on the screens of the televisions we see in these settings since these broadcast soap operas, football matches or variety shows, while the rest of the shot is frozen, as though it were a still image. The effect is striking, for rather than being drawn to the tiny moving picture on the television screen within our television screen – as are all of the people in these shots who are literally transfixed by the TV, situated in that part of the image whose movement has been arrested – our eyes are rather pulled across the whole image, free to appreciate the composition of the image, the saturated high-contrast, almost surreal colour palette, the wonders of the everyday objects in this place. Occasionally the image cuts to a close-up shot of the television set in the shot, as though we had become one of the inhabitants of Cairo oblivious to all around them, able to see only the images on the screen before them, but rather than render these TV images less banal, they appear even more so since we can no longer see the far more aesthetically interesting world in which they are situated, a world filled with local colour and specificity that is in stark contrast to the broadcast images that could originate from anywhere at all.

TVs within TVs, the status of the image and the banality of consumer culture all figure prominently in another short film that Grandrieux made in 1982, though they are, this time, invested with a political charge. *Une Génération*, shot in black and white, was made by Grandrieux for another INA-produced televisual anthology entitled *Le Changement a plus d'un titre* [*Change has more than one name*]. It begins with a shot of a television set that seems to float in a void, moving into the centre of our screen as the handheld camera pans across it until it brings it to the centre of our screen, then slowly zooming in so that we can see the image it broadcasts. At this point, the *mise-en-abîme* is taken further still as we see, face on, a group of well-dressed twenty-somethings watching a television in an apartment. A subtitle appears reading 'mai 1981' and we quickly realize from the conversations in the

room and the announcements coming from the programme they are watching that we are witnessing the overjoyed reaction of a group of friends at the very moment when the election of François Mitterrand was announced, France's first socialist president under the Fifth Republic who brought with him France's first left-wing government in twenty-three years. We cut to footage of people celebrating in the streets – still filmed from a television – and a voiceover provides a commentary on this intense outpouring of emotion, seeing it as entirely natural and recognized as such by a massive storm in Paris that night. As we hear a peal of thunder, the image of celebrations on the television is slowed down to a pace that is held as we cut to scenes of May '68 and Jimi Hendrix's 'Machine Gun' takes over the soundtrack. As the television screen still seems to float before us, on it we see now famous images of a student hurling a Molotov cocktail, the image slowed then frozen as though it were being animated by stop-motion and inviting us to see in this image of violent rebellion a balletic impulse. We cut to a series of other iconic images from the riots of May '68 that appear and disappear, each one brought before the camera in time with a strobing light that continually returns the screen to black as participants in the events of May '68 talk in voiceover about the impetus behind their actions and their deep-seated commitment to an anti-establishment ideology. As they talk, the images we see are interspersed with images of other key left-wing figures of the time: Mao Zedong, Che Guevara, Jean-Paul Sartre.... We cut and see appearing on the TV screen, line by line, a computer image of Mitterrand that seems as inhuman as the machinic hum that accompanies it on the soundtrack.

This image from the present of the film effects a shift in time and focus, for when we return to the voiceover narrative, it now recounts a gradual shift towards democratic ideals, an abandonment of ideologies whose effects can be nefarious and bring about a concentrationary rather than liberatory political climate. As we listen to this narrative, we are shown a succession of images of just such political contexts before the camera pans quickly across them to take us back to our original shot of video footage of friends celebrating on election night. Rather than hear their conversation, this time, however, as they toast a new era for France, a voiceover asks, 'Who are we today? Have we changed? Have we grown old? Have we become more responsible? What is the division between

responsibility and servitude? Between reason and submission?
What is it to be left-wing today?'

An answer to this question is subsequently provided by one of
the '68 interviewees who suggests that to be left-wing today is to
live an 'ancient nostalgia, an old utopia', a kind of melancholy for
Bloom, Lenin, the Battleship Potemkin, Vertov, at the same time as it
is an assertion of the uncertainty of the times. The second interviewee
adds a slightly different perspective, voicing disappointment
with the current climate and the total political disengagement of
young people today who care nothing at all for the situation in
El Salvador – this being the period of the Salvadoran Civil War
and the El Mozote massacre carried out by the Salvadoran Armed
Forces. Both of these interviews, however, play out over the top
of an image on the still mobile television screen that provides yet
another answer to this question and perhaps suggests a reason for
this political disengagement, namely, the now infamous images of
Mitterrand, eleven days after his election, supposedly spontaneously
visiting the Panthéon to lay a rose on the tombs of great men who
had died for the freedom of their fellow citizens: socialist leader
Jean Jaurès, Resistance hero Jean Moulin and slave abolitionist
Victor Schoelcher. If the preceding sentence reads somewhat
strangely, this is entirely normal because this incident has become
so infamous precisely because it was not a run-of-the-mill tradition
that any newly elected president would be expected to perform but,
rather, a carefully orchestrated media event, meticulously planned
in advance, directed by Serge Moati and designed to upstage former
President Giscard d'Estaing's farewell ceremony two days earlier.
If Mitterrand was able to enter the mausoleum carrying but one
red rose, a symbol of socialist ideals, yet to lay down, seemingly
unaccompanied, a rose on each of the three tombs he visited, this
is because the whole event was so carefully staged, choreographed
and edited.

The message could not be clearer: if the youth of today are
disengaged from politics, then this is because politics in France has
become nothing more than media spectacle, 'juste une image' we
might say, a symbolic event that one watches on TV from the safety
of one's living room over a glass of wine or two. Fittingly, it is at this
point that the Tom Tom Club's 'Genius of Love' starts to play, one
of the 1980's most iconic songs that gives expression to this same

shift from the political activism of the 1960s and 1970s to the self-indulgent, mindless hedonism of the 1980s with its opening lines:

What you gonna do when you get out of jail?
I'm gonna have some fun.
What do you consider fun?
Fun, natural fun.

Underneath this soundtrack, however, the images strobing before us show scenes of bloody massacres, dead bodies, political protesters lying face down in the street with their hands behind their heads, watched over by armed soldiers, Ronald Reagan, Castro meeting Brezhnev, guerrilla groups. We pan back to the TV screen on which we now see slow-motion footage of Giscard d'Estaing's final farewell as president; as he stands and turns away from the camera, marking a turning point in France's history, one of the interviewees comments how surprising it is that France should vote the left in at this particular moment in history, when the whole world was running scared and implementing extreme fiscal conservatism in the face of a looming financial crisis. That, for the interviewee, is a good thing.

Grandrieux's film does not end at this point, however, nor does it seem really to share this positivity. Indeed, in the film's final sequence, the camera pans quickly away from the television to stop on a hand, which picks up and then discards, under a strobing light, a series of Polaroid images of consumer culture – a McDonalds cup set against the backdrop of a McDonalds logo, the drugstore on the Champs-Élysées, a video store, advertising images, a sign offering free credit – all of which are accompanied by Laurie Anderson's 'O Superman', the anthem to a dehumanized, automated, militarized society devoid of human compassion if ever there was one. As is clear from this ending, Une Génération is obviously a critique of the different level of political engagement between the generation of May '68 and that of 1981, but it is also consistent with all of Grandrieux's work up until this point insofar as it is also a meditation on the image. While it would undoubtedly be an overstatement to suggest that there is here a relation of cause and effect, what seems incontrovertible is that the shift from the iconic or ultraviolent images of political struggle or political repression to expendable

FIGURE 2 *Screenshot from* Une Génération. *Courtesy Philippe Grandrieux.*

Polaroid images of throwaway consumer culture functions as a call to arms, an invocation to the viewer to understand the power of the image and its potential to forge a more meaningful contact between the world it depicts and those who come into contact with the image. To fail to realize this, to allow our relation to the world to become as fleeting, transitory and shallow as a Polaroid image is, in effect, to throw away an entire generation – and this is precisely what is suggested by the film's final shots of Polaroid portraits of young adults being discarded (see Figure 2).

The 1980s

Grandrieux would subsequently take his own call to arms seriously and continue to interrogate the power of the image and its relationship to the world and the real it represents. In 1983, along with Thierry Kuntzel and Jérôme Prieur, Grandrieux conceptualized

and directed a programme for France 2 under the auspices of l'INA entitled *Pleine lune* [*Full Moon*]. Grandrieux himself carried out and filmed an extensive interview with Orson Welles for the programme and found an obvious ally in doing so. Welles, indeed, rails against the current state of film and television in this interview, suggesting that the introduction of sound and colour to moving pictures brought these media forms closer to an approximation of the life of the public, meaning that less was asked of the public which, in turn, lessened the impact of these media forms. In a commentary that resonates very strongly with what I have suggested of *Une Génération*, Welles is particularly critical of the television news:

> You don't assist television, it's just on, like the *lumière*, and [Anouar el-] Sadate is killed and Lux soap is used and people sit eating food during, while a soldier bleeds to death in Lebanon and it's unreal. The first act is to give up watching the news, very hard to do, because you imagine you are getting more than you do.

The rest of this programme does not give up on television, however, but, rather, seems to want to reignite in the viewer something of that original sense of wonder, promise and potential that the medium held for its early viewers. The remainder of the programme, indeed, is made up of a medley of clips that talk to the different ways that moving images have been created, disseminated and perceived since the nineteenth century. It contains, among other things: a clip from Méliès' *Éclipse du soleil en pleine lune* [*The Eclipse: The Courtship of the Sun and Moon*] (1907); an archival clip from the very early days of the television in France (1930) in which a woman lights a cigarette and asks the viewer to marvel at how realistic the curls of smoke look on the screen before her; an interview with V. Ronchi, director of the Institute of Optics in Florence; examples of video effects; a clip from 1890 shot on a chronocinematograph showing a visual breakdown of the human body in motion; an interview with Alexander Shure, director of the New York Institute of Technology, claiming that with special effects we can now render any image that exists in an artist's mind; examples of digital images produced at MIT in 1983; an archive clip of Nixon talking to the crew of Apollo II on the moon; an interview with Audouin Dolfus who explains how light

passes through the atmosphere and the why and how of filming
the sun; the video of the Residents' song 'Perfect Love', one of four
1-minute films made to accompany their album of 1-minute songs,
The Commercial Album (1980); an interview with Nam June Paik
talking about his use of the video format; a clip from a 1935 French
variety television show; Paik's 'Lake Placid'; a clip of a video game;
Pope Pius XII's television address from 1950, the first time a pope
had made an address to a television audience, in which he talks of
the link between religions and television, claiming that the latter can
help turn around the decline of the former; the Eurythmics' video
for 'Sweet Dreams (Are Made of This)' (1983); a demonstration
of computer analysis of mouth movements for simulated speech;
an extract from Fritz Lang's *Metropolis* (1927) showing Maria's
awakening; more of the interview with Orson Welles in which he
talks about the marionettes of Osaka and how a computer will never
be able to render the human; the one-way mirror scene from Lang's
The 1,000 Eyes of Dr Mabuse (1960); some early experiments in
3-D television images from MIT; an extract from a 1965 variety
show with Johnny Hallyday and Sylvie Vartan; and an image of a
solar eclipse accompanied by the musings of Jorge Luis Borges on
the different words for moon across different languages.

As is hopefully clear from this enumeration of elements, there is
here no particular didacticism, no single narrative core that would
unite all of these disparate elements into a unified whole, which
is not to say that there is no intended message behind the images
that we are presented with. This message, however, as with *Via la
vidéo*, *La Peinture cubiste* and *Une Génération*, is generated by the
ways in which the individual elements resonate together across the
whole – a methodology akin, perhaps, to the intellectual montage
of the 1920s Soviet film-makers. Even though this message seems
often to be somewhat pessimistic about the current state of the
image, what is clear is that Grandrieux still believes in the capacity
of the artist or creator to harness the power of the image in such a
way as to forge an entirely different relation with the world.

This idea is expressed in a somewhat surprising yet very direct way
in Grandrieux's next project for television: the conceptualization and
creation of a pilot for a new series he was commissioned to produce
by l'INA, *Grandeur Nature* [*Life-Sized*] (1984). The concept of
the programme was to pair up a fashion stylist with a pop music
icon and to document the transformation of the pop star's image

resulting from this meeting. For the pilot (and only) episode directed by Grandrieux in 1984, the pop star Sheila – who found fame in the 1960s but still enjoys continued success in France today – was made over by a very young Jean-Paul Gaultier. The documentary itself is of little or no interest in relation to the development of Grandrieux's own aesthetic, nor really is the video that he directed for Sheila's song 'Emmenez-moi' ['Take Me Away'] (1984) that features in the documentary and in which Sheila wears the outfits designed for her by Gaultier. Even though we find here none of the formal innovation that would come to characterize his later work, however, *Grandeur Nature* is still testament on a conceptual level to Grandrieux's belief in the transformative power of the image.

After an early foray into the world of feature-length fiction films working as first assistant director on Raúl Ruiz's *Treasure Island* (1985), from 1985 to 1989 Grandrieux continued to explore the potential of the image and the medium of television to transform our perception of the world around us in documentary works such as *Long courier* [*Long Haul*] (1985), *Comédie/Comédiens* [*Acting/ Actors*] (1986), *Berlin* (1987), *Berlin/Paris/Berlin* (1987), *Le monde est tout ce qui arrive* [*The World is Everything that Happens*] (1987) – a series of thirty 15-minute news segments for a local television station in Saint-Étienne – and *Azimut* [*Azimuth*] (1989), a four-part series produced for FNAC TV interrogating the nature and status of the image. Each episode of *Le monde est tout ce qui arrive* juxtaposes footage filmed in Saint-Étienne over a two-day period with world news items from the same period. Items of local news, footage of local residents or local children reading out world news summaries thus rub shoulders with images of major political figures and events overlaid with text explaining the context of the images. In doing so the series exemplifies its title, putting on open display the radical discontinuity and incommensurability of scale that exists across events taking place within a strictly delimited temporal frame. There is undoubtedly a political dimension to this methodology, yet the form this takes is arguably not fully apparent until we read a text written by Grandrieux a few years later as a pitch to Canal Plus for a themed evening of programmes on the topic of 'Television, Power, Morality'. Arising out of his frustration at the increasing difficulty of creating an image of reality that would be radically different from the dominant mode of televisual representation, Grandrieux's text is a voiceover monologue that

kicks against the insidious normativity of the television image.
Quoting Heidegger's own vituperations against television's tendency
to lump everything together 'into uniform distancelessness', a fate
that for Heidegger is in many respects worse than the destruction
of everything in a nuclear apocalypse – 'Is not this merging of
everything into the distanceless more unearthly than everything
bursting apart?' (Heidegger 1971, 164) – Grandrieux writes:

> 'Everything bursting apart' here and now and for ever, there is
> no more radical means of capture ... the machine as medusa, it
> holds us on the precipice of the world, in nothing but its own
> spectacle ... simultaneity and morality ... that is the question ...
> but we didn't know anything, we protested not that long ago so
> as to excuse ourselves the indelible mistake of the camps ... and
> now ... what do we know ... Rwanda ... the lottery draw ...
> Bosnia ... the football final ... adverts ... earthquakes ... AIDS ...
> disembarkation ... Chechnya ... series ... sects ... weather
> forecast ... is everything not right there ... the definitive
> statement ... in the TV schedule [*dans la grille*] ... in this kind of
> senseless succession that is the TV schedule ... that's everything
> right there, a history of the keys to understanding [*une histoire de
> grille de lecture*] ... the world held at the same, constant distance,
> erased after a fashion, covered over by the same informational
> rhetoric ... (1995, 18)

A similar methodology is employed for the first three episodes
of *Azimut*, although here the images juxtaposed differ more in
terms of type than scale. In addition, the work of commentary
effected across the gap between images is here (as in the voiceover
text just quoted) supplemented by explicit reflections on the status
of the image in the contemporary sphere, each of these episodes
consisting primarily of a filmed interview with a thinker talking
about the relation between the image and the outside world intercut
with news footage (mostly depicting scenes of conflict or extreme
political events) and video art works. In the first episode, *Le Monde
est une image* [*The World is an Image*], we find Paul Virilio talking
about the erasure of the boundary between the world and the image
today intercut with scenes from Bill Viola's *Reverse Television –
Portraits of Viewers* (1983–4) and (among other things) Afghan
rebels launching rockets; in the second episode, *Le Trou noir* [*The*

Black Hole], Juan David Nasio delivers a remarkably clear lesson on Lacan's theory of the Real intercut with footage of the aftermath of the murder of the Colombian drug dealer Gonzalo Rodríguez Gacha in 1989, scenes from Peter Campus' *Third Tape* (1976) and Steina Vasulka's *Somersault* (1982), the episode finishing with the full 19 minutes of Edmond Bernhard's film *Dimanche [Sunday]* (1963); the third episode, *Le labyrinthe: le temps, la mémoire, les images [The Labyrinth: Time, Memory, Images]*, intercuts footage filmed by Grandrieux of a backlit hand in front of the camera, a hand reaching out towards television images and images of drawings and a hand stencil from the Lascaux caves[4] with newsreel footage of conflict, war, death and the swearing in ceremony of George W. Bush before cutting to an interview with Jean Louis Schefer talking about the nocturnal quality of the image and the inseparability of image and world, this being in turn intercut with more shots of a hand reaching towards television images, of a hand turning over the pages of a book of reproductions of El Greco paintings and scenes from Orson Welles' *Citizen Kane* (1941), Sergei Eisenstein's *Battleship Potemkin* (1925), the Lumière Brothers' *Arrivée d'un train en gare de la Ciotat [Arrival of a Train at La Ciotat]* (1895), Gérard de Rubiana's *Portrait de Français [Portrait of the French People]* (n.d.) and Jonas Mekas' *A Visit to La Ciotat* (1974), before cutting to one final image of the Lascaux hand stencil that is gradually overexposed until it burns the screen to white. While there is in this third episode already some footage filmed by Grandrieux, the final episode of this series (inspired by the writings of C. F. Ramuz and entitled *La Taille de l'Homme [The Size of Man]*) consists of footage filmed by Grandrieux, a single heady collage of newsreel footage showing major political figures, events and massacres, and extracts from Carl Dreyer's *Ordet* (1955), Andrei Tarkovsky's *The Mirror* (1975) and Michelangelo Antonioni's *La Notte [The Night]* (1961). Grandrieux's footage (that interestingly resonates strongly with some of the shots of Bernhard's film screened as part of one of this series' previous episodes) consists of erratic handheld (often backlit) camera shots looking up into trees, down at the grass or off towards a distant mountain, shots in which we can then see the very beginnings of the idiosyncratic style and aesthetic that would later become Grandrieux's trademark.

In 1989 Grandrieux conceptualized and directed the first episodes of a new series for Arte, *Histoire parallèle [Parallel history]* which,

as its name implies, presents two parallel versions of one historical moment, this being the Second World War as seen by the French and then the Germans. Once again, the series is very standard fare for a programme of this kind, yet the idea of presenting two different perspectives and allowing the meaning that they generate to come not from a narrative imposed upon them but, rather, via forces internal to the different elements of the work is here, more than ever, revealed to be a defining feature of Grandrieux's approach.

Live (1990)

It is not until 1990 that the ideas in formation in Grandrieux's head for well over a decade led him to a conceptual breakthrough. It is necessary to talk about this shift as a conceptual breakthrough rather than a stylistic innovation because what is produced is not simply a single work by Grandrieux himself but, rather, a principle or diagram for a new mode of image production that can be put into operation by any film-maker. Accordingly, Grandrieux set up an atelier for this project entitled Live and commissioned thirteen film-makers to produce a 60-minute film for the series, Grandrieux himself shooting the fourteenth in the series. The concept was simple: film a 60-minute film (60 minutes being the recording capacity of a Hi8 video cassette), alone, in one take, with no interruptions, using a single camera, no cuts, editing, mixing or post-production. While this does not perhaps seem like the most radical idea in the world and is obviously articulated to antecedent works such as Andy Warhol's Sleep (1963) or Empire (1964) or Michael Snow's Wavelength (1965) – even though the latter actually contains edits – these works from the 1960s are connected more to the kind of long-duration drone pieces of this time created by, for instance, La Monte Young's Theatre of Eternal Music that sought to radically reconfigure the relationship of the work to the spectator or listener, testing their endurance – and it should be noted in this regard that Warhol actually conceived of Empire as an anti-film and considered it unwatchable. While the receptive modes elicited by the films in the Live series are undoubtedly different from those required for the understanding of or engagement with a film conforming to a more classical narrative structure requiring familiarity with a grammar that would allow the viewer to reconstitute the whole from its

separate parts in conformity with the original narrative schema, the primary interest of this series for Grandrieux seems to lie not here but, rather, in the conceptual framework itself and its implications for the way that the resulting films would be produced. The idea for this series of films finds its origins in a phrase that he had previously used as a title for the series of current affairs segments he produced for a local Saint-Étienne television station, 'le monde est tout ce qui arrive' [the world is everything that happens].[5] One could be forgiven for imagining that this title was simply invented as a fitting description of the content of this news programme that juxtaposed snatches of news images from all over the world, but the phrase is in fact lifted from Wittgenstein's *Tractatus* and it gives rise, in the *Live* project, to a specific methodological principle that hangs on an understanding of reality as consisting of the sum total of all events without any one event or perspective being accorded some sense of primacy. As Grandrieux has explained in an interview:

> With *Live* it was the question of duration, of flux, of the continuum of time that interested me. To film a single take that lasts an hour destabilises you. You can build something in 10 minutes. Over 30 minutes it already starts to become difficult to have an idea of the beginning, middle and end, but with a single take shot that lasts an hour you end up not knowing what you are filming, no longer having any anchor points to orient yourself. It was interesting to me to see what would happen when you put yourself into this situation of no longer knowing. You start to film 'the world that happens'; *Live* was very much linked to this phrase of Wittgenstein's at the start of the *Tractatus* that says 'the world is everything that happens'. (Renaud et al. 1999)

As can be seen clearly here, the intention of the *Live* experiment was to set up a series of parameters – determined by the immanent material and spatio-temporal conditions within which the work would come to be – and to enable the work henceforth to be produced as much by the internal forces generated by those conditions as by the external, imposed intentionality of the creator. Given this, it is particularly significant that for his own film in the series entitled *Histoires* [*Stories*], Grandrieux chose to film the painter Jean-François Maurige at work in his studio. Maurige's work is explicitly influenced by the work of the Support(s)-Surface(s) group that was

so important for Grandrieux's very first foray into the work of video art. Like them, and indeed similar to the concept behind the *Live* series, Maurige uses a whole series of different operations, a 'protocol' as he calls it, which is designed to remove a large portion of his own agency and intentionality from the process of image production, intended to ensure that the artist 'as a subject forget[s] somewhat the operation' (2013).

While the precise methodology employed here was a one-off for Grandrieux, and while he would never again allow such a long take to appear in such a raw, unadulterated form in any of his subsequent works, *Live* constitutes a turning point for all of his work from this point on. The methodology laid down for the film-makers taking part in this experiment required them, like Paulhan feeling his way across his apartment, to adopt a different relationship to the world in which they moved, to allow their navigation through the world to become one determined by their own embodied form in relation to the other objects and embodied forms around them. Generated only out of a response to what happens in the time and space of filming, these films do not only emphasize the embodied being of the film-maker but also give rise to a new form of narrative that is generated from within the formal constraints and situational parameters in place, a narrative that cannot then be meticulously mapped out in advance because it arises only as the artefact of a movement or relation between different things – and we are here very close to the distinction made by Deleuze and Guattari between striated and smooth space (see Deleuze and Guattari 1987, 361–2 and 381–2).

This reconfiguration of the relationship of narrative to the work and the ways in which the work is produced in relation to narrative is something that would later become incredibly important for Grandrieux's fictional feature-length films and, as we will see, in interviews he will consistently rail against the classical form of narrative cinema in which everything is determined in advance by the scenario or script. The methodology used for *Live* also, however, places great emphasis on chance operations, and this is something that would play an even greater role in his next documentary for television, *Cafés* (1992). For this documentary, Grandrieux filmed people in the cafés of Berlin with no predetermined itinerary, allowing the encounters taking place to determine what his next destination would be, a methodology that took him not only to various parts of Berlin but then on to Nîmes, Almeria and Jerusalem.

It is in 1993, however, that all of the experiments, protocols and principles that Grandrieux had been putting into practice for over twenty years finally coalesced into a form that he would subsequently develop through the later stages of his career and that we can see the birth of what we might consider to be Grandrieux's own particular style – a notion that is somewhat problematic given the importance that has been accorded to minimizing the direct intentionality of the 'auteur' in much of his work up until this point, yet not insurmountable. Indeed, as can be clearly seen in the work of Maurige and Viallat, the desire to make works of art that are in part generated by forces internal to the work itself do not necessarily produce a series of works that have nothing in common; indeed, quite the opposite can be the case. For even though there is in the work of all of these artists and Grandrieux a desire to allow the work to form itself from within the specific constraints and situations put into place in order for the work to exist in the first place, all of these conditions are nonetheless set in place by the individual artist. And so it is that Grandrieux arrives at a particular formula for the creation of the work of art that produces something unmistakably recognizable as his with the two short segments he made for a collective documentary on riders in the Tour de France entitled *La Roue*.

La Roue [*The Wheel*] (1993)

Grandrieux was commissioned to make two of the short, 7-minute episodes of this programme on the cyclists Brian Holm and Gert-Jan Theunisse. The whole series was conceptualized as a way to introduce the public to the racers taking part in Le Tour as people, precisely, and not merely flashes of colour or cyborg hybrids of flesh and metal performing a superhuman feat of endurance. Le Tour for all riders is an extreme situation, the most important bicycle race in the world and the most gruelling, requiring years of preparation. In and of itself, then, it is a situation imbued with a high coefficient of tension and intensity, a situation in which the participants live in a state of heightened sensation and intensified contact with everything around them – be this the media or the other riders in the pack – precisely because the stakes are so high and the personal investment required to reach this moment is so

great. This intensity is registered in Grandrieux's segments via the conversations that he films, but it is expressed in a far more tangible way via formal means in the sections of the film where we see the cyclists actually training or racing.

To understand how this work comes to express more through its form than its content, let us attempt to describe as best we can in words the episode on Gert-Jan Theunisse. A subtitle tells us we are in Oss, the Netherlands, in 1993. We open on a close-up image of a cyclist, so close that we can only see his hands on the racing handlebars and his legs pumping up and down. This part of the image is blurred, however, not only because of the movement of the cyclist's body itself and in relation to the background he speeds past, but also because the focal point of the camera does not rest on him but, rather, on some trees in the mid-distance behind him. The effect is strange and complex, for it seems as if, firstly, the figure we see is bleeding into the environment around him, inseparable from it and therefore part of it, defined not so much by any coherent internal form that would separate him from the environment in which he moves but, rather, by his movement through and relation to that environment. More than this, however, even though we cannot see his head nor, therefore, his line of sight, we imagine that our point of focus is also his, that these trees in the mid-distance are precisely what he is so focused on, that towards which every fibre of his being strains in an effort of great concentration and physical exertion as they are that to which our eyes are drawn by the sharp focus yet which we need to actively fix with our gaze through the blur and motion. Not only does this shot obliterate the boundaries between form and background, but it also conflates different perspectives and enables both us as spectator and the figure that we observe to inhabit the same space from perspectives that are complementary yet incommensurable, irreducible to either one of them and existing only in the relation between them. Accompanying this scene we hear a slow, deliberate bass pedal note overlaid with a single plucked violin chord that does not follow the same rhythmic logic yet seems nonetheless to work in relation to rather than against the bass line.

We cut to an interview scene, filmed with a far more conventional, documentary-style shot, a static close-up on Gert-Jan's face, and we hear him talk about the doping scandal that has been plaguing him and how it will follow him for years to come. He says that he has always abided by the testing regime, that this is the ugly side of the

sport, that some results come just from the human body, that the scientists don't understand everything. The soundtrack pulses like a heartbeat as we cut back to a series of frenzied pans across a crowd watching a race. We hear a cacophony of street sounds, cars, cries, shouts and horns. This, seems to be the suggestion, is what it feels like to be in Le Tour once you lose focus, once you are no longer staring at that tree line with one single goal, this is what happens if you let the media circus, doping scandals and chaos of the event distract you from the main game. And then all sound drops out and the pedal note returns. The frenzied pans of the camera turn the entire world into a wash of colour, a blur of light and movement, yet gradually we seem to find a point of focus again as little by little the camera seems to find an anchor point, to be pulled towards the bright yellow flash of the yellow jersey, a focal point that never stays still long enough for us to be able to hold it in place, which doesn't hold any of the calm focus, concentration and purpose of the opening sequence, yet which nonetheless seems to have become a miraculating centre that is not buffeted around by all that surrounds it but, rather, seems to pull everything around along with it, and us too.

We cut back to the interview footage shot as before. This time Gert-Jan's partner talks more than he does and points out that he has only got a couple of years left in him to compete at this level. As if this statement awakens in Gert-Jan (and indeed us) a renewed sense of urgency, of the need to focus once again on the primary goal and not to be distracted by the peripheral chaos, we cut to an image that is a variation on the opening shot. The slow deliberate music based around a rhythmic succession of pedal notes returns and we see a shot of Gert-Jan on his bike. Shot from a car travelling alongside him, we see only his headband, his hair blowing in the wind, the arch of his back that turns the yellow jersey he wears into an abstract coloured shape contrasting with the green fields flashing by behind him and the blue sky of the horizon line dividing these two spaces into perfectly bisected zones of colour, broken only by a line of trees in the mid-distance that, once again, provides us with a focal point.

We cut back to the interview, but this time Gert-Jan talks not of the distractions and his troubles but, rather, of how good it feels when you are in the zone and take yourself to the limit. He talks of the extreme physical exertion required, of pushing to the end,

never imagining it may be too much and bad for the health, about how, after mountain races, when you cross the finish line you feel dead, but then rest and eat and realize it was good to have been able to go so far. This, he says, is where the satisfaction comes from, it's not about the money, you do it because you like it, and even though the commercial side comes along later, that's not why you start.

We cut to a shot of a photo shoot, shot with an absolutely motionless camera that could not feel more different from the shots of Gert-Jan on his bike that moved with him and seemed to inhabit the same space as him both in terms of movement, energy and focal point. We hear a 35 mm stills camera firing as Gert-Jan's image is washed out by the blinding light of a flash gun. As we hear the high-pitched glissando of the flash recharging, we watch Gert-Jan sitting awkwardly on his bike, leaning slightly forwards, towards the camera, holding multiple rolls of Agfa 35 mm film in his hands, his face struggling to maintain a serious, photogenic pose for a shot that, while a classic advertising shot, could not, we feel, be less in harmony with its subject if it tried.

If I am claiming that it is with these two episodes for *La Roue* that we can see Grandrieux's particular style and methodology emerge for the first time, this happens in the shots of Gert-Jan Theunisse and Brian Holm on their bikes. Indeed, as Raymond Bellour has also suggested, it is in these short films that 'Grandrieux developed his sensual approach to filming, founded on the intensely physical relation of the camera to its objects' (2009b). The methodology is clear: a situation is found that is shot through with a certain tension, with great intensity, a constellation of elements and forces that exert great pressure on the figures we observe and who, consequently, seem to become but a function of those forces, to surpass the limitations of their identity, form and flesh, to move with the outside in which they find themselves just as we, via the formal mechanics of the camera shot, are also pulled into this space defined only by the relational movements between light, colour, line and focal point. This is a principle that Grandrieux will take even further in a series of short segments for a current affairs programme *Brut*, having found an opportunity to expand his palette even further during the making of a segment based around an extended interview with Philippe Starck for the programme *L'Atelier 256* in 1993.

La Chasse au Starck [*The Starck Hunt*] (1993), *Les Enjeux militaires* [*Military Stakes*] (1994), *Brut* (1995–7)

Entitled *La Chasse au Starck* (a nod to the French title of Lewis Carroll's nonsense poem The *Hunting of the Snark* [*La Chasse au Snark*] (1876)), Grandrieux's film is a fascinating exercise in various camera techniques that he would use in much of his later work that seems, to all intents and purposes, to have little or nothing to do either with Philippe Starck or with what Starck says in this extended interview. Having said that, in this interview Starck talks almost exclusively about the contemporary status of the image, a theme that has haunted nearly all of Grandrieux's television work as we have seen. Throughout the interview, however, Grandrieux seems almost incapable of keeping his camera fixed on the talking head who is, one imagines, the primary point of interest of the programme. The film opens with a shot of a forest; the image is suddenly overexposed as the camera pans to shoot directly into the light, creating a flash effect that washes out the image, followed by the evisceration of nearly all light from the image as the camera overcompensates by shrinking the aperture, turning the trees into solid bars of black and the golden glow of the forest floor a deep, earthy brown. The image cuts and then returns to a similar dark, backlit image. The camera pans wildly from side to side, moving up and across the trees, appearing not so much to be seeking out any particular point as to seek to produce the effect of movement and blur generated by this shot. At a certain point, however, we do see a small figure appear in the bottom right-hand corner of the frame, a man wearing a woolly hat, sunglasses and a bright orange bomber jacket. We realize that this is the man whose voice we hear, that this is Philippe Starck, the subject of this programme and yet, wonderfully, this seems to matter little, for off flies the camera again, cutting to a different shot of the forest, zooming in and out on it frenetically, panning across expanses of trees cut by shafts of light so as to create a strobing effect and motion blur that is then replicated via alternate means as the focus is pulled in and out, setting the focal point in the mid-space before the trees so that their fixed forms bleed into the light between them. The camera does, occasionally, come back to Starck, but he is treated

not as a talking head but, rather, as just another opportunity for formal experimentation: he is filmed in extreme close-up, backlit, front-lit, overexposed, underexposed, using a steady handheld shot, jerky pans or a violent shaking. The image is at times slowed down and speeded up and all the while Starck is heard talking about the abstraction of digital images and satellite communications, about how we will soon be able to use digital trickery to make any image appear real, to film him, for instance, in a desert but to make it look as though he is in a lush green forest so that we no longer know what is real and what is fake. At key points during his diatribe, we cut from the images of Starck in the forest to examples of CGI images of bodies and trees that look, despite Starck's assurances to the contrary, very artificial indeed. These computer-generated images, indeed, seem cold and clinical in comparison to the images of the forest, they appear calculated – as they are –, precise and perfect yet somehow impoverished for being so. There is then somewhat of a disjunct between Starck's speech and the message conveyed by the images alone, for while Starck claims that 'matter brings about imperfection by definition, matter sweats, ages, stinks, oozes [... while] the virtual entity brings about perfection', the images we see make the organic, bleeding unpredictability of materiality seem infinitely preferable to the clinical exactitude of the computer image. Indeed, in the images filmed by Grandrieux that are generated through a ballet of light and movement, via the relations between bodies in direct contact with each other and their environment, we find something that will remain always in excess of the computer image no matter how perfect it may be, namely something of the poetry and emotion of the scene that moves the content of the image beyond the brute communication of the information that it carries.

To convey something of the emotion or tension of events through a ballet of light and movement is precisely what we find also in a series of short shots that punctuate his 1994 documentary *Les Enjeux militaires*. The majority of the documentary is (much like *Le Siècle des hommes* and *Histoire parallèle*) composed of archival footage from the Second World War, footage depicting in this particular instance the historical backdrop leading up to and following the Normandy landing and the subsequent unravelling of Hitler's grip on power and liberation of Minsk, Poland, Strasbourg and Paris. This footage is accompanied by a voiceover narrated

by Grandrieux himself that makes clear just how complex and turbulent this period was, how none of these events really served as the crowning moment that would bring an end to conflict and dissipate the massive tension between opposing forces, even in the post-Liberation era. Some of these images, and especially the scenes of warfare, are accompanied not by the voiceover but by the sorrowful strains of Henryk Górecki's *Symphony No. 3, II, Lento e largo – Tranquillissimo* (1976). Other shots, showing the faces of soldiers who had just disembarked from the boats on the Normandy coastline or wounded soldiers and children, meanwhile, are left to speak for themselves in silence with no accompanying music or commentary. At six key points across the duration of this 45-minute documentary, however, we are presented not with archival material but footage filmed by Grandrieux himself. The first of these is similar in many ways to an early scene in Grandrieux's later feature film *Sombre* as the camera shakes violently, panning erratically and jerkily over a dawn skyline, the black mass of the backlit earth engaged in a Saint Vitus dance with the bright yellow burst of the sky above, each vying for position in the frame. A later shot pitches black and gold against each other in a more tranquil manner as the sun reflects off waves gently lapping a shoreline, land and sea here bisecting the frame horizontally into two distinct zones of light and dark. Later still we watch backlit blades of grass swaying against a golden sky, cutting black lines through the light, then a lateral panning shot rushing across the leaves of backlit trees, creating an abstract blur of light in motion. And then, as we are told of the struggles still taking place even as de Gaulle was triumphantly marching into Notre Dame Cathedral for a *Te Deum* ceremony following the liberation of Paris, we cut to a series of shots rushing over this Cathedral's stained glass windows, and another series of shots paying close and careful attention to details in some of the paintings adorning the Cathedral's walls. Lingering on the agonized faces and outstretched hands of the figures in paintings such as Charles Lebrun's *The Stoning of Saint Stephen* (1651), these shots resonate strongly with shots of people in the short documentary films Grandrieux would subsequently make for the television series *Brut*. There, as here, his intense concentration on specific details and tendency to blur the image through out-of-focus shots remove these figures from a narrative context and force our attention onto them as individuals caught up in extreme moments. It is this

idea, what is more, this focus on the interplay of figures and their environment and the need for close, quiet attention to this tension as it is deployed in specific sites and figures too often forgotten by the grand sweeping gestures and narrative lines of history and politics that enable us to connect Grandrieux's own footage to the archival material here. Grandrieux's studies of light and shadow that punctuate this film are ultimately nothing other than this, the quiet contemplation of the ever mobile relation between things, rendered here in the simplest way possible through the geometry and brute contrast of the image. Nowhere is this made clearer than in the film's final image, a slow tilt shot across a shimmering body of water that follows the bright golden stripe of the reflected setting sun upwards until nearly all light is eclipsed, this shot being accompanied by the sound of Grandrieux's voice reading an excerpt from Maurice Blanchot's text *L'Attente l'oubli* [*Awaiting Oblivion*]:

'Do you think they remember?'
'No, they forget'.
'Do you think they remember by forgetting?'
'No, they forget and retain nothing in this forgetting'.
'Do you think that what is lost in the act of forgetting is preserved in the forgetting of forgetting?'
'No, the act of forgetting is indifferent to forgetting'.
'So, will we be marvellously, deeply, eternally forgotten?'
'No, forgotten with no marvel, no depth, no eternity'.

<div align="right">(Blanchot 1962, 47)</div>

Les Enjeux militaires sets itself against this text, seeking to ensure that oblivion is not something that awaits the individual players in the history that Grandrieux casts his gaze upon here. There is then some considerable and terrible irony that this film would never be shown on FR3 (and thus not at all), the television station that commissioned it in the first place. Already unhappy with the film's depiction of the Normandy landing that did not display the full military might of this operation and with Grandrieux's refusal to provide a voiceover to render explicit the emotion on the faces of the soldiers just after the landing, the television station hammered home the final nail in the coffin of this project when Grandrieux refused to bow to the demands of a historian working

as a consultant on the project to remove the film's final shot and the text by Blanchot.

While it is of course unfortunate that *Les Enjeux militaires* was never screened, in making this project, as with all of his previous projects, Grandrieux was nonetheless able to further develop his own particular method and sensibility. Indeed, he himself has said that his hallmark 'blurry images' are something that he started to experiment with as part of his documentary work in the 1980s when he realized that 'in losing focus, my desire to film increased' (Grandrieux and de Sardes 2013, 53–4). The experimentation with a very physical approach to film-making and a very particular relation to light, focus and camera movement that we find in *La Chasse au Starck* and *Les Enjeux militaires* are then fascinating for the ways in which they allow us to witness the emergence of a cinematic style in formation. However, the most complete expression of Grandrieux's short-form work for television where this kind of experimentation is refined and extended across the entire work comes in 1995 with the segments that he filmed for the ARTE current affairs programme *Brut*. Consisting of a series of short films by different directors intended to cast an alternative eye on the current affairs and *faits divers* of the day, *Brut* provided Grandrieux with an opportunity to combine the principle of filming an intense situation that had proven so fruitful for his films for *La Roue* with the formal experimentation of these films and the kind of camerawork we find in *La Chasse au Starck* and *Les Enjeux militaires*. Grandrieux filmed eight of these short 5- to 8-minute segments, and chose, for each of them, a situation shot through with high emotion of one kind or another. The events filmed were, in order of broadcast:

1 *Balladur* (22 May 1995) – in which we see Édouard Balladur watching a figure-skating display shortly after his crushing defeat in the first round of the presidential elections;

2 *Jean-François Deniau à l'Assemblée Nationale* (21 June 1995) – in which we see Deniau deliver an impassioned address to the National Assembly about the situation in ex-Yugoslavia;

3 *Dans la rue à Vitrolles* (3 July 1995) – which records the reaction in the streets of Vitrolles (the town chosen as the emblem for the rebirth of the extreme right-wing party,

the National Front) following the narrow defeat of that party in the second round of the 1995 municipal elections;

4 *La Garde Républicaine* (10 July 1995) – which provides a behind-the-scenes look at the final preparations of the soldiers of the Republican Guard as they get ready to welcome Philippe Séguin, the president of the National Assembly;

5 *Nicole Notat* (5 January 1996) – in which we follow the secretary of the CFDT (French Democratic Confederation of Labour, one of France's largest trade union confederations) in the hours leading up to and just after the social summit of 21 December 1995 held by Prime Minister Alain Juppé to try and bring to an end the widespread strikes organized in opposition to Juppé's spending cuts and welfare state reform programme;

6 *Place de la Bastille* (19 January 1996) – where Grandrieux joins the crowds gathered in the streets on 10 January 1996, two days after the death of former President Mitterand;

7 *La Vente aux enchères* (15 March 1996) – that takes us inside a Parisian auction house during the sale of paintings by Picasso and Poliakov;

8 *L'Ancien Premier Ministre* (6 June 1997) – in which we observe, in tight close-up, Alain Juppé – the former prime minister (and possibly the most unpopular prime minister of the Fifth Republic) who was defeated during the snap 1997 elections held shortly before this – as he listens to the debates going on around him in the National Assembly.

In one of these films in particular, Grandrieux wears his political colours on his sleeve, providing a voiceover to the segment filmed in Vitrolles. 'In the afternoon, in front of a polling station', he says, 'some children play with me, with the camera'. As we watch the results of the vote come in in silence, however, and see the reaction of people, Grandrieux's commentary changes. He says, solemnly,

Here is a France I thought had long gone. Something has happened, in Marignane too, and Orange and Toulon, but not only. The whole of France has just shifted and I wonder if we realise what lies there, right under our eyes, what is creeping in with this man, that we don't want to see.

Save, perhaps, for a brief contextual statement, for the most part Grandrieux provides no commentary on the images he films and leaves them and the people in them to speak for themselves. In all of these films, Grandrieux takes us very close to the people he shoots, either walking among them (in *Place de la Bastille*, for instance) or else using a zoom lens to take us almost uncomfortably close to those from whom he is obliged to maintain a certain distance. This is the case in the remarkable footage of Jean-François Deniau in the National Assembly. Rather than starting with a long shot that would be more appropriate to survey the chamber and then seek out Deniau, Grandrieux begins filming with the zoom already fully engaged, the camera needing to pan across the ministers in the room, turning them into a blur of colour and light as it searches for its subject. When we find him, we see the elderly Deniau being helped from his seat and up to the speaking platform. Deniau adjusts his microphone, issues the standard formal salutations and then, having spread out a page of notes before him, launches into an erudite, heartfelt speech imploring the ministers assembled and in particular the new Prime Minister Alain Juppé to change their position in regard to the situation in ex-Yugoslavia. As he speaks, the camera zooms in tighter still, such that we see only specific gestures and feel every movement of the camera amplified tenfold by the zoom. At key points we pan across the room to fix on Juppé and watch his reactions, then swing back to Deniau who seems to talk more with his body than with his words, his hand gestures expressing the full force subtending words over which he is required to exercise some restraint, given the extreme formality of the context. The camera struggles to stay with these gestures, refusing to pull back in order to record them faithfully but, rather, entering into a dance with them, following their lead. We pan back to Juppé's face, then down to a shot of Juppé's hands that rest immobile in his lap, unmoved, then back up to his eyes that watch Deniau talk yet are unable to maintain their focus, constantly wandering away, whether through disinterest or shame. The contrast between the two men could not be more striking: one is invested entirely in the moment, in the situation, every fibre of his being reaching out into the room in the service of something much bigger than his own self; the other seems almost to recoil from this emotion, to withdraw within himself. As we might expect, this difference is registered by the camera also, since if it seems to dance with Deniau, when focused on Juppé its

movements are merely exploratory, panning across his face to his hands and back to see if any life at all can be detected here. At one point Juppé seems to notice the camera, but immediately looks away, pretending not to have noticed and acting henceforth like a case study of bad faith from Sartre's *Being and Nothingness* (1943), like someone pretending that they don't know they are being filmed. Deniau, for his part, is too engaged in his struggle to connect with the ministers present to even notice anyone else, and this is so even after the applause that greets the end of his speech, after he has been helped from the platform and after we see him in close-up return to his seat and watch his entire body drop and slump from the extreme effort and expenditure of what he has just lived.

The relationships between the figures filmed and the camera and of the figures to the situation they find themselves in play out somewhat differently in another of Grandrieux's segments for *Brut*, *Balladur*. The film opens with a voiceover stating, simply, 'there was one big loser' ['Et il y a eu un grand perdant']. For those watching this programme at the time, it would have been obvious that this referred to Balldur's heavy defeat in the first round of the 1995 presidential elections, a loss that signalled if not the end of his political career, then certainly a fall from grace and one that took down some close personal ties with it due to the circumstances in which it took place. When the image appears on screen, though, the first thing we see is not Balladur but, rather, a pair of figure skaters heading towards the camera then veering off to the left in a blur of light and motion as the camera pans to follow them, then loses them yet continues the trajectory of the line they traced, scanning the expanse of a barrier and moving upwards to find Balladur. The camera rests on him and he is pulled into focus. He shakes his head, smiles and says something to the person next to him. A spotlight from the ice rink suddenly illuminates his face and he smooths down his hair. He appears to be watching the skaters, but only distractedly. We hear and see the flashes of multiple cameras; whether they are pointed towards him or the skaters we do not know. Balladur seems gradually to lose his own focus, to stop even pretending to watch the skaters, staring into the mid-space instead. Someone nearby catches his attention and he registers their presence with a slight smile. As if unable to keep looking at this spectacle of a man defeated, required to go through the motions of an official engagement yet unable even to fake interest in the demonstration

before him, a man entirely consumed by his own interiority, who gains no pleasure from the situation he is in yet must pretend that things are otherwise, the camera pans away to find the skaters once more and again enters into a ballet of light and movement with them, allowing its pans, arcs, lines and sweeps to be pulled along by the skaters' choreography. As the performance comes to an end, however, and the male skater leaves his partner lying on the ice and skates off to the side, the camera follows his line once more to come back to Balladur and find him clapping yet entirely unmoved.

All of Grandrieux's segments for *Brut* are remarkable for their ability to translate something of the intensity of these situations via the formal mechanics of filming, via the framing of the image, the complex choreography between observer and observed. Indeed, if Grandrieux later states that the documentary form trained him to be 'extremely attentive to everything around' (Grandrieux and Copeland 2015, 120), then these segments are the very best exemplification of this sensibility at this point in his career. Yet, to think through this via cycling again, this is not simply a matter of staying with one's subject matter, of moving the camera at the same speed as the leader of the pack (as one does when filming Le Tour for a sports programme) so as to maintain focus and to allow the cyclist's form to be seen and identified, effectively annulling the speed and movement of the moment wherein lies the true excitement of the race. This is, rather, a different way of being in the world that resonates with the immanent terms of what is being filmed. As Grandrieux says of his work from this last period of his work for television in an interview for the ARTE programme, *Court-circuit* [*Short Circuit*]:

> Framing is a way of being there in the ontological sense, an inscription in the world, a presence, it's a way of inhabiting the world, occupying it, feeling it, perceiving it and then retransmitting it, letting yourself be touched by it, letting yourself be imprinted by it [se laisser impressionner]. (Grandrieux 2002)

In spite of the fact that we can see this ontological mode of being in the world expressed via the formal means of film-making, however, oftentimes, as we have seen, there is in the subject matter filmed by Grandrieux a widening gap between the deep ontological relationship between himself and the world as seen through his

camera and the disengaged, self-interested politics of the world that
he films. The latter, indeed, is a world in which the image does not
express a deep engagement with a situation but is, rather, like the
paintings he films in the auction house, a commodified object, a
never-ending photo opportunity staged for mass consumption. Even
though what is perhaps most remarkable about Grandrieux's choice
of subjects and situations for his *Brut* films is his way of capturing
those moments when those he films let their guard down such that
we break through the veil that is worn for the 24-hour news cycle
in the age of mass media, the very fact that this is what the status
of the image had become, that the superficial, throwaway aesthetic
of the Polaroid consumer culture he railed against in 1982's *Une
Génération* had prevailed eventually led him to abandon this kind
of documentary work. As he continues in the interview cited above:

> At a certain point the gap just seemed too great between these
> objects and the actual thing itself, the thing you are trying to
> touch, and that annoyed me, and I said to myself that I needed
> to stop with documentaries, with that kind of thing, and that
> I should try to get close to what is in my head. (Grandrieux 2002)

Before abandoning the documentary form for good and
concentrating rather on fictional feature-length films, however,
Grandrieux would make one more long-form documentary that
would extend the logic of the other long-form documentary he
made in 1994 before his work for *Brut*, *Jogo du bicho* [*The Animal
Game*], while integrating into it more of the formal logic that he
had devised in making these *Brut* segments.

3

Long-form documentaries

Jogo du bicho/Le jeu des animaux [*The Animal Game*] (1994)

Formally speaking, *Jogo du bicho* is fairly standard documentary fare. It consists of interviews with various commentators (an anthropologist, a sociologist, a judge, the Attorney General) talking about the history, rituals, financial reality and political backdrop of the gambling game that gives its name to this documentary and is so beloved of large sections of the Brazilian population. This interview footage is intercut with some newsreel documentary footage and live footage of the people who fuel this underground economy, both the workers and the players. The interview footage is shot with a static camera and direct address to the interviewer; the everyday scenes of players and operators, meanwhile, are shot with a handheld camera that shares some of the qualities of sympathetic movement that we have observed in *Brut* and *La Roue*, but to a much lesser degree. While Grandrieux is then able here to film in such a way that his presence as film-maker is undeniably felt both by us and the people he films, that presence is never so overbearing as to make us, nor indeed the characters he films, overly conscious of the act of film-making. The effect of this is that we have the distinct impression that what is filmed is 'authentic' (as problematic as this very concept might be) or, rather, that we gain access to this space and to these practices via a sympathetic third party who has gained the trust of these people, who moves among them as though one of them and thus enables them to carry on with their everyday lives without modification, even when they are providing a running

commentary on their rituals, practices and beliefs for the camera. Stylistically, apart from a brief sequence shot from a car at the very end of the film showing trees and mountains rushing past, there is here none of the formal inventiveness that Grandrieux would become famous for and yet I feel that this is still an important work in the development of the vision in his head. If I claim this, it is because of the kind of environment that this film put Grandrieux into contact with. By this I do not mean simply that he was inspired by his time among the players in this underground economy to make (with *La Vie nouvelle*) a film about a different kind of underground economy and criminal activity. Rather, in filming *Jogo du bicho*, Grandrieux finds himself immersed in what is, to all intents and purposes, a parallel universe whose inhabitants all follow a code whose principles are not only strange and ritualistic but almost entirely incomprehensible to somebody coming from the outside, yet whose investment in this alternate reality is so complete as to be contagious, pulling the spectator into the logic governing this space.

The almost mythological origins of the animal game are recounted at the start of the documentary by the sociologist Hélène Soarez who explains that the game was invented in 1892 by the Baron of Drummond, the owner of Rio's zoological garden. The story goes that as the gardens fell on hard times with Brazil's move to a republic and the withdrawal of many subsidies, Drummond worked in collaboration with a Mexican named Manuel Ismael Zevada to set up a gambling game in his gardens inspired by Zevada's game of flowers. Entrants into the gardens would be given a card figuring one of the animals from the zoo, a draw would take place and the bearer of the winning card would win back twenty times the entrance fee paid. Three months later, crowds would throng at the gates, eager to enter into the gardens just to be able to play the game of animals. Given its popularity it would not be long before the game spilled out into the streets and then be taken over by organized crime syndicates. In spite of many attempts by the authorities to stamp it out, however, its popularity only spread and, according to the anthropologist Di Matta quoted at the start of the documentary, the animal game can now be considered one of the four base elements of Brazilian society, the others being 'Carnaval, football [and] cachaça'.

Since this time the format of the game has remained relatively unchanged and still revolves around a lottery system figuring the

effigies of various animals rather than simple numbers. What is most interesting about the game, as analysed by Soarez, is the way in which the game itself and in particular the choice of animal open the players up to an entirely new, superstitious and almost magical relation to the world around them. Soarez, indeed, is quoted as saying that she has identified three main stages in the player's experience: the perception of a sign that prompts her to play; the interpretation of the sign that leads the player to choose a certain animal; and the final phase during which the player believes that the animal chosen through her own personal interpretative system will intervene in order to increase her chances of winning.

Other interviews conducted for the documentary provide information about the game's links to organized crime, the financial mechanics of the rings running the game, their support of community organizations and vicious retribution against authority figures who have tried to stamp out their activities. What is of most interest for the purposes of this analysis, however, are those scenes where Grandrieux walks with the game's players and workers, allowing them to express the extent to which their entire existence is pulled along by the strange forces and belief systems of this game, how their entire world view is conditioned by an openness to a chance occurrence that may hold the key to future riches. This is a mode of being in the world characterized by an extreme, intensified attention to the world, to every single element of every single day in the belief that any random event may be significant, may be the crucial event that will change everything else to come irrevocably.

While this mode of intensified ontological sensitivity to a situation or life in general should resonate strongly with claims that have already been made here about the importance for Grandrieux of situations in which the protagonists exist in a state of heightened sensation and, indeed, to the aesthetic principles of Bacon's painting in which competing forces from within and around the figure instigate a movement from within the figure that carries it beyond the bounds of a predetermined, known identity, beyond the indexicality of representation, what, in my opinion, is new about *Jogo du bicho* is the way in which Grandrieux is able to transmit something of this world to us and allow us not only a glimpse into but a *sense of it*, even though it is one whose codes remain (in spite of the historical, sociological and anthropological explanations we are provided with) almost entirely alien to us. This, or such will be

my claim, will become a critical element of Grandrieux's approach in his later fictional films.

Retour à Sarajevo
[Return to Sarajevo] (1996)

Even though the idea for Retour à Sarajevo originated with Guy Darbois, it is easy to understand why it would have appealed to Grandrieux. Indeed, if in the segments he filmed for Brut he sought out situations charged with a certain intensity, the idea of filming a small group of women returning to Sarajevo to be reunited with their families following the signing of the Dayton agreement in 1995 that put an end to the horrific and brutal three and a half year Bosnian War could not have been more suited to his methodology. The film begins with an on-screen scrolling text, read out aloud, that provides us with the contextual conditions of the film, a short text that nonetheless brings with it a whole history and complex of political and religious issues. It reads:

> Sada, a Bosnian Muslim from Sarajevo was, before the war, the chief engineer for public works.
>
> Four years ago, a few hours before the siege and its attendant horrors, she managed to flee and took refuge in Paris with her children.
>
> Immediately following the signing of the Dayton Peace Agreement, she wanted to see her birth town again as well as her family that includes, as it always has, Bosnian Muslims, Orthodox Serbs, and Catholic Croats.
>
> On her way back to Sarajevo Sada stopped in Croatia in a refugee village on the Adriatic coast. There she was reunited with her cousin Slavica and her two daughters, Maja and little Ivana.

We cut to a shot of the sea striped with reflections from the sun, filmed with a handheld video camera that trembles slightly, pans left then right as the credits roll over the image, its movement seeming neither to seek out any object nor to situate us in a defined and recognizable space as would an establishing shot but, simply, to establish a relation, to register the perspective we share as one that

is simply there, mobile, moving in response to what it sees rather than what it wants us to see. We cut to a close-up shot on Sada who is telling the story of the very moment when, four years prior, she left her father. A tear rolls down her cheek and we pan right to see another younger woman also wiping away a tear, Maja, as we will learn, then on to another woman doing the same, Slavica. Slavica says that she would like Maja to wait a little longer before going back, another four months, as she is still afraid something might happen to her, but Maja says she has to go back now. As these women, and later little Ivana, talk, the camera moves from one to the other, drawn, it seems, not necessarily by their conversation, by who will be talking next, but simply by the rhythm of what is happening, to borrow Wittgenstein's phrase once more. Here and throughout the film, however, a strange effect is created by the contrast between the constant use of extreme close-up shots and cut-ins that focus, often, on people's hands and the apparent invisibility of the camera and its operator. For in spite of the fact that Grandrieux is obviously not, for the most part, using a zoom lens to achieve a sense of proximity to his subjects (as he often did for his *Brut* segments) but is, very literally, moving among them, they seem almost without exception to be totally oblivious to his presence, entirely engaged in their own situation, their own conversations and relations with the people and places around them – the one obvious exception to this being when Sada shows Grandrieux around an apartment belonging to members of her family where most of her remaining possessions are stored and provides a commentary directly to him, in broken French, addressing him as Philippe. This is the case no matter where we go, whether we follow Sada as she visits friends and family members she has not seen for years, talks to strangers on a bus who are also returning to Sarajevo or who, alternatively, never left, goes to a concert of a local rock group or meets the people who now live in the apartment that was once hers. While this is a claim that cannot, of course, be substantiated, the impression we have is, firstly, of a sense of absolute trust between the people being filmed and the man behind the camera and also of absolute authenticity, of bearing witness to events and interactions that are not coloured in the slightest by the presence of the film-maker, even though the film-maker's embodied presence is indelibly inscribed in every shot by the movement of the camera. If this does then seem to us to be an inscription simply of some of those things that happen in the

world under a specific set of circumstances, the impression we have is simultaneously one of this all taking place with no direction – to gesture towards the title of a 2007 film by Sarah Bertrand for which she interviewed a number of film-makers, including Philippe Grandrieux, *There is No Direction* (Grandrieux and Bertrand n.d.). At this point a word of caution is required, however, for having suggested that we are witness to a recording of how things really are and that the film-maker does not overly colour the presentation of on-screen events via his own style, it would be tempting to assume that we are dealing here with the kind of degree zero of film-making favoured by André Bazin for whom the 'primary aim of the cinema should be to maintain the sanctity of the reality with which it comes into contact' (Rushton 2013, 10). What this means for Bazin is that 'the task of the filmmaker is to refrain at all costs from intervening in or interfering with … prior reality', a task that is guaranteed through the avoidance of overwrought formal interventions via editing, for instance, and the use of objective shots employing a great depth of field that do not guide the eye towards any particular element in the shot (Rushton, 10). At this point we need to redouble our note of caution and point out that this representationalist representation of Bazin is one that has been greatly contested in recent times, most notably by Richard Rushton who takes great issue with the dominant consensus view of Bazin that he paraphrases only in order to discredit. Such differences of interpretation ultimately matter little for the purpose of the present discussion, however, and it is important only to note that what we are dealing with here is resolutely not this kind of film-making, regardless of whether or not this conception of cinema can be imputed to Bazin. Indeed, in spite of the fact that there is undoubtedly here a non-interventionist methodology at work, one might go so far as to suggest that what we are faced with here is the very opposite of this conception of the cinema that would hold the world at a distance in order to present it in its pure form. Here, in place of the objective wide shot with great depth of field, we have only extreme close-up shots with a very shallow depth of field, shot from the perspective of a film-maker who is imbricated in the shot and the situation not by dint of any ideological standpoint that would bias the presentation of events in any way but, rather, of his material presence that remains both inescapably present yet, in relation to those he films, unnoticed since he does not so much film

them or observe them – and thus bring into the fray all of those modifications of behaviour that can be found on reality TV shows even when the cameras remain hidden – as *move with them.*

In thinking about *Retour à Sarajevo* in the context of Grandrieux's work both before and after this point, it is tempting to see its importance as coming from its extension of some of the formal aesthetic principles formulated in *Via la vidéo*, *Live* and *Brut* or, looking forwards, from the fact that it introduced him to a landscape – both physical and perhaps psychological also – that would greatly influence his 2002 fictional feature-length film *La Vie nouvelle* in which we find a character named Boyan, the name of one of the real-life people in this documentary. All of these things are undoubtedly true and, what is more, there are passages in the film, particularly in the short segments that punctuate the shifts from one place to another, in which we often see (as in the film's opening shots) a camera rushing over a landscape or, alternatively, a landscape rushing past the camera that are stylistic precursors to many of the more experimental shots of his later work. Yet I believe that the real importance of this film lies precisely in this idea of the film-maker as somebody who moves with the subjects and objects that he films, whose work is produced out of this very movement, a movement that is determined by a harmonic relation between the film-maker and what he films.

In suggesting this, I want to gesture towards a few things that will be unpacked further as we progress. The notion of harmonic relations is intended, firstly, to figure the space and relations taking place in that space as resonant, not having a fixed or pure form that could ever be said to pre-exist and thus be objectively represented from a distance but, rather, constantly exceeding the impression of any fixed form, going always beyond the limits that vision imposes on the world and extending always into that which lays beyond that impression of form. This is a primary characteristic of any sonorous body and this kind of ontological formulation about the entangled nature of Being conceptualized in terms of wave-like behaviour is itself in accordance with a quantum view of the universe. Rather than having recourse to the pseudoscientific terminology of quantum mechanics that might then be used, as it often is these days, to 'prove' what are essentially the products of the imagination, epistemological positions and conjecture, to conceptualize this space in terms of sonic phenomena and the forms

in it as sonorous bodies is to retain something of the mythopoetic
function of the cinema and not to pretend it is something it is not.
More than this, however, the idea of a harmonic relation taking
place between Grandrieux and the scenes he films enables us to
understand how he is able, in *Retour à Sarajevo*, to move with these
characters and to film them and what they experience in such a
way that we are not so much moved by their joys and sorrows as
we are invited to move with them. What we are witness to here is
not a facile manipulation of emotion in which a tale of sorrow or
happiness invokes in us a corresponding emotion at the same time
as it allows us to classify that event and so separate ourselves off
from it in the very move that would appear to link us to it, a trigger
mechanism of the most automated kind that is as predictable as
it is fleeting. Rather, we are here dealing with events and forms
made up of intensities that vibrate before us, captured by a film-
maker who moves with these events at a different level of frequency,
never pretending to 'understand' what he sees, to claim his own
perspective as somehow equivalent or equal to that of those he
moves with, yet able, nonetheless, by resonating at a frequency in
a harmonic relation to the events he follows, to fold himself into
them. To put this another way, when Grandrieux films buildings
pockmarked by thousands of tiny craters chiselled into them by
years of heavy artillery fire, he does not allow us to labour under
the illusion that he is moved by them in the same way as those he is
with, that those marks mean the same to someone whose family has
been massacred in some such building as they do to someone who
has not lived through such horror. At the same time, however, even
though he remains silent, knowing that a voiceover enumerating
the exact number of losses would be entirely superfluous, he does
not strive for the kind of cold documentary objectivity that is the
preserve of the cinema itself according to a certain strand of Bazinian
criticism – if not necessarily Bazin himself, as has been suggested –
but chooses instead to move with these scenes. This is achieved
through many different means: through the literal movements of
the camera both big (via pans) and small (via the tremble and shake
of the handheld camera); through the secondary movements that
are produced by the constant framing of the shot in extreme close-
up; via the complex choreography of the film-maker and the events
he films that is not planned in advance, mapped out in a routine to
be followed, but that arises only as a result of the relation of objects

to each other in space and time and the intensities flowing across them and between them; and (as in *La Roue*) with a very particular use of the focal plane.

All of these elements come together in the remarkable final sequence of *Retour à Sarajevo*. Following Sada's return to her old apartment, at the end of which the emotional and political gravity of the conversation is lightened by Sada's parting joke that they must have changed the mirror she used to look at herself in every day before leaving for work because she looks fatter now, we cut to a shot of Maja walking through a snow-covered street in Sarajevo. Shot from behind and slightly to the side of her, we pan to follow three men, one of whom is in a wheelchair, walking in the opposite direction, but pause for a beat when we meet instead Sada and a friend. The pan continues to look back towards the three men just passed, then we cut to another shot of Maja, filmed this time slightly off to the side but from the front so that we can see her face and her eyes staring into the middle space before her and seemingly disengaged from the conversation that we hear between Sada and her friend about the weather. The camera pans around and finds itself almost entirely covered by the backs of Sada and her friend and we hold this position, walking with them, the screen filled with the blackness of their silhouettes offset against the blue flashes of night-lit snow and strobing brilliance of the headlights of passing cars that we glimpse between them (see Figure 3). As we follow them down the street we occasionally pass groups of people standing on the pavement or walking past, people who cross into the focal point of the camera and are brought into sharp focus even though the screen is still filled predominantly with the dark mass of Sada and her partner. The effect is in no way threatening, quite the opposite, indeed we come to occupy a place akin to that of Maja, moving through this space that exists, that can be seen clearly, yet inhabiting a place defined more by an openness, by a sense of kinship that is not so much seen and understood as lived and felt as an embodied sense of proximity. Sada's and her friend's conversation turns to the topic of love during the war, of how people felt alone and needed each other more, given the situation. Sada asks if her first love is still alive and says you never forget your first love as their conversation is gradually overshadowed by the third movement (*lento cantabile semplice*) of Górecki's *Symphony No. 3, Symphony of Sorrowful Songs* that swells to fill the soundtrack. We cut to a shot of some

FIGURE 3 *Screenshot from* Retour à Sarajevo. *Courtesy Philippe Grandrieux.*

strangers in the street who we see in perfect focus laughing as they
walk by and glance into the camera, yet we feel somehow lost, like,
perhaps, the parent who has lost a child in Górecki's symphony.
This is a strangely unsettling moment and we sense a certain relief
as we quickly pan back to find the familiar comfort of Sada's dark
mass, this formidable presence that we follow too closely as though
never wanting to lose her again. Fade to black.

If it is, for the Bazinian school of realist cinema, particular
cinematic techniques such as deep focus that present an objective
view of reality that fixes that reality in place and imbues it henceforth
with a certain authority and capacity for commentary on that reality,
in Grandrieux's work it is, conversely, this very shallow focus, this
lack of depth of field that draws us into a different kind of relation
with the image. This is an image that we *cannot* see clearly, with
which we are therefore forced to entertain a very different kind of
relation and that, simultaneously, makes its presence in and with
the world in which it moves and its proximity to us felt through
its opaque materiality and imposing mass. And yet, as suggested,
perhaps it is better to talk not of an imposing, embodied presence

but, rather, a sonorous body, for this is precisely a body that constantly threatens to exceed the limits that matter would impose on form. To borrow another musical term, what we are dealing with here in this harmonic relation between forms is not so much an imposition as an ethics and aesthetics of *accompaniment*. This is a concept I take from Mireille Rosello who uses the term in a complex analysis of Rachid Boudjedra's 1975 novel *Topographie idéale pour une aggression caractérisée* [*Ideal Topography for an Aggravated Assault*] (Rosello 2016). Telling the tale of a poor migrant newly arrived in Paris who has neither the cultural codes nor linguistic and cartographic literacy to be able to navigate the metro system and who, as per the title, ends up the victim of a vicious assault, Rosello's analysis uses Boudjedra's novel as a means to think through a different mode of relating to migrant peoples that would not rely upon the imposition of a foreign culture – as is always the case with any integrationist stance. The politics of displacement and belonging in *Retour à Sarajevo* are very different from the scenario in Boudjedra's novel, yet this idea of accompaniment describes very well, I believe, the demands or, perhaps better, invitation opened up to us by Grandrieux's film. For Rosello,

Accompanying is what we do when we cannot be *like* or even *with* the person but still accept that there is something to do, to the bitter end that we cannot prevent. Accompanying also means being with, without being, the hero of the story. (2016, 87)

To accompany is then to move with somebody, in harmony with that person without a need for there to be an absolute confluence of perspectives or knowledge. It is, like the idea of a harmonic relation, to open oneself up to a relation with the world that is not entirely one's own, to allow oneself to resonate in harmony with a different way of being in the world and thus to understand one's own positionality in the very moment that it is rejected as essentially arbitrary. As in Boudjedra's novel, to open oneself up to this possibility and to abandon all of those codes that enable us to feel situated in the world, to feel our way through the world and also to feel like our self, can be a profoundly disturbing experience, and Rosello does an excellent job of showing how this sense of disorientation for the reader is generated by Boudjedra's text. It

is precisely because Grandrieux's film is so successful in achieving
this mode of accompaniment that, by the end of *Retour à Sarajevo*,
our sense of dislocation is so short-lived and we feel some sense
of relief as we find Sada again and accompany her on her walk
through a life that we could not possibly understand. The same
cannot be said of how we will feel about the characters that we
accompany through the fictional universe Grandrieux will start to
create from this point onwards in his career, yet to accompany them
and to move with and according to a mode of being that is deeply
disorienting and that asks us to leave behind all of the frameworks
through which we navigate our way in the world is precisely what
he will ask us to do.

4

Intermezzo

Before getting stuck into the analysis of Grandrieux's fiction films, it will be worth briefly considering the difficulties that doing this presents. Grandrieux's films are, in many respects, a continuation of the aesthetic and stylistic explorations of the production and power of the image that we have observed in all of his work up until this point, and I would contend that it is this aspect of them that deserves the most attention. Indeed, if Grandrieux's films have, in the critical literature available, been talked about primarily in terms of 'affect', 'sensation', 'haptic cinema' and so on (see for instance Bonino 2013; Beugnet 2007; Ramdas 2013), this is no doubt because, in part at least, plot or narrative elements are not only minimal here much of the time, but also escape the kind of hermeneutic closure required by those schools of criticism that would seek to uncover the *meaning* of a film, be this via an unpacking of the psychological elements of the characters, the unravelling of a particularly convoluted or enigmatic narrative or the importation of contextual frameworks that render a text comprehensible by situating it within a larger whole, be this the director's oeuvre or a specific historical, geographical or sociopolitical reality. Grandrieux, indeed, is used by William Brown in his work *Supercinema* as the exemplar of a certain kind of cinema that resists representational modes and seeks instead 'to maximise "sensation"' (2013, 140), that seems 'to be more affective than cerebral' (142). Brown's argument, however, is that even though certain kinds of films may travel further down this road than others, 'all films combine representation with sensation, in the same way that all films are "monstrative," even when they form part of what is more obviously a narrative' (140) and that 'all films are always both affective and cerebral' (142). There are

certainly ways in which what Brown says is absolutely correct, but the problem with this idea is that it seems to imply that we can engage with all films in a similar way and this, to my mind, is resolutely not the case.

To take one of Brown's favourite examples, it is true that the action sequences of a film like *Transformers* (2007) contain images that are so hyperstylized and move at such speed, in such high-definition technicolour splendour, with such eardrum-popping, pumping soundtracks that they take on a certain abstract (which is to say non-representational) quality that acts directly on a 'sensory' rather than 'cerebral' mode of reception, appearing then, as Brown claims, to deploy 'seemingly avant-garde techniques' (139). The difference in relation to the films of Grandrieux, however, is that these sequences in *Transformers* invariably serve to heighten our response or empathic links to certain events or characters, to underscore our horror when the Decepticons seem to gain the upper hand and destroy one of the heroic Autobots or, conversely, to inject a shot of adrenaline into those pleasure-inducing moments that put us back on track towards the *jouissance* that comes with the fulfilment of a well-trodden narrative convention. Thus, even though there are elements here which may well seem to bring about an aesthetic rapprochement between *Transformers* and Grandrieux's 'blurry films' (143), these elements are, in a film like *Transformers*, always subservient to narrative whereas in Grandrieux the very opposite is the case.

Let me explain. It is, of course, resolutely not the case that there is *nothing* in Grandrieux's films that might be called a narrative, even in his recent performance and installation work that I will examine later, which strips back any semblance of narrative to a far greater extent than ever before. This narrative, however, serves a stylistic end, rather than vice versa, and is akin, in many ways, to Viallat's method of setting up formal parameters that create a movement within the work that produces an affect that cannot be reduced to either narrative or simple authorial intentionality. Or, alternatively, one might think of the process in play here as being akin to what we find in Paulhan's *La Peinture cubiste* in which a narrative – returning home late and not wanting to wake his wife – becomes the situation out of which a new way of engaging with the world arises. As has been seen in Grandrieux's documentary work such as the segments created for *La Roue* and *Brut*, the image

here, rather than being a purely formal element (as is the case with Viallat), is often generated via a resonant relation with a specific situation already ripe with 'sensation' or heightened intensity, a situation that is, then, out of the ordinary. As he moves into a fictional realm, such situations are precisely what Grandrieux will need to produce out of the psychological situations and narratives he will create, situations and narratives that will then serve to lift us out of the ordinary, out of the known, into a realm in which we have no choice but to respond non-cerebrally because it will remain to a large extent incomprehensible – if by that term we mean that a situation does not conform to any of the interpretive frameworks that we habitually use to render the world around us meaningful. Grandrieux himself addresses this very tension that inhabits all of his films in a journal entry written during the filming of his latest fictional feature-length film, *Malgré la nuit* [*In Spite of the Night*]. Reflecting on his producer Catherine Jacques' reaction to the daily rushes, which for her at one point leave narrative and emotion behind and tip over into the pure sensation of an image, Grandrieux writes:

> It is precisely at this point that can be found my own *exceptional flaw* [in reference to Blanchot]. This line which sets emotion against sensation is also what enables the film's greatest strength and its greatest weakness. It is between these two extremities, these two irreconcilable tensions that pit plasticity against narration, that the cinema must pass. (2016a, 7; see also 2016b)

In this scenario, plot and narrative then become those elements responsible for generating the forces within the work that will subsequently produce its aesthetic effects, that will produce the image itself, and it is for this reason that it is, to my mind, problematic to engage them in the way that one might normally engage narrative elements.

To engage narrative on these terms, however, is perhaps not an easy thing to do and it may go some way towards explaining why Grandrieux's cinema has at times elicited responses that must be qualified not only as negative but downright hostile. Indeed, even for a critic as sympathetic to Grandrieux as Jenny Chamarette, there seems to be a reluctance to let go of the ways in which narrative and knowledge operate in relation to film viewing.

Taking me to task for something similar to the approach outlined
above, Chamarette writes:

> Hainge describes 'this other logic' as a mode of viewing
> Grandrieux's film, in particular *La Vie nouvelle*, as if one co-
> existed within the form, structure and images of the film, as if
> in fact, the spectator always viewed the film's aesthetic elements
> in a pre-œdipal, pre-cognitive, pre-worldly way of the kind
> Beugnet suggests or as if every spectator were a pre-cognate in
> the intimate, terrifying womb of Grandrieux's film. However,
> such a commentary paradoxically supposes that there are rules
> for viewing Grandrieux's work – that in order to apprehend fully
> what is at work in the films, one must watch in a manner that
> assumes no *a priori* social subjectification, nor any awareness of
> the historical significance of, for example, an Eastern European
> setting in *La Vie nouvelle*, or indeed a setting in the heart of
> France in *Sombre*. The spectator must sense Grandrieux's world
> but without the spaces of their own. This intimate, dystopian,
> otherworldly mode of viewing seems perhaps overly prescriptive,
> given that the films themselves offer up no easy interpretation.
> Furthermore, such a consistently immersive viewing mode
> potentially distances the possibility of a more ambivalent ethical
> critique, both of the film and with the film. (2012, 71–2)

In taking the approach outlined herein and considering narrative
to partake first and foremost in an aesthetic expression rather than
a hermeneutic one, it is not my intention to disallow other possible
readings of Grandrieux's work, such as the very sensitive reading of
Chamarette herself, nor indeed others that vehemently reject what
Grandrieux proposes on the basis of preformed ethical or moral
positions that hold his works to account against them – and to attempt
to prohibit such readings would surely be an exercise in futility if
ever there was one. In suggesting that we engage with Grandrieux's
films according to another logic, one that will indeed require the
spectator to 'sense Grandrieux's world ... without the spaces of
their own', however, I am proposing that to engage with the works
in this way is consistent with their formal operation, with the way in
which they come to be in the world. One might be tempted here to
suggest that what is being called for is then a mode of reading that
remains true to the author's intention and consequently to dismiss
such an approach as a retrograde if not positively reactionary move.

This, however, is not what I am suggesting for the simple reason that in making his work, Grandrieux, like Viallat, can no longer be considered an 'author' if we take this term to invoke a figure who exerts complete control and claims responsibility for every aspect of a work. Indeed, just as the story of Gert-Jan Theunisse becomes but an element in the creation of an image or expression whose potential and force exceeds the boundaries of the man, so Grandrieux himself is subject to these same kinds of figural movements in the creation of the work taking place within a set of parameters either found (for his documentaries) or imposed (in his fictional works), is implicated in the situations he films (in his documentary work) or stages (in his fictional works) such that he is directed by them as much as he directs them.

Without wanting to flirt with the issue of intentionality again, it is undoubtedly important to note that Grandrieux has described his method in somewhat similar terms. In the interview conducted for Sarah Bertrand's film *There is No Direction*, briefly mentioned already, Grandrieux says to her:

> It's something that folds you into it, which occupies you, in the truly territorial sense of being occupied by, and there's the paradox because deep down it's something that you produce, that you construct, yet which comes at a certain moment to take hold of you in such a way that this grabbing, you're not really in charge of it. It's like something taking place between something elaborated and something undone, a shuttling between something built, mastered, precisely, and then a kind of work from inside, opaque, obscure, from out of this mastery that produces from within you a strange kind of body that you move into, that you end up inhabiting, that you dream with, that you move with and that you make films with. (Grandrieux and Bertrand n.d.)

In suggesting that one leave pre-existing modes of apprehension and knowledge behind when approaching Grandrieux's films, then, I am arguing for the adoption of a receptive mode that works along similar lines, an immanent mode, to use Chamarette's term, a mode that would be, as suggested, more of an accompaniment. If this is *not* a prescriptive approach, it is precisely because, firstly, it does not preclude other approaches but also, more importantly, because even if adopted, the kind of body produced by this approach cannot be determined in advance and must arise only ever through this

immanent contact with the situation or, here, text. This approach is one that then absolutely allows us to retain these films' resistance to easy understanding. As Chamarette rightly points out, 'the films themselves offer us no easy interpretation' (2011, 72), which is all the more reason why we should not attempt to impose an interpretation on them with recourse to other kinds of knowledge pre-produced elsewhere. If this approach is prescriptive in any way, it is then only insofar as it requires us to pay close attention to what happens *formally* in the film, because it is precisely via these movements from inside the image itself that the film is created and establishes a different kind of relation with the spectator, everything, narrative included, partaking in this movement that is generated from within rather than being imposed from the outside.

We are left here in somewhat of a quandary, however, because it is being suggested that the 'narrative' of Grandrieux's fictional films is at best minimal and fundamentally resistant to a cause-and-effect logic that could be reconstituted in such a way that it might be said to contain, if not explain, the film. Yet at the same time, my contention is that these films' narrative is an important element in the establishment of the parameters necessary for a certain kind of situation to arise that will in turn produce a figural movement within the image that will exceed those parameters. Given this, in what follows I will have, paradoxically, no choice but to attempt to recount the narrative line of these films in order to show how they stage a scenario that produces a series of forces that then constitute the image and its potential relations to the spectator, but in doing so risk giving the impression of a causal, teleological progression that does not necessarily conform well to the experience of watching these films. In taking this approach I hope to avoid the vagaries and generalizations that, for Eugenie Brinkema, have characterized much scholarly work (and especially Deleuze-inspired scholarly work) that attempts to deal with 'affect'. She writes:

> One of the symptoms of appeals to affect in the negative theoretical sense – as signalling principally a rejection: *not* semiosis, *not* meaning, *not* structure, *not* apparatus, but the felt visceral, immediate, sensed, embodied, excessive – is that 'affect' in the turn to affect has been deployed almost exclusively in the singular, as the capacity for movement or disturbance in general. (When Lone Bertelsen and Andrew Murphie succinctly

declare 'affect is not form', it is because they align affects with *transitions* between states' and the very essence of what is dynamic and unstable, against an impoverished notion of form as inert, passive, inactive.) Deleuzians, with their emphasis on affect as a pure state of potentiality, tend to be particularly guilty of the sin of generality. (2014, xii–xiii)

If I am keen not to lay myself open to this kind of criticism by describing the ways in which affective relations are established through formal means, I also wish to take seriously Grandrieux's idea of what can be described as a resonant relation with the world out of which films are produced and to continue to articulate his cinema to a more musical or sonorous mode. If I set out to do this and to privilege terms such as 'resonate' and 'accompany', this is not only because of the very important role that sound plays in his work – indeed these are terms applicable to the films' images as much as to their sounds. This is also because I hope to avoid another set of problems that beset much criticism of films that invoke the spectre of a haptic relation to the cinema. Situated in a phenomenological tradition, haptic criticism also argues for a different mode of perception that would heighten the chiasmic nature of the relation between film and spectator by figuring the possibility of a different kind of receptive mode that would not display any of the distancing, perspectival and totalizing tendencies of vision. Rather, haptic phenomenology suggests that we can engage with images differently, that the cinema can arouse a sensory mode more akin to the intimate and immanent contact of touch. Exemplary of this approach is Vivian Sobchack's analysis of Campion's *The Piano* in her article 'What my Fingers Knew: The Cinesthetic Subject, or Vision in the Flesh' (2004, 53–84). Countering Carol Jacobs' comments on the film's opening shot which described it as an almost entirely abstract and therefore undecipherable image, 'nearly no view at all – an almost blindness, with distance so minimal between eye and object that what we see is an unrecognizable blur' (cited in Sobchack, 62), Sobchack suggests that the scene is in fact meaningless only if restricted to a visual regime, for somatically she understood what she was looking at. She writes:

Despite my 'almost blindness', the 'unrecognizable blur' and resistance of the image to my eyes, *my fingers knew what I was*

looking at – and this *before* the objective reverse shot that followed to put those fingers in their proper place.... What I was seeing was, in fact, from the beginning, *not* an unrecognizable image, however blurred and indeterminate in my vision, however much my eyes could not 'make it out'. (63)

While a fine piece of analysis, my discomfort with the haptic approach in relation to Grandrieux's cinema is that even though a cross-modal form of perception seems to be in operation in Sobchack's account, the sensing subject remains constituted as before and there is no sense in which the very existence of that subject is troubled, that it is required to abandon itself to a different logic – and to a certain extent this is possibly a symptom of phenomenological approaches more generally for all of their claims for chiasmic relations and figurations of the body as simultaneously 'an objective *subject* and a subjective *object*' (Sobchack 2004, 2). What is more, the 'haptic' mode described here does not appear in fact truly to inaugurate a fundamentally different perceptive regime but, rather, to retain the primacy of the scopic. In other words, as Sobchack herself says, '[her] fingers knew what [she] was looking at' (63), which is to say that the only possible relation to the cinematic text continues to be figured in terms of visuality, even if the sensory organ in play has changed, and the only possible mode of apprehension of the forms in the text remains mired in the scopic regime's privileging of a representational mode that requires all dynamic forms to be fixed in place, anchored to coordinates that will render them both static and identifiable or knowable (in the most reductive sense of the term).

To figure the body in terms of a sonic body, however, and in doing so to go beyond the 'musical analogy' suggested by David Bordwell (1980b) or even to go beyond the sonic as an auditory phenomenon to understand it rather in an expanded acoustic sense, is a very different proposition, for it is to constitute the body not as something that pre-exists, that has a fixed form, but only as something that propagates itself in space and time, a wave form whose qualities are constantly formed by its environment and the other bodies it encounters. What is being suggested goes far beyond the way in which the bodies that we see on screen are conceptualized, however. Indeed, if it is important to conceptualize the forms of Grandrieux's cinema in ways that prohibit us from

tracing them back to any kind of subjectivity, this is because it is the entire body of the cinema that is constituted in this way, not only the forms figured but also the form of the figures. As with Paulhan's *La Peinture cubiste* and Deleuze's analysis of the relations between chromatic zones and figure and background in Bacon, so here the interplay of figure and ground, light and dark, word and image is such that it is no longer possible to clearly delineate one term in each binary pair from the other. To put this another way, to figure the body of the cinema like this is to suggest that it is no longer possible to establish the presence of a cinematic space in which various figures and forms would be placed. The very concept of space, indeed, seems to suggest an already there, but there is no such space in Grandrieux's films and just as we are asked to enter the worlds of his films on their own terms, leaving behind the spaces of our own, so they in fact only ever emerge through the movements and relations that take place within them. To figure *this* body as a sonic body is then to highlight the expressive and relational aspects of their ontology, to suggest that Grandrieux's films, like sound, exist only when they are actually expressed, that they are resonant and as such are constantly re-formed both by the interactions of their own forms and by those forms' relations with their environment, that they create forms that do not bear an indexical link back to *objects* in reality and, as such, that their forms cannot be *known*, but only sensed, they can only be felt to vibrate in harmony with each other and with us or, on the contrary, to instigate a jarring, dissonant relation.

To suggest that the forms we find in Grandrieux's cinema are formed and transmit themselves to us in a manner more akin to sonic phenomena may seem at first somewhat counter-intuitive and then, perhaps, somewhat redundant, since from the point of view of physics, sound is constituted by and transmitted to us by phenomena not unlike those that explain the existence and carriage of light, which is to say that both propagate themselves through space via waves – even if light also displays particle properties, being emitted in photons. As cinematic spectators, however, we do not watch films from such a perspective, no matter how much we may know about the physics of light, and it is most often hard not to trace the light reflected off a body back to the fixed form of that body, to reduce it to the identity of its indexical referent in the world, be this real, imagined, fictional or historical. Yet this is something we

are unable to do with sound, for even if we may be able to identify
the source of a sound just by hearing it, the sound we hear is never
coterminous with a material object in the way that light reflected
off the surfaces of an object is, it is rather a separate expression that
is not reducible to the instrument or body producing it and that is,
what is more, necessarily shaped not only by the signal-emitting
body but also, to a far greater and more perceptible extent than is
the case with light, by the characteristics of the medium or space
into which it is emitted – as proven in a remarkable manner by Alvin
Lucier's *I Am Sitting in a Room* (1969). To conceptualize cinematic
forms or the cinematic body in terms of the sonic is then to insert
them into a set of theoretical axiomatics able to retain the inherent
instability of forms through which is deployed what is referred to as
affect. Affect, indeed, can here be conceptualized as the carriage, via
form, of the forces that are involved in not only creating the form
but also those that are implicated in the undoing of that form, in
carrying that form beyond itself and instigating transversal relations
between it and the outside in which it is situated and with which
it is necessarily entangled – not necessarily at a subatomic level as
physicists would have us believe, but in a complex choreography of
mutual becoming taking place in an ontological sphere where the
very idea of being-in-itself is an impossibility, in which all ontology
is necessarily expressive and relational. This is a dance in which
every aspect of the film's form is a player since, to put my argument
in the simplest possible terms, the figural processes that take place
on screen via stylistic means and that break with a representational
model (in a manner similar to that described by Deleuze in relation
to Bacon's painting) are also effected beyond the screen in the
ways that the diegetic content acts on the viewer, breaking apart
the possibility of any form of representational thinking that would
make the content presented conform to a prior existing reality,
and in this move creating a zone of indiscernibility between the
viewer and the figures on screen, both being subjected to a move
that carries their forms (forms of knowledge in one case, physical
forms in the other) beyond themselves. For this to become clearer,
however, we must now turn to the films themselves.

5

Sombre (1998)

Sombre, as befits its name, begins with a simple, sober title credit, the brilliant white of the letters of the title in a lowercase, sans serif font creating a sharp contrast with the pitch black of the background. Things will not remain so black and white for long, however. We cut to a shot of a station wagon that we follow as it winds its way slowly around mountain roads; the soundtrack, consisting of nothing but a low, ominous rumbling that seems to straddle the diegetic and non-diegetic realms, proximate to the sound of tyres rolling over tarmac yet obviously not being produced directly by what we see, while nonetheless seeming to belong to and emanate from the scene we contemplate. There is something else strange and unsettling here, however. The muted browns, greys and greens of the mountain landscape that almost fills the screen with a dark imposing presence give the impression that this is a scene shot at twilight, that moment when the distinct forms of the physical world start to seep and bleed into each other, that time before the darkness of night envelops everything in its own form. Yet the blue of the sky is not of this time, it retains a hue that does not belong here and contains none of the gradations or vestigial flare of the sunset that we would find at twilight, but is rather a deep, consistent tone verging on midnight blue. As we follow the car round a 180° hairpin bend, our suspicion is confirmed as we drive into the sun sitting high in the sky (see Figure 4). If initially the impression of darkness was created by the underexposure of the image, now, as we face into the sun, the contours of the forms we see are washed out by a slight overexposure, as if the aperture setting had been fixed rather than allowed to automatically adjust for the optimal realistic representation of the world, given the ambient light conditions,

FIGURE 4 *Screenshot from* Sombre. *Courtesy Mandrake Films.*

and fixed, what is more, at a point that thrusts the forms in the world depicted into a state of flux. We quickly cut to another shot of the dark silhouette of trees picked out clearly this time against a slate grey blue sky. At least half of the frame here is pitch black, which produces, once again, a somewhat uncanny feeling. Indeed, even if we can now discern the outline of forms more clearly than before, something is still not right, for even though the image is predominantly black, we see before us, shining out from behind the trees in the left of the frame, the sun sitting high in the sky. This effect in and of itself is, of course, nothing particularly radical, it is simply the effect produced by shooting directly into a bright light source, meaning that the objects in the foreground are backlit. In the context of a film called *Sombre*, however, that is in many respects nothing but a meditation on darkness and light in both the chromatic and metaphysical senses of these terms, this formal technique is imbued with an affective charge that will resonate through the whole film. *Sombre*, indeed, will trouble the distinction between darkness and light, good and evil, if not overthrow it entirely, and this shot does precisely that, turning day into night, producing blackness out of light – as is gestured to already by the French term for this technique, *contre-jour*, which suggests here not only filming *against* the day(light) in a spatial sense, but in a

moral one too. This technique is not only sustained as we continue to follow this car as it winds around these mountain roads, it is intensified, because even though we continue to see glimpses of the sun and know then that we are still in broad daylight, the shot is framed such that the blackness of the trees gradually fills more and more of the screen until all light is eclipsed.

We cut to a shot of children in a darkened room, screaming. Given the ominous space we have come from, the effect is terrifying, yet we gradually realize that these children are, for the most part, also smiling, screaming in ecstatic terror, every fibre of their being captivated by whatever it is they are watching, oblivious to everything but the spectacle playing out before them. They shout out instructions and warnings: 'There, there', 'Behind you!', 'Hit him, hit him!', implicating themselves in the situation, seeing themselves as agents in it and not merely passive spectators held at bay by what, we surmise from their screams, the way their bodies recoil and the look of fascinated horror in their eyes, must contain a high coefficient of darkness. The children's screams are joined by a new rumbling at a higher pitch than before, and then a pulsing, throbbing, ear-piercing sibilance that is like the sound of 100,000 crickets, and then a slow, regular chiming of two bell-like sounds, a semitone apart, that enter into a complex interplay, sometimes alternating, sometimes sounding together and highlighting their discordance. As we cut to a close-up shot that pans across another row of children's faces, all diegetic sound suddenly drops out and we are left only with this nightmarish noisescape. The effect is striking, for it intensifies our sense of the children's rapture, drawing our attention to their eyes which track the movements before them, and their bodies which seem to be held in suspension by what we cannot see, floating in the menacing yet somehow ethereal soundscape. This, indeed, is a space of relations in which bodies and forms are drawn beyond themselves, where the children seem to emerge from the darkness behind them, where they are entirely entangled with whatever they are watching, where sound, light and movement are engaged in an intricate choreography that erases any distinction between diegetic and non-diegetic space to present us with one single dance. As this panning shot left reaches its end, this dance of movement, light and sound is transferred into the very mechanics of the cinema, for we pause on a close-up of a young blonde-haired boy transfixed, mouth agape, eyes wide open. As he starts to react

to the scene playing out before him, pointing and gesticulating, his mouth forming words we cannot hear, we notice that time seems to be somehow out of joint, that his movements seem irregular and erratic, sometimes too fast and jerky. The strangeness of the image that pulls us out of a relation to an unmediated real (to the extent that there can be any such thing) governed by the strict regularity of chronological time is accentuated further by the focal plane, for as the boy's body jumps back and forth, alternately repelled by and then drawn into what he sees, he falls in and out of focus. These two effects are achieved without the need for any radical avant-garde hacking or preparation of the technological tools being used: the non-realistic time of the image is produced by accelerating and decelerating the frame-per-second rate of the film passing through the gate, while the blur and bleed of the figure is produced by maintaining a fixed focal point with a minimal depth of field so that the form in front of the camera moves in and out of the focal plane with the slightest change in distance between it and the camera – regardless of whether this is the result of the camera shaking or the form in front of the camera moving, the important thing is precisely the relation between them. In addition to the strangeness they generate, what these two techniques draw our attention to are the ontological characteristics of the cinematic as opposed to simply photographic image. For if photography, true to its etymology, can be thought of as a technologically-mediated form of writing with light, the cinema supplements this base ontology with movement and time.

In this opening 2½ minutes of the film, Grandrieux seems to want to intensify certain qualities of the cinema, the relations out of which it is constituted, to present us with an image more than a representation, with an expression that operates first and foremost aesthetically before the dance of sound and light is sublimated into a story or plot. This desire, indeed, is explicitly laid out in his filming notes [*notes d'intention*] that figure on the original French DVD of the film and comment on various aspects of it. Under the heading 'light', for instance, we read:

> I went back to the region [where *Sombre* was filmed] a few days ago to do the first test shots with different film stock, different formats, to seek out the pose, the opening, to check out the amount of light, the impression, this muffled image, against the

day [*contre le jour*]. I want the film to be directed against the day. You see, the light has to be won over, it is not what makes us seek, it comes from far away, from behind, it is seen through the foliage of trees or a tangle of hair, it holds the opacity of bodies in suspension, it is above all a relation to the world, an originary dazzling which returns each night to light up our dreams. (Grandrieux 1999)

Of 'movement', meanwhile, he writes:

The film is a whole, it is a movement, and this question of movement is very important. Marey or Muybridge, of course, for the archaeology of the cinema, with regard to its origins, but above all Ingrid Bergman, from Hollywood to Stromboli, for the desire that sets us off. The relation with the actor (whether professional or not) is above all a relation with alterity. I want my directing of the actors to be the staging of this relation. The film, the fiction in all of this would then be 'the documentary' in which we would see this movement leaving from itself to go towards the other, then returning from the other back to the self: there is no relation other than a reciprocal one. (Grandrieux 1999)

If this notion of alterity is vital in these opening sequences of *Sombre*, it is not only because of these relations to light and between actors, it is also because of the intertextual and metatextual nods that they provide. The opening travelling shot that follows a car driving through a mountainscape, for instance, cannot help but recall and indeed gesture towards Stanley Kubrick's *The Shining* (1980), even if the opening credit sequence of the latter is shot from a helicopter and not a car, even if the camera follows behind Jack's car at a greater distance than we trail Jean's car and even if Kubrick's film is shot with and not against the light.[1] Yet while Kubrick's opening sequence, like all 'good' establishing sequences, serves to contextualize the diegetic content to be rolled out before us, to convey the extreme isolation of the setting where the action will take place and that will be so important to the narrative progression of the film, the information conveyed by the opening sequence of *Sombre* is very different. In this opening, indeed, we see exemplified the reversal of the scenario played out in William Brown's analysis

of Hollywood blockbuster movies, as the narrative content here serves a stylistic end, priming the viewer for a different kind of relation or aesthetic engagement with the film to come. For what is suggested by the description of this opening above is that there is an absolute indiscernibility here between every element of what we see and hear, between all of those terms that would normally be held apart from each other in a dichotomous relation, between light and dark, diegetic and non-diegetic, form and ground, near and far and form and content. In each case, these are terms that no longer really remain operational, just as the distinction between inside and outside in the affective scene is similarly rendered redundant since the body is 'always already wholly implicated in its milieu', as Moira Gatens puts it (2004, 115). The manifest content of the film here then becomes only the stage or situation in which a set of dynamic relations are played out between both the cinematic and cinematographic forms and Figures of the film – forms and Figures that are never stable, always mobile and, as such, never knowable. It is then through this indiscernibility that the film folds us into its body, prefiguring the extreme precariousness of knowledge in the scenes about to play out before us.

If there are in this first sequence both intertextual and metatextual relations, the same can be said of *Sombre*'s second scene which could almost be a remake of the puppet show scene in François Truffaut's *Les 400 coups* [*The 400 Blows*] (1959) – even though Grandrieux deliberately does not cut to a reverse shot as Truffaut does to show us what the children are watching. Both of these intertextual references are entirely apposite: Kubrick's film also places horror in the very heart of the everyday, while *Les 400 coups* is ultimately the story of a boy who, like Jean, the main protagonist of *Sombre*, is unable to fit into the world in which he finds himself. In Truffaut's film, however, this scene serves to show the extent to which the teenage Antoine is alienated not only from the adult world whose strictures he resists throughout the film, but also from the realm of childhood, for if we see the younger members of the puppet show audience in the same kind of enraptured terror as in Grandrieux's film, we also see Antoine and his partner in crime René sitting at the back of the show, utterly unmoved and discussing what they can steal and hock to get money. There is no such moment in Grandrieux's film and this scene serves rather as a metatextual nod to us the viewer, an indication of the position we

will be asked to adopt, of the kind of experience that awaits us. For if, as we will later find out, these children are watching a Punch and Judy show performed by Jean, then we too will spend the rest of the film watching him not so much play the role of the Big Bad Wolf as, rather, live and move in this world as the very embodiment of the ultimate alterity, of horror. But to understand how we may also contemplate such a figure with the same rapturous ecstasy as these children and see in their hypnosis our own image (to use Bellour's term (2009a, 123)), we must first attempt to summarize the plot that creates the conditions for this affective shift to occur.

Story

Jean is a puppeteer travelling around France according to an itinerary that seems to follow that of the Tour de France, a spectacle that keeps reappearing throughout the film. He is also, however, a serial killer who murders women with his bare hands. And so it is that, after the opening sequences analysed above and then a brief, more 'experimental' sequence we will analyse in detail later, we cut to the scene of his first kill, then a shot of a boy, blindfolded, feeling his way through a rural landscape, his fingers finding, in a shot that lasts the briefest of moments, the corpse of Jean's victim. We follow Jean as he wanders among the crowds watching the Tour de France, practices the balletic movements required to animate the Big Bad Wolf of his puppet show, drives to his next destination, visits a peep show, kills again, picks up a hitchhiker then kills again. The inevitability of this pattern is broken one day, however, as he pulls his car alongside another that has veered off the road in a torrential downpour. He invites its driver, Claire, into his car and takes her to see her sister, Christine, in the supermarket where she works, then dropping them both off at a family gathering from which he later picks them both up again and takes them to a club. In the club, Jean starts to drink heavily and picks up a couple of women with whom he continues to drink. They go to his parked car and, as one of them dances in its headlights to the instructions of Jean who barks orders from the car, he makes out with the second woman and then starts to strangle her. Unable to hear her friend's cries over the music, the first woman continues to dance. But then Claire, who has left the club to go for a walk, appears and stares at Jean

through the car window. She does not try to stop him and, indeed, it seems as though he could continue this act until the desired end with her looking on. Having noticed her, however, Jean stops what he is doing and returns Claire's gaze, giving the woman in the car time to flee.

While one might imagine that Claire would, at this point, also flee and get as far away as possible from Jean – indeed the plot summary provided on the American DVD of the film describes this decision to stay near Jean as 'inexplicable' – Clare returns instead to Jean's hotel room to shower, while Jean goes to the beach where he watches Christine swim naked. As Christine emerges from the water, he tells her to get dressed and asks her if Claire is seeing someone. Claire, Christine replies, is a virgin. Back in the hotel room, meanwhile, Claire goes through Jean's bags and finds his puppets and a Big Bad Wolf suit that she puts on and dances around in, only to be caught in the act as Jean returns. Claire asks after her sister, obviously concerned that Jean may have done her harm, but Jean replies that he has taken her home. Claire takes off the wolf suit and leaves; Jean goes for a drive, picks up a prostitute and kills again.

The next day, Jean, Claire and Christine all go swimming together in a lake. Claire swims off leaving Christine and Jean together. They swim for a while and then, as they head towards the shore, Jean grabs Christine and tries to smother her but she fights back and they wrestle in the mud. We cut to a shot of Claire, who has swam far away; suddenly panicked, she calls out for Christine, swims to the shore and sprints across land back to where she left Jean and Christine. She finds her sister naked and covered in mud, in a state of shock, almost catatonic, but not dead, and Jean standing waist-deep in the water, his back turned and hunched over, like an animal that has some sense of having done wrong. Claire shouts at Jean to move away from them and he wades further into the water. Christine and Claire return to the car and Claire tells her sister that while everything is not fine now, one day it will be, and that her sister was right, the water is good and she's no longer afraid. Christine, though, is very much afraid and as she sees Jean a look of terror comes across her face and she starts to breathe heavily, transfixed.

Even at this point Claire does not run from Jean, however. Instead they all go back to his hotel room. We first see Christine,

still terrified, with tears in her eyes, barely able to watch what is taking place before her, then cut to the reverse to see what she is watching: Jean straddling Claire on the bed, pinning her down with his hands on her naked breasts. He gets up, holds both of them by the hair, pulls them to him in more of a wrestle than an embrace, pushes Christine away then wraps his forearms around Claire's neck, holding his hands apart as though unable to follow through with the next step in his usual choreography, then falling to his knees and burying his face in Claire's crotch. He gets up and ties Christine to the bed, leaving Claire to watch, then drives Claire to a club, ordering her to drink from a bottle of spirits the whole way.

In the club we watch Claire dancing in an almost trance-like state to a track of deconstructed hardcore techno that seems entirely suited to her movements. As a burly guy in a suit and loosened tie tries to cut in on her dance with herself, however, this music fades down in the mix to be replaced with Little Richard's 'Tutti Frutti'. Claire seems to return to the space she is in and smiles at her new dance partner, then tells him repeatedly, with the same ecstatic smile on her face, that she is in danger. The guy suggests they go elsewhere but Claire says she can't because she's not alone and that, what is more, the guy she's with is really dangerous, a line that she delivers in the giddy style of a young girl declaring her love for a boy. The guy eventually persuades Claire to leave with him to go for a party, but just as she agrees Jean appears by her side. She tells him they are all going to go and have a party, but it seems as though Jean doesn't even understand the concept of the word. Nonetheless, they all go to the house of a friend of the guy from the club and in a long, nightmarish scene, it becomes obvious that these two men are attempting to stage what will essentially be a gang rape. With Bauhaus' 'Bela Lugosi's Dead' playing at full volume, the two guys give Claire more to drink and then start to make out with her as Jean paces in the background, seeming unsure what to do, staring into mid-space, unable to look at this threesome in formation. We hear the sound of a zipper and Claire gasps as the big guy takes her from behind. Unable to take it anymore, Jean intervenes and pushes him off her, awkwardly. The suited guy, much bigger than Jean, pushes him to the ground easily and punches Jean in the face repeatedly. His friend tries to stop him and Claire seems also to reach in to help but instead takes Jean's keys from his pocket and runs out of the house.

Claire drives back to the hotel room to untie her sister and then takes her to a train station. Once there Claire asks her sister to come to Paris with her, but Christine declines as she boards a train presumably taking her home, away from Claire and Jean. Claire drives through the night and eventually finds Jean walking on the side of the road, his face a bloody mess, his whole body huddled in on itself. Claire takes him by the arm and sits down with him by the side of the road. She takes Jean's obviously tender hand and presses it to her breast, leaning in close to him. Jean responds by pushing her to the ground and forcing his thumb into her mouth and hand over her face. While this is normally the first move of his murder sequence, here it turns into the prelude to a caress and an embrace that ends with Claire undressing, unbuckling Jean and letting him climb on top of her. As he thrusts into her violently, a tear rolls from Claire's eye and Jean's hands seem to tremble around her face, as though wanting to throttle her yet unable to do so. Jean rolls off and Claire watches him walk away into the darkness, a look of tender longing and melancholy on her face. She walks up to him, goes to touch him, but is unable to and says instead, tenderly, 'Did you hear? That made me cry.' Jean grabs her hand, drags her back to the road and then walks on ahead. Claire shouts after him, saying that the car is in the other direction and that she can't run to keep up with him because of her heart murmur. A car heads towards them and Jean throws himself in front of it, flagging it down. He opens the door and throws Claire inside, screaming at the female driver to drive away, kicking the car and swearing at her. Jean hobbles off into the night leaving Claire and the owner of the car to drive away. As they leave the woman asks Claire if she's OK, if her man is always so violent. Claire replies that he isn't, that if he was she would divorce him, that they fight a lot but this time she's really afraid he's going to leave her. She explains, continuing to ventriloquize a fantasy of normality, that it's because of his job, that they're always on the move and that that's not easy with kids. Back at the woman's house, sitting at the kitchen table, the woman says that her husband died two years ago, describes what a good man he was, but then declares that she never really loved him. Claire asks if she has ever been in love and she replies she was once, when she was fifteen, but their parents separated them. As she is telling this story, one of her children wanders in half asleep and she carries him back to bed. Over a slow, out-of-focus shot over the torso of the sleeping

child, across his curtains and then a shot of Claire with her head resting on her arms, the woman's story continues in a whispered voiceover, the story of how she found out that her former lover had fallen very ill later in life, so they decided to meet up in Paris, somewhere they'd always wanted to go together. Not knowing what to do, they wandered around for hours, too scared even to hold hands, but eventually went back to their hotel room. And then they each went their own way the next day, and then he died days later. As we approach the end of this story, Claire slowly lifts her head, her eyes shut, and the shot tilts upwards very slowly, making it seem as though she is sinking, her head gradually disappearing off the bottom of the screen. From the top right hand corner of the screen, filled with a dawn blue sky, a plane high above traces a diagonal white line across the frame, bisecting it in two. We cut to an extreme close-up shot of Jean staring up towards the top right of the frame, the shadows of tree branches cutting across his face on this same diagonal line as he sways back and forth to the sound of twigs snapping underfoot.

We cut to a night-time scene as Jean returns to type, forcing himself on a woman in a field, pinning her down, pulling up her dress, staring between her legs, penetrating her and then smothering her. Jean stands and walks off into the woods, stumbling and coughing. The camera tracks Jean as he walks through the trees. We cut to a shot of his face, the light coming from above casting shadows across his face, blackening his eye sockets. His every movement casts different zones of his body into darkness, the interplay of light and dark mirroring what is taking place in the forest, where shafts of light dance between the thick black lines of silhouetted trees that cut the screen into vertical strips. Jean buries his face in his hands and falls to a crouch, the camera following him and plunging us into near total darkness. What light we can see reflected here seems textured, the grain of the image being so great that a near pointillist effect is created. We cut to a mid shot of Jean, barely distinguishable from the background around him, the blurring of the boundaries between figure and ground created by the saturated hues and pointillist effect now intensified by camera shake that seems to make the whole image vibrate from within as Jean walks through the forest, becoming nothing but a zone of shadow. We cut to one final trembling, extreme close-up on his face, staring upwards and off to the side, like one of the many figures in El Greco's paintings

(including Christ as he carries his cross) who cast their eyes towards heaven, his face seeming briefly to glow in the light.[2] This though is not a moment of enlightenment or salvation, for he lowers his head, returning within, casting his face back into the shadows, filling the frame with blackness that prefigures a final wide shot of Jean, his figure barely distinguishable against the forest floor on which he now lies motionless in the fading light. Fade to black.

We cut to a travelling shot filmed from a car driving along a mountain road and watch as the endless procession of Tour de France spectators on the side of the road passes before our eyes. Sitting in camping chairs or on the ground in front of their parked cars, they stare ahead of them, their eyes sometimes drawn by the camera passing in front of them. The scene starts in complete silence with a non-diegetic soundtrack cutting in only after a long pause, a version of Serge Gainsbourg's 'Les Amours perdues' performed by Elysian Fields (1997), a song that tells of the irrecuperable nature of love lost that leaves behind an ineradicable void.

Form

The description of the final three sequences of the film above – namely, Claire with the woman, Jean in the forest and the Tour de France crowds – should indicate clearly that there are no easy answers here, no simple cause-and-effect relations that will allow us to ascertain the definitive meaning of these final moments and thus of the film as a whole. This, though, is in effect the principle of the film as a whole which asks us to move with it, to leave behind our own hermeneutic and moral frameworks and to accept that killing is simply what Jean does and that Claire, in full knowledge of this, will be capable of loving him, of truly loving him – a point that has been understood well by Raymond Bellour who classifies *Sombre* as a love film and says that this is precisely what constitutes 'its strength and its paradox' (1998, 7). We are asked, in other words, to accept Jean as does Claire, to accompany him and in doing so to relinquish our own positionality, our own sense of self, to stare into the abyss where we cease to exist as an autonomous being in control of our own self and to allow ourselves to be swept along by intoxicating forces both terrifying yet potentially beautiful also, capable of inspiring ecstasy. This, of course, returns us to the

very beginning of the film and the children screaming in ecstatic terror, and this scene in turn resonates strongly with the final shot of the Tour spectators who are not yet living but waiting for the moment when the pack speeds past them in a blur of colour and pure movement, a movement that will pull every fibre of their being with it for one brief moment of joy, cheers, screams, cries and a sense, even if fleeting, that they are a part of something bigger than their own atomized existence. In framing the film with these two sequences of people watching a spectacle, Grandrieux implicates us as spectators, suggesting that in watching this film we also might experience this heady rush of sensation and forget ourselves for a moment if we are willing to let go, to let ourselves go with the film not against it, to stare into the origin of the world with Jean, fascinated by the spectacle of life and how quickly and easily it can tip into death.

To suggest this is not to claim that Grandrieux is glorifying rape and murder or exhorting us to become serial killers, it is to say, rather, that the scenario's extremity serves to test the limits of our willingness to let go, to accompany the film and allow it to work on us in a relational mode analogous to that between Jean and Claire, which is to say not according to a normative narrative mode where the events depicted on screen (even if entirely fictional) would need to somehow make sense or remain comprehensible when measured against our own prior life experience. As John Bradburn puts it, we are here faced with 'a horror of subconscious drives and desires that over run so much so that the logical constraints of the world are destroyed' (2008).

If *Sombre* succeeds in its quest to get us to relate to it in this way and to place ourselves in a situation analogous to the relation between Claire and Jean, it achieves this in part via the remarkable sequence taking place following the club scene during which we find ourselves siding with Jean, wanting to believe that he actually does love Claire and willing him to pull the guy thrusting into her off of her, even if Jean's lovemaking is just as or possibly more violent. This mode of relating to the film is also rendered in the very form of the image in a number of key, more 'experimental' sequences throughout the film, however – sequences in which the very movement of the image as an abstract aesthetic expression presents us with different relational modes and possibilities. The first of these comes at the start of the film, after the scene of children screaming

at Jean's puppet show and before his first kill. In this sequence, we struggle to make out a mountain landscape shot in washed-out greys that obliterate the forms of this alpine topography and turn them into tonal gradations, the difficulty of fixing these forms in place being compounded by the movements of the camera which does not so much tremble as jerk from side to side and up and down as though in a seizure, seeming not so much to desperately seek something out in this landscape as to be unable to rest on any one part of it. The camera pans jerkily across the jagged line of the mountain ridge that would normally bisect the screen sharply into distinct zones of matter and air, rock and sky, black and blue, but instead the frenetic spasms of the camera create only a blur of three mildly differentiated zones of grey, degrading the sharpness of the line, washing out the contrast. This sequence is accompanied by the low rumbling heard throughout the opening sequences of the film, but as we progress through this shot the rumbling is joined by a higher pitched drone that gradually crescendos up and intensifies. As it does so, the focus of the image drops out, creating an even greater degree of indiscernibility between the forms, tones and contrast of the image. We cut. All sound drops out and the camera remains still. Our eyes gradually adjust to the darkness of this new shot, having been conditioned by the wash of light, muted greys, blues and browns of the previous sequence, and when, finally, we are able to discern some movement in this scene, shot in extreme low-light conditions, we see Jean emerging from the darkness or, rather, with it, for his form is never clearly delineated against the backdrop and is discernible more as an infolding of or ripple across the blackness. Even though the principles according to which the space of these two sequences is generated are the same, the relative stillness of this second sequence comes as a relief following the extreme disorientation produced by the preceding 'experimental' sequence. If the first sequence provides us no fixed coordinates at all to orient ourselves, all semblance of line and form bleeding into an undifferentiated volume, then the same can be said in many respects of this second sequence, the difference being that we now have a guide able to see in this world who seems to miraculate the image around him, to serve as a centre of gravity that pulls the forms in motion along with it and create then a perspective that anchors vision, since it moves relative to the movement of the space that produces it.

If we share Jean's vision here, after his second kill the movements of the camera seem to express a certain hesitancy in doing so, an uncertainty as to whether or not to stay with him. Jean has given a ride to a woman who, as they drive, tells him a story of her childhood. They stop briefly so that Jean can join a group of roadside spectators and watch the Tour de France pack pass by, taking up the same position behind them as we occupy behind him. Back on the road, the woman looks across at Jean but says nothing. We cut to a shot from behind Jean who is staring at the ripples of reflected light on the deep blue surface of a river. The camera moves closer but seems unable to stay with him in this moment of contemplation and pulls off to the left, catching a glimpse of something, of what seems to be a body lying in the grass on the river bank. The camera hovers, pulling away slightly as though not wanting to look, cautiously returning to verify what it might have seen. We see the body once again and recognize the woman from the car; the camera tilts quickly up towards the sky as if unable to look any longer, then dives back down to check once more before panning back to our place at Jean's back. We pause for a beat, in his space, with him in still contemplation, but then quickly cut. The camera pulls away jerkily from Jean, seeming to want to get away from him but losing its anchor in the process, the image becoming unstable once again.

While undoubtedly instructive in allowing us to understand the grammar of the cinematography in operation here, this sequence – like the scene of Claire drunk and fleeing the house party in a car – is nonetheless comprehensible also in terms of its relation to the plot and the recognizable identities and forms and not, then, another of those moments in which our relation to the image is figured in purely abstract, kinetic terms. This, however, is precisely what we find shortly after Jean meets Claire for the first time when he picks her up from her parents' house. Back on the road, we are presented with a frontal shot of Claire sitting in the back seat of the car, her hair blowing in the wind, staring at Jean. We cut to a three-quarter rear close-up shot of Jean driving and staring out at the road in front of him. We cut to a slightly out-of-focus shot of the world rushing by alongside the car: trees, fields, buildings, cars, bridges. The car passes through a section of the road bordered by a dense thicket and the image suddenly darkens, the trees now rushing by in close proximity to the car and discernible only as a constantly

shifting field of greens and blacks. We cut to a similar shot of grass, filmed from much closer, but do not imagine for one moment that we have actually changed our viewing perspective. Indeed, this new shot operates in precisely the same way as the shot of trees rushing by, as a ballet of colour and light is produced by the movement taking place between the camera and what lies in front of it (see Figure 5). The image seems to morph a number of times after this, its hues, tones and texture changing as though the same principle were being applied to a number of different exteriors, but the effect is always the same, producing what can perhaps only be described as an abstract painting in motion. The end result, indeed, is akin to what might be produced if one were to animate a Jackson Pollock action painting, and like those paintings we can here discern no recognizable form that would be said to represent an object in the world yet we can intuit a pattern, an order that emerges out of what might at first seem to us nothing but chaos and anarchy. There is, then, a logic here that is not necessarily that of our habituated relation to the world but a logic nonetheless, a logic that transports us back into the diegetic sphere of the film and back into the car as this action-painting technique is applied to an extreme close-up shot of Claire's hair blowing in the wind, individual strands of which glint in the sun, caught in a complex choreography that cannot be

FIGURE 5 *Screenshot from* Sombre. *Courtesy Mandrake Films.*

understood but must simply be sensed. Indeed, there is in what is being described here no suggestion that this sequence provides some psychological insight into Jean, that this is actually how he sees the world, it is simply an invitation to adopt a different relation to what we are presented with, to what is happening before us, an experience that operates not on a psychological or moral level as is the case with the scenes of violence, but, rather, a purely aesthetic and sensual one.

If the first 'experimental' sequence of the film (framed by close-up shots of Jean staring ahead of him) plunges us into the disorientation and chaos of a world in which we have no point of reference and this second one (framed by close-up shots of Christine staring in terror and horror at what she sees before her) brings some logic and order to this chaos now that we have accepted the invocation to accompany Jean, the final scene of this kind again shows us in abstract form what happens if one does not move with this space and resists its logic. This final 'experimental' sequence comes after the episode at the lake when Jean has tried to strangle Christine and before the scene when Claire submits to Jean and Christine watches Jean manhandle her sister. While it is, given these circumstances, perhaps unsurprising that Christine should resist Jean's logic and not wish to accompany him in the way we have been describing, the resistance to this logic is once again rendered not only via indexical means through the unmistakable emotions registered on Christine's face but also in abstract, aesthetic terms. At the very moment that Claire registers her acceptance of the danger that Jean represents and tells her sister that she is no longer afraid, Christine senses the presence of Jean. She starts breathing heavily and stares in front of her, terrified. We cut to an extremely out-of-focus shot of Jean and then to a shot of the lake, shot from above. The setting sun glints off the surface of the water, creating a high contrast between one half of the image and the other which is filled with the black silhouettes of the surrounding cliffs. As beautiful as this might sound, this is resolutely not a sublime moment of contemplation and the camera once again seems to jerk around uneasily, wanting to get away as the whole image falls in and out of focus, all the while trembling with seismic force. We cut to a new shot in which different shapes, lines and forms are thrown into a chaotic movement. We are able to ascertain after a while that what we are seeing is a road and other cars, that this is the journey back from the lake to the hotel, but these forms are registered not as identifiable referents in the world

but a terrifying, destabilizing movement with which we are entirely out of sync and that drags us along with it rather than offering the possibility of accompaniment.

Relation

What should hopefully be clear from this account of *Sombre* is that, in regard to both its narrative and formal content, this is a film that can only be apprehended if, paradoxically, we are willing to relinquish our desire to 'understand' – by which we mean to ask the film to cohere and conform to a model that would be comprehensible in terms existing outside of the film itself. To make this claim is to contend that here there is a confluence of form and content, to suggest that the situation crafted in the narrative content seeks acceptance on its own terms and demands that it not be held up to standards or norms – psychological, moral or otherwise – coming from elsewhere and that the image also asks to be allowed to function and talk to us according to its own internal dynamics rather than always serving as an indexical trace of something existing as an individuated entity existing in a different time and space. This is why we insert quotation marks when using the term 'experimental' in relation to the more visually abstract passages of the film and why we reject the summary of critics like Tim Palmer who describe Grandrieux's films as 'a clear example of the fusing of mainstream plot elements with genuinely avant-garde cinematic motifs' (2011, 64). For when thought of in this way, the whole film is 'experimental' or, rather, since this is an unsatisfactory descriptor for what is at work here and one that Grandrieux himself explicitly rejects, every aspect of the film operates according to the same logic in order to establish a specific kind of relation to the viewer that is produced solely from within the text and that abstracts the work from anything outside of it. For this reason, no matter what impression may have been given by the preceding account of the film, it is important not to imagine that the more visually abstract passages of the film are here somehow privileged, nor to think that the plot is meticulously crafted in order to effect this split from the world. Indeed, if *Sombre* works in this way, always from the inside, exceeding its own forms so that these never cohere into a stable identity or correspondence with an external reality, this may well be

because the film was produced according to a very similar logic and a methodology entirely in keeping with the claims made here about the effect it has on the viewer. *Sombre* started out as a forty-page script that was used to pitch the film to potential backers. Once this had been increased to a 130-page script with far more dialogue than in the original to satisfy the financiers, Grandrieux was finally able to finance the film but did so while retaining a great deal of creative freedom that enabled him not to adhere slavishly to this expanded version of the script. There are many passages of the film that do stick closely to the script nonetheless, but the more the film advances, the less the final product resembles the written version. This is never more apparent than with the ending of the script which sees Jean, after a revelation in front of an ancient handprint on a cave wall which reveals to him his deep connection to an archaic humanity, save a child from drowning only to be dragged out to sea himself by a strong current. While it is not unusual for there to be differences between a script and the final film, what is perhaps different here is that an explicit injunction to allow this difference to emerge is coded into the film as one of its guiding principles. Indeed, in the filming notes that Grandrieux wrote for himself before starting filming, we read: 'Do not simply follow the script, do not make the film but unmake it/let yourself be imprinted [*impressionner*] by the film, by what comes along, welcome what comes, what is there, the presence of the actors and things'. This, for Grandrieux, is quite simply how the cinema operates, as a relation between various elements, all of which are internal to the film, and it is undoubtedly for this reason that Deleuze's text on Bacon has such relevance to the cinema for him. Like Bacon's canvases, indeed, one of the most important aspects of the cinema that creates these different relations and forces in the image and in the soundtrack comes from the frame and act of framing, for it is in this act that, firstly, a relation to the people and objects filmed is established and within the frame that, secondly, all of the forces at work in the image are played out. As he says in his filming notes:

To frame: to film between/between bodies/it's a sensation: first of all a sensation, an emotion, that's what framing is, to let myself be carried away by what I feel, it is to forget myself, that's it … the presence of the other, of what is in front of me, and

then the oblivion of the light, eyes tight shut at times ... and yet it hits the mark, it frames, I don't know how to explain it better, these questions of presence and oblivion, it is movement and it goes from one face to another, it is a rhythm, a means of moving brusquely or, on the contrary, hesitating, of going beyond what is there, then to come back, to bring into focus or to remain blurred, to be too close, a way to follow the action and then to distance myself from it and allow it to finish outside of the frame, to go back there when nothing is happening any more, just before the cut/.

The operations of framing and shooting the image are then what enable figural forces to be deployed in Grandrieux's cinema, forces that take the apparent self-identical fixity of the subject beyond itself, and that require the script to serve as a diagram rather than a programme, to lay out the conditions within which the actual expression to be produced will take place rather than attempt to determine precisely what that expression will be in advance. There is then a somewhat paradoxical (yet very common in a post-deconstructionist age) commingling of presence and absence here, a cohabitation of opposites that infuses every aspect of the film as forms merge with their surrounds and darkness is produced by light. As Grandrieux says in response to an interviewer who asks why he talks about his cinema not in terms of images but bodies:

> Because it's written into the shot. The notion of the shot interests me more because it already contains the idea of duration and of a proximity or a distancing. There is already a relation to focus, it's completely concrete. And it's curious, it's a paradox because the cinema comes from a projection, from immateriality – a film traversed by a beam of light. But at the same time this immateriality is fed by an incredibly material, fleshy and erotic investment. (Grandrieux 2001, 12)

If there is something erotic here, this is because of the relation between bodies, because in Grandrieux's films, every body relates to another body or to what lies beyond it, the way that bodies move in relation to each other or to their environment. For Grandrieux this is necessarily the case in the cinema because the primacy of relations between things is inscribed into the cinema at every level,

not only the relation between shadow and light that enables an image to be captured in the first place, not only because relations in space and time are determined by the parameters of the frame and the shot, but also because this is a technological medium that instigates a very specific relation to the bodies it films according to the hardware used – be this the film, the camera, the lens, etc. As Beugnet writes, for Grandrieux, 'the pro-filmic reality takes hold of the filmmaker driven by a desire to make certain images' (2007, 118). Take, for instance, the director's own comments on the filming of *Sombre*:

> With *Sombre* everything was related to movement, the way I moved around and the choice of lens: to film with a 50mm lens, for instance, instead of a 40mm lens, completely changes the relation – it's only a 10mm difference but that's considerable because the points are no longer the same, the presence, the mass of the bodies in the frame is no longer the same, the perspectival relations, the separation of bodies and background, all of that is modified entirely and suddenly you no longer have the same relation, you don't move in the same way. (Grandrieux 2001, 16)

The cinema is always in some way, then, as he says in this same interview, a question of alterity, and, as a result, it necessarily brings into play a moral dimension. He suggests:

> [The cinema] is also a question of a relation to your desire, of what makes you want to make a film, so this 'carnal', bodily desire of the cinema, in both documentary and fictional forms, is something that is very important for me. So when I film a face, my engagement as a filmmaker filming this face – my distance from it, the lens I use, the way I deal with the light – all of those things are acts in which there is an engagement on the part of the filmmaker that is moral in nature. If the distance is not right, the lens is no good, etc., what comes out [*la parole*] will not be truly engaged in a relation with the other, it will be something that you have taken, stolen, a kind of dishonesty on the part of the filmmaker in the moment of filming. (Renaud et al. 1999)

As with the production of the image itself, however, which is produced via the forces internal to the frame and must be

conceptualized from inside and not in relation to objects in the world that would be faithfully represented in a strictly analogical or indexical relation, the morality in play here must be conceptualized in this way, as an aesthetic morality, which is to say, once again, that the challenge laid down by Grandrieux is to leave behind our preformed moral framework and to accept that what we are confronted with here operates according to a moral schema. It is perhaps in this regard that *Sombre* and, to an even greater extent his next feature, *La Vie nouvelle* test the limits of even the most sympathetic critic, for even if we may be able to accept the relation that Grandrieux establishes between himself and his actors as one that is governed by a fundamental concern for alterity, to see Jean as a character operating according to a moral code may be a bridge too far for many. It is for this reason, perhaps, that at other times Grandrieux prefers to completely disavow the moral dimension of the film and to suggest that to judge it in terms of morality is to completely miss the point. He says, for instance,

> If there is in the film a great deal of the real – by which I mean the perception of things, of things that are not symbolic, that cannot be captured in spoken language – there is nonetheless very little worldly reality or social reality. I think that the film situates itself almost entirely outside of this reality. So if one asks about morality in the film, it may be that I have completely missed my mark, because for me to ask about morality would be like asking about the morality of dreams. (Renaud et al. 1999)

This, then, is the challenge of *Sombre*, to accept Jean as precisely a cinematic, a fictional character who is in effect nothing but a conduit through which the relations that constitute the cinema pass. This does not abstract the cinema off from our reality (or our Real, to be precise) completely, however, because for Grandrieux there is something incredibly primal in this that goes to the heart of what the cinema is and can do to us, something here that has the potential to return us to a pre-oedipal state akin to that of the children watching a puppet show at the beginning of *Sombre* who are set ablaze by the intensity of the spectacle before them, or possibly a state prior even to this, a time prior to language when our relation to the world was simply one of a base response to sensory stimuli. For Grandrieux, Jean is the very embodiment of this state. He explains:

The character of Jean, who is an archetype, has no psychological finesse: he is given to us as a childhood block, a block of sensations cut off from other men. And from this point on the question of morality doesn't even need to be posed. ... *Sombre* invokes the most archaic instincts. Hearing and sight, two sensations that constitute us from the very first moments of life. And it is through these sensations, and only through them that the film interrogates questions of form and substance. (Grandrieux, de Baecque and Jousse 1999, 39)

When considered in this way, the challenge that we are asked to accept in this film, the challenge of accompanying Jean, becomes all the greater, for we are effectively being asked, in watching the film, to adopt his relation to the Real (and lack of relation to reality, therefore). While this may seem to many a hard ask, Grandrieux would only up the ante with his next film.

6

La Vie nouvelle
[*A New Life*] (2002)

Sombre, perhaps unsurprisingly, was not to everyone's taste and even at the Locarno film festival in 1998 where the film was in competition and received a special mention (which is to say, not the prize itself) in the Conféderation Internationale des Cinémas d'Art et Essai Award category (the International Confederation of Arthouse Cinemas), the press release announcing this result was at pains to stress that 'a *part* of the jury wishes to draw attention to Philippe Grandrieux's film *Sombre* which provoked "incredibly virulent discussions" amongst its members'.[1] Incredibly, the extremes that the film provoked could sometimes be found within one single reaction to it. In a critique intended to be damning, Élie Castiel writes somewhat confusingly that the film is 'a banal tale that leaves behind the plot's more anecdotal aspects in favour of a profound enrichment of its sensory ones' (2003, 25). Similarly, reviewing the film for a screening on the TV channel ARTE in 2001, Sonya Faure, writing in *Libération*, provides a beautifully poetic evocation of the film's beginning, themes and formal tropes only to conclude that 'Grandrieux's film becomes heavy-going and can annoy you greatly' (1 June 2001). The review of the original theatrical release published in this same paper and penned by Gérard Lefort, meanwhile, found no redeeming features in it at all and slammed the film primarily on ethical grounds, accusing Grandrieux of expressing, both thematically and formally, 'an old school, uptight catholic ideology' (27 January 1999). This opinion of the film, as Manuela Morgaine pointed out in a rebuttal to this article, published in the same newspaper a couple of weeks later

(10 February 1999), however, was based on a baffling interpretation of the plotline that, for Lefort, is a tale of salvation and whores. Yet no matter how much Lefort was troubled by his (mis)apprehension of *Sombre*'s plot – a misapprehension that I believe results from a desire to imbue the film with a narrative coherence that it resists – his problem ultimately seems to come from what he considers to be an over-aestheticized treatment of brutal realities. For him, the film in the final analysis 'is able to get across only one advertising message: murdering whores, raping women, redemption through love, the Tour de France pack, that's all nice [*c'est du joli*]' (27 January 1999). To a certain extent, Lefort's problem here is intrinsic to all art that deals with this kind of subject matter and particularly any photographic medium. This indeed is the point made by Susan Sontag in her book *Regarding the Pain of Others* where she writes:

> Transforming is what art does, but photography that bears witness to the calamitous and the reprehensible is much criticized if it seems too 'aesthetic'; that is, too much like art. ... Photographs that depict suffering shouldn't be beautiful. (2003, 76–7)

Leaving aside the fact that to view *Sombre* in this way (as should hopefully be clear by now) is potentially to miss the point entirely by making it conform to a morality and metaphysics that exist outside of the universe it creates, it was precisely this kind of criticism that plagued Grandrieux's next feature film *La Vie nouvelle* to an even greater extent, predominantly because of the lead actress' dress. As Philippe Azoury wrote in *Libération*:

> 'Mademoiselle Anna Mouglalis is dressed by Karl Lagerfeld.' There I was looking for a way to sum up the numerous problems of both form and substance contained in Philippe Grandrieux's second film (four years after *Sombre*) when the closing credits handed it to me on a plate. This girl, who is supposed to incarnate a whore chained to the toilet of a stinking brothel in the arsehole of Eastern Europe, pimped out by Russians wearing three-quarter length leather coats and sporting a haircut styled by an Opinel knife nonetheless found the time to swing by the Avenue Montaigne to bling all of that up a little. (27 November 2002)

Other critics, however, seemed to be simply bored or frustrated by the film and their inability to follow the plot. For example, having quoted the entire plot synopsis contained in the press release materials and qualified the film as 'an ambitious investigation into every element of cinematographic matter itself', Jean-Michel Frodon in his review for *Le Monde* goes on to write, 'I have no qualms whatsoever about providing this plot summary here since the "story" in question is entirely indecipherable from what we see on the screen' (26 November 2002). For Frodon, indeed, this 'psychosensory experience' is not even really a film but is, rather, 'at the forefront of a very rich development of the links between the plastic arts and the cinema'. While this may seem to be a good thing, for Frodon the very opposite is true and in refusing to conform to 'the temporality of the cinema' – as though there were only one possible cinematic temporality – the film is in the end, for him, 'terribly boring'.

The almost unanimously negative reception in the press that greeted *La Vie nouvelle* led to it being pulled from cinemas after only two months, much more quickly than normal, rendering the film almost invisible. In order to counter the negativity of these knee-jerk reactions to the film and to make it visible once again, Nicole Brenez curated a collection of considered responses to and analyses of the film that were published in a book released with an accompanying remastered DVD of the film – *La Vie nouvelle – nouvelle vision, à propos d'un film de Philippe Grandrieux* [*A New Life – A New Vision: On a Film by Philippe Grandrieux*] (2005). Brenez's initial ire and subsequent desire to undertake her project seem to have been provoked in particular by a reaction similar to Frodon's. As she writes in the preface to the volume:

> With regard to *La Vie nouvelle*, the very apogee of blindness, that is almost burlesque, came in a TV show about the cinema: following the screening of the film's trailer, whose every frame set ablaze with beauty the dull screen of the TV, a journalist concluded superbly, 'all in all a fairly banal film'. This complex, difficult and lavish film was suddenly being accused of the very opposite, of banality. Once my laughter had subsided, this statement suddenly appeared somehow magnificent also. (2005, 13)

If such a flippant dismissal of Grandrieux's film can seem somehow magnificent to Brenez, this is because it lays out an entire utopian project that would strive for the creation of a society in which such a challenging piece of art could seem to be, precisely, banal, which is to say nothing out of the ordinary. As Brenez puts it: 'Here then is our utopia: we want the enlightened society in which *La Vie nouvelle* would constitute not a scandalous, transgressive object but, rather, just an ordinary film' (14).

While an extraordinary and wonderful way to defend a film via a deliberate *détournement* that redirects the force of an attack back towards its perpetrator, my fear is that in doing so, even within the context of a utopian fantasy, one fails to understand precisely why *La Vie nouvelle* could ever seem to be either banal or boring. For as in the case of Frodon, if the film can be said to appear either boring, banal or ordinary, this is surely not because the critics who would make such claims are overhabituated to such extreme aesthetic expressions but, on the contrary, because they have no idea how to engage with a cinematic expression that does not conform to the norms and conventions of the cinema that they take to be well established and intransigent, whether these have to do with cinema's temporality, as for Frodon, or any other reason. Thought about in this way, there is a great deal of convergence between those critiques that, like Azoury, condemn the film from an ethical standpoint and those that, like Frodon, find the film deeply unsatisfying on a narrative and aesthetic level because in both cases the film is held up to a standard that originates elsewhere and that it then fundamentally rejects. This, of course, is precisely the contention we have formulated in relation to *Sombre*. Like that film, *La Vie nouvelle* will present us with a confronting situation that we are asked to accept rather than condemn, a situation that we cannot register on an intellectual level, that we cannot understand according to the precepts, axiomatics and ethical frameworks via which we navigate our way through the outside world, a situation which is, once again, expressed via formal means that demand of us a different relational mode. *La Vie nouvelle*, in both the extremity of the situation it presents us with, its resistance to narrative coherence and its formal inventiveness, intensifies the principles we have observed in *Sombre* to the extent that if that film can be described as an invitation to accompany Jean and Claire, as suggested, then *La Vie nouvelle* might rather be said to drag us down into hell and, what is more, to consider this a good thing.

La Vita nuova

Given this description, anyone who was to be told that the film is in part based on a Dante text would naturally assume that the text in question was *Inferno*, the first canticle of his *Divine Comedy*. However, as is clearly indicated by the film's title, the source text here is, rather, *La Vita nuova*, Dante's early work that challenges the conventions of courtly love poetry and seeks to go beyond the individualism of his poetic heritage instead to write works that would evoke in poetic form something of the magnificence of sacred love, embodied here in the figure of the ideal and unattainable Beatrice. Precisely what any of this might have to do with Grandrieux's film is likely to be entirely baffling for anyone who thinks that the synopsis of the film provided in the press release materials, quoted by Frodon and reproduced on the cover of the commercially released DVD, provides an accurate account of the film. This reads as follows:

> Seymour, a young American, arrives in an Eastern European town accompanied by Roscoe who has come to negotiate the purchase of men and women. Seymour discovers Mélania, one of the 'girls' belonging to Boyan, who controls this human trafficking. In order to possess her, Seymour will have to pay a terrible price ...

There are many reasons why this is a dreadful summary of *La Vie nouvelle*, not least of which is the fact that it seems to be based on the screenplay that Grandrieux wrote with Eric Vuillard rather than the final film – and just as with *Sombre*, there are very significant differences between the script and the end product. In addition, however, this synopsis places the emphasis of the film on Seymour, whereas the true subject of the film is Mélania, just as in Dante's text the point of interest is primarily Beatrice, even if what we learn of her comes via the perspective of the poet narrator and the events taking place in his life. More than anything, though, this attempt to impose an impression of intrigue and narrative coherence on the film is unsatisfactory simply because, as suggested by Frodon, it is very hard to see how what we are presented with on screen might be said to coalesce into such a form. In saying this I am by no means wanting to align myself with Frodon but – like Nicole Brenez whom we have seen attempt to turn a negative criticism against

itself, to see in the charge of banality something magnificent – to suggest, *contra* Frodon, that this refusal of the film to cohere into a recognizable form with cause-and-effect relations between its different parts is, in fact, the film's strength. Indeed, it is in doing this that, in conjunction with specific formal operations, the film is able to maintain a consistent state of tension, which is to say a force that is never resolved within the frame and that, what is more, seems to drag us with it, to leave us in an incessant state of incommensurability or unrest.

Without wishing, once again, to slip into the realm of intentional fallacy, it is important to note in this regard that this lack of narrative coherence or, rather, the film's refusal to adhere to a narrative structure with a clear sense of progression and resolve is once again hardwired into the film's genesis. If in *Sombre*, however, Grandrieux wrote a series of notes for his own filming process, which reminded him not to feel a need to stick slavishly to the script, the very script of *La Vie nouvelle* itself seems to have this principle encoded into it. The script of *La Vie nouvelle* does not, most of the time, read like a script at all: dialogues and plot elements are for the most part relatively minimal and the script is filled with notes that serve rather as a diagram or programme of intent, an explicit reflection on the kind of principles that should produce an outcome rather than a map of those outcomes. In its opening pages, for instance, before the enumeration of the possible scenes to come, we read: 'Each stage stands alone. This is not a *bildungsfilm* [*film d'apprentissage*]. There is no one meaning. Every experience is closed in on itself. There is no progress.'

This is not to say that the script contains no plot elements or storyline; while much less developed in a narrative sense than the screenplay for *Sombre*, there are nonetheless some events described throughout the script between which there are relations of cause and effect. What is more, there is always, in a very real sense, a cause-and-effect relation between the script and the final film, even if they end up resembling each other relatively little, for as Grandrieux explains, 'I often access the film's images through the writing. And yet, during filming, I try to enter into an intuitive relation with the scene to be filmed' (Grandrieux and de Sardes 2013, 55). This describes well the way in which *Sombre* came to be and things would be no different for *La Vie nouvelle* in which, once again, many plot elements were either drastically altered – oftentimes becoming far

more evocative than indicative – or simply abandoned. The final film version of *La Vie nouvelle* does, then, contain fragments of the story found in the script concerning Seymour's betrayal of Roscoe, but these remaining fragments are so minimal – both in terms of their relation to the broader narrative context and the screen time devoted to them – that it is hard to think of them as narrative elements that would allow us to understand precisely why Roscoe is ripped apart by a pack of dogs or what the relationship is between Roscoe and Boyan.

Given the contention here that the individual scenes and gestures towards plot elements do not ultimately cohere into a narrative framework and thus instigate a state of permanent irresolution, it would be misleading to do here what I have attempted to do with *Sombre* and describe some kind of narrative trajectory – albeit one that resists the psychological and hermeneutic frameworks through which an *understanding* of the film in relation to a reality that lies outside of it would be generated. What I *will* suggest, however, is that *La Vie nouvelle*, while remaining fragmentary, becomes a very different film if we take seriously the idea that Grandrieux's film is a version of Dante's text of the same name and that ultimately, then, it is a film about a woman, Mélania, who exists only as an icon, an unattainable figure existing in an entirely different sphere and who exerts an incredible power over those who worship her. This may seem a somewhat strange assertion when we consider what happens to Mélania in the film, yet this suggestion would seem to accord with what Grandrieux had in mind when making the film. As he explains:

> The title was there from the outset. I had read *Vita Nuova* and I found it so beautiful, this love that Dante feels for Béatrice, who is just glimpsed, like an apparition who shuffles all of the cards of his existence. Life is new in every instant. (Grandrieux and Vassé 2002)

What is more, when talking about Mélania and Seymour's relationship to her, he explains that 'Mélania is a fantasy for Seymour, an icon, a figure who rises up, who emerges out of the darkness and who appears, shining in the night' (Grandrieux and Vassé 2002). Mélania, then, is Beatrice, an icon of love, and yet in the film she is subjected to all kinds of violent acts in scenes

Dante / icon of love

that have generated a great deal of controversy and condemnation. For James Quandt, the sex and violence of such scenes is entirely gratuitous, intended to shock and is symptomatic of a 'failure of both imagination and morality' (2004, 132). Vehemently rejecting this view, I want to suggest that these scenes are, firstly, (loose) narrative elements insofar as they generate within Mélania a force and relation to the world in which she moves that enables her in the end to transcend not only her social but also ontological condition and, secondly, that these scenes instigate a relation to us, the spectator, akin to that between Dante and Beatrice.

In tension

The first time we see Mélania she is slung over Boyan's shoulder, naked except for her bra. We imagine that she may have been one of the men and women stripped naked and lined up for inspection from the preceding scene, although hers is not one of the faces we saw there. Boyan looks for a place to put her body down, eventually lying her on the floor. Moving her onto a table, Boyan turns her over by her legs, seeming to want to reposition her. He picks one of her legs up by the foot and holds it at an angle, looking down the length of the leg like a craftsman checking his work. He lets the leg drop and it falls like a dead weight, as though lifeless. Boyan seems to back away from the body, pacing hesitantly, looking at the body and then away as though unsure what to do. We cut to a shot on Boyan, still standing over the body, a hunting knife now in his hands. We hear heavy breathing coming from the body that seems to be waking from whatever state it was in and a smile comes over Boyan's face. He walks up to Mélania, knife in hand, and proceeds to use it to cut her hair. We watch in close-up as he grabs handfuls of her hair and draws his blade across the locks he holds in sweeping gestures of differing speeds, each one cutting through strands of Mélania's hair roughly and producing a nauseating sound of ripping more than cutting, a sound that combines with Mélania's gasps of pain, repressed cries, agonized groans, whimpers and uncontrollable sobs to create a sickening symphony. The whole scene lasts an agonizing 4 minutes and 40 seconds, a time that seems to extend indefinitely yet during which a definite shift occurs in

Mélania's demeanour. While fear never seems to register on her face at any time, she seems to pass from discomfort to varying levels of pain, and from total subjugation and submission to an assertion of acceptance that brings with it a certain power and control in spite of the situation she finds herself in. Indeed, at one point she seems to gather herself and stare directly into Boyan's eyes, challenging him (see Figure 6). She cannot maintain this pose, however, and when she loses her composure once more she starts to sob through gritted teeth, seemingly broken down by this torture. She appears frenzied, unable to control herself, and then, once again, turning gasps into deep breaths she finds focus once more and stares into Boyan's eyes. Boyan stops cutting for a moment and presses his lips onto Mélania's face in a gesture that resembles a nuzzle more than a kiss, and when he starts to cut again a look comes across Mélania's face that seems somehow closer to pleasure than pain.

This is an extremely difficult scene to watch and it is perhaps unsurprising that some audiences have reacted so vehemently to it.[2] For Christa Blümlinger we are here faced with 'almost animal tears [that] affect us more directly than the tears of human emotions', 'an intense somatic sympathy', 'an empathy that precedes all other emotions' (2006, 74). This scene is difficult not only because of the violence that we see, however, but also because we are given no key to understand what is happening. It is here, when we find 'all our normal expectations transgressed and reversed', that real terror

FIGURE 6 *Screenshot from* La Vie nouvelle. *Courtesy Mandrake Films.*

lies, as Adrian Martin has suggested drawing on ideas formulated by Thierry Kuntzel in the 1970s (Martin 1999). In the original script the plan was for Boyan to shave Mélania's pubic region and then to penetrate her. This, though, would have lent the scene a pornographic character that could then have been read in terms of a recognizable psychosexual drama replete with shades of rape fantasy. In making Boyan cut the hair on Mélania's head with a knife, we are instead plunged into much stranger territory that evokes (to French audiences, in particular) the head shavings dealt out to women in post-Liberation France as punishment for having slept with German soldiers. What is more, similar perhaps to the relationship between Jean and Claire in *Sombre*, given the scene that we behold, it is nigh impossible to understand what the nature of the relationship is between Boyan and Mélania and to fathom how something resembling pleasure could flicker across her face in this scene, how she could manifest any semblance whatsoever of power and control. This, though, is precisely what we are presented with, and in doing so this scene directs its violence squarely towards us, the spectators, leaving us, far more than Mélania, totally helpless, incapable of understanding what is happening, subjected to something that we instinctively register as unbearable and that then scrambles our codes even further when we do not find our own reaction mirrored and confirmed by what we see on screen. This is to say that instinctively we want this to stop, we feel that there is a violence being done to Mélania here that is necessarily bad, that she would also wish this to stop, yet this is not what her body tells us unequivocally, especially when she submits at the end of this scene to the gentle caress of Boyan, turning her face towards his in a gentle slump, like a lover exhausted by the throes of passion.

The reading proposed here will undoubtedly not find agreement with everyone, yet I believe that it is what we see if we are able to read it outside of our habitual moral and psychological frameworks, and it is a reading that seems to accord also with the intention laid out in the original script – and this in spite of the changes already noted. There we read:

Drowsiness.
He shaves her sex – or eyebrows.
He penetrates her.

And this is not desire.
It is not force.
There is no musical key.
She could *withdraw herself*. But she doesn't know.

This must disarm the spectator.
He cannot take her out of the film.
It has no reason of a moral order.
This is obviously not a question of consent.
Boyan thus becomes the rival. An invincible rival (for the spectator).

These two bodies do not put *our* affairs in order.
What we have here is an accumulation of sensations that cannot be assigned.

What is suggested here in effect is that Mélania becomes *for us* a figure akin to Beatrice, who exists in an entirely different realm, separated off from our reality, untouchable and unsalvageable – if indeed salvation is what she needs, and what I am trying to suggest is that if considered outside of our own moral framework, we must admit that she does not. This, as per the script, is completely disarming for us, for an appeal is created that draws us out of ourselves towards what we see on screen while ultimately the scene simultaneously disavows the consummation of that relation, holding it in unbearable tension. This scene does not so much tug at our heartstrings as thrust a fist down our throat, pull our guts out through our mouth and leave us quaking on the floor, unable to do anything and incapable of understanding what has just happened and what might come next.

The effect of this scene is so great that it almost comes as a relief when Mélania, with her new haircut and decked out in one of those infamous dresses, is soon after pimped out to Seymour and shows herself to be very much in charge of the situation, leaving Seymour in a state of post-coital shame, lying in a foetal position, then able only to raise himself up partially and sit hunched over on the bed, cowed and unable to do anything but nod as Mélania asks in the most matter-of-fact way imaginable, 'okay?', checking if their contract has been fulfilled so that she can gather up his money and leave.

The respite, however, if this can be counted as such, is short-lived, for when Mélania leaves Seymour's room she crosses the corridor to go to another client, the Frenchman. The scene with the Frenchman is even more harrowing than the earlier scene of Boyan cutting Mélania's hair; like this earlier scene, however, there is no fall into clichéd pornographic stereotypes here, but, once again, a sequence of events whose motivation, purpose and originating desire seem entirely alien. Similarly, this scene is almost unbearably extended in time, lasting a full 10 minutes from the time she enters the room until the moment she leaves, and there is the same level of tension generated by a scene that is suffused with a constant potential for great violence, a violence that for the most part remains potential rather than actual, quickly dissipating again once the tipping point into actual violence is finally reached at a seemingly arbitrary moment that takes us by surprise. The scene unfolds as follows.

The Frenchman

Mélania walks down the corridor followed by one of Boyan's heavies who says something to her in Bulgarian. She arrives in front of a door and we cut to a shot of the interior behind the door and see a man wearing a black suit and tie sitting on a couch with his eyes shut and a cigarette hanging from the corner of his mouth. We hear a knock, but rather than raise his head and look in the direction of the door, the man bows his head slightly and remains otherwise motionless, his eyes still shut. He tips his head up towards the ceiling, leaning into the back of the couch, his eyes still shut. He draws on his cigarette and then stubs it out. We cut to Mélania, who is still waiting on the other side of the door, hesitating and then knocking again. We cut back to the man in the room who looks around and then down to the floor but still does not move. After a long pause, he gets up from the couch and opens the door to let Mélania in. He watches her enter the room from behind, slams the door, stands close to her and then looks her up and down at close range, staring shamelessly at her breasts for a long beat and then, with no change of expression, indeed with no real discernible expression at all, stares straight into her eyes as he loosens his tie. He folds his arms and scans her body with his eyes once again, shuffling in closer and then staring into her eyes, never touching her.

He takes off his jacket, folds it, places it on the couch and removes his cufflinks as Mélania walks to the other side of the room. 'Take off your clotheses,' he says in a heavy French accent. We see him take off his shirt and then we cut to Mélania who starts to strip. He watches unmoved from the other side of the room, only reacting when she starts to take off her panties, saying 'just your clothes' to stop her from going further. Now wearing just his underwear, he walks across the room and stands next to her, shoulder to shoulder, his arm pressed against hers the only contact between them, his hand hovering next to hers like that of an awkward teenager on a first date. He lifts his head up and rolls it around in a stretch, eyes shut. He turns and stares at her breasts and then places his hands on either side of her face in a gesture somewhere between that of a lover preparing a kiss and a serial killer about to snap his victim's neck. He draws the skin taut across Mélania's face, contorting her mouth into a hideous grimace, turns her face from side to side as if inspecting it for flaws then suddenly, out of nowhere, slaps her across the face, once, twice, three times. Mélania returns his stare, wary yet seeming unaffected by this treatment, flinching only as he mimics a larger strike, stamping the ground. He rips open the curtains and stumbles backwards across the room, leaning against a wall and pushing a lamp brusquely to one side. We see Mélania, still standing at the other side of the room, yet strangely he instructs her in French, repeatedly, to stand up. 'Debout, debout, debout, là, debout, debout'. He grabs her by the shoulders and tries to make her stand straighter, taller, still repeating his instruction like a mantra. Mélania now seems genuinely afraid, breathing heavily, panicked, not understanding his words, not understanding what is happening, what is expected of her. She seems to gather herself, calms her breathing and stares him in the eyes. Holding her by the shoulders, the Frenchman walks her backwards and she falls onto the couch. The man pulls her up again, shouting at her to get up: 'relève-toi, relève-toi, debout, debout, debout' ['get up, stand up']. He stops and then runs his hand between her breasts, cups her left breast and squeezes the nipple, his other hand at the back of her head. Mélania seems finally to have found a pose that pleases the man who says, 'Isn't it easy? You see, it's easy,' but he then suddenly tilts her whole head upwards and pushes her away roughly, saying, 'I do what I want.' We cut and see Mélania naked and lying on her side, her knees drawn up. The Frenchman walks his fingers up

her legs, counting in French as he goes as though he were doing a version of 'Round and round the garden'. There is nothing playful here, however, and as his fingers walk across the back of her legs, over her naked buttocks, ribs and up towards her head, we are filled with a terrible sense of dread that once he reaches the number ten something awful will happen. He stops at nine, however, and repeats this number twice, before drawing his finger down her arm gently and standing up. He looks at himself in the mirror and then lies on top of her, holding himself up on his arms and staring down at her as though in a prelude to sex. But then, without warning, he slaps Mélania across the face, harder this time, causing her to cry out. 'Merde, excuse-moi', he says softly as Mélania wails and howls in pain and terror. 'Pardon, pardon', he mutters, then holds her tight and strikes her again and again and again. Shot now from behind his back, the sound is unmistakably that of a slap across the face, but his gestures resemble more those of the final moments of a street brawl as the victor slams his fist again and again into the face of the vanquished with the full force of his body. Mélania thrashes wildly from side to side, her cries now desperate, each one so forceful that she almost retches. She falls to the floor and crawls away, pulls herself up and sits, pressed into the wall like a beaten animal, a look of terror on her face, cries still wracking her body as she stares into mid-space, not daring to look towards this man who has withdrawn and is now singing an a capella version of a classic *chanson française* title, Jean Ferrat's 'Heureux celui qui meurt d'aimer' [Happy is he who dies of love], which he concludes with a line from a different Ferrat song, 'Aimer à perdre la raison' [To love to the point of madness – literally, of losing reason]. As he sings, Mélania pulls herself to her feet and pulls herself together while the Frenchman sits back on the couch and starts to jerk himself off slowly, his hand in his underwear, eyes closed and head pointed towards the ceiling as before Mélania's entrance, still singing gently to himself. Recomposed, Mélania walks across the room to get her clothes, watching him as she passes in front of him. Once dressed, we watch her leave the room and then cut back to the Frenchman, now naked on the couch, slowly stroking his erect penis, an action that we can still make out in spite of the extreme blurriness of the image, a technique that seems to express not so much prudishness, given the explicit nature of what we are shown, but, rather, a

FIGURE 7 *Screenshot from* La Vie nouvelle. *Courtesy Mandrake Films.*

correlate of our own lack of clarity in relation to precisely what we have just witnessed (see Figure 7).

Collapse

If this scene, like the scene of hair cutting, leaves Mélania at an agonizing remove from us, leaving us helpless to do anything but watch, to relate to her as an image no matter how much our entire being is drawn towards her, and turning her once more into a Beatrice-like figure, in this later scene, more than previously, the impossibility of containment or consummation is explicitly figured in the on-screen action and relations taking place. Indeed, if, as before, it is incredibly hard here to know how to classify what we are seeing, to know whether there is something here that is not pure brutality, whether this is even a sexual act or something of a different order entirely, then this state of irresolution is explicitly figured in the dynamic taking place between Mélania and the Frenchman. For what takes place between Mélania and the Frenchman is precisely a relation that is never consummated, that remains open-ended, that maintains a constant tension that outlives the time they are in this room together. There is a force here that perdures, that is not dissipated into any kind of ending either happy or tragic,

no possibility of shutting off what we see by solving a mystery, reconstituting a plot, arriving at a point of narrative closure, coming full circle, only a state of tension, a force generated by the relation between distinct semi-individuated entities or such an entity and its environment that keeps each of them mobile.[3]

If I refer here to semi-individuated entities, rather than simply individuals, this is because the very idea of an individual carries with it a sense of closure and self-identical identity that is disavowed by everything that is being claimed here. Indeed, just as I have suggested that there is here no possibility of containing or interpreting what we are presented with according to a world and principles that we would already know in advance, to partake in a shared knowledge, so the universe we move in here seems to operate according only to a logic generated from within the figures who wander through this landscape and through events that intersect them, a logic that needs to be reformulated at every turn in relation to the changes taking place within it if that figure is to survive. Seen in this way, the themes of betrayal and human trafficking, the relations between pimps and prostitutes, hookers and clients become not so much elements of a plot but, rather, symptomatic of a general principle of primordial survival, an affirmation of a desire to perdure, a life wish.

What we find here thus has something in common with the historical break identified in Deleuze's analysis of changes in the sensory-motor schema of cinematic action and the shift from a movement-image to a time-image. In the period following the Second World War, in Deleuze's analysis, Europe is thrown into a crisis, and the axiomatics that had previously governed life or according to which life was conducted were suddenly no longer sufficient to account for what was happening, nor up to the task of prescribing forms of behaviour sufficient or suitable for meaningful action in this world. At this juncture emerges a new form of cinematic expression via the Italian Neorealists, for instance, in which the causal relations between perception and action are thrown into disarray, in which it is no longer the case that certain kinds of situations lead to specific kinds of actions that modify that situation (Deleuze 1989, 1–24). Deleuze writes:

> If the major break comes at the end of the war, with neorealism, it's precisely because neorealism registers the collapse of sensory-motor schemes: characters no longer 'know' how to react to

situations that are beyond them, too awful, or too beautiful, or insoluble. ... (Deleuze 1995, 59)

In *La Vie nouvelle* we are presented with a situation that has something in common with this, especially with regard to the relational mode established with the viewer, but there is nonetheless an important difference. Apart from the fact that, as I have argued, we would be mistaken in tying the scenario we are presented with here to any specific historical or sociopolitical referent, the universe of *La Vie nouvelle* is not one in which the shared axiomatics that previously gave meaning to life have now been blown apart, leaving people to wander aimlessly through desolate war-torn landscapes; rather it is one in which there never were any such sets of shared knowledge. The world we enter into here, indeed, is a dog-eat-dog world which is highly individualistic and yet in which each individual (or semi-individuated entity) must be constantly attuned to the movements of everything else in this landscape, must live according to a principle of constant awareness, open to every possibility, given the impossibility of knowing what might happen, what might be required in order to survive.

In a sense, what we find here is then not so much a breakdown of the sensory-motor scheme as an intensification of it, by which I mean that the sensory apprehension of every moment of life experienced as an incessant confrontation with the new – which is to say with a life that can never be known in advance – needs necessarily to lead to a motor action of some kind that emerges from a movement within the character (or Figure, to return to our Baconian vocabulary) in relation to lines of force around it. As in the case of the Neorealists in Deleuze's analysis, these lines of force are generated in part by the architecture of the environment in which these characters move. Deleuze writes: 'In the city which is being demolished or rebuilt, neo-realism makes any-space-whatevers proliferate – urban cancer, undifferentiated fabrics, pieces of waste ground – which are opposed to the determined spaces of old realism' (1983, 212).

In *La Vie nouvelle*, however, the architectural landscape we are presented with is mostly not of this kind. Indeed, while this description would serve well as an account of the space in which the film's opening scenes of human trafficking take place (during which there is a long out-of-focus slow zoom on an abandoned building), following the scene with Mélania and the Frenchman just

described, there is a very unusual shot (for Grandrieux) that seems intended to draw our attention to a different kind of architectural landscape. Let us recap. Mélania leaves the room; we cut to an out-of-focus shot of the Frenchman masturbating on the couch. We then cut to a shot of the corridor between the two rooms that Mélania has visited, between the two closed doors behind which we have seen very different forms of individual desire play out. Our attention is drawn not so much by the corridor itself, however, as by the square window at the end of the corridor that looks out onto a sea of concrete. Abandoning for once – indeed perhaps the only time in the film – his predilection for trembling, handheld shots, Grandrieux then delivers a slow Steadicam tracking shot that takes us down the corridor towards this window, the window frame eventually forming a frame within our frame that is then drawn out beyond the frame of the film as the shot progresses further and the entire screen is filled with a shot of the high-density high-rise tower blocks outside that seem to stretch out indefinitely to the horizon. Once the travelling shot stops, we pause for a long beat, a full 10 seconds, transfixed on this scene that we have no choice but to contemplate. What we find here as we explore this landscape is not a war-torn wasteland, yet it is perhaps even more depressingly devoid of life, for what we see is a vast expanse of grey concrete, perforated by thousands of tiny black rectangles, each one of which is an apartment window. The sheer scale of this urban housing project seems inhuman in and of itself, but this is compounded further still by the uniformity of the colour palette that seems to convert these apartments into prison cells and the buildings into 'granite gravestones' (Ladegaard 2014, 165) rather than living spaces – in contrast, for instance, to the photographs of high-density urban developments taken by Andreas Gursky in which flashes of colour or discernible traces of human habitation and personalization allow the human back into the frame. Shot from an upper floor of a building of a similar scale and employing a very great depth of field that keeps both the dark shapes of the door and window frames in the corridor and the light grey expanse in the distance outside in sharp focus, a specific kind of relation is established here between what we have just witnessed and what we now look upon: this space, the shot seems to tell us, is symptomatic of, or produces, or is, perhaps, somehow equivalent to what we have just witnessed, it is a space conceptualized only with the

survival of the individual in mind, with no sense of shared values or compassion. Given this, the following shot becomes all the more significant, for we cut to a shot of Seymour standing in front of this window, silhouetted against the light and in sharp focus, unlike the concrete towers outside which are now out of focus, a shallow depth of field casting them into a different focal plane, the implication being that Seymour does not belong in this space, that he does not understand how to navigate it – as will become increasingly clear from this point on. As Beugnet describes this shot, we see here the 'motif of the human form caught in the figural field as if trapped halfway between two planes of appearances', a recurrent trope in Grandrieux's films that represents 'the visualisation of the human form's disjointed violent relation to the world that surrounds it' (2007, 114–15).

This tracking shot down the corridor is also seen to be particularly significant by Nicole Brenez who asks Grandrieux about it in an interview she conducts with him. Grandrieux agrees with Brenez that there is in this shot a certain clarity, an openness, but when Brenez goes on to suggest that it is with this shot that we realize for the first time the political dimension of the film, being careful to specify that she is referring to the politics of the world as a material and not sociological entity, Grandrieux modulates her idea slightly and resituates it within a metaphysical frame, saying that it is about, 'What links us very intimately to chaos, to disaster. Which takes us to the question of what it is to be human, this constant menace, a pressure so great that it envelops us' (Grandrieux and Brenez n.d.). Making a similar move in response to Brenez's prosecution of this point, Grandrieux goes on to unpack the link between the scene with the Frenchman and this tracking shot, stressing once again the metaphysical and, here, existential dimensions of what we witness. He says:

> The travelling shot comes after a long sequence where a client strikes Mélania – after that, there's a possibility of understanding that in each of these little windows the same story is happening. Or maybe some other story, but always this story of what it is to be human, i.e. confronted with alterity, with the other who is infinitely possible and yet infinitely closed and inaccessible, no matter what one does. And it's from there that one journeys, works, loves, fucks ... (Grandrieux and Brenez n.d.)

The dynamic described here is similar to the one that has already been seen in *Sombre*, for what is suggested is that life is generated via a relation with an Other, with something that lies outside of the self, which presents to the subject a realm of infinite possibilities and openness yet which remains ultimately unreachable and opaque – in part because that alterity is itself nothing other than this very same field of infinite potential that simply cannot be contained or known in its entirety. The Other thus operates, as we have said of our relation to Mélania in these scenes, as both an appeal and a refusal, drawing us towards it yet remaining definitively out of reach, like Beatrice, and in doing so it creates a relation which remains in tension, a force that is not resolved in a meaningful act, not dissipated via transference into a movement that would bring us to a predetermined destination. It is because he cannot accept this principle, because he wishes to 'own' Mélania and to save her by pulling her out of this situation that Seymour remains apart from this space and, ultimately, frustrated by it, unable to access Mélania at all and left instead to attempt in vain to fulfil his desires with another girl who is a poor proxy for Mélania and in doing so to become, ironically, the kind of being suited to this space, driven by a vicious, primal force that seems to erupt from within and defigure his body in a final, senseless cry that is for Grandrieux, 'a devastation, but also perhaps a rebirth' (Grandrieux and Brenez n.d.).

This possible rebirth comes, though, at the very end of the film, and up until this point Seymour, as indicated by the focus on him in the synopsis given in the press release, serves more of a narrative purpose or, rather, wishes to introduce an externally validated narrative trajectory into this space which is fundamentally resistant to any such thing. In this respect, Seymour serves as a possible mirror of ourselves as spectator or, rather, of the spectator who would wish to find here the same kind of narrative logic and syntactic operations to which we have become habituated due to the dominance of a narrative-based form of cinema that serves to validate our understanding of the world in which it is set. As Brenez writes in the introduction to her interview with Grandrieux:

> *La Vie nouvelle* explores all the ways in which we fail to understand the world. Sleep, dream, fantasy, trance, delirium, the plunging of the main character (Seymour, played by Zach Knighton) into the incomprehensible logic of the mafia, affective

vertigo, the general confusion of bodies and perceptions. In order to grasp this originary, repressed dimension of human experience, it is clear that we must turn to completely different logics than those of the usual descriptive economies, invent other textures, forge other descriptive paths, employ instruments other than language and its normative links. (Grandrieux and Brenez n.d.)

If Seymour is symptomatic of the kind of engagement that will not allow access to this universe, he is also, as Grandrieux and Éric Vuillard recognize in the correspondence they exchange during the preproduction phase of the film, a necessary element for our engagement with the film, that element that provides us with a point of identification that draws us into the film only for that identification to be withdrawn, leaving us in a state of irresolution, in tension, needing to invent other modes of engagement with the film once the possibility of narrative coherence and moral certainty has disappeared. As Vuillard writes to Grandrieux:

> Of course, narrative weighs heavily on expression. And yet it is what enables the cinema to transport man somewhere. It authorises an identification, which is perhaps to the cinema what transference is to analysis.
> Part of the difficulty with Seymour comes precisely from this. He is a narrative entity, he recounts a bit too much. But it's also thanks to him, to his story, that the film will be an experience for the spectator. There must be someone of this kind. With this, movement becomes possible. The other surges forth. (Grandrieux and Vuillard 2002, 34)

A model for this other side of life (or this non-life) that emerges once one has abandoned the desire for transcendent meaning and abandoned oneself instead to primal blocks of sensation that rub up against each other violently – as do the very images we are presented with in the film – is offered to us in the form of Mélania. For this is, I believe, the challenge laid down to us by the film: to accept that the treatment that Mélania undergoes is necessary in order for her new life to appear, to enable her to live life not as an imposter – which is how Grandrieux sees Seymour's relation to life and explains why he is unable to reach her – but, rather, intensively. Such, at least, seems to be how Grandrieux and Vuillard conceptualized the

relation between these two characters, Grandrieux suggesting in his correspondence that 'Only Boyan, the power of the real of Boyan, his brutal truth, his raw youth, transports Mélania' (Grandrieux and Vuillard 2002, 27). Further still, in this correspondence that takes place, let us remember, while the project is still in formation, before shooting has begun, the early scene of Boyan cutting Mélania's hair with a knife is formulated precisely as an element in the coming to life of this character, a fashioning, if you will, of a new being. Having agreed with Vuillard that Mélania's hair needs to be hacked off, slashed rather than cut, Grandrieux writes:

> Her hair hacked off, the true violence of the act immediately confronts the actress with what the body must undergo in order for Mélania to exist. I think it is very important to find an act of great force, a real constraint, an act that would affront her, and me just as much. These are the first gestures of the film. As I was saying to you, they are decisive. (Grandrieux and Vuillard, 26)

While referring here to the actual making of the film, Grandrieux's method is such that his comments apply also to the character in the film and, indeed, to the effect that this scene in the final film should carry for the spectator. The film, in other words, needs to create a break, to rupture any sense of complacency in order for its various elements – both those internal to the film and external to it (which is to say us, the spectator) – to be able to vibrate and resonate in harmony with the form of the film. As Grandrieux puts it to Brenez:

> There's the impression that everything is moving all the time, like a kind of vibrant, disturbed materiology. That's what we were looking for: a disquieting film, very disquieting, very fragile and vibrant. ... It was conceived and developed on questions of intensity rather than psychological relations. My dream is to create a completely Spinoza-ist [sic] film, built upon ethical categories: rage, joy, pride ... and essentially each of these categories would be a block of sensations, passing from one to the other with enormous suddenness. So the film would be a constant vibration of emotions and affects, and all that would reunite us, reinscribe us into the material in which we're formed: the perceptual material of our first years, our first moments, our childhood. Before speech. (Grandrieux and Brenez 2002)

The intention here is then to create an expression or image of
the world that would affect the viewer directly, that would not be
bypassed through any other kind of axiomatic, belief or structure
but, rather, reach us in its own immediacy as expressed in the film's
very form. This, for Grandrieux, is precisely why the accusations
of immorality levelled against the violence in the film cannot be
considered a response to the film itself, because the film seeks to
present us with a vision of the Real that would be prior to the
instantiation of any such narrative structure and that would bring
into being then only what he calls 'a morality of forms'. While this
may render the film apolitical insofar as it separates it from any
reality overcoded within the strictures of any kind of discourse, this
does not make of it a mere aesthetic object separated from the Real
and this, for Grandrieux, is precisely why the film is troublesome.
As he explains:

> [the film] belongs on the side neither of the symbolic nor the
> Imaginary. It's created within the framework of the Real, in the
> sense that it develops a perception of the world which is of an
> immediate order, a 'first look'. Instantly the whole world is given,
> without anything needing to be said, without any discernible
> distance, no gap wedged. A first look – of course this is a pure
> phantasm – belonging to a child. Everything's there, all at once,
> a totality is seized. When I talk about vibration, that's what I'm
> trying to convey. (Grandrieux and Brenez)

Grandrieux returns to this idea in a piece written for *Les Cahiers du
cinéma*, unpacking it to show how it can be actualized in cinematic
form and carried into the life of the spectator. He writes:

> This originary image, inaccessible, lost inside of each of us, is
> not a stable image, figuring this thing or that thing, a body or a
> face or a landscape, it is not resemblance. It is, on the contrary,
> an image undone, uncertain, multiple, fragmented, an image
> through which the first sensations of the body coalesce with as
> yet unarticulated emotions, inaccessible to language. It is not
> an image but, first and foremost, a *montage*, not continuity
> cuts that would create a coherent space and linear time, but
> intensive relations to use Deleuze's term, an affective matrix.
> From this point on this image is like the dark background of

every figuration, a point of blindness, a black hole that we eternally project onto every other image. It is an image for ever lost, perfectly inaccessible, buried in our body, assembled in the body, and it is through this image, through its deployment that we enter into the visible. (Grandrieux 2014)

In acknowledging that this idea of a first look is a 'pure phantasm' and the image itself 'inaccessible', Grandrieux points us to the impossibility of attaining this prelinguistic state via some kind of direct access, as though we could regress to such a condition purely through the force of the image itself. This is why the story is invested with a narrative hook that pulls us in only to leave us hanging, in tension, and this is also why we and Mélania must undergo a baptism of fire to be reborn, must be deprogrammed in order to be able to perceive the world anew, to glimpse the Real that lies beneath reality.

For Mélania, as we have seen, this renewal is directed by Boyan who, even in the midst of the apparent violence he inflicts on her, seems to treat her as a treasured object, holding her tenderly, carrying her to safety, aware of his role as both guardian and creator. Like a sculptor who must decide at a given moment that his work is complete and ready to speak to the world, however, at one point Boyan must release Mélania, allowing her to pass into another realm entirely. The scene in which we see Boyan play the role of puppet master cutting the strings has been wonderfully described in great detail by Adrian Martin in an article published in *Kinoeye* and freely available online, 'Dance Girl Dance' (2004).[4] Martin's prose is a brilliant exemplar of writing on film that is both insightful and poetic in its own right and it contains some extraordinary insights into this scene. While I then commend it highly to everyone reading this text, for my part I see some aspects of this sequence differently from him and will therefore attempt my own description of it, fully aware of the fact that in many respects my own prose pales in comparison to Martin's.

Dance and descent

At the start of this sequence, we see Boyan and Mélania and hear a low rumbling sound. Boyan holds his hands up to Mélania's face,

cradling it without touching her. She turns slowly before him as he moves his hands down across her cheeks, still with no contact, looking at her lovingly but not so much as if she were a lover, more as the product of his labour. She continues to turn between his hands, hands that start to move in sync with her body and to take on a generative function, appearing to produce the slow pirouette that inhabits her body, as though Boyan were bringing his statue to life, the sculptor turned into a puppet master. He brushes his hands across the back of her neck in a gentle caress and then holds them wider, seeming to set her free, encouraging her to move on her own. A slow chiming sound joins the rumble and Mélania starts to pirouette slightly faster, looking at Boyan at every turn, fixing on him as the point of reference to which her head whips back, his hand now seeming to generate each turn of her body with a simple flick of the wrist. Every turn now seems to produce or be accompanied by a whipping sound, perfectly matched to her movement. We cut to a reverse shot at Mélania's back and see Boyan over her shoulders, his arms now raised like a high priest casting out a blessing or a blissed out master of the dance at a rave. A techno beat enters the sound mix and Boyan's head starts to nod in time with the music as Mélania still spins before him. Boyan turns and dances to the music, his arms still outstretched but now pumping to the rhythm. He hunches his back, draws his hands in and rocks his whole body backwards, his dark hunched form seeming suddenly non-human, monstrous, terrifyingly reminiscent of Murnau's *Nosferatu* (see Figure 8). He turns to face us, sweeping his hands in a long arc across the screen in a movement that transforms into the gesture of a magician at the moment of reveal as his body leans back and a smile falls across his face. He pirouettes and then dances to the camera, swaying from side to side at close range, turning his body into a blur of light and movement. We cut to a tight close-up on his face, out of focus, bobbing before us in time with the music, sudden snaps and lurches making us feel like he is about to headbutt us. His dance continues, it consumes him, he appears totally taken by this beat, transported by it, his immersion going deeper as the music becomes more complex as more layers are added, the whole scene building in density and intensity at the same time. Boyan pulls Mélania into the dance once more, pulling her into each pirouette with two hands now, then egging her on with his arms stretched wide and both hands beckoning like someone trying to start a fight,

FIGURE 8 *Screenshot from* La Vie nouvelle. *Courtesy Mandrake Films.*

laying down a challenge. His hands start to flutter wildly, driving
Mélania to spin faster and faster and, as he does so, time in the film
becomes elastic also, speeding up and slowing down, contracting to
the rhythm of the dance. The camera moves in closer, exaggerating
every movement before it and turning all fixed form into a blur
of movement and light, then adds to the disorientation by joining
the dance and tracking around the figures turning before it. An
apogee is reached and many of the musical layers drop out to be
replaced by a higher pitched note that seems to herald a celestial
moment as Mélania's pirouettes reach a point of fever pitch as she
spins impossibly like an out-of-control wind-up ballerina. There
is something almost unwieldy and precarious about Mélania's
movements here that seem too fast, like a toddler taking its first
steps, released for the first time from the hold of its parent. And as
Mélania turns, indeed, we see that Boyan's hand no longer spins her
from afar, puppet-like, but holds her hand above her head like a
dance partner providing a pivot point for a movement that is all her
own. At the same time the frame rate of the film speeds up, adding to
the sense of slight unreality or, rather, transferring the rhythm that
occupies Mélania and Boyan and miraculates their movement into
the very fabric of the film itself so that we too are taken inside this
space, our very sense of space and time generated from within the
frame and cut off from the outside world. All sound drops out save
the constant whipping sound which now accompanies a sequence

of rapid fire cuts, each shot juxtaposing angles and movements with no sequential logic between them, only a choreographic logic as the dance is transferred into the form and mechanics of the film itself. Gradually a recurring shot of Mélania's face looking up to the sky, her eyes rolling back in her head, brings some sense of stability back to the image and slowly the techno beat fades back in. Mélania seems to come to and looks around, dazed and confused. We cut to Boyan, his fist pumping in the air to the music, and then hear roars of approval from a crowd. We cut to a shot from behind his back and see a sea of people dancing below him. For Martin, there seems to have taken place here a shift to a different physical location entirely, for he writes that during this scene,

> there is a subtle transition – from the reddish background of the rehearsal room to bright lights piercing darkness. The transportation has (although we don't realise this immediately) reversed its direction and fallen back to earth. Mélania is now in a nightclub. (2004)

This is possible, yet it seems more akin to a scenario one would find in a David Lynch movie. Here, I would suggest, we are dealing in fact with a scene similar to the nightclub scene in *Sombre* where Claire is seen dancing to music that is the music to which she dances, rather than the music that is actually playing in the club.[5] And just like this scene, we then cut back to a shot of Mélania and Boyan dancing opposite each other in the club as though possessed, seemingly oblivious to the presence of the other, yet both thrashing their head around to a common pattern, driven by the same force. Mélania falls in a faint and, as she does so, the intensity of the music drops off, becoming muffled. Boyan catches her and picks her up tenderly, then carries her through the seething mass of dancers up to a vantage point above the crowd. He pauses to survey the scene below him with her cradled in his arms and we cut to an extreme close-up on his face. He looks directly into the camera, fixing our gaze for a long beat. A smile slowly creeps across his face and he pushes his tongue between his teeth, before breaking into a full grin, throwing his head back.

There is in Boyan's direct address to us something incredibly significant, even though he says nothing. Staring straight at us, his eyes burning into ours, we cannot help but feel he is signalling to us

that something has just happened, something irrevocable, something of which he is fully aware and we are not, hence his grin. We do not find out what this is straight away, however (if we ever really do), because we now cut to the sequence of Seymour's betrayal of Roscoe. While the exact transactions taking place are far from clear, we understand enough to know that Seymour is here paying the price required for him to be taken back to Mélania, and it is Boyan who takes him there. In this sequence, we see Seymour following Boyan so closely it seems as though they are slow dancing. They pause and their heads nuzzle into each other. 'I show you the girls,' says Boyan. 'I'm looking for a special girl,' replies Seymour. Boyan grins, raises his arms in his now familiar pose and runs down a flight of stairs. He turns to face Seymour sideways on, one hand still raised towards him; he raises his other hand higher still in a matador pose and turns slowly as though inviting a bull to come close for the kill, rotating a full 360° until he is facing Seymour again, his arms open wide, beckoning to him. Seymour walks slowly down the stairs. We cut to an extreme close-up on Boyan's hand moving slowly through space, fading in and out of the darkness as it arcs across the screen, falling out of focus as it moves in front of the camera that follows its trajectory until it finds Seymour's face in the darkness. Boyan's hand slowly turns and covers Seymour's mouth, as though preparing to smother him, but then tracks upwards in a gentle caress across Seymour's face, over his eyes now shut in an ecstasy half hypnotic half erotic. The camera moves down to Seymour's mouth and follows his lips as he turns his head towards Boyan, their mouths coming close as though to kiss, their heads conjoined in the overriding darkness. 'All the girls are special,' whispers Boyan. Extreme out-of-focus close-ups on Seymour's then Boyan's faces turn their features into zones of muted reds emerging from the blackness and then, conversely, a wash of red punctuated by black holes. 'Come,' whispers Boyan who turns and descends into darkness, followed closely by Seymour.

We cut and enter a new space where nothing seems the same. All colour has dropped out of the frame to be replaced by blacks, greys and piercing points of brilliant white that burn through the darkness. The liminal relations that have until now made form bleed into background in the half-light of this universe seem to have become a generalized principle, the entire image displaying a textural grain that flattens everything into one plane and turns the

movement of any element into a change of intensity that creates a ripple on the surface of the plane, a wave whose shape takes on the appearance of a form. The first such quasi-form we make out is a hand with black bars for fingers that fade up into a zone of light grey traversed by veiny streaks of burning white light. The hand floats in space, groping its way across the image plane, then finding another hand, this one an incandescent white, and as the two meet and brush over each other they bisect the screen into two halves, one black and one white, their meeting point turned into the dividing line between zones constituted by the absence or presence of light. We cut and are blinded by an almost entirely white screen stained with light grey patches that coalesce into something resembling the features of Seymour's face as our eyes adjust to the light. Something here is wrong, though, for while we are blinded by light we seem nonetheless to be in darkness and, indeed, as we cut to a shot of other figures groping their way through this space, we realize that for all of their luminescence, these figures are blind. The interplay of blinding light and sensory blindness seems to signal an inversion, as though we are looking at a negative image in black and white, yet we know that this cannot be so for the saturated blacks through which these figures slide remain black, and those parts of the body covered with hair and that would normally be darker than skin remain so. Other body parts that would normally not be differentiated within a representational form operating according to chromatic principles, however, become black holes, the space where a nose or ear should be turned into a void, a gaping chasm in the middle of a shape we can hardly recognize as a body anymore (see Figure 9). As we move deeper into this space, all semblance of form dissipates into a ballet of abstract shapes in black and white that scream at us, filling the soundscape with a deafening cacophony that is the sonic correlate of what we see, a space of pure intensity that carries no meaning.

The scene recounted here is perhaps the most famous scene of the film and also perhaps its most unsettling moment if not the most explicit by any means. Shot on a thermographic camera that inscribes an image on film according not to the intensity of light but, rather, heat, the image that we see appears strange, breaking the representational norms to which we are accustomed purely by dint of living within an embodied form in which images are produced by the activation of sensory stimuli by electromagnetic energy – or light. As strange as it may seem, then, this scene is in many respects

FIGURE 9 *Screenshot from* La Vie nouvelle. *Courtesy Mandrake Films.*

but an intensification of the principle governing the entire film, which is to say the creation of an expression that is generated from the inside by differential forces set against each other within the space of the film – be this conceptualized as the space in which the project is formulated and written, the space in which the project is enacted and filmed, or the space projected onto the screen. In changing the means of image capture in this way, Grandrieux makes it harder than ever before to resist the film's own logic, to follow the tired old indexical logic of the photographic image and trace these forces in tension with each other back to a fixed referent in the real world. In this scene more than ever before, then, we are asked to relinquish our attachment to a relation of equivalence between what we see before us and anything we might have seen before, which is to say that the film asks us to dance to its rhythm and to accept what happens here on its own terms without it having to make sense according to a logic, meaning, narrative or moral framework that would originate from anywhere but here. Indeed, there would seem to be no other way to engage with the final phase of this sequence, for having pushed past the forms of a host of anonymous individuals who seem literally to scream their faces off into ours, we stumble across a slightly more tranquil scene. Here the screams are more muffled and we see a lone figure rise and fall. This, we realize straight away, is Mélania, or rather, it is the heat form of Mélania. Crawling on all fours she bends down and seems to nuzzle into

another form on the ground that glows white like her. What seems like the prelude to a sex scene quickly veers into horror, however, for when Mélania lifts herself up, we make out the shape of something dangling from her mouth, something that moves with the quiver of flesh. Mélania chews whatever it is she grips between her teeth, gradually drawing it into the black hole of her mouth, ingesting this form. We cut to a shot of the form of a black hand running over a white heat body form, unaware of who or what these forms belong to, whether they are living or dead. One body then seems to roll and lull, lifeless, and Mélania rises again, chewing or perhaps roaring, her mouth open wide and stretching a gaping chasm through her face to the bridge of her nose. We cut and pull back slightly to see her naked on all fours, turning and padding away, haunches held high and displaying a bright gash between them, feline, on heat. We cut to a shot of Seymour, dumbstruck, mute, paralysed by the scene before him. We cut back to Mélania, now further from us, and watch her circle on all fours like a lion after a feed, preparing the ground for sleep then lying down and stretching to rest.

In the context of a film that has been, if not a model of classic narrative cinema nor one with obvious referents to a specific geopolitical situation, nonetheless invested with a certain degree of realism and absence of supernatural elements, this scene is somewhat puzzling and can elicit, I feel, one of two main reactions. We can, firstly, attempt to understand what is happening here and necessarily fail to do so, adopting a pose like that of Seymour who seems incapable of grasping what lies before him, or else we can allow these images simply to exist and to operate on their own terms, to generate a poetry which is not of the order of meaning or closure, which cannot be grasped or internalized, in relation to which there can be no transcendence. To adopt the latter stance is, I believe, what the film calls for, and to do this is to adopt the stance of Dante, the poet who accepts the distance that will always separate him from his ideal love object, Beatrice, but who knows that it is in this breach that life is ever created anew, that it is from this gap that poetry, life as an active principle with no complacency, is born.[6] This is not to suggest that this scene is entirely gratuitous, random or unrelated to any other part of the film, of course. While there may not be a strict causality or narrative closure in the move from the earlier scenes featuring Mélania and this one, there are certainly serial relations established between the scene with the Frenchman

and this. In both scenes, for instance, we see Mélania on all fours, animal-like; if in the former scene she screams like a beaten animal and cowers in the corner, here she roars like a lion, stands over her prey and marks this territory as her own with her slow, deliberate movement in it, embodying fully the claim made in the song she sang in the nightclub and that seems in retrospect prophetic: 'I am woman, hear me roar.'[7] My suggestion here is not that she has literally become the animal that she is turned into by her beating at the hands of the Frenchman, that she is now able to assume and fully embody that state as master rather than victim, simply that a transformation has taken place in which the forces acting on her throughout the film bring her to a point where everything tips into another realm, a realm where the contours of the image, the narrative line and the boundaries that lie between different moral categories are dissolved to an even greater extent than ever before.

In saying this I am arguing that we find here a dramatization of the dynamic forces of the idea of the figural and that this dramatization plays out in both the manifest content of the film as well as its form. Mélania is a figure who is, from the very first time we see her, subject to intense forces, placed in situations where the limits of her being are stressed to near breaking point, suspended between the competing pressures of bodily and financial self-preservation, pleasure and pain, terror and ecstasy. In the dance sequence, all of these forces seem to pass into Mélania herself and generate a movement from within that carries her beyond any semblance of fixed form, a figural force that converts her into, firstly, an entity defined only by movement and then a pure zone of intensity, of differential relations in a space no longer governed by a scopic regime in which identity is produced as a secondary effect of appearance. To put this another way, by the time we reach the scene of the descent shot with a thermographic camera, it is quite simply no longer possible to say what we see, to know what it means, for to be able to do either of those two things would require us to be able to find here some fixed points, points that simply do not exist in movement and intensity.

Openings

Thought of in this way and accepting the suggestion that the confluence between form and content implies that the shift in

Mélania figured in the content is one that the film wishes to effect in the spectator via its form, *La Vie nouvelle*'s opening sequence can be thought of as a mirror sequence that provides us with a picture of what we are to become – as does the sequence of children screaming in enraptured terror at the start of *Sombre*. In this sequence we see a group of people wandering slowly and apparently aimlessly through the darkness. The group is shot with a very unsteady, trembling handheld camera, out of focus. The camera then seems suddenly to race towards discrete individuals in this group, the movement of the camera seeming jerkier than ever as a secondary artefact of the speed of the forward movement of the shot which, as in later sequences of the film, seems too fast. As the camera races up to frame these faces in extreme close-up, they come into sharp focus, this being achieved not thanks to a focus pull but, rather, simply because the camera has moved into the correct focal range for its object of contemplation to appear in focus. The camera dwells on these faces for a long beat, but every time it does so the slight movements generated by the camera itself and the barely perceptible facial movements of the people in these otherwise ostensibly static images indicate that the spatio-temporal relations here are elastic, contracting and expanding as the frame rate slows and accelerates. In every respect, both in relation to the treatment of time and the focal plane, then, the image here is enacted by forces internal to the very mechanics of the shot, as the image is produced via a relation instigated between the various elements of the shot and not in accordance with the exigencies of a standard imposed from the outside. Configured in this way, the shot remains in tension, it is never resolved into a final form with a fixed identity and indexical relation to the Real – as is generally argued to be the case with the photographic image – and something similar can be said of the people photographed here. This is a people dispossessed, wandering aimlessly through the night, their faces deeply etched with lines that trace a tale of suffering yet wearing a look of stoic determination. It is perhaps somewhat unsurprising, then, that these people have been likened by critics to those peoples displaced by sociopolitical unrest and who, throughout the course of history, have suffered massive trauma. For Fabien Gaffez, indeed, this opening is 'the most profound fictional rendering of the Shoah and every other genocide that has taken place in the heart of Europe that has ever been seen' (2005, 31). In a similar vein, for Martine Beugnet this group is

'emblematic of the uncertainties of our transnational age' (2007, 148). Grandrieux himself does not necessarily reject such an idea completely and has suggested that this group of wandering people may indeed evoke 'other forms of tragic assemblages in the twentieth century, linked to the Shoah or to deportation'. Ultimately, however, he is loath to tie the image down to anything so specific and goes on to say that we are presented here with nothing but 'an image that provokes a very complex, a very dense sensation' (Grandrieux and du Mesnildot 2003, 24).

Eric Vuillard follows this line, seeming to be unwilling even to let this image evoke the figure of a specific historical reference, saying,

I don't think you can tie this group to any kind of identity. ... We had started a project called *A Natural History of Evil*, which was not to be a social history, nor a historian's history, but a natural history of bodies, of looks, of movements. And it's out of that project that the people we called the Third People were written and thought, in no way as a reference to or identification with any specific figure. What interested us more was this: what would it be to look at a light, simply to look at it, to the point of blindness? What is looking? These people come out of this primordial night and look. What are they looking at? Neither we nor they know. (Grandrieux and Vuillard 2005, 190)

Something similar is suggested by Grandrieux during an interview with Claire Vassé when he describes the group of people in this opening scene in the following way:

It's like a swell, an advance, an opaque mass, a pressure that comes mostly from the faces. They are dazzled, taken captive by the light. They appear from out of the deepest darkness, they seem to advance, fascinated by we know not what. It's impossible to give the countershot image, an image of what occupies their gaze. (Grandrieux and Vassé 2002)

As can be seen very clearly here, if the mechanics of this shot produce an image that remains in tension, that is produced by a force internal to it that is not resolved via correspondence with a reality external to the image itself, the very same forces are in operation in the relation of the content of the image to the reality

in which it is produced and, indeed, in the gaze that is figured on screen which is never closed down by the reveal that would be produced by a reverse shot. As at the beginning of *Sombre*, we might then think of this people wandering through the night as a mirror image of ourselves as spectators of *La Vie nouvelle*. Like them we are cut off from any place that might be called home, thrust into a space in which we can find no coordinates to orient ourselves in the blackness, condemned therefore simply to look ahead and to advance, groping our way through the dark with no possible end in sight, no hope of arrival at a point that might provide some respite, at which desire might be fulfilled once and for all or at least provide us with the illusion that this is a possibility, no matter how remote. What is more, if we think of ourselves as being reflected in the screen in this way at the start of the film, figured as a body whose desire can never be fulfilled and that must remain in tension, pushed beyond itself by forces both internal and external to it, then the film's final shot of Seymour surely provides us with yet another image of ourselves.

Having realized that his desire for closure, for the consummation of desire with Mélania will always remain beyond his reach and that no other woman can take her place, Seymour looks to the heavens and starts to shout, his entire body projected into a cry that carries his flesh with it, his Adam's apple straining at his skin, seeming to want to burst out of his throat and follow his screams that are accompanied by the whipping, whooshing sound we heard at the moment of Mélania's final transubstantiation. And then the noises, drones and rumblings of the soundtrack that have been present throughout the film (and served as one of the main elements that maintain the principle of tension and unease that the film generates) are joined by what sounds like the screams of a million damned souls rising up from the inferno and being channelled through Seymour's body on their way, alternately accompanying and replacing his own cries, mashing together diegetic and non-diegetic space and distending the spatiotemporal relations of the image once again as time itself flexes and the entire space of the film becomes a scream that intensifies and crescendos in a rush of pure energy that rips through us, tearing us apart until suddenly the high-pitched celestial note from Mélania's dance scene enters, obliterating all other sound as it passes and then dragging the image with it as we cut to black and are left with only the fading echo of this clarion call.

With this final image we come perhaps closer than at any other
point in Grandrieux's career to a likeness of a Bacon painting and
this artist's claim that he wished 'to paint the scream more than the
horror'. This is not simply a matter of aesthetic proximity, however,
for the implications of Bacon's declaration here and the privileged
place he accords to the scream as an act that brings many of the
principles deployed throughout his work to their highest point
bring us close to what we have said of *La Vie nouvelle*. Indeed,
if we have suggested that *La Vie nouvelle* is concerned not with
representational forms or narrative lines, not with establishing
relations of equivalence between it and something that would pre-
exist it in the world but only with forces that it would generate
from within, if we have claimed that a privileged model of the
sensory regime instigated by the film itself can be found in the
opening sequence showing a group of people who do not look *at*
something but only look, and that the space of the film is one in
which sensation itself is primary and sustained via tension rather
than being dissipated in the sight of the spectacle itself, then we are
very close indeed to what Deleuze has said of Bacon's screams. He
writes:

> We must consider the special case of the scream. Why does
> Bacon think of the scream as one of the highest objects of
> painting? 'Paint the scream …'. It is not at all a matter of giving
> color to a particularly intense sound. Music, for its part, is faced
> with the same task, which is certainly not to render the scream
> harmonious, but to establish a relationship between these forces
> and the visible scream (the mouth that screams). But the forces
> that produce the scream, that convulse the body until they emerge
> at the mouth as a scrubbed zone, must not be confused with the
> visible spectacle before which one screams, nor even with the
> perceptible and sensible objects whose action decomposes and
> recomposes our pain. If we scream, it is always as victims of
> invisible and insensible forces that scramble every spectacle, and
> that even lie beyond pain and feeling. (Deleuze 2003b, 60)

What is 'curious' with Bacon's screams for Deleuze is how, when
considered in this way, the violence of sensation that they carry
(rather than the violence of the unseen spectacle that might produce
the scream) is positively invested, becoming an expression not of

despair but, rather, of vitality. Talking of Bacon's painting of Pope Innocent X, he writes:

> Innocent X screams, but he screams behind the curtain, not only as someone who can no longer be seen, but as someone who cannot see, who has nothing left to see, whose only remaining function is to render visible these invisible forms that are making him scream, these powers of the future. This is what is expressed in the phrase 'to scream at' – not to scream *before* or *about*, but to scream *at* death – which suggests this coupling of forces, the perceptible force of the scream and the imperceptible force that makes one scream.
>
> This is all very curious, but it is a source of extraordinary vitality. When Bacon distinguishes between two violences, that of the spectacle and that of sensation, and declares that the first must be renounced to reach the second, it is a kind of declaration of faith in life. … But why is it an act of vital faith to choose 'the scream more than the horror', the violence of sensation more than the violence of the spectacle? … When, like a wrestler, the visible body confronts the powers of the invisible, it gives them no other visibility than its own. It is within this visibility that the body actively struggles, affirming the possibility of triumphing, which was beyond its reach as long as these powers remained invisible, hidden in a spectacle that sapped our strength and diverted us. It is as if combat had now become possible. The struggle with the shadow is the only real struggle. (61–2)

To claim that *La Vie nouvelle* is shot through with this kind of positivism and vitality (and that we should then take its title very seriously) may seem to many either patently absurd or else unforgivable. Yet this is precisely the claim that I wish to make and it is why I suggest that the final note of the film is a clarion call. Nicole Brenez also finds positivity in the film but for her it comes more from the very existence of the film itself. Considering the film to offer 'an inventory of the state of the human psyche at the turn of the twenty-first century', a bleak vision if ever there was one, Brenez continues, 'All the same, we absolutely cannot despair, since *La Vie nouvelle* exists, and since work of this quality shows us, despite everything, what beauty, profound intelligence and gestures of love the human spirit is still capable of' (Grandrieux and Brenez 2002).

While I concur with Brenez's sentiment here in relation to the film itself as a testament to hope, where I differ is in seeing it as offering an inventory of the problems of the world, the expression of 'a collective nightmare ... into which we have all been plunged since revolutionary ideas revealed their non-viable character and left the world without the slightest hope, cast into a ruin not only material but also moral' (Grandrieux and Brenez 2002). To understand the film in this way is to find in it indexical links between the forms it depicts and objects, people or events situated in a world that lies outside of it, whereas I would contend that the film's link to this world is only instigated in the relation to the spectator, that what we see figured on screen serves only to transmit a force to us that will henceforth alter our perception of and actions in that world. This is to say that Brenez is undoubtedly right when she says that the world into which the film is born is one in which the human psyche is 'hooked on sentimentality, dazed from unhappiness ..., devastated by lucidity', but rather than the inventory of this state of being the film is instead that which is sent to shock us out of this comatose state of complacent impotence. It is for this reason that its violence is so great, for when we are confronted on a daily basis with an almost incessant spectacle of various forms of violence invested with a meaning or, at least, reason – be this political, aesthetic, documentary or denunciatory – a *truly* senseless violence that cannot be recuperated and that is then sensed in its raw, brutal form is what is required to break through the anaesthetic fog of our desensitized eyes, to in-sense us, if you will.

To make this claim is to identify an affinity between *La Vie nouvelle* and Artaud's Theatre of Cruelty (1958) – even if, for Artaud, cinema was part of the problem of the impoverished state of the theatre. In an assessment that resonates with Grandrieux's own analysis of the classical narrative-based model of film-making, Artaud writes, 'Movies ..., murderng us with second-hand reproductions which, filtered through machines, cannot *unite with* our sensibility, have maintained us for ten years in an ineffectual torpor, in which all our faculties appear to be foundering' (1958, 84). For Grandrieux, cinema may be not only part of the problem that has produced this state of paralysis but also part of the solution, a solution that can be conceptualized along lines that follow those traced by Artaud in his manifesto for the theatre (a term that for him signifies far more than the normal colloquial usage of the term

would imply[8]). Artaud writes that 'we need a theater that wakes us up: nerves and heart', and later,

> In the anguished, catastrophic period we live in, we feel an urgent need for a theater which events do not exceed, whose resonance is deep within us, dominating the instability of the times.
>
> Our long habit of seeking diversion has made us forget the idea of a serious theater, which, overturning all our preconceptions, inspires us with the fiery magnetism of its images and acts upon us like a spiritual therapeutics whose touch can never been forgotten.
>
> Everything that acts is a cruelty. It is upon this idea of extreme action, pushed beyond all limits, that theater must be rebuilt. (84–5)

It is not only the idea of what the theatre is that is reconfigured in Artaud's work, however, for the concept of cruelty is also put to the service of an idea that exceeds the normal usage of this term. For if Artaud proposed a 'theater in which violent physical images crush and hypnotize the spectator seized by the theater as by a whirlwind of higher forces' (83), a theatre which, what is more, abandons psychology, this is proposed not as an act of sadism against the spectator but, rather, a means to stage an interplay of forces that will be transmitted to the spectator and reconfigure her relation to the world henceforth, giving her, in effect, a new life. A theatre of this kind, a Theatre of Cruelty is, for Artaud, one that 'presents itself first of all as an exceptional power of redirection' (83). Artaud recognizes the dangers of this strategy, the risk of violence in the theatre begetting further violence in the world, but believes that the disinterestedness of the theatre makes of this violence something very different indeed (82) and that, in any case, in the present circumstances from which he writes this 'is a risk worth running' (82). He continues:

> I do not believe we have managed to revitalize the world we live in, and I do not believe it is worth the trouble of clinging to; but I do propose something to get us out of our marasmus, instead of continuing to complain about it, and about the boredom, inertia, and stupidity of everything. (83)

There is in what Artaud says here a great deal of resonance with an idea expressed much later in Deleuze's book *Nietzsche*

and Philosophy (1986a). There also we find a call to arms, a
suggestion that philosophy must be invested with a certain violence
and aggressivity if it is to be able to break through the wall of
complacency and acceptance of the world as currently constituted.
Deleuze writes:

> Philosophy does not serve the State or the Church, who have
> other concerns. It serves no established power. The use of
> philosophy is to *sadden*. A philosophy that saddens no one,
> that annoys no one is not a philosophy. It is useful for harming
> stupidity, for turning stupidity into something shameful. Its only
> use is the exposure of all forms of baseness of thought. Is there
> any discipline apart from philosophy that sets out to criticise
> all mystifications, whatever their source and aim, to expose all
> the fictions without which reactive forces would not prevail?
> Exposing as a mystification the mixture of baseness and stupidity
> that creates the astonishing complicity of both victims and
> perpetrators. Finally, turning thought into something aggressive,
> active and affirmative. (1986a, 99)

My suggestion in citing these sources here is that *La Vie nouvelle*
is just such a cinema of cruelty,[9] an aggressive philosophy. If it
cannot be indexically mapped to any framework or coordinates in
the outside world, this is because it fundamentally rejects any such
pre-established order and generates its forces internally rather than
in relation to something that lays outside of it, because it generates
something that is new in the truest sense of the term. This is not
to say, however, that it is entirely abstracted off from the outside
world. As with Artaud's Theatre of Cruelty, there is here, I believe,
a desire to generate the power of redirection that Artaud talks of,
to revitalize our relation to life – and this is explicitly signalled
in the soundscape of the film's dying moments when the sounds
that had previously signalled Mélania's passage to a new life, her
final transformation into a dervish-like figure straight out of the
pages of Artaud's text (1958, 83) are all that remain as the screen
cuts to black, leaving us with no figure to attach them to other
than ourselves. To claim this is to suggest that the ultimate aim
of the cinema for Grandrieux is to present us with a vision of the
world that is fundamentally different, somehow unworldly, so as
to transform our relation to the world. This does not change as

we pass into the next phase of Grandrieux's career, even if the method seems to shift in certain respects and the explicit violence of the image is replaced with something very different. Whether this occurs as a response to the critical reception of *La Vie nouvelle* matters little and it is not something that Grandrieux has chosen to talk about. All that matters is that the vision remains the same, even if the image changes.

7

The turn to nature

In 2005–6, Grandrieux produced three short video works for gallery installation: *Grenoble* (2006) – comprising two separate films (38½ minutes and 17 minutes) intended for simultaneous projection onto two screens placed at a right angle to each other; *Met* (2006) – a 5-minute-long video work played in a continuous loop; and *L'Arrière-saison* [*Indian Summer*] (2005), comprising two video works (9 minutes and 10 minutes) played consecutively in a continuous loop. Even though two of these works contain images of naked bodies alone (*Met*) or in various kinds of couplings (*Grenoble*), there is here none of the explicit violence of *Sombre* or *La Vie nouvelle*. These works, indeed, contain predominantly – exclusively in the case of *L'Arrière-saison* – images of nature: flowers, trees, rivers, clouds filmed in long, slow takes, time being distended further still in *Met* and *L'Arrière-saison* by the use of a digital manipulation of the frame speed such that the moving image is reduced almost back to a still image, motion only being produced across the break created by the succession of images in a freeze frame effect, slowing beta movement to the point that the persistence of movement in perception is no longer maintained. Yet if at first these images seem to signal a complete change of direction for Grandrieux in relation to his feature films, if they seem hypnotic rather than psychotic, it soon becomes apparent that a very similar aesthetic and philosophical operation is in train here and that the violence contained in the image is, despite appearances to the contrary, just as great even if it is now transmitted solely in the form, temporality and relations of the image rather than in conjunction with the manifest content of the image.

This point has been understood well by Boris Gobille who conducted a 6-hour long series of interviews with Grandrieux between 8 December 2006 and 26 January 2007. These interviews were intended in part as a way to produce material for and simultaneously conceptualize a joint book project – a project that would unfortunately never come to fruition – as well as to further Gobille's understanding of Grandrieux's approach for a text that he was to write to accompany an installation of *L'Arrière-saison*. In their conversations and the latter text, Gobille quotes Bacon's comment on Van Gogh that,

> Van Gogh got very near to the violence of life itself. It's true to say that when he painted a field he was able to give you the violence of the grass. Think of the violence of the grass he painted. It's one of the most violent and abominable things, if you really want to think about life. (Bacon in Sylvester 2000, 243)

Taking his lead from this idea, Gobille writes in his text 'L'Éblouissement, l'effroi' ['Glare, Dread']:

> With Heraclitus philosophy is born from the definition of thresholds and opposites – darkness and light, wakefulness and sleep, death and raw life – and from organisation, in the interval of these pairs, from a life conducted and perhaps saved from disorder by a considered knowledge of the world. But in Philippe Grandrieux's cinema the place where this is born is not in the interval. It is not the in-between. Here we have the zones of excess themselves, the opposites, the extreme. This is the final frontier and it is nondescript because it is nothing other than the state of exception. We only exist in the world in a regime of crisis. The violence that erupts from the vision imposed by Philippe Grandrieux comes from the fact that we do not find here human life but 'bare life', which is to say the unrepresentable, the non-figurable, the unbearable. (2007)

With these concepts of bare life and the state of exception, Gobille is of course referencing Giorgio Agamben's book *Homo Sacer: Sovereign Power and Bare Life* (1998), a book that Grandrieux himself brings up in the course of their conversations. For Agamben, bare life finds its most complete expression through the

figure of *homo sacer*, the man who cannot be sacrificed yet whom anyone is permitted to kill without committing homicide, a figure who thus exists in a juridical state of exception. This figure, for Agamben, is a remnant of a pre-social mode of being and one that also invokes two different figures that resonate strongly with the main protagonist of Grandrieux's first feature. Indeed, drawing on the work of Rodolphe Jhering, Agamben brings the figure of *homo sacer* close to that of 'the *wargus*, the wolf-man, and of the *Friedlos*, the "man without peace" of ancient Germanic law' (1998, 105). For Agamben, this figure is not simply the 'monstrous hybrid of human and animal' that it 'had to remain in the collective unconscious', but a far more troubling, liminal figure who casts into doubt the very categorical imperatives of society and civilization. As he writes,

The werewolf ... is, in its origin the figure of the man who has been banned from the city. That such a man is defined as a wolf-man and not simply as a wolf ... is decisive here. The life of the bandit, like that of the sacred man, is not a piece of animal nature without any relation to law and the city. It is, rather, a threshold of indistinction and of passage between animal and man, *physis* and *nomos*, exclusion and inclusion: the life of the bandit is the life of the *loup garou*, the werewolf, who is precisely *neither man nor beast*, and who dwells paradoxically within both while belonging to neither. (105)

Agamben's description of the wolf-man here, a figure who lives divided between the forest and the city, fits *Sombre*'s Jean like a glove – or wolf costume, rather. In understanding the relation between the wolf-man and *homo sacer* and the concept of bare life more generally, however, we can firstly deepen our understanding of the philosophical import of Jean's violence and, secondly, begin to see how the principle of violence that governs Jean's life is in fact merely an explicit and extreme expression of a fundamental principle that exists in nature, 'the violence of the grass'. This violence, the violence of being that has no peace, that is not integrated into a social structure tending the possibility of respite via the abdication of the responsibility of *Dasein* into a larger transcendent structure, is one that is both rejected by yet subtends man as a political and social animal. For Agamben, indeed, 'there is politics because man is the living being who, in language, separates and opposes himself to his

own bare life and, at the same time, maintains himself in relation to that bare life in an inclusive exclusion' (8). In Grandrieux's work, however, as has been our contention throughout, there is no such possibility of figuring the relation itself as a synthetic form. Instead, we are presented with extremes that deploy a force across the gap that separates them from each other irredeemably both within the work on a formal level and beyond the work in their relation to us as social and moral beings. Or as Gobille puts it:

> By deploying itself on the edges of the interval in which philosophy is born and that it brings into being, Philippe Grandrieux's cinema carries with it a much more radical disturbance: a state of unrest[1] – *desassossego, Unruhe* – faced with the fabric of the real which is fashioned out of a night too black and unwatchable suns. (2007)

In saying this, Gobille points us, elliptically and poetically, towards the way in which this violence is transmuted from a literal, corporeal and psychological violence in *Sombre* and *La Vie nouvelle* into a violence that inhabits the image itself and the relations between the various on-screen bodies out of which the image is composed. Like the idea of violence already seen in Artaud's Theatre of Cruelty, this is not the kind of violence that we find in real-world conflicts but, rather, a force that cannot be sublimated or transcended, that never resolves itself into a secondary narrative but incessantly rips asunder the boundaries of any sense of fixity or form before they even have a chance to coalesce instead to generate an expression that passes directly to the spectator via sensation rather than the intellect, such that what we witness is sensed and not understood. This is what is produced by Grandrieux's 'night too black and unwatchable suns' that are unwatchable insofar as they can be seen but not traced back to an index in the world, to an identity or form, since they operate not in the mode of an individuated entity but, rather, a haecceity, that mode of individuation that, for Deleuze and Guattari, 'consist[s] entirely of relations and movements and rest between molecules or particles, capacities to affect and be affected' (1987, 261). While such modes of individuation were very much in effect in *Sombre* and *La Vie nouvelle*, the fact that their violence was expressed not only in this state of unrest but also in more literal and explicit forms of violence meant that there arose, for many viewers and critics, a

moral imperative that required these films to be held to account and answer to the realm of reality – which is to what Gobille terms 'the fabric of the real' what political and social life are to bare life. This form of violence disappears in *Met*, *Grenoble* and *L'Arrière-saison*, intensifying the incommensurability of the extremes figured on screen and disallowing to a greater extent than ever before the establishment of a relation of equivalence between what we see and what we already know.

Met (2006)

In these three installation pieces, the deployment of violence takes place in differing ways, although there are commonalities running across all of them. In *Met*, the soundtrack fades in before the image and we hear a low electronic bass note droning and gently throbbing, its metallic buzz joined, after 45 seconds, by a much higher pitched, searing shard of electronic scree that slowly modulates on top of the bass drone and fades out, then back, for the remainder of the 5 minutes and 50 seconds that the piece lasts. While there is great timbral similarity between the bass and treble lines of this score, and while they are sustained in a slowly modulating relation to each other for the duration of the piece, they never resolve in any way, never fall into a harmonic relation with each other, never crescendo up or fade away at the same time in a synchronized move scored to flag a particular moment of drama in the action on screen. Rather, throughout *Met*, these two lines maintain their own rhythm and pitch, oblivious to the presence of the other yet creating an almost unbearable tension between them, the low rumbling drone carrying a sense of menace that is cut through by the squeal and electrical charge of the high-pitched line in such a way that the sensation of unease is only increased by what sounds like and threatens to inflict something resembling pain as our capacity to hear and to endure sound is taken to its limits.

When the image appears underneath this soundtrack, we see through the scan lines of the video image a wash of variegated greens that shift and morph as the camera rushes over a clump of leaves as though searching for something among them. We pan left and the screen is punctured by a sea of pointillist white dots as we track across a patch of wild flowers. We quickly cut

to black and then back to these flowers, to black again and back to a different field that punctuates the green with brilliant points of purple blurred into abstraction by the focal plane that does not coincide with any discrete visible on-screen element. A jerky camera movement adjusts the light levels and brings down both the contrast and saturation of the hues. We cut to black and then back to a shot of this same scene, now overexposed such that we are almost blinded by brilliant white points fringed with lilac that burn through the screen as we zoom towards them then cut to black. We cut back to a grid of deep green and white lines stained with bursts of auburn, orange and scarlet. We cut to black and back to this scene which reveals itself to be another field of flowers now that the image is back in focus and the colour saturation has returned to a more realistic level. The camera moves quickly, restlessly, seeming to want to search something out or perhaps simply not to stay still, to be itself that which flees our gaze even if it is through it that we are able to see. We cut to black again and return to a different space entirely. If the previous shots seemed to want to remain on the move so as to maintain light and colour in an abstract choreography that would resist figuration, here the image is slowed, drawn out, still, and we see a field of yellow tulips, their petals picked out perfectly against the dark green backdrop of their foliage.

Yet something here seems not quite right, for even though we can see the object of our gaze like never before and are invited to contemplate it by the languorous pace of slow motion, this very technique and the quality of the light seem once again to turn these flowers into something else entirely. These tulips, indeed, seem somehow unreal, unworldly, and the entire image seem to be somehow not quite right. Like the opening scenes of *Sombre*, the image here is dark yet we sense, counter-intuitively, that it is shot in broad daylight. What is more, even though the light reflecting off these tulips is muted, it nonetheless creates a luminescent effect that paints each petal with a sheen that seems to plastify their surface, lending them a strangely artificial appearance, turning them into elements that exist not as indices of a natural world but, rather, as objects configured to produce a certain aesthetic effect (see Figure 10). This impression is compounded as we cut to a different iteration of the shot and the camera again starts to jerk around, the slow motion intensifying the motion blur produced and making it seem as though the tulip heads are brushes painting yellow streaks

FIGURE 10 *Screenshot from* Met. *Courtesy Philippe Grandrieux.*

across the screen. We cut to black and then back to a shot looking up towards the sun through the branches of a tree. Rays of light refracted by the lens cut across the screen in the shape of a tripod, each limb of which is dressed in a rainbow glow. The slightest movement of the camera and change in the relation to the sun pitches the light levels into almost total blackness and then back to a blinding overexposure daubed with pink and white blossom. We cut to black and then back to a shot much like one of the opening shots in a field of purple flowers. This time, though, the camera movement is measured, a slow zoom slowed further still by slow motion, and the scene is shot in that light that is neither day nor night, that maintains the contrast between figure and ground while equalizing the colour tones. The zoom continues in so slowly that a freeze-frame effect is created as each point grows larger. We cut to a slow-motion sequence of the green lines and orange bursts seen before and again watch as light and colour are modulated through a seemingly infinite series of variations in successive shots.

And then, at the very moment that we feel a pattern is being established, we cut to black and back to a pair of high-heeled

patent leather shoes worn by a woman who wears nothing else and of whom we see only her legs and, centre screen, her vagina. The disjunct we feel with this shot is remarkable and is rendered all the more intense by the fact that this image is shot in black and white. The only element that seems to remain constant here is the slow motion into which the whole film now seems to have slipped, but this in fact only underscores the contrast as we watch her hands appear under her buttocks and run slowly up the back of her legs in a move that is unmistakably sexual, all the more so in slow motion. We cut to black, now unsure what we will return to, and when we do cut back we are again at the base of a tree looking up into the sun, shards of light cutting across the screen. We cut to black and then back to a black and white shot of a different naked lower female torso. The image resonates with the first such shot, yet seems to instigate a relation with the previous shot as well since the tripod form created by the shafts of light that bisected the screen is here mirrored in the line of this woman's splayed legs and that of her pudendal cleft. More than anything, though, these two seemingly very different series of images seem to resonate together insofar as they are both an address to the eye, an invocation to a pure look from an image that serves no other end.

Given this suggestion, it may well be that this last image also resonates strongly with an artistic precursor. While it would be tempting to suggest, given the pose figured, that this image (as is the case with an early shot in *Sombre*) sends us to Gustave Courbet's *The Origin of the World* (1866), Courbet's work was, I think, too explicitly concerned with his own particular view of Realism in art and a desire to shock the bourgeoisie to serve as a precursor for what we find here. Rather, this image recalls another installation piece, perhaps one of the most famous and mysterious of all installation pieces, Marcel Duchamp's *Étant donnés* (1946–66). In Duchamp's work we also find an image of a naked female lower torso in this same pose, but more than this, Duchamp's work is an appeal to vision, signalled most obviously by the two peepholes cut in an old wooden door through which the work is viewed. Duchamp's work also juxtaposes many different elements that cannot easily be united within a narrative framework that would bring together the objects named in its subtitle, 'The Waterfall' and 'The Illuminating Gas', to say nothing of this female figure. Instead, these elements appear merely as givens in their own right, abstracted from any unifying

grammar or syntax in the same way that Duchamp's title that turns a conjunction into a quasi-nominal form through pluralization prevents us from reading what is presented to us as we normally would.[2] Like what is being suggested here of *Met*, indeed, *Étant donnés* is not so much a work to be *read* as a work to be looked at. This, at least, is the claim made by Hans Belting for whom Duchamp 'constantly asked the question of whether there can be a kind of representation that is not a representation of *something* – that is, not a likeness or imitation of the sensory world – but rather refers back to itself, that is, to nothing but representation as such' (2010, 47). *Étant donnés* represents the most advanced point of Duchamp's thinking about this question and stands as the work that perhaps more than any other resurrects the question of perspective from the tomb to which modernism had condemned it as 'a metaphor for a problem', as Belting puts it, perspective being figured here not simply as a way of looking but, rather, 'a new manipulation of the viewer's gaze, interrupting the view of the work' and enabling Duchamp to ask 'what does seeing mean once art has parted ways with depiction?' (Belting 2010, 8).

If these black and white images of female genitalia resonate strongly with Duchamp's work, they do so also with Grandrieux's earlier work, particularly *Sombre* and the photographs that he would publish around the time of *Met* in the magazines *Le Teaser* (Grandrieux 2005) and *Edwarda* (Grandrieux 2010) – the latter including images both of female nudes and motion blurred flowers. It seems, indeed, that female genitalia constitute for Grandrieux a site that is both an appeal to vision and simultaneously that which cannot be seen, a locus that generates a complex knot of forces that cannot be *understood* yet which nonetheless mobilize and bring about a shift in perception. What is generated here, to borrow a term from Linda Williams, is then a 'frenzy of the visible' (1999, 36). However, rather than being symptomatic of the modern age's construction of a *scientia sexualis* intended to reveal ever greater truths about sexuality that participate in a regulatory function on bodies and pleasure (an idea originating in Foucault's *The History of Sexuality* and used by Williams to think through hardcore pornography and the ways in which 'a variety of discourses of sexuality … converge in, and help further to produce, technologies of the visible' (36)) the 'frenzy of the visible' generated here is one in which the very act of looking produces an entire complex of

incommensurable relations – rather than being directed towards the excitation of a certain kind of desire with predictable ends.

While this is undoubtedly important for thinking through many scenes in *Sombre* and in particular those where Jean is seen staring between the legs of the women he encounters, what is important for our consideration of this particular installation piece is that we can see here the same logic in operation, the same desire to reconfigure the scopic (to use Metz's term (1982, 61)) or, more broadly, sensory regime through which we apprehend the world, to produce the kind of look in which the Third People at the start of *La Vie nouvelle* are engaged. Here, however, this logic is intensified or, rather, isolated in such a way as to carry greater force since the way in which this new regime of perception is created and transmitted to the spectator takes place not via a violence that asks her to abandon any prior moral or psychological frameworks through which she would normally approach and understand the world but, rather, through the brute force of formal procedures that work upon the optical qualities of the images themselves and the relations between them, removing them from any associative, narrative, indexical or logical contexts – just as the two tones of the soundtrack have been said to operate. The violence figured explicitly on screen in Grandrieux's first feature-length films is then here translated into the violence of the grass, a brute statement of fact about the very nature of being that subtends the representations we make of that being, but also into the violence of the image itself and, indeed, the violence of a look that would break apart the secondary syntheses that are effected on the world when it is not simply seen but understood or lived according to the mutually constitutive processes of social being.

An alternate mode of being in the world is perhaps figured in some of the final shots of *Met* in which we see, from behind, a human figure camouflaged among the branches and blossoms. The figure seems to be an older woman, judging by the colour of her hair, but this ultimately matters little for what seems to be of interest here is precisely the chromatic similarity between her hair and jacket in among the play of colour and light as the sun passes through branches and reflects off blossoms, the zone of indiscernibility that is created by the pictorial elements of the image itself. We zoom in closer to this still figure, then cut to a shot filmed closer still and then, lest some semblance of identification arise from this focus on

a lone figure, we cut to an image shot into the sun in which the tripod of light is almost all that can be seen, and then to another very dark image in which all sense of time and scale is lost. The image seems to be shot in daylight, judging by the light source we see before us, but here more than ever the underexposure of large portions of the image produced by shooting directly into a bright light darkens the entire image, confounding any indexical links that we might have to a temporality existing outside of the duration of the image, which is to say a time of day in the world. This lighting effect flattens all of the planes of the image into a single sheet, making it impossible to know whether the black, ragged mass at the centre of the image belongs to the black branches hanging in the foreground of the image or whether, on the contrary, it is a large mass such as a mountain in the distance scaled down by the effect of perspective in a space in which there are no points of reference that enable the laws of perspective to become fully operational.

This shot and the next, in which silhouetted, skeletal trees are shot through an opening that shrouds the left and right of the screen in complete blackness, seem very different to the rest of the piece, yet they do not signal any kind of apogee or point of arrival, they do not express a concluding logic and, as if to prove that point, we then return to two more images of women's bodies then back to wild flowers and tulips. In robbing us of the possibility of performing a secondary synthesis on these various images and producing out of them a *meaning* – whether via a direct indexical relation or an associative logic that would be effected between them, as in intellectual montage – Grandrieux overturns the privilege of human perspective and strips this vision of reality of its social overcoding. We might even go so far as to say that, just as many of his images in *Met* flatten perspective and thereby effect a different form of relation between the separate elements of the image as figural forces create zones of indiscernibility between figure and ground, so the work itself in its relation to us effects a kind of flat ontology, places us in a relation of equivalence with the image, stripping us of any privilege that would make of us the necessary conduit – as critic, interpreter or analyst – through which the work of the work would need to pass and be augmented by some act of synthesis in order to become operational.

To make this claim is to argue, in effect, that what is privileged here is vision rather than visuality when 'vision suggests sight as a

physical operation, and visuality sight as a social fact' (Foster 1988, ix). This distinction is made, however, by Hal Foster in the preface to a volume arising out of a symposium intended to problematize and complicate this neat division. As Foster continues:

> [Vision and visuality] are not opposed as nature to culture: vision is social and historical too, and visuality involves the body and the psyche. Yet neither are they identical: here, the difference between the terms signals a difference within the visual – between the mechanism of sight and its historical techniques, between the datum of vision and its discursive determinations – a difference, many differences, among how we see, how we are able, allowed, or made to see, and how we see this seeing or the unseen therein. With its own rhetoric and representations, each scopic regime seeks to close out these differences: to make of its many social visualities one essential vision, or to order them in a natural hierarchy of sight. (ix)

While I do not fundamentally disagree with anything that is said here, I nonetheless want to claim (and this no matter how impossible it may be in an absolute sense given Foster's contention) that in attempting to figure and generate in the spectator a pure look, Grandrieux *does* wish to de-socialize the gaze, to return to a form of vision that is not clouded by the kinds of social and discursive formations that would lead us towards visuality. This is not to claim that, as per the end of the quotation from Foster above, Grandrieux wishes to propose his 'nouvelle vision' (to borrow the title of Brenez's edited collection on *La Vie nouvelle*) as *the* essential and definitive vision that would be somehow more true than any other, to propose it as somehow closer to a more 'natural' way of seeing. But it is to suggest that if one is dissatisfied with those modes of seeing or apprehending the world – and the corresponding modes of artistic apprehension allied to such scopic and hermeneutic regimes – that have been so thoroughly socialized as to appear 'natural', then a radical gesture is required that might reinvest our vision of the world with something of the immediacy of desire that is lost in the overdetermination of the real that takes place in each successive scopic regime that strives to essentialize itself and turn visuality into vision.

A wonderful analysis of precisely what is lost when the real is overdetermined in this way is proposed by Martin Jay in this same volume. In a text that seeks to exemplify the ways in which the modern era has been characterized by a number of different, competing scopic regimes, Jay writes of what is arguably the dominant scopic regime of the modern era, namely Cartesian perspectivalism:

> A number of implications followed from the adoption of this visual order. The abstract coldness of the perspectival gaze meant the withdrawal of the painter's emotional entanglement with the objects depicted in geometricalized space. The participatory involvement of more absorptive visual modes was diminished if not entirely suppressed, as the gap between spectator and spectacle widened. The moment of erotic projection in vision – what St. Augustine had anxiously condemned as 'ocular desire' – was lost as the bodies of the painter and viewer were forgotten in the name of an allegedly disincarnated, absolute eye. (Jay 1988, 8)

If we find in Grandrieux a rejection of this Cartesian perspectivalism in favour of a flattening of three-dimensional space that serves a levelling function through the abuse of the 'proper' techniques for manipulation of light and focal planes for optimal 'realistic' effect, everything within and beyond the frame being placed in a relation of ontological equivalence that rejects the implied hierarchy of perspective with its unitary point of view, it cannot be said that this 'de-eroticizing of the visual order' is accompanied in his work by the kind of 'de-narrativization or de-textualization' that Jay identifies in the latter part of the fifteenth century. For Jay, at this time, 'as abstract, quantitatively conceptualized space became more interesting to the artist than the qualitatively differentiated subjects painted with it, the rendering of the scene became an end in itself' (8). While I have argued herein that we also find in Grandrieux a radical de-narrativization and de-contextualization, far from accompanying the rise of a scientific world view signalled by perspectivalism, for Grandrieux the rejection of such a neatly ordered rendering of the real goes hand in hand with a reinscription of the image in the realm of desire since the dominant social narratives that govern relations between subjects are no less pernicious than the de-eroticization effected by the overdetermination of space by perspective.

Grenoble (2006)

This, indeed, is precisely what seems to be suggested by the second
installation piece created by Grandrieux at this time, *Grenoble* – or,
to be more precise, by one of this piece's screens. *Grenoble* consists
of two screens placed perpendicular to each other and meeting at
one end, forming a corner. Onto each of these screens is projected a
different short video piece, one lasting 38½ minutes and the other
17 minutes. In the longer of the two, we see a number of interior
scenes in which people, generally one man and one woman, are
engaged in an awkward choreography with each other, unsure of
how to approach, seeming to want to touch the other yet somehow
unwilling or unable to do so. These figures are most often seen
clothed at first, then undressing themselves or each other for what
can only be described as a sexual act given their state of undress,
yet an act which does not seem to be governed by the kinds of
actions or reactions that would generally be considered erotic. We
remain at all times unsure of the relationship between the figures
on screen at any one time, always entering into each scene *in media
res* and with nothing that might serve to provide us with some
understanding of the psychology in play or scenario in train. Nor
are any of these various scenes, often verging on tableaux, allowed
to develop internally such that they would begin to generate their
own context or to provide any semblance of progression towards
a point of narrative climax that could then be mapped back onto
what has come before so as to make sense of what we see. Instead,
each scene is cut as abruptly as it starts, any relation between
the scenes being fractured by the interpolation of shots of water,
clouds and mountains, images that are produced out of a complex
interplay of shadow and light that draws these elements into a
choreography that blurs and doubles the contour lines of their
borders, sending them into a state of flux as the forces generated
by differential relations create a movement out of which the image
is created. If there is any relation to be found between these two
types of image, it would seem only to be one of extreme contrast,
for the majesty of the interplay of form and light in the spacing
shots is matched only by the awkwardness of the choreography
between human forms that attempt to move together, to find the
position that would enable them to go beyond the bounds of their
own closed self and attain the ecstasy afforded by the transcendence

of one's own fixed form. At one point the inability to achieve this communion brings one male figure to breaking point as he turns away from the woman huddled behind him and screams, his entire body wracked (like Seymour's at the end of *La Vie nouvelle*) by a physical exertion that seems like an attempt to convert his entire being into sound and to empty that being out through his mouth so as to leave behind the bounded vessel that is the cause of his anguish. And then, without warning, he is joined by the other two men we have seen in other scenes, scenes we imagined to be taking place at different times and perhaps a different place, their appearance alongside each other here casting into doubt anything we think we may have understood up until this point, melding together time and space as their individual forms seem to merge into a single, undifferentiated mass, their dark backlit forms advancing towards the camera, blocking out all light. We cut to a reverse shot of a naked female form backlit by the light coming through a window towards which she retreats, seeming to back away from these male figures and then, just as a narrative threatens to develop, we cut away to sky, clouds and mountains, then back to another scene of attempted touch between two solitary figures clearly delineated from each other in the harsh light of the day and the sharp focus of the image. This time, however, it seems as though contact is made for a brief moment. The man lifts the woman's leg in the air, exposing her vulva. He stares down between her legs, hovering above her and seeming somehow entirely unmoved and irrevocably separated from her in spite of the intimacy of the situation. His hand moves upwards towards her crotch without making contact with her and then, more tentatively than gently, finally touches her sex. And yet, even once this contact has been made the camera shot, from behind his shoulder, seems to place these two figures in a different space from each other, the man's proximity to the camera throwing out all sense of scale and perspective and casting each of them into separates planes of the image that do not seem to relate to each other. The woman, indeed, seems lost in her own world and we cut to a shot of her head, turned to the side with her eyes shut, as she starts to moan and build towards a climax as, we suppose, the man brings her to orgasm. We cut back to a shot of him staring down at her, his face displaying not the slightest hint of emotion or indication that this act has forged a meaningful bond between them. We cut to water, clouds, mountains, then back to an extreme

close-up on the man's face lying on the bed where the woman had been. He stares into the middle distance and a tear rolls from his eye as he starts to sob uncontrollably. We cut to a shot composed of zones of blues and greys that melt into each other, the distinction between the different forms of the landscape out of which the image is carved marked only by chromatic contrast. This shot translates the man's stare into middle distance to the perspective of the camera, but rather than being indicative of a failure to connect as it is for the man who seeks some kind of externally sanctioned connection, to live the fantasy, the lack of specific focus here is that which creates harmonic relations between the elements of the image, it is the expression of a pure look that is not goal-oriented but, rather, merely an accompaniment, a mode of being in which each element is produced out of the relation between the immanent conditions of the situation. It is according to this mode of being that the final shots of this piece are constructed as we see clouds whose line follows that of the mountains among which they nestle, creating a zone of indiscernibility between the very elements as vapour and rock become common attributes of the substance of this purely optical space.

If the longer of the two pieces that together constitute the installation piece *Grenoble* thus appears to show us socialized man's need to filter desire through a set of preformed axiomatics that dictate how desire should be expressed and leave him frustrated or even catatonic when unable to fulfil his desire through the resulting maladroit choreography, which is to say his inability to achieve a true communion, to exist in the world in anything but an entirely atomized state far removed from the ecological condition of the world surrounding him, the shorter of the two pieces provides us a very different possibility from the outset. This piece begins with a shot that is more erotic than anything found in its companion piece as we see a hand approach a translucent white gob of sticky sap oozing out of a crack in a tree trunk. The hand pinches off a sample of this sticky discharge and rubs it between its fingers, savouring the sensation before seeking new ones as these now glistening fingers are drawn up to a face to be sniffed and then, inquisitively, licked, hesitatingly at first, then tenderly and increasingly eagerly as licking turns to sucking. We cut to a shot of the same hand, now resting by the side of its owner, trembling. We cut to a succession of long takes of tableaux in which we see a human figure or detail thereof in a

natural setting. In each case an element of the shot cuts through the distance that would separate figure from ground and casts every element of the image into the same plane: a man standing in a forest merges with the branches high above him in the backlight of the shot; a woman joyously stumbling across uneven terrain, her eyes closed, is filmed by a camera whose movements are just as erratic as hers; an arm extended across the screen follows the geometry of a branch on the forest floor; a hand held high among the leaves and berries of a tree moves as though blown about by the same breeze that makes them wave from side to side; an extreme close-up of the rear of a woman's head and the backdrop of a mountain in the distance are shot using a focal plane situated in the middle distance between them, collapsing perspective and drawing all elements of the shot into the surface plane of the image; a male figure is camouflaged by the chromatic coincidence of the colour of his shirt and the grassy hillock before him and the strict alignment of the dark hair on his head and the shadow cast across the upper portion of this landscape; the movements of individual strands of hair and blades of grass are choreographed by the same gentle breeze... . These tableaux of individuals opened out to their environment then give way to a shot of a group of individuals lying on a grassy hilltop. Here also a certain indiscernibility is created between these individuals and their environment by the use not of a blurred image but, rather, a sharp image with great depth of field that also pulls the distances figured in the image into a single coterminous sphere. This indiscernibility that is deployed vertically across the image, however, is here doubled by an indiscernibility that moves horizontally across the image, between the individuals lying side by side and whose limbs are so enmeshed as to make it nigh impossible to know where one body starts and the other one ends. In contrast to the individuals in the longer piece of *Grenoble* who exist separated off from nature and from each other, these individuals seem to have achieved a genuine mode of being in the world that moves in sync with the rhythms of that which lies beyond and around them, to live life as an accompaniment, as an active principle of adaptation that arises always from within, from immanent contact with the outside (that through this contact is no longer truly an outside) and this same principle extends to the intersubjective relations between them. Here we are witness to the possibility of communion, a different form of desire far removed from the ventriloquized blueprint of a

simulacrum of desire found on *Grenoble*'s other screen, a desire born of direct contact between individuals and that exists only in that contact. And so it is that this piece ends with shots of these individuals licking and nuzzling each other, kissing as though for the first time, like someone who does not know how to kiss, yet instinctively seeks out new sensation and the pleasure that comes from truly being with someone for the first time.

L'Arrière-saison [*Indian Summer*] (2005)

The third installation piece made by Grandrieux at this time takes its title from the French title of the nineteenth-century *Bildungsroman* by Austrian author Adalbert Stifter, *Der Nachsommer* (1857) (translated into English as *Indian Summer*). The first-person narrative of the novel recounts the life of Heinrich, the main character, who has been brought up in a very strict household and is, as a result, thoroughly socialized. As he approaches manhood, Heinrich is given the freedom to make choices about his own future and he decides to become a natural scientist, spending long hours hiking through the Alpine landscapes around him and observing the nature he finds there. As he does so, there is a noticeable shift in Heinrich who seems, at privileged moments, to open himself up to the world, to exist alongside nature rather than attempt always to analyse and understand it. During one of his outings, Heinrich stumbles across an isolated house as he seeks shelter from a storm. The owner, the mysterious and enigmatic Baron von Risach, offers him refuge in the house which comes to be known as the Rosenhaus since one side of it is entirely covered with roses and many different kinds of roses are found throughout its grounds – an image that seems to have had a great impact on Grandrieux since the script that he wrote for an (to date unfilmed) adaptation of Conrad's *Heart of Darkness* begins with a description of a rose-covered wall that resembles something from Stifter's novel far more than anything we might find in Conrad's (see Grandrieux 2012). Von Risach becomes a mentor to Heinrich, his particular vision of the world becoming very influential in all of the young man's decisions henceforth.

Even though Grandrieux's *L'Arrière-saison* takes its title from Stifter's book, there is no real way in which this installation piece

could be said to be an 'adaptation' of the book, even in the broadest possible sense of this term. Rather, we might think of Stifter's work as more of an inspiration for Grandrieux's video installation, related to it only in terms of the sensibility they both share up to a point and the recurrent trope of roses. Grandrieux's *L'Arrière-saison*, indeed, consists solely of two 10-minute slow-motion single take shots of roses, shot from a constantly mobile perspective and in the changing light of the later afternoon sun of the season of the work's title. In claiming that there is in this work an affinity with the sensibility found in Stifter's novel, my suggestion is that these shots in and of themselves are able to express a very different mode of relation to and being in the world, one that is in certain respects consonant with the philosophy expounded in *Der Nachsommer* and that, what is more, finds its most complete expression in the commentary that von Risach provides on the roses that adorn his house and its grounds.

During Heinrich's first visit to von Risach's property, their conversation turns to the weather or, to be more precise, von Risach's ability to forecast the weather with an extraordinary degree of precision. This he is able to do, he tells Heinrich, because of a specific set of instruments he has at his disposal, namely nerves – not his nerves, however, but those of the animals all around. Man's nerves, he explains to Heinrich, have been attenuated and desensitized by too great an influx of stimuli, unlike animals who retain the ability to sense in advance through their nerves when a particular constellation of conditions will lead to a specific kind of meteorological event. While not able to enjoy this kind of direct communion with the natural world, man is nonetheless imbued with something that is, according to von Risach, far superior to this, namely understanding and reason, traits that allow him to analyse the world around him, to understand the patterns and meanings of certain animal behaviours and to draw conclusions from this that enable him to be in tune with the natural environment to an even greater extent than animals (Stifter 2000, 97). This very same attitude is what enables von Risach to grow such perfect specimens of many different varieties of rose even in conditions that would not generally be conducive to their healthy cultivation. Over a long period of time and attentiveness to their every sign of health or sickness, and by assuming that what roses needed for optimal nourishment would necessarily come from roses – an assumption

that led him to return all of his rose cuttings to the earth in which his roses grew – von Risach explains that he was able to grow roses superior to those that would grow unaided by human hand, to improve on nature if you will (114–17). While today such a phrase smacks of genetic engineering, von Risach's method is far more basic since this improvement comes simply by providing and nurturing the optimal conditions for the rose to flourish – and von Risach goes on to explain how this involves the cultivation of an entire ecosystem including the establishment of the optimal conditions to attract and preserve large numbers of song birds to eat the pests that would otherwise destroy his roses and crops. To put this another way, von Risach's entire modus operandi consists of an extreme, slow attention to the rose itself and to what the rose tells him about itself, to what it expresses by simply being in its environment. To use a term common to us now, we might say that von Risach merely accompanies the rose, remains with it in order that it may express itself. And it is in this way that we can think of Stifter's text as the inspiration for Grandrieux's work which is, in effect, nothing other than a slow, focused attention on the rose as an expressive object.

To think of the rose in this way is to see it very differently from how it is generally figured, for the rose – in Western culture at least – is perhaps the most overcoded of all flowers, the very archetype of a symbol that is considered to express many things but rarely if ever anything that would have to do with the rose itself. That Grandrieux did not want to apprehend the rose in this manner, to integrate it within a preformed narrative structure is, of course, entirely unsurprising given everything that we have said about his method up until now, and just as many of his previous works were created out of an active process derived from interactions with his interlocutors, actors, editors and sound collaborators, so here, by his own account, *L'Arrière-saison* resulted from an encounter with roses in which the site and the roses themselves played an active part. As Grandrieux explains in his interviews with Gobille:

> I started off trying to film in the Jardin des Plantes, but I didn't know, there was too much, probably too much presence all around me perhaps, too much … too much life all around. In Bagatelle you only have these planes passing overhead and the beautiful sound you hear in the film of these planes taking off,

the sound you hear in the background comes mainly from those planes passing overhead and that come from Roissy. And the light, the axis of the light was very interesting because from four o'clock in the afternoon in October the sun falls across the axis of the roses. So I would go there about two or three in the afternoon and I'd wait for an hour, an hour and a half for the sun to be on this axis, and at that point I would look for the rose, the one that would capture me, because it had to capture me, it wasn't me who decided, in a way, the roses need to capture me. Of course it was me, but not only me: it had to capture me. So my gaze floated as can listening, a look floating over the roses, and then suddenly there would be a rose that was *there*, which invited me from deep within. So I'd set myself in front of the rose and start to shoot. In fact, all the roses were done like that, one rose each day. (8 December)

The attitude towards the world and the roses before him described by Grandrieux here resonates strongly with the attitude of von Risach. This attitude might also, however, be likened to the openness to the world required in order to attain what Henri Bergson would term an *intellectual sympathy*, the operation by which, as Bergson writes, 'one places oneself within an object in order to coincide with what is unique in it and consequently inexpressible' (1912, 7). For Bergson, this intellectual sympathy or intuition as to the nature of Being is opposed to analysis, 'the operation which reduces the object to elements already known, that is, to elements common both to it and other objects' (7). For Bergson, metaphysics must by necessity proceed from intuition since it is only in this way that it is able to attain the absolute, the goal of the metaphysician, since analysis, 'in its eternally unsatisfied desire to embrace the object around which it is compelled to turn ... multiplies without end the number of its points of view in order to complete its always incomplete representation, and ceaselessly varies its symbols that it may perfect the always imperfect translation' (8). Such a stance towards '*a reality that is external and yet given immediately to the mind*' (65) – which is for Bergson a given – can only fail adequately to capture the essence of that reality since it proceeds by dividing reality into separate entities, objects, things, frozen moments in time that can be apprehended and analysed as a whole, which is to say according to principles and concepts that are anathema to the very

nature of reality. As he explains: 'This reality is mobility. Not *things* made, but things in the making, not self-maintaining states, but only changing *states* exist. ... *All reality, therefore, is tendency, if we agree to mean by tendency an incipient change of direction*' (65). To engage with reality in this way, however, is contrary to our normal mode of being in the world since, as Bergson continues,

> Our mind, which seeks for solid points of support, has for its main function in the ordinary course of life that of representing *states* and *things* ..., it substitutes for the continuous the discontinuous, for motion stability, for tendency in process of change fixed points marking a direction of shape and tendency. (65–6)

If our mind does this, this is because, for him, 'This substitution is necessary to common sense, to language, to practical life' (66), and this long habituation occasioned by the practical exigencies of our lives makes it extremely hard for our intelligence to 'follow the opposite method ..., place itself within the mobile reality, and adopt its ceaselessly changing direction; in short ... grasp it by means of that *intellectual sympathy* which we call intuition' (69). Though 'extremely difficult', to do precisely this is nonetheless possible, according to Bergson, but only via extreme means that accord entirely with what we have said of Grandrieux's approach. In order to do this, to depart from its habituated modes of engagement with the world and apprehend reality from within rather than from without, to allow it to express itself according to its own internal forces rather than demand that it conform to the exigencies of a pre-established set of axiomatics that would precede any possible act of cognition, the mind, Bergson states, 'has to do violence to itself, has to reverse the direction of the operation by which it habitually thinks, has perpetually to revise, or rather to recast, all its categories' (69).

The idea of a violence of thought necessary to break through the accreted layers of habituation and thereby access a vision of the world which is not only new but incessantly new, only ever produced from within, seems to correspond to all that we have said of Grandrieux's approach up to this point. A note of caution needs to be sounded, however, for if a vision of this kind is what we find in the second 'nature' piece of *Grenoble*, the natural world that we encounter here is not one that would pre-exist the human

subjects moving through it but, on the contrary, a reality in which there are only zones of indiscernibility between that reality and the subjects moving through it. Rather than constituting a point of difference between Bergson and Grandrieux, what this points us to is perhaps rather a flaw in Bergson's theory of intuition via which we are able to fall into intellectual sympathy with a pre-existing reality in spite of the fact that his entire philosophical premise is founded upon the necessity of apprehending reality from within and not, therefore, reconstituting the phenomena that we encounter as pre-existing entities imbued with a certain stability. This is indeed the fundamental problem of Bergson's system for Merleau-Ponty – once the latter has moved beyond the foundational work in phenomenology for which he is best known and in which the idea of a necessary phenomenological reduction intended to regress to the immediacy of things by bracketing out the outside world rests upon the kind of interpolation of a pre-existing reality that Merleau-Ponty would take Bergson to task for in his later works. Reacting against Bergson's philosophy of intuition intended to access the immediate presence of existence, Merleau-Ponty writes:

Coming after the world, after nature, after life, after thought, and finding them constituted before it, philosophy indeed questions itself concerning its own relationship with it. It is a return upon itself and upon all things but not a return to an immediate – which recedes in the measure that philosophy wishes to approach it and fuse into it. The immediate is at the horizon and must be thought as such; it is only by remaining at a distance that it remains itself. There is an experience of the visible thing as pre-existing my vision, but this experience is not a fusion, a coincidence: because my eyes which see, my hands which touch, can also be seen and touched, because, therefore, in this sense they see and touch the visible, the tangible, from within, because our flesh lines and even envelops all the visible and tangible things with which nevertheless it is surrounded, the world and I are within one another, and there is no anteriority of the *percipere* to the *percipi*, there is simultaneity or even retardation. ... When I find again the actual world such as it is, under my hands, under my eyes, up against my body, I find much more than an object: a Being of which my vision is a part, a visibility older than my operations or my acts. But this does not mean there was a fusion or coinciding of me with it: on

the contrary, this occurs because a sort of dehiscence opens my body in two, and because between my body looked at and my body looking, my body touched and my body touching, there is overlapping or encroachment, so that we must say that the things pass into us as well as we into the things. (1968, 123–4)

The name that Merleau-Ponty gives to this relation of overlapping or encroachment between the sentient and the sensible and, indeed, between any dichotomy whatsoever, is chiasm, a form of relation that substitutes the dichotomy for a dialectic. He writes:

> Dialectical thought is that which admits reciprocal actions or interactions – which admits therefore that the total relation between a term *A* and a term *B* cannot be expressed in one sole proposition, that that relation covers over several others which cannot be superimposed, which are even opposed, which define so many points of view logically incompossible and yet really united within it – even more that each of these relations leads to its opposite or to its own reversal, and does so by its own movement. (89)

In saying this, Merleau-Ponty is in large part mounting a critique of those philosophers – and in particular Sartre – who posit an essential schism at the heart of existence between being and nothingness. In the same move, however, he begins to formulate a solution to the problem he finds in Bergson – to reiterate, the latter's recourse to a primordial, pre-reflective Being as the ground which is given immediately to the mind and with which we must strive to attain intellectual sympathy. The solution he finds extends the logic of Bergson's appeal to a philosophy generated from within the flow of existence. Merleau-Ponty writes:

> Between the thought or fixation of essences, which is the aerial view, and life, which is inherence in the world or vision, a divergence reappears, which forbids the thought to project itself in advance in the experience and invites it to recommence the description from closer up. For a philosophy conscious of itself as a cognition, as a second fixation of a pre-existing experience, the formula *being is, nothingness is not* is an idealization, an approximation of the total situation, which involves, beyond *what* we say, the mute experience from which we draw what we

THE TURN TO NATURE

say. And just as we are invited to rediscover behind the vision, as immediate presence to being, the flesh of being and the flesh of the seer, so also must we rediscover the common milieu where being and nothingness are only λέκτα labouring against each other. Our point of departure shall not be *being is, nothingness is not* nor even *there is only being* – which are formulas of a totalizing thought, a high-altitude thought – but: there is being, there is a world, there is *something*; ... One does not arouse being from nothingness, *ex nihilo*; one starts with an ontological relief where one can never say that the ground be nothing. What is primary is not the full and positive being upon a ground of nothingness; it is a field of appearances. (1968, 87–8)

In erasing the division between being and nothingness, between the perceiving subject and the world perceived and positing between them an irrevocable and necessarily dialectical relation that imbricates one in the other without ever allowing the possibility of one being subsumed under the other, of a synthesis being produced, obviating the possibility of any totalizing thought, Merleau-Ponty goes a step further than Bergson in arriving at a vision of the world produced from within and that necessarily remains always in motion, only ever formed out of the relations taking place between the incompossible forces, events and beings that constitute Being. This is what he terms the flesh of the world, a term that may appear to perform the kind of reification that his philosophy here is intended to avoid, yet which does not because in and of itself it remains invisible. The flesh of the world, indeed, describes the imbrication of the flesh of being and the flesh of the seer, it is what is produced in the chiasmic relation at the intersection of two axes that remain irrevocably separate from each other yet produce Being itself out of the relations between them. As a relation, however, this point is not visible in and of itself, is not fixed in space or time; it is, rather, merely the fulcrum around which these axes turn and produce Being, the visible, inherence in the world, vision.

It is precisely such a vision of nature that we are presented with in *L'Arrière-saison*, an image (a term not beloved of Merleau-Ponty) of a world that exists only as the expression of dialectical relations between elements, between the body of the film-maker and the body of the rose, between the axis of light and time and the axis of light and the roses, between light and shadow, light and the

camera, between, this is to say, every conceivable element involved
in the creation of this image which is constantly mobile, moving, not
because it is directed towards any particular end or goal but simply
because its Being, its flesh, is only produced out of movement and
only exists in movement, never settling into a stable identity that
would correspond to a fully knowable thing in the world. Given
this claim, it is interesting to note that in the working notes for *The
Visible and the Invisible*, Merleau-Ponty also seizes upon the rose
as the object through which to think through this new conception
of nature. In an entry dated February 1959 he writes:

> Discovery of the (verbal) *Wesen*: first expression of the being
> that is neither being-object nor being-subject, neither essence
> nor existence: what *West* (the being-rose of the rose, the being-
> society of the society, the being-history of history) answers to
> the question *was* as well as the question *dass*; it is not society,
> the rose seen by a subject, it is not a being for itself of society
> and of the rose (contrary to what Ruyer says): it is the roseness
> extending itself throughout the rose, it is what Bergson rather
> badly called the 'images' – That in addition this roseness gives
> rise to a 'general idea', that is, that there be several roses, a
> *species* rose, this is not insignificant, but results from the being-
> rose considered in all its implications (natural generativity) –
> In this way – striking all generality from the first definition of
> the *Wesen* – one suppresses that opposition of the fact and the
> essence which falsifies everything – (1968, 174)

Unpacking this dense and somewhat evocative passage in the
context of the work as a whole, Alphonso Lingis explains in his
translator's preface:

> The sensible thing is not in space, but, like a direction, is at work
> across space, presides over a system of oppositional relationships.
> It is not inserted in a pre-existing locus of space; it organizes a
> space of fields and planes around itself. Likewise its presence
> presents a certain contracted trajectory of time. It is for this that
> it occupies our vision, that it is not transparent like a sign that
> effaces before the signified. ...
> The unity of the thing is not that of a contingent cluster of
> particles, nor that of the ideal foreign to spatial and temporal
> dispersion; its unity is that of 'a certain style, a certain manner

of managing the domain of space and time over which it has competency, of pronouncing, of articulating that domain, of radiating about a wholly virtual centre – in short a manner of being, in the active sense, a certain *Wesen*, in the sense that, says Heidegger, this word has when it is used as a verb'.
...
And the things come into presence, come to command a field of presence, by their style. They hold together like the body holds together. Their unity is neither the unity of pure assemblage nor the unity of a law; it is produced and reproduced as the 'bringing of a style of being wherever there is a fragment of being'. The style is that interior animation of the color, that interior rhythm that assembles the forms and shadows of the rose, that organized fluctuation that makes the thing arise as a relief upon a depth of being. The thing is borne into presence by a scheme of contrasts that commands a constellation, that modulates a trajectory of time, and that makes it leave its place to come reverberate in the receptive sensitive flesh that perceives it. (Lingis 1968, xlviii–xlix)

If there is indeed sympathy between this idea of nature as it plays out in Merleau-Ponty and *L'Arrière-saison*, this adds further weight to our contention that we need to conceive of bodies in Grandrieux's films and the body of the cinema itself in sonic rather than haptic terms, for even though the term Merleau-Ponty himself uses is 'flesh', the way in which it is conceptualized has in many respects little to do with the fleshy materiality and opacity of matter and far more to do with reverberation, modulation, resonance and harmony – as we see from the quotations above. It is then remarkable that a consideration of the rose should figure in the deployment of this idea in both Merleau-Ponty and Grandrieux's works, yet somehow entirely unsurprising, for the rose is surely one of the most overcoded of nature's objects in terms of its symbolic investments and, arguably, one of the most familiar and most represented of all of nature's forms and it thus presents as the ideal candidate for a philosophy or artistic expression that would wish us to reconsider entirely the fundamental nature of being and our relation to it – and this should be sufficient to indicate that I am by no means inferring direct intertextuality here. It is for this reason, no doubt, that *L'Arrière-saison*'s roses look, for the most part, nothing like roses at all. Let me explain.

Despite appearances to the contrary

L'Arrière-saison opens with a shot in which an imposing, dark presence seems to loom above us, a backlit form that seems almost insect-like set against a web of silhouetted branches high above that seem both somehow proximate to the closer form in terms of the species we are dealing with yet inescapably other at the same time. A slight pan of the camera presented in extreme slow motion – that is maintained for the duration of these films – makes the image stutter, gradually recalibrating the relation between the dark shadows at different points of remove above us. We pan towards a break in the clouds at the top left of the screen through which the diffuse glow of the sun struggles to break through, able to cast enough light out on to the edges of the form hanging above us now to imbue it with the slightest hint of colour, a colour produced not as a quality within this form itself but only out of the differential relation of light falling across (in the sense of both on top of and through) its surfaces, from the tension between the backlight and frontlight, reflectivity and transparency. The form whose colour seems to escape us then seems to transmogrify, imperceptibly, into something stranger still, not so much insect-like as cnidarian or simply alien, with tendrils hanging down from what may or may not be something recognizable as a body. The camera movement displaces this body within the frame before it moves out of frame to be replaced by black insectoid limbs as the locus of movement becomes indiscernible and we are no longer sure whether it is the camera that is moving, the entity it films or both. Either way, these limbs gradually align with the backlit branches of the tree high above and a kinship is created between them such that these limbs become stems, vegetal rather than animal. We slowly pan up the length of this stem, the movement displacing the tree branches high above from the frame, clearing a light slate blue space into which emerges a dusky pink form, heavy yet fragile, thrusting upwards yet crumpling at the edges, a dynamism that creates a series of folds and curls across the origami planes of its membrane. It is only once it fills the screen entirely that we can tie this object to its indexical referent in the world and recognize a rose, shot in profile and from slightly below (see Figure 11). Far from an image of a symbol of eternal love, this rose is indelibly inscribed in time and subject to its forces, at the very point where its structural integrity begins to wane

FIGURE 11 *Screenshot from* L'Arrière-saison. *Courtesy Philippe Grandrieux.*

yet still resists the slow entropic forces of age, gravity and decay that pull its every fibre back towards the ground from which it sprang. A movement takes place that hides the remaining branches of the tree high above behind these wilting petals, a movement that seems like it must be produced by the camera panning around the rose and yet the aspect in which it is captured does not seem to change at all, its position in the frame being held as though it were itself moving and pulling the camera with it. What does change in this movement is the hue of the rose that shifts imperceptibly as its position relative to the sun is altered until a magenta light flare created by the effect of light hitting the lens directly erupts into the image, seeming to make the rose glow from within. The camera waivers and rocks from side to side, intensifying these solar flares, making them dance around and above the rose until they coalesce into rays of brilliant white light fringed with pink that cut contrasting slashes across the rose before intensifying further still, turning into a burst of white hot light that seems to consume the rose, making half of it disappear before our eyes. Ever mobile, the camera continues on a trajectory determined, it would appear, by this play of light,

and the rose, backlit once again, darkens as though charred, before the magenta flare glows from its core once again, resurrecting this burnt-out remnant, phoenix-like. The camera pans back towards the sun once more and a similar ballet is choreographed, the rays of light cutting through the rose yet seeming this time not to consume it but to shine out from its sacred heart. We move in closer to the rose, whether via a zoom or a travelling shot it is impossible to say since those coordinates that may have enabled us to understand the logic of this movement in relation to fixed points in space have passed out of frame and the rose, now filling more and more of the on-screen space, is contrasted starkly against a pure wash of pale blue grey. The rose waves from side to side, almost disappearing from sight and then appearing, when it takes up its place at the centre of the frame once again, closer still, to have changed once more, to have undergone a miraculous transubstantiation in which the petals' curls are made the folds of flesh. And so it is that this form, neither flower nor flesh yet somehow both at the same time, sways in the space before us, before finally falling away.

The second piece of *L'Arrière-saison* is a variation on the same theme, a work produced out of the interplay of light, movement, colour, scale and image capture technology. We find here the same kind of incommensurability, the same inability at times to attribute a particular movement or shift in tonality to any particular variant, to any source. This is perhaps never more the case than in the opening shot of the second piece in which we see clouds slowly floating by above our heads, an illusion that is broken as soon as some treetops enter into the bottom of the frame and we realize that this motion belongs to the camera, to our viewing perspective rather than to the clouds. The uncanniness of the effect created here, however, opens a breach in which we are perhaps able to glimpse something of the necessarily relational aspect of all Being from the inside, a moment in which we understand, via a strange intuition, that when we lie on our back and stare up to the sky, the apparent movement of the clouds is as much the product of our displacement in cosmic space – attached as we are to a rock turning in space – as it is the result of thermal fronts, barometric pressure and wind patterns within our own planet's atmosphere. As we pan down further still another rose enters into this frame and the indiscernibility of motion on this cosmic scale is repeated on what is, relatively speaking, a microscopic scale as the fleshy pink

folds of the rose seem to float in space, the dark stem that supports it camouflaged against the backdrop of silhouetted treetops above and the certainty of perspective obscured by the discrepancy of scale between these elements that share the screen space before us.

While it would be tempting to give a blow-by-blow account of this second movement of *L'Arrière-saison*, to do so is perhaps superfluous since all that matters, ultimately, is that here also we encounter again and again an indiscernibility between elements of the shot, between moves and transitions effected in the very materiality of the image by the changing conditions in which the image is produced out of the mobile relations between the constituent components of the shot's form and content. This is entirely consistent with the vision of reality described by Merleau-Ponty examined above, for we have also here a figuration of the real that is produced only out of the relation between incommensurable elements, an 'interior animation' to use a term seen before. In light of this, and in spite of my stated intention not to describe every shot in detail, it is nonetheless worth noting that there are, in this second movement of *L'Arrière-saison*, a number of shots in which the relation between incommensurable elements is on full display. Indeed, here there are repeated shots of – or, rather, since these films are shot in a single take, repeated returns to – the rose picked out in sharp relief against the blue sky and clouds of the opening, shots in which each of these elements, one in extreme close-up, the other at infinity, is held in focus.

Far from producing the kind of reality effect favoured by Bazin, the deep focus here creates an unreality effect, the rose appearing almost like a digital cut-out or, conversely, the sky and clouds like a surrogate background dropped in behind the rose via chroma key compositing. This unreality effect might better be described, however, as a denaturing effect, for what is figured here is the kind of chiasmic relation described by Merleau-Ponty. For Merleau-Ponty, as we have seen, the chiasm serves as the figure that enables him to describe the way in which diametrically opposed terms are held in a dialectical relation with each other such that there is a zone of indiscernibility at the point at which the body touching itself becomes the body touched and the subject perceiving the world becomes the world perceived. It is a figure of this kind that is posited here, a chiasm in which elements that seem somehow to hold themselves apart from each other enter into a relational contract

with each other out of which a movement is created that is nothing other than the expression of Being from within. Even though it is at the point of intersection of these disparate elements that the visible is born, that being is contracted into actuality from the realm of virtuality, this point in and of itself remains invisible, merely the fulcrum, axis of rotation or virtual centre around which those negotiations take place. This point of intersection is then in no way punctual, it is not really even an intersection, a point of meeting, but only the gap between incommensurable terms, both of which are necessarily implicated in the contraction of Being into actuality that is produced out of the relation between them.

What we are witness to here might then be likened to a kaleidoscope, for it is via the relations between discrete objects within a scopic environment that a moving image is produced at the point of intersection where different refractions of reality meet. And while the objects between which these relations are instigated are not the glass beads or pebbles of the toy kaleidoscopes to which we are accustomed but, rather, objects in the world with their own discrete identity, the image produced is no less surprising. Indeed, true to the etymology of the word, we might suggest that what we are presented with in *L'Arrière-saison* is nothing other than a beauty (*kalos*) or that which is seen (*eidos*) and that is given to us to examine (*skopcō*); to examine, however, with a pure look stripped of any intention or prior knowledge, a gaze both pure in relation to its fixation only on light and form yet impure insofar as it is in its very existence proof of the mutual imbrication of the gaze and that upon which it falls.

8

Un lac [*A Lake*] (2008)

Grandrieux's approach towards his art has been, from the very outset, both singular yet influenced by a great number of texts, collaborations and external forces that have had a profound impact on his work. *Un lac* signalled a slightly different approach towards the use of such intertexts, however, insofar as it is the first time that we can discern a clear relationship to the narrative trajectory of a pre-existing text written by someone other than Grandrieux himself – and in saying this I am of course presuming that the use of Paulhan's text in *La Peinture cubiste* should be considered slightly differently. Even here, however, things are not quite so simple because, firstly, there are at least two intertexts of great importance to the genesis of *Un lac* and, secondly, because these intertexts do not provide a blueprint as much as some guiding ideas and principles that inform the writing of an original screenplay that is then, once again, radically altered in the creation, filming and editing of the end product.[1] While it will be interesting to examine briefly the intertexts that guide certain elements of the final work, what will be more important in what follows is then an understanding of what happens to them in this process.

In an interview with Alyosha Saari for the website *Stardust and Memories* conducted during the 2009 Mostra de Venise, Grandrieux was asked where the idea for *Un lac* came from. He replied:

> You never really know where ideas come from, they're made out of a thousand things, but there was a desire to tell a story about a family, the whole question of the family, and in particular the relationship between a brother and sister. I like Georg Trakl a lot,

his poems, the extremely violent story that he lived with his sister. A crazy love story. And I had also read the novels of Tarjei Vesaas, the Norwegian author. So the inspirations are multiple but what you then do with them when you are making a film, you don't really know, it's quite strange. (Grandrieux and Saari 2009)

If Trakl can be considered important for an understanding of *Un lac*, as Grandrieux points out here this is because of his relationship with his sister. An early twentieth-century Austrian lyric poet, Trakl's relationship with his sister Grete was, however, far more troubled and extreme than that between *Un lac*'s Alexi and his sister Hege. Trakl and his sister, five years his younger, were by all accounts very similar, both highly sensitive and uninhibited, sharing a common 'feeling of being different from other people' and later a drug-taking habit facilitated by Trakl's profession as a pharmacist (Schneider 1998). Whether their relationship contravened the incest taboo or not seems less certain; what we know for sure is that Georg flew into a jealous rage when his sister began an affair with one of his best friends, and retreated into a cathartic writing frenzy when she later married a bookseller. The marriage was not a success, however, and did nothing to fundamentally change either the relationship between Grete and her brother or their drug-taking habits, leading some to speculate that Grete chose to terminate a pregnancy – a traumatic time during which George stood by her side – because the child was her brother's. Such speculation remains precisely that, however, since it appears that the family destroyed the brother and sister's correspondence and the arena in which Georg aired his feelings, namely his poetry, remained cloaked in the symbolic ambiguity proper to its Expressionist form – and much the same will later be said of Grandrieux's film. What we do know for certain is that Georg enlists as a medical officer at the start of the First World War, is deeply traumatized by what he sees there and is hospitalized, taking his own life shortly afterwards by overdosing on cocaine. Grete, meanwhile, sees her marriage break up, tries unsuccessfully to kick her drug habit and then, three years after her brother's death, takes her own life by shooting herself in the head.

While the screenplay that Grandrieux wrote for *Un lac* also contained high drama of this kind, Tarjei Vesaas' novel *The Birds* is in many respects much closer to the scenario that unfolds in the

final film, yet here also what we are dealing with is far from what might be called an adaptation in the true sense of that term – and it should be noted that the inscription to Grandrieux's screenplay in fact describes the film as a homage to Tarjei Vesaas. Vesaas's novel tells the story of Mattis, a young man with learning difficulties who lives with his sister Hege in an isolated house near a lake. Mattis, it quickly becomes apparent, struggles to fit in to the society around him, to understand the most basic of human interactions. Keen to not be such a burden on his sister, he attempts to earn his keep firstly by helping out on a farm and then, later, by becoming a ferryman, carrying passengers across the lake in a decrepit rowboat. If Mattis is not well adapted to the human world around him, however, he seems strangely attuned to the natural environment in which they live, finding great significance in the flight of a woodcock, another peculiar bird that appears on a path before him and a tree struck by lightning. This attitude towards the world around him smacks of an almost primordial innocence and naivety that will have disastrous consequences for him in key moments of the novel when he reveals the path of the woodcock to a young hunter and then later ferries a lumberjack across the lake and brings him home. This lumberjack, named Jurgen, will become Hege's lover and gradually draw her further and further away from her brother, teaching Mattis to fell wood in a kind of training programme designed to make him self-sufficient so that the young lovers will one day be able to leave him. Sensing that his sister is slipping away from him, Mattis orchestrates a test of her loyalty to him, sabotages his boat and rows it out into the middle of the lake one last time.

Even if there are some obvious and significant changes, and in spite of the fact that Grandrieux's film makes no mention of the birds that are so central to Vesaas' novel, the account given of *The Birds'* storyline here contains the essence of the extremely minimalist narrative of *Un lac*, the official synopsis of which, found in the *Dossier de presse*, reads as follows:

> The story takes place in a country about which we know nothing: a country of snow and dense forests, somewhere in the North.
>
> A family lives in an isolated house near a lake.
>
> Alexi, the brother, is a young man with a pure heart. A woodcutter.

An ecstatic, prey to epileptic fits, he is entirely opened to the nature that surrounds him.

Alexi is terribly close to his younger sister, Hege. Their blind mother, their father, and their little brother are the silent witnesses to their overwhelming love.

A stranger arrives, a young man barely older than Alexi ...[2]

The stranger who arrives is Jurgen, a woodcutter – as is Alexi in Grandrieux's film – who, as in Vesaas' novel, will become Hege's lover and eventually take her away. While Alexi is then an accomplished lumberjack and not a somewhat inept ferryman, and while he suffers from epilepsy rather than learning difficulties, the core of Grandrieux's film remains close to Vesaas' novel, save the addition of the other family members. The addition of these members is in many respects somewhat puzzling, as there is little in the film itself that might provide an explanation as to why these protagonists are added since they seem to serve no specific narrative purpose and figure only at the margins of the main story. This is resolutely not the case in the screenplay that Grandrieux wrote for *Un lac*, however, in which he added significant plot elements that require the presence of these other family members. The summary that opens the screenplay of *Un lac* reads as follows:

A family lives in an isolated house near a lake.
The brother, Alexis, is a young man with a pure heart.
A force of nature in spite of a slight disability.
He is very close to his sister Hege. Much too close.
Alexis is devastated by epileptic fits.
The mother is the silent witness of the brother's love for his sister.
A stranger arrives. He is only slightly older than Alexis.
He has come to kill the father, to avenge his own father.
The father is away for a few days.
Straight away the stranger and Hege are troubled by each other.
Alexis is also fascinated by the stranger.
The father returns.
His cowardice is so great that the stranger spares him.
Alexis witnesses this event.
That same night Hege leaves with the stranger.

Alexis goes to look for them in the city.
He finds them.
He kills the stranger.
He wants his sister to come back with him.
For everything to be like before.
Alexis returns home.
The next day he throws himself into the icy water of the lake.

My intention in including this summary here is resolutely not to provide further clues for the viewer of *Un lac* who would wish to disambiguate some of the many evocative and elusive moments of the film. In many respects, indeed, one might say that this summary has almost no relevance to any analysis of the film since it is for the most part unrecognizable in relation to the final product. This is true not only in relation to the diegetic content – since the major dramatic elements, namely the confrontation between Jurgen, the father Christiann (or Rainer as Jurgen calls him in this scene, thereby revealing a secret past life) and Jurgen's murder carried out by Alexis, do not figure in the film in any way, shape or form – but the psychological profile of the characters and the relations between them also. Indeed, while it is perhaps interesting to note that the screenplay suggests that Christiann/Rainer is in fact Jurgen's father, that this is the reason why Jurgen has come to kill him, and that this fact transfers the suggestion of an incestuous relationship from Alexi and Hege explicitly onto Hege and Jurgen, there is once more nothing in the film that might lead us towards this possibility. And yet, while the attempt to elucidate these aspects of the film on the basis of new elements found in the screenplay would constitute an act of wilful misdirection and an attempt to make claims about the film that could not be substantiated on the basis of an analysis of the film itself, a consideration of the differences between Vesaas's novel, Grandrieux's screenplay and the final film can tell us a great deal about the importance or, rather, function of the narrative content in Grandrieux's films.

The question of narrative

In a recent interview, Lorenzo Baldassari and Nicolò Vigna put it to Grandrieux that rather than proposing a non-narrative cinema he

deals with what might be termed 'weak narration' and go on to ask him about his relationship with narrative and its importance in his films. Grandrieux replies:

> Well, it is important. I mean, it's a question, the narration, the story. Yes, it is a question, because otherwise you are making pure experimental movie [sic] and I don't feel myself as an experimental filmmaker, because I need to be inside of a kind of a story, maybe if it's a very simple story, of a man looking for a woman, like in fairy tales, like *Sombre*, you know, the beast. All this kind of very simple structured story, like a fairy tale precisely ... That's why Western films are very interesting, because it's just a man coming from nowhere, getting inside of the city, going in the bar, falling in love, having to fight with the bad guys and then killed and got out of the city ... It's simple ... The story is so simple that you can really do what you want. You can build the world that you want with this simple story but I think that you need this story to be able to construct the movement inside of the movie, the movement of what we are following like a wave. So stories are important for me and also this question of [t] aking the audience inside of something that is possible to follow, even if it is very difficult to follow, even if it is very confused, very obscure, very hard to understand, but the structure is very simple. (Grandrieux and Baldassari)

Grandrieux's comments here are extremely important for an understanding of the mode of engagement that his films require of us, even if I would like to modulate his idea that it is possible to 'follow' what is happening in his films and suggest that, as argued previously, we are in fact able only to accompany them – which is perhaps close to his earlier suggestion in this quotation that the movement produced by narrative in his films is one that we must approach in the way that we would 'a wave'. Indeed, to think about the source texts, the screenplay and the relation of these to the final films is to realize that many of the narrative and psychological cues that may have produced a certain dynamic on set are quite simply absent from the film, not available to us spectators as pieces of a puzzle that we would henceforth be able to reconstitute. To put this another way, while we might think of plot elements or psychological cues as those aspects of a film

or, indeed, any narrative that enables us to establish cause-and-effect relations between the various characters and events we are presented with, oftentimes here the elements that would create this relation of cause and effect are simply not present, leaving us only with the relation itself, the movement that is effected between these punctual elements.

The point being made here is very close to what has been said of *La Vie nouvelle* and adds further weight to the suggestion that we should not attempt to map the events of that film back onto any kind of pre-existing reality or sociopolitical situation. Indeed, in his critique of the film, Arnaud Hée suggests something of *Un lac* that is extremely close to what we have said of *La Vie nouvelle*, writing,

> No moral norm seems to have penetrated this space, a primitive and animistic atmosphere seems to join the characters to each other and to their environment. There is a kind of original cosmos in play here and the absence of any geographical or temporal markers reinforces this aspect of the film. (Hée 2009)

This last point is crucial and it is rendered explicit not only in the film's synopsis, but also in Grandrieux's filming notes for *Un lac* which open with the very same line as his synopsis:

> The story takes place in a country about which we know nothing.
> In the north.
> The light is devoid of strength.
> The sun never climbs high in the sky. It remains on the horizon.
>
> Everything happens with great suddenness.
> Nothing prepares it.
> It just happens.
> The scenes are somehow connected underground, by deep currents invisible on the surface.
>
> Few dialogues.
> Lines delivered rapidly.
> The film is a tragedy.
> The power of cinema is that it enables us to live within a world, as the dreamer lives within his dream.
> Thus, we walk in the image.

More than simply a set of filming notes for this particular film, what Grandrieux lays out here is an entire artistic project for the cinema in which the status and ontological modality of the image is radically reconfigured. As described here, the image to be produced is one that does not arrive preformed but that struggles into being, the weakness of the light (counter-intuitively) producing an image in which differential zones across the image are made more apparent by the lack of contrast, in which forms do not so much appear as gradually materialize before our eyes, enfolding the dark materiality of the image that pulls us into its depths around a centre that produces a movement in the image and the semblance of an object that remains always on the threshold of visibility, at risk of dissipation, never able fully to differentiate itself from its environment. Similar to what has been said in relation to Merleau-Ponty's idea of the flesh of the world and the relation between the visible and the invisible, the image here is produced in much the same way as relations are forged between the various scenes, events and characters of the film in Grandrieux's description, which is to say that the image enters into perception via 'deep currents invisible on the surface'. And yet, to suggest that the image comes into perception and that there would be a static, perceiving subject waiting to receive this image is somewhat misleading, for, as is suggested by the final stanza of this lyrical manifesto, the chiasmic relation via which the image comes into being here and that produces the image as a movement that in and of itself remains invisible, refusing to coalesce into a series of surface effects that might provide us with an impression of fixed form and identity or definitive meaning, is one that enfolds us into it also such that 'we walk in the image' 'as the dreamer lives within his dream'.

Lest this all seem a little abstract and risk slipping into the kind of unsubstantiated rhetorical excess I have I promised to avoid, let us turn our attention to a specific scene from *Un lac* in order to explain the point differently and, at the same time, understand how, as we move in the image, we are invited to adopt not the *perspective* of Alexi but, rather, his relation to the world that he moves in. The scene in question is the film's opening, a sequence that immediately places us in the midst of the movement, rhythm and resonant relation taking place between Alexi and his environment.

The film begins with Grandrieux's now customary sober title credit. As soon as this disappears the film begins with a heavy

percussive downbeat synchronized with the sound of a rapid exhalation. This is repeated again and again, punctuated on the upbeat by a sharp breath in. A punctual rhythm is quickly established that instigates a diastolic and systolic movement as the attack of the downbeat pulls us down and the rise of the upbeat pulls us up again. This movement is rendered diagonally in the image track of the film as the arms and mid-torso of a figure clothed in red swing and pivot in a downwards arc from upper left to bottom right and back again in time with the downbeat and upbeat, the geometry of the movement set against the vertical gridlines of the black silhouettes of trees in the background. After sixteen punishing beats, we stop and cut to a close-up shot on a face that stares intently ahead, the only movement in the image now coming from the trembling of the camera that seems to translate the continuation of the systolic and diastolic movement that we hear now only in the deliberate breaths of this man. He looks up towards the sky, tilting his head back, interrupting his breathing for a long beat that seems to suspend time for a brief instant, then returning his gaze to its previous centre of attention as the movement starts again, firstly with his breath and then again with a second salvo of twenty-four heavy strikes. This time, however, the camera stays on the man's face and eyes that remain intently fixed on a point in space before him and towards which his arms swing repeatedly in a diagonal line from top right to bottom left, a silver flash confirming what we already guessed from the soundtrack, namely that he is wielding an axe (see Figure 12). We cut to a low-angle very wide shot looking up towards a cold light grey sky striated by the vertical lines of the silhouetted forms of tall spindly trees. Time and movement are again suspended but gradually return with the stuttering crack of splintering wood that eventually produces yet another diagonal as a tree slowly falls and leaves its companions still standing, shaking and trembling in its wake across a series of similar shots, each held for a long beat as the aftershock sways of the trees gradually slow and bring the image once more to a still, strict verticality (see Figure 13). We cut to a close-up, and then an extreme close-up shot from above looking down onto the woodcutter who lies on the snow-covered ground, staring up into the trees. We cut to a wide shot in which we see him walking a horse through the snow, dragging the trunk of the felled tree behind them. We cut to a close-up on his face as he continues on his way, the proximity of the

FIGURE 12 *Screenshot from* Un lac. *Courtesy Mandrake Films.*

FIGURE 13 *Screenshot from* Un lac. *Courtesy Mandrake Films.*

camera now exaggerating the movements of the handheld camera and creating a sense of menace, of impending chaos as a low rumbling fades into the soundtrack and the man looks anxiously around him. As the man's breathing intensifies, the movements of the camera become more erratic, seeming unable to remain fixed on him, as though buffeted around by a greater force, as though the whole world has suddenly entered into a state of flux and started

shaking. A brief hiatus in his breathing and the sound of the thud of a body hitting the snow are all that tell us that the next quick movement we see belongs to the man and not the camera, but no sooner has he dropped out of the frame than we cut to a series of shots of the landscape that do not so much tremble and shake as thrash around, accompanied not by the roar of an earthquake or avalanche as we may expect, however, but by the sound of fabric rubbing against itself. We cut to an extreme close-up on the face of the woodcutter thrashing around inside the frame as has the landscape. This time, however, the movement produced comes not only from the camera but also from the woodcutter or, rather, it is impossible to disentangle these movements since it quickly becomes apparent from the whites of his eyes rolled back in his head and the spittle foaming at his mouth that the woodcutter's body is being racked by the spasmodic convulsions of an epileptic seizure.

It would perhaps be tempting to suggest that the violent shaking of the camera in the latter part of this sequence as the camera pans jerkily over the mountainscape and skyline presents us with a subjective point of view shot from the woodcutter's perspective. This, however, is obviously not the case as we understand when we cut to what would be this shot's reverse and see Alexi's eyes rolled back in his head, unable to see anything. More than this, however, the geometric and rhythmic construction of every aspect of this film up until this point indicates to us clearly that everything produced within the frame in both image and sound tracks exists in a relational space where there is no privileged term, no dominant perspective or subjectivity. The entire space of the film, this is to say, is one which pulses and convulses, in which the formal elements from which all of the subject matter here is constructed, both man and world, subject and objects, are contracted into being by the same lines of force, by the contrapuntal relation of the diagonal to the vertical and the rhythmic throb of the systolic and diastolic contractions of space and time.

To make this claim is to suggest that there exists here an entirely chiasmic relation between form and content, and it thus becomes apparent why the narrator of Vesaas' novel is chosen as the medium via which to channel Grandrieux's film, because he is, as we have seen, a being entirely open to the outside world, existing in harmony with the messages he receives from the outside more than he is impelled by his own internal imperatives or desires. While what might be

termed the open subjectivity of Mattis is evident throughout the novel, it reaches perhaps its most complete expression in the novel's final scene where we hear Mattis saying to himself, 'But where's my body? he thought. Who is it who's doing all these things? This isn't me. Now we'll see what's meant to happen' (Vesaas 2013, 223). Grandrieux himself has conceptualized Alexi's seizures in a similar manner and likened his own mode of relating to his subject matter while filming to this character, saying in an interview: 'There is this kind of trembling in Alexi's body, this body which is subjected to a force that carries it away, devastates it, that's it ... and there is no doubt something close here to ... in some way I am Alexi when I film' (Grandrieux, Foti and Lécuyer 2008).

The reversibility or, perhaps better, a directionality of the relation between subject and world that we find in Mattis/Alexi returns us to the chiasmic relation that, for Merleau-Ponty, is expressed in the idea of the flesh of the world. It is perhaps because of this term that much work in the philosophy of film that engages Merleau-Ponty's work or else deploys the concept of the haptic more generally has placed such emphasis on the embodied tactility of cinematic spectatorship. Laura Marks, in a now seminal text, talks of cinema's 'haptic visuality', a term that for her describes the way that the cinema can elicit a tactile mode of vision that can produce the impression of 'touching a film with one's eyes' (1999, xi). Here, as in the work of Sobchack already critiqued in Chapter 4, for all of the claims being made about the activation of an entirely different mode of sensory apprehension, there is still a retention both of a primarily scopic regime (in other words, it is still the *eyes* doing the touching) and, in addition, the retention of a fully embodied subject and subjectivity whose relation to the world may be troubled by the ambiguity of the location of the primary agent in any tactile event (see Barker 2009, 11) yet who remains nonetheless a fully constituted, autonomous entity deploying an internal coherence and external form. To put this another way, the emphasis on the idea of the tactile, of a relation sensed through the flesh of the subject, maintains a Cartesian perspectivalism that ultimately betrays the stated desire of so much work in this field and, indeed, Merleau-Ponty's concept of the flesh of the world which posits a thoroughly extensive relation between subject and world in which the material or formal properties of bodies and the environment into which they extend cannot be differentiated from each other.

While the geometric and rhythmic principles described above that govern the production of bodies and space in *Un lac* arise out of precisely this kind of quantum entanglement, criticism on this film has oftentimes proffered analyses that draw on the haptic concepts formulated by Sobchack (2004), Marks (1999), Barker (2009) et al. and thus retain this same Cartesian perspectivalism that, I argue, does not describe well either the ways in which space and bodies are produced in *Un lac*, or, indeed, the attitude towards the world expressed by Alexi – which here, as in so much of Grandrieux's work before, can be considered to entertain an analogic relation to the formal genetic and relational processes in play. Stéphanie Serre, for instance, suggests that 'the obsessive proximity of the camera caresses in a very real sense the film's faces and bodies' and that 'the trinity of eye, camera and hand brushes and grazes the skin with the magnificence of its photographic beauty' (2009, 3). That many critics have proffered analyses such as this is perhaps not all that surprising given the large number of close-up shots of hands in *Un lac*, the fact that Alexi's mother is blind and must feel her way through the world and know her children's faces with her hands and that Grandrieux has stated in interview that at times he films with his eyes closed.[3] If we take seriously the idea that one of the main reasons why Vesaas's novel was so appealing to Grandrieux was because of the openness of Mattis and that Alexi's epilepsy is a symptomatic intensification of this open subjectivity that problematizes the location of agency, however, the retention of the kind of embodied sensory subject figured in these analyses of *Un lac* must necessarily fail to account for the relational mode deployed here.

Far closer to what is suggested here is the short commentary on *Un lac* by Raymond Bellour reproduced in the programme notes of a retrospective of Grandrieux's career at the Museum of Contemporary Art in Lyon in 2009, 'Philippe Grandrieux: De la télévision au cinéma'. Bellour writes:

> The entire film is plunged into a dark tonality which becomes all by itself a dull violent hue on the threshold between colour and black and white. … It is as if the gaze, both that of the film maker and of every character that becomes in turn the gaze of the spectator, was born of one and the same impulse coming from the inside and the outside of these bodies.[4]

What Bellour describes here is an entirely immersive space in which the porosity between inside and outside is so complete that these very terms can no longer remain operational. In turn, the ramifications of this for any critical or sensory engagement with the film that relies on the retention of an embodied subject are devastating and it is at this point that the need for an alternative mode of engagement becomes most apparent. Throughout this study, I have already paved the way for this alternative and suggested that we need to conceptualize the relational modes of Grandrieux's film not in haptic but, rather, sonic terms. As should be clear from my use of Bellour's commentary, in saying this I am by no means referring only to the film's soundtrack (although this will of course play a major part in this reconfiguration of cinematic space) but, rather, figuring an alternative mode of engagement with the film and understanding of the various relations deployed within and by the film including – as in Bellour's commentary – the film's various bodies and its colours, hues and tonality. Having said that, even though I wish to expand the idea of the sonic beyond the acoustic realm, in order to understand the mode of attention and desubjectification that is called for by *Un lac*, it will be instructive to turn to a text that is born of a consideration of the act of listening, namely Jean-Luc Nancy's *À l'écoute* [*Listening*].

Listening in/to the Dark

In *Listening*, Nancy figures the practice of listening or, rather, 'being in listening' (*être à l'écoute* – an expression rendered in the English translation sometimes by the idiomatic expression 'to be all ears' which, to my ears, retains far too much of the kind of embodied phenomenological subject that Nancy is here writing against) as an alternate mode of relation to the world that would fundamentally problematize the unidirectionality of the intentional subject he finds in Husserl, the meaning-directed stance of the philosopher and the ontological boundary between subject and world. He writes: 'If "to hear" [*entendre*] is to understand the sense ..., to listen is to be straining toward a possible meaning, and consequently one that is not immediately accessible' (2007, 6).[5] The fundamental question that Nancy seeks to ask is then: 'What does it mean for a being to be immersed entirely in listening, formed by, listening or in listening,

listening with all his being?' (4). The answer he provides is that to adopt such a relation to the world is to become a sonorous body that resonates with the world outside it, that is in fact nothing in and of itself but only ever this resonance [*renvoi*]. He writes: 'To sound is to vibrate in itself or by itself: it is not only, for the sonorous body, to emit a sound, but it is also to stretch out, to carry itself and be resolved into vibrations that both return it to itself and place it outside itself' (8).

To conceptualize the subject or a relation to the world and meaning in this way (there being a structural equivalence for Nancy between the constitution of self, meaning and sound) is to fundamentally overturn the interiority, priority and intentionality of the subject or Cartesian cogito. He states,

> One can say, then, at least, that meaning and sound share the space of a referral, in which at the same time they refer to each other, and that, in a very general way, this space can be defined as a space of a *self*, a subject. A *self* is nothing other than a form or function of referral: a *self* is made of a relationship *to* self, or of a presence to self, which is nothing other than the mutual referral between a perceptible individuation and an intelligible entity. (8)
>
> ...
>
> To be in listening will always, then, be to be straining toward or in an approach to the self... .
>
> Approach to the self: neither to a proper self (I), nor to the self of another, but to the form or structure of *self* as such, that is to say, to the form, structure, and movement of an infinite referral [*renvoi*], since it refers to something (itself) that is nothing outside of the referral. (9; translation modified)

At stake here, then, is a radical reconfiguration of our relation to the world that rejects the phenomenological precepts of Husserl – and of the haptic phenomenologists also therefore. As Kane writes, wonderfully, 'perhaps the phenomenological subject gets what it deserves: a static, foundational subject disclosing a world of static, constituted objects' (2012, 445). Nancy's project, as Kane surmises, is thus

> to offer a way of considering the subject that contrasts with the identification of the subject as the punctual I or imago – the figure who conditions the classical triad *ego – cogito – cogitatum*, ... an

intervention aimed at thematizing ways in which the question of the subject can be posed anew, outside of the horizon of the phenomenological subject. (446)

Nowhere is this made clearer than when Nancy writes:

> To listen is to enter that spatiality by which, *at the same time*, I am penetrated, for it opens up in me as well as around me, and from me as well as toward me: it opens me inside me as well as outside, and it is through such a double, quadruple, or sextuple opening that a 'self' can take place. To be in listening is to be *at the same time* outside and inside, to be open *from* without and *from* within, hence from one to the other and from one in the other. Listening thus forms the perceptible singularity that bears in the most ostensive way the perceptible or sensitive (*aisthetic*) condition as such: the sharing of an inside/outside, division and participation, de-connection and contagion. (2007, 14; translation modified)

For Nancy it is thus through sound that this retreat from the phenomenological subject can be figured because of the 'homologous structure of perpetual referral' that they share (Kane 2012, 446). In *Un lac*, however, it is not only through sound that such structural homology between self and world can be found. Bellour's comments on the experience of the spectator in front of – or in – this image whose chromatic hues eradicate the boundary between forms and complicate the relation between inside and outside indeed seem to suggest something very similar to what Nancy claims in relation to the subject immersed in sound, and a similar structural homology has been highlighted in this chapter's analysis of the geometrical construction of the images of the film's opening sequence that posits a homology between Alexi and the forest. In many respects we might then think of the process described by Nancy as an extension and intensification of the figural processes enacted on the subject by the geometric and chromatic forces exerted on the subject by its environment, since in both cases we are dealing not with forms, with constituted objects, but, rather, only with lines of force, centripetal and centrifugal movements, systolic and diastolic rhythms. These movements and rhythms are deployed within the frame but inscribed in the materiality of the film itself through a choreography that folds multiple agents into the dance. In an

interview conducted for a screening of *Un lac* in the context of Marseille's International Film Festival, Grandrieux describes his filming process in a manner entirely consistent with what is claimed here, describing it as a rhythmic relation between his body (and the camera) and the actors, landscapes or objects he films:

> The things that guide me are actually very concrete questions, how to film a hand, how to remain on that hand and then how at a certain moment to move to a face, and then I cut, and how do I return to that hand, and then back to the face, and then back again, and that rhythm gives rise to something in me that allows me to move towards something I don't really know, to get close to a space where there is an immense desire. (Grandrieux, Foti and Lécuyer 2008)

And later,

> I think that the way that I try to capture the image is not so much as a kind of theatrical representation but rather the way in which it also constitutes a relation of opacity, of rhythm or touch.

These movements and rhythms are not solely internal to the film but also extend out to govern the relation between spectator and film. In this same interview, Grandrieux talks of the ways in which the cinema places us in a similar kind of relation to the world, in a kind of dreamscape, which is to say a space in which our mode of perception is entirely altered, slowed down, floating and rhythmic, akin to the perception of astronauts floating outside of their spaceship, weightless. Citing Kubrick as the best example of this idea, he suggests that 'films should place us in that possibility of being weightless, and in our veins', an image that resonates strongly with what has been said here about a mode of being that would be anchored in a brute materiality while simultaneously always going beyond that materiality, leaving form behind. In *Un lac*, this movement and transmission to the spectator is achieved in a number of ways. First, there is a preponderance of extreme close-up shots that place us always too close to the image, unable to pull back from the forms on screen and to situate them in their constituted form. Secondly, as gestured towards by Bellour, the overpowering darkness of the image leaves the possible forms that

appear in the image always on the threshold of visibility, always at threat of being pulled back into the blackness from which they struggle to differentiate themselves. In doing so, these images place us in a gaze that troubles the very foundations of our subjectivity, as is the case with Nancy's being in listening. Indeed, the darkness here is at times so close to complete that we cannot say that we see, that we are able to reconstitute a form that would be present in itself and give itself over to us to be seen; rather, our effort to see, the gaze itself, becomes the means by which the image is formed at the same time as the blackness of the image draws us into its depths and infinite density, deconstituting both our ability to see and that of the image's forms to figure.

For Grandrieux this is yet another way in which the spectator, like Alexi, comes to inhabit a completely open relation to the image and the world which is simultaneously deeply material and physical yet defined first and foremost by a relation that takes the body beyond itself and the perspective presented by the film beyond the psychological or narratival strictures so common in the cinema. As he explains:

> I even thought that the film should allow the spectator's eyes or pupils to dilate. You don't see the film if your pupils don't dilate, and that's why it's extremely important for the cinema to be in complete blackness, very dark. Then at a certain point the pupil dilates and I think that in that moment the spectators are ... have their eyes completely open, and the slightest trace of light imprints itself on them. It's very physical, it's a question of bodies and of the relation between the body and the image. These are experiences that seem important to me because they allow me to have a different perception of things and again, to set it free from a simple psychological or novelistic function. (Grandrieux, Foti and Lécuyer 2008)

If the visual architecture of *Un lac* opens up our eyes completely, foreclosing the possibility of closing them (as is said of our ears), in doing so it thrusts the spectator into a space of reconfigured subjectivity akin to that in which Nancy's subject in listening finds herself. Yet it is by no means only in the treatment or construction of the image that we can find such processes in play and – as might be expected – there are numerous ways in which this kind of relation is instigated in the film's soundtrack also. Even though the film's

dialogues are (once more) extremely minimal, Grandrieux ruptures our perception of language as a mere vehicle for meaning, an index of psychology or function of narrative by casting Russian and Czech actors who repeat their (French) lines phonetically. In doing so, he renders language strange unto itself, disembodying it from those who speak while simultaneously stressing the physicality of the speech act as these mouths struggle to form the shapes required by this language not their own and to make language cohere within its correct syntactical, grammatical and rhythmic structures, structures that would normally efface themselves in the service of a higher purpose but that here impose themselves in their brute materiality. Far from being simply an artefact of a casting choice, this is a deliberate strategy on Grandrieux's part and he writes in his filming notes:

I want to place the French language in mouths able to articulate it only with difficulty.
A language foreign to itself in a way, that stutters.
The actors will not know how to speak French. They will pronounce it phonetically.[6]

In addition to this, just as the image is oftentimes saturated with an overriding blackness that makes us struggle to see, so the dialogues and soundtrack in general are (with obvious exceptions, such as the opening wood chopping scene) extremely quiet, requiring of the listener an extreme attention and stillness that holds her in a relation requiring an abnegation of self that is at the same time an intensification of the physical act of listening as she strains towards the possibility of sound. As with the saturated blacks of the image track, however, it should by no means be thought that what we are presented with here is silence; on the contrary, the entire soundtrack of *Un lac* is made up of a dense post-production mix of sounds that are choreographed, once again, to imbue them with a rhythmic rather than indexical function. As Grandrieux explains:

Every sound, the noise of every step in the snow is made up of completely fabricated sounds, totally … field recordings recorded during filming with the actors in the snow, in powdery snow, in more icy snow, in the morning, the evening, at night… . The work involved is insane because each step was completely redrawn, rebuilt, which means that if you hear the sound of the

film correctly, if it is well screened, in complete darkness and with good sound, you really experience the film, and it's important because, for instance, the rhythm of the movements through the snow and the rhythm of the breathing are things that have been entirely fabricated. (Grandrieux, Foti and Lécuyer 2008)

As was the case with Alexi's seizure in the film's opening scene in which we hear the sound of fabric rubbing against itself while contemplating a seismic landscape, the effect of this treatment of sound is, paradoxically, to draw us in towards the image from which these sounds seem to issue – thanks to the intimacy of the relation created by whispers and sounds at the threshold of audibility – while simultaneously preventing us from enclosing these sounds in the objects before us. Sound here appears to be at one and the same time in abeyance and in excess, both too quiet and too loud all at once, never simply the secondary effect of an event that we see on screen but a whole series of events in itself ultimately irreducible to any physical form. This is perhaps what is suggested by Grandrieux's filming notes where we read: 'The field recordings, perceived separately, must display great clarity. Too great'. And this is surely also why the only indication he gave to his sound engineer was that 'we must be able to imagine that the film could be listened to without being watched. That we might go into the cinema, shut our eyes and in hearing the film receive its vibrating heart' (Grandrieux and Vassé 2009).

Every aspect of *Un lac* can thus be seen to effect this double and paradoxical move described by Nancy's subject in listening whose embodied, material presence is at one and the same time present in its crushing materiality yet pulled beyond itself in a resonant relation with what lies beyond it such that it is nothing but this relation (for Nancy, *renvoi*) that structures both inside and outside, self and other according to what takes place between them.[7] Sound, colour, film-maker, actors, spectators, form, geometry and line are here all pulled into a resonant and rhythmic choreography which obviates the possibility of any kind of Cartesian perspectivalism or semi-stable phenomenological subjectivity and in which scale is incommensurable. As Grandrieux himself puts it:

It is indeed the cinema that accords such an important place to the presence of things, to the frame, to the light, but above all

I think that the cinema, the power of the cinema is its capacity
to film in an equal distance a mountain and a face so that from
within this equal distance something much more powerful than
novelistic psychology – a bad hangover from the nineteenth
century – is played out. (Grandrieux, Foti and Lécuyer 2008)

While maintained for nearly the entire film, there is one key
moment when this schema is broken and it is signalled primarily
by a dramatic change in the soundtrack, namely the first and only
appearance of music in the film. *Un lac* was originally conceived
of by Grandrieux as a film that would be constructed around a
total absence of music, the soundtrack coming only from the
natural sounds of the environment, albeit sounds processed as
already described. But at a certain point in the making of the film,
Grandrieux decided that the entire film should be accompanied
by music and he commissioned a score, set up meetings, engaged
a symphony orchestra and started to record the music in Prague.
Upon hearing the music, however, Grandrieux felt that it wasn't
right and so abandoned it entirely, retaining nonetheless the desire
for the film to contain one solitary song. At some point along the
way, Schumann's 'Mondnacht' [Moonlit Night] from his *Opus
39 Eichendorff-Liederkreis* 'imposed itself' – to use his own term
(Grandrieux, Foti and Lécuyer 2008). This song tells of a new love
that brings a departure and, accordingly, it appears in *Un lac* at
the very moment when Hege decides to leave Alexi and depart
with Jurgen.

Following the lovemaking scene between Hege and Jurgen, the
return of Christiann and a tense dinner-table sequence involving
all of the film's characters during which Alexi says, as Jurgen joins
them, 'Tu manquais Jurgen' ['you were missing Jurgen'] (a phrase
that in both its grammar and inflection leaves us uncertain whether
this is said ironically or not), we cut to a handheld big close-up shot
of Alexi that tracks backwards as he walks towards the camera, his
brow creased with worried thoughts, his head crashing from side
to side within the frame with every step. 'Hege, elle l'a fait' ['Hege,
she did it'], he says before we cut to an extreme close-up over the
shoulder shot of Hege staring up into Alexi's eyes, the remnants
of a tear running over her upper lip. We cut to the reverse and
see Hege's hand pass over Alexi's closed eyes to gently caress his
brow then cradle his cheek. Hege starts to sing and Alexi's eyes

snap open to fix her with a cold stare and then, with no break in
the music, we cut to a high-angle reverse close-up shot of Hege
singing. On two counts this shot strikes us as somewhat strange:
firstly, continuity logic would suggest that her hand should still be
cradling Alexi's face at this point, but this does not appear to be the
case – although we cannot actually see her arm. Secondly, however,
there seems to be a direct correlation between sound and image,
which is to say that it seems as though we are dealing here with a
directly recorded soundtrack. Up until this point, it is not that the
soundtrack has been employed in a non-synchronous manner, but it
is the case, as noted, that the layering of sound in post-production
has made it seem both too quiet and too loud, undeniably linked to
and arising from the images that we see yet somehow too much so,
to the extent that the sound is simultaneously of yet estranged from
the image. This new relation of sound to image may not even have
been consciously registered by many up until this point, but here,
as we are plunged into this new and far more normative relation of
sound and image, the contrast is striking and we can but register the
change and in doing so become aware of having been pulled out of
a space in which elements were conjoined differently.

This difference seems to be registered in the image itself also,
for while Hege is still framed in close-up and while the scene is
still shot with a handheld camera, it is both more steady than most
other shots up until now and Hege is framed in complete isolation,
there seeming to be no point of contact between her and anything
else in the shot in contrast to the many shots throughout the film
of different bodies or objects touching each other, striking each
other, rubbing against each other, melting into each other. What is
more, in this shot Hege is clearly delineated against the crisp white
backdrop of the snow-covered ground shot in sharp focus with
a shallow depth of field that pulls her yet further away from her
surroundings. We cut to a low-angle reverse close-up shot looking
towards Alexi whose facial features, in the centre of the frame,
seem to disappear into the depths of his backlit face set against
the glare of the sun diffused through the clouds above him (see
Figure 14). If previously Alexi seemed to emerge from and always
return to the darkness of his surrounds, to move through space by
enfolding differential zones of tone and contrast before and behind
him, here the darkness seems to be directed solely inwards towards
his core in a centripetal movement that pulls him down and away

FIGURE 14 *Screenshot from* Un lac. *Courtesy Mandrake Films.*

from the light behind him. 'C'est pas comme avant … ta voix' ['It's not like before … your voice'], he says in a monotone infused with despair, a sentence which encapsulates perfectly our own relation to the sound and image which are no longer as before. As if to deliver the final death blow to the kind of wholly immersive and immanent space that we have moved in up until this point, as soon as Alexi has stopped speaking we cut back to the high-angle close-up shot of Hege and, just as she stops singing, the music of her song is taken up by a piano melody in the film's first and only instance of non-diegetic music – or indeed sound.[8] We cut to a low-angle medium close-up shot of Alexi completely silhouetted against a now dark blue twilight sky. Even though this backdrop has darkened, Alexi's form still stands against these sombre hues rather than emerging from them, no longer serving as the point around which darkness is enfolded but rather a point of infinite and complete blackness collapsing in on itself, a void at the centre of the screen (see Figure 15). Hege's voice, singing the same song as before, joins the piano, ripping her in effect from the diegetic space of the film and placing her in another space entirely.[9] We cut to a very wide shot composed mostly of dark clouds cut through by a brilliant circle of light towards which a tiny silhouetted figure walks alone. As the music continues unabated we cut to a shot that seems to function as a variation on shots from earlier in the film as we see the cabin in the snow. However, rather than simply remain on this cabin, out

FIGURE 15 *Screenshot from* Un lac. *Courtesy Mandrake Films.*

of focus as before, we now pan down across the snow to find Alexi
lying completely motionless. Whether or not this is the result of
another seizure or mere dejection we do not know; all that matters
is that this shot has none of the formal dynamism and kinetics of
the shot the last time we saw Alexi lying in the snow, a shot whose
very mechanics created a deep symbiotic relation between Alexi, his
environment and us as spectators and that thrust us into the same
space as him, a space in which no relation was generated from a
privileged perspective.

Nothing from this point on is quite the same. Christiann comes
and picks up his son and carries him away with Jurgen following
awkwardly behind. Something seems to have come between Hege
and Jurgen also, the latter telling Hege that she does not even
know who he is. Then, in a remarkable dream sequence, we see the
silhouetted figures of Jurgen and Hege embrace, their dark forms
appearing to cut through the very centre of Alexi who lies asleep
behind them. We cut to an extreme close-up on Alexi's face that fills
the screen as much as his rhythmic breaths saturate the soundtrack
as he sleeps. These breaths continue across the image cut as we pass
to a shot of a hand with long locks of brunette hair woven between
its fingers. This shot is not lit as before, however, tending towards
a flickering yellow rather than the burnt orange of Alexi's sleeping
face. The hand brings the hair up to a face that we (barely) recognize

as Alexi's and we watch as he slowly pulls his head away from an embrace. We cut to the reverse and see Hege, her face consumed with concern, and, as the light continues to flicker, to the beat of Alexi's breath we watch as his hand pushes Hege's face away into the depths of the darkness behind them. It is only after this that Hege tells her mother that she is leaving with Jurgen, yet we, like Alexi, knew this already, since we, like Alexi, have experienced the change in Hege's voice, have felt her pass into another realm entirely, to become nothing more than the fading afterglow of an idealized love that made everything whole yet is now impossible, beyond our reach.

What is perhaps most remarkable about these final scenes of *Un lac* is the way in which Grandrieux manages to entirely subvert the operations of non-diegetic music. For when diegetic music is transformed into non-diegetic music, this is almost always done to heighten the drama or pathos of a scene, in order to draw us further into the diegesis playing out before us by extending one of its key elements out into 'our' world. In *Un lac*, however, up until this point there has been no such distinction between the world on screen and 'our' world, for the film has been constructed according to a wholly immanent logic. There is then a wonderful irony in the fact that a melody as gentle as Schumann's is used for such violent ends, and all the more so since Schumann thus becomes the brutal counterpoint to the film's opening sonic salvo of axe strikes whose apparent violence serves, in fact, to draw us in to this logic, to sever all ties to 'our' world in order to make us move to the rhythm and line of Alexi's.

9

Recent works

Il se peut que la beauté ait renforcé notre résolution – *Masao Adachi* [*It may be that beauty has strengthened our resolve* – *Masao Adachi*] (2011)

Grandrieux's film essay on Masao Adachi is the first work in a projected series of films conceived of by Grandrieux and Nicole Brenez to be united by the series title *Il se peut que la beauté ait renforcé notre résolution.*[1] Conceptualized as a response to André S. Labarthe and Janine Bazin's series *Cinéastes de notre temps* [*Filmmakers of our time*] that, from 1964 to 2009, produced almost 100 documentaries about some of the world's most important film-makers, Grandrieux and Brenez's series, in the words of the latter,

> pays tribute to known and unknown filmmakers who have participated with guns, camera, or both simultaneously, in the struggles of resistance and of liberation throughout the 20th century, and to those who today continue to fight against all dictatorships. (Brenez and Grandrieux 2012)

Given this brief, it is entirely fitting that the first film in the series should be dedicated to Masao Adachi, who has been associated with experimental political film-making since the 1950s, who travelled

to Palestine to join the Palestinian struggle in 1974, spent twenty-three years in refugee and activist circles before being imprisoned in Lebanon in 1997 for multiple passport violations, was extradited to Japan in 2000 where he was arrested again and served a further eighteen months in prison, subsequently returning to film-making and releasing *Prisoner/Terrorist* in 2005, a film that stands as undeniable evidence that time had done nothing to dull his radical and engaged vision of the cinema.[2]

Taking into consideration much of what has been said herein about Grandrieux's work, it might be thought that *Masao Adachi* constitutes a radical new direction for Grandrieux whose films consistently attempt to thrust us into a space entirely divorced from a pre-existing reality or a realpolitik. This is not the case, however, since to make this claim is not to suggest that Grandrieux's practice is divorced from the *real* or from a political relation to the world. Nowhere is this made more evident than in the extract from Julio Le Parc's manifesto 'Cultural Guerrilla' (1968), quoted by Brenez in an article she wrote to accompany a series of screenings around the work of Masao Adachi at the Museum of the Moving Image in 2012. Le Parc writes:

> Reignite [the] power of aggression against existing structures. Instead of seeking out innovations in art, change, whenever possible, the fundamental mechanisms which condition communication. ... Organize a sort of guerrilla warfare against the present-day cultural state of things, highlight the contradictions, create situations in which people can regain their potential to effect change. Counter tendencies that opt for stability, the definitive, all that breeds a state of dependence, of apathy, of passivity tied to habits, to established criteria, to myths and other mental schemes born of a conditioning complicit with structures of power. The systems of life, even during political regime changes, will continue to be maintained if we do not question them. (Quoted in Brenez and Grandrieux 2012)

Unpacking the ideas here, Brenez goes on to argue that avant-garde cinema responds to this clarion call by reinscribing a technology born of military and industrial needs 'within a dynamic of emancipation ... continuously reconfiguring the symbolic [... questioning] the division between art and life', since for the

avant-garde artist, 'art only has sense in its refusal, in its contesting, its pulverization of the limits of the symbolic'. Art, or the cinema more specifically, is then 'a means of directly intervening in the real', yet this by no means implies that it must slavishly reproduce the ambient historical reality in which it is created, being 'caught up in the material urgencies of history, while remaining indifferent to aesthetic issues'. On the contrary, 'the cinema of intervention exists solely to pose fundamental cinematographic questions: Why make an image, which one, and how? With and for whom?' (Brenez and Grandrieux 2012). In his section of the text, meanwhile, Grandrieux expresses much the same in his own way, writing:

> The series does not stem from a dogmatic list of the rules of the game. It is precisely the opposite, which conducts the movement of films; a gesture of freedom, without weight, by which the filmmaker can witness the work of another filmmaker, of his aesthetic, ethical, and political engagement, of his struggle with the world and with himself. In other words, at which point is the cinema at the heart of the project, the cinema and friendship.
>
> Each film from the series is thus in itself a particular object which will have been thought out, produced, and realized according to the necessity that it brings. Each film addresses a common concern shared by all the others – that of transmitting the power of cinema when cinema and life are so deeply affected by one another. It is this concern that forms the unity of the series.

While this is ostensibly a commentary on this specific series, what we find here is the very same approach that has characterized Grandrieux's work up until this point, namely a methodology that operates according to almost entirely immanent principles and, as a result, an approach guided by what might be termed an ethics of accompaniment. In Grandrieux's own film, this manner of proceeding returns him to the purest possible form of this ethics, there being – as in *Retour à Sarajevo* – no guiding text or blueprint, no plan other than to exist alongside other people in a specific situation and environment.

By Grandrieux's own account, the decision to return to this kind of film-making was a somewhat risky endeavour since he did not know Adachi particularly well, having only met him once before

during a retrospective of Grandrieux's work in Tokyo when they took part in a post-screening discussion. Unsure if he would even return to France with a film, Grandrieux nonetheless set off with his camera to spend some time with Adachi to see what transpired. As he describes their first meeting on this trip:

> Well, it was strange how this film came in, because I met Adachi the first time when there was a retrospective of my movies in Japan, in Tokyo. Adachi saw *La Vie nouvelle*, and I think he loved it, and we talked together. Then Nicole Brenez and I decided to make a series of films about the filmmakers who fight with the aesthetic aspect, the political aspect of filming. She said to me why not Adachi, so I said ok, but I didn't know him so much, we didn't have any money and so we just decided to try. So I went to Tokyo and I shot *Il se peut que la beauté ait renforcé notre résolution – Masao Adachi*. So, it was very strong because at the very beginning when I shot with him there was a bar and we drank beer, sake, and at a certain moment I took my camera, I was alone, there was only a guy with me with the sound and I saw his hands when he took the glass to drink. I saw his hands and I was very close to his hands. So I took the camera and shot his hands, and it gave me access to the movie, this first shot of his hands, then I shot his face, it was just trying to approach his body. (Grandrieux and Baldassari)

To a certain extent Grandrieux's fears were undoubtedly unfounded because, as Brenez makes clear, there are obvious affinities and parallels between Grandrieux and Adachi's bodies of work, both being 'inspired by Antonin Artaud and Georges Bataille, ... placing the body at the center of their aesthetic economy [..., constructing] their fictions by taking trips to the unknown mazes of the human psyche [..., dedicating] documentary essays to the resistance of people submerged in historical tragedy' and creating works that combine 'historical experiences on information and counter-information' (Brenez and Grandrieux 2012). The extent of the affinity between them becomes even more apparent in the film itself, however, in which Adachi expresses a number of ideas on his conception of the cinema that are remarkably close to Grandrieux's own. The affinity between them is perhaps expressed even more deeply by Grandrieux's film itself which in many respects can be

seen to arise out of a resonant relation not only with Adachi the man but with his work also, a methodology that produces a final product that, nonetheless, itself resonates forcefully with much of Grandrieux's own previous body of work.

Resonance is produced when the natural frequencies of two bodies enter into a sympathetic relation with each other, a phenomenon which can be demonstrated in a very simple way by the act of pushing a swing, as explained by John Rayner:

> Imagine you want to push a child's swing. The swing has a natural frequency or rate of vibration at which it swings. If you push the swing at a rate much faster than its natural frequency not much happens; the same goes if you push at a very slow rate. But, if you push it at a rate that is the same as its natural frequency, then with very little effort you produce very large oscillations. We have resonance. (Rayner 2012)

Given the specific example used here to explain the concept of resonance, it is tempting, almost too tempting, to find incredible, uncanny significance in the long opening sequence of Grandrieux's *Masao Adachi* which shows the elderly Japanese film-maker pushing his grandchild in a swing, shot at close range by Grandrieux who, for his part, allows his own movements in this space to be dictated and guided by the trajectories of those that he films, each shot being, as so often before, not the product of a rigorous process of meticulous storyboarding but, rather, of an ever mobile, responsive relation aware of its own positionality yet allowing that to be constantly altered by whatever it finds itself faced with. Nonetheless, to imbue this aspect of the shot with too much significance would be a mistake for this very same reason, because, precisely, the scene is not choreographed, is not laid out in advance. What *is* undoubtedly of great significance, however, is the way that Grandrieux allows his own film-making style and, at times, content to enter into a resonant relation with Adachi's own body of work – and in particular those films that will appear at various points in Grandrieux's own film.

The primacy of the relation that is foregrounded by this approach can be found, firstly, in the title of this series of films. 'It may be that beauty has strengthened our resolve,' indeed, is a line from Adachi's 2007 film *Prisoner/Terrorist* and it is a line that appears in Grandrieux's own film when we see a clip from

Adachi's film played (as are all of the extracts of Adachi's films that appear sporadically throughout the essay) on a laptop with its volume turned up to the point that the white noise hiss and clicks of low-grade analogue to digital conversion threaten to overwhelm the overdriven tinny dialogues that struggle to remain intact as they are pushed out from small inbuilt speakers pushed beyond their capacity. The noise that accompanies these clips itself seems to resonate with or wish somehow to acknowledge the sonic scree and detritus of the Sachiko M-composed noisescapes of *Prisoner/Terrorist*. Likewise, the long sequence of shots of cherry blossom trees shot from different angles and in different gradations of light that seem to make of them something else entirely with every different permutation recalls the trope of *sakura* in Adachi's film while also resonating deeply with Grandrieux's *L'Arrière-saison*.

To return to the film's opening, however, in which we watch Adachi push his grandchild in a swing and hear him muse in voiceover on themes of loss, regret, death and many other topics besides linked only by a kind of freeform associational logic, if we would be mistaken in finding here a literal representation of the film's resonant logic, what we can suggest more forcefully is that this scene (and indeed many other scenes in the film that employ a voiceover narration whose content is to all intents and purposes disconnected from the images over which this plays, images of people moving in their environment) resonates with many of Adachi's films from the 1970s that were governed by the principle of *fukei-ron* or landscape theory. This theory, developed with Mamoru Sasaki and Masao Matsuda, started with the premise that all landscapes, 'even those such as the beautiful sites shown on a postcard, are essentially related to the figure of a ruling power' (Adachi 2007). This theory led, most famously, to Adachi and Matsuda's 1969 pseudo-documentary *Ryakusho Renzoka Shasatsu-ma* [*A.K.A. Serial Killer*] which tells the story of Norio Nagayama, known for being one of Japan's most infamous serial killers and who murdered four people while still a minor. Rejecting the sensationalism of the media coverage of this affair, Adachi, as Fumiwo Iwamoto notes, 'took his camera to simply see what Nagayama might have seen [and] captured urban landscapes that were rapidly standardized by nationwide development projects led by economic growth' (2015). The anonymity of this urban landscape indicated to Adachi 'a certain socio-economic direction of the state power and people,

such as Nagayama, who were alienated from a changing society'
(Iwamoto). In choosing simply to film the landscapes in which
Nagayama grew up and to accompany these images not with a
description of this young man's crimes (these being revealed only
in the most matter-of-fact way possible in the film's final frames
which present us with a screen of Japanese text detailing the bare
essentials of the facts) but, rather, a jazz soundtrack interspersed
with factual details about Nagayama's life intoned by Adachi in
an emotionless voiceover, the film shifts the responsibility for these
acts of horror away from the monstrous individual portrayed in all
other accounts of Nagayama onto Japanese society as a whole and
the global forces of capitalist homogenization more broadly.

The resonance to be found between *A.K.A. Serial Killer* and
Grandrieux's *Masao Adachi* comes not only via the combination
of voiceover intercut with music and shots of everyday scenes of
ostensibly banal moments and settings, however, but also via the
relation between individual shots. If *A.K.A. Serial Killer* presented
shots of a landscape in which all traces of local specificity were
gradually being erased, this process is shown to have run its full
course by the time we get to *Masao Adachi* which, as Ben C. writes
of one of this film's shots showing Adachi standing against a neon-
lit Tokyo streetscape, 'bears witness to the director of *AKA Serial
Killer* standing against a landscape seemingly entirely superseded
to capital [that] blurs into one homogenous mass of light behind
him' (2014) (see Figure 16). Within the film, this image itself
resonates with other overexposed shots such as that of Adachi
walking through a temple garden, his shock of white hair barely
distinguishable against the washed-out background and noticeable
only thanks to his movement, just as in the opening sequence we
are able to discern the figures of Adachi and his grandchild on
the swing thanks to their movement which enfolds differentiated
zones of dark tonal contrast into a pattern that, through repetition,
enables us to develop a relation with the image, allows our eyes to
develop the image, allows us to see.

As the example of the swing shows so beautifully, then, resonance
is intimately bound up with rhythm and it is also according to
rhythmic principles that Grandrieux's film is constructed and to
which it is drawn. Indeed, in a film ostensibly about an engaged
film-maker, it is perhaps hard to understand why Adachi's long
opening half-whispered rambling monologue is given pride of place

FIGURE 16 *Screenshot from* Il se peut que la beauté ait renforcé notre résolution – Masao Adachi. *Courtesy Epileptic.*

and left to run for so long because there are many other passages in the film during which he surrenders far more information about his films and his view on the cinema. This is only the case, however, for as long as one attends only to the ideas and not to the timbre and grain of the voice and the rhythms of the speech which become, once we relinquish the desire to understand and make meaning cohere within a logical framework – something that Adachi warns us against repeatedly in this monologue – akin to elements of a musical composition, a different kind of intervention in the world.

This rhythmic construction of the film that creates a resonant relation between its different parts is nowhere more apparent than in the sequence in which we are shown an excerpt from Adachi's 1971 film *Sekigun – P.F.L.P Sekai sensô sengen* [*Red Army – P.F.L.P. Declaration of World War*] played back at full volume on a laptop (as already described). As the revolutionary exhortations and call to arms of the voiceover end, we are left, in the soundtrack, only with the white noise hiss and rhythmic click provided by the sonic artefacts of the video conversion process and playback technology. We cut to a different scene entirely, an image of a bus stuck in traffic in a Tokyo street beneath the harsh horizontal concrete girders of an overhead freeway. This image has seemingly nothing to do with the scene from Adachi's film we have just been watching and displays none of the

granularity produced by that image's double mediation. The same rhythmic click seems to have continued across into this scene without skipping a beat, however, and it is only when the shot starts moving that we realize we are in a car and that the click we now hear is the sound of an indicator light heard from within the cabin.

If a common rhythm here links together two seemingly disparate spaces and two cinematic texts, as this scene develops we seem suddenly to be transported into a different space, time and intertext as the car from within which this scene is shot sets off as the lights change and drives through the streets of Tokyo. It heads up onto the elevated freeway and then down into a long tunnel, winding its way through and under Tokyo on a route that repeats a journey already taken and a camera shot already seen in Tarkovsky's *Solaris* (1972). The resonance here is cued not only by the image track, but by the soundtrack also, not only because of the white noise road rumble and Doppler whoosh of passing cars that fill the auditory space of both films with a menacing and already unworldly presence, but also because Grandrieux here samples the mysterious high-pitched beeps and bleeps of data sonification that creep into the soundtrack of Tarkovsky's film as if to signal an alien transmission that becomes here a sonic echo across time. The sequence ends and we cut to a shot looking down onto the streets we have just driven through. This shot seems also, in its own way, to enter into a dialogue with the final shot of the Tokyo driving sequence in Tarkovsky's film, for if in *Solaris* the extreme long aerial shot turns the individual cars on these roads into data bits circulating on an information highway, their headlights and tail lights an abstract blur of red and white, here the entire image, shot through the tinted windows of a hotel room, is washed out in shades of blue in an abstract composition that prevents the lines of the landscape outside from coalescing into recognizable forms as Grandrieux says in voiceover:

> Last night the taxi that took me back to the hotel took the freeway that crosses Tokyo. I thought about Tarkovsky, about *Solaris*, the long sequence in that film shot in this same location. Cinema passes from one film to another, through time, above and beyond those who make it.

If Grandrieux's cinema has, up until now, been said to be one governed by a principle of immanence that stages and comes into

being via a series of relations that contract forces into semi-stable forms traversed by lines of flight that constitute them in the very same move that they are pulled apart by them, this principle is here translated into an understanding of the cinema itself. Cinema, indeed, becomes in this description an open whole, a whole that, as Deleuze says in *Cinema 1*, 'is not giveable ... because is it the Open, and because its nature is to change constantly, or to give rise to something new, in short to endure' (1986b, 9). This, then, is the cinema as a body without organs, the sum total of all possible relations between, across and beyond the set of all possible images, an infinite field of vibration waiting to be contracted into perception by a specific relation that miraculates movement around itself and imbues it with a *rhythm*, a beat whose throb and pulse is in and of itself proof of a life. This power, for Deleuze, is nothing other than the expressive or aesthetic act that gives birth to and inhabits all art, imbuing it with the capacity, via its affects, to render mobile once more lives petrified within the forms that they mistake for their nature. Deleuze writes in his book on Bacon:

> This power is Rhythm, which is more profound than vision, hearing, etc. Rhythm appears as music when it invests the auditory level, and as painting when it invests the visual level. ... What is ultimate is thus the relation between sensation and rhythm, which places in each sensation the levels and domains through which it passes. ... It is diastole-systole: the world that seizes me by closing in around me, the self that opens to the world and opens the world itself. (2003b, 37)

We are here close once again to Merleau-Ponty's chiasmus, that threshold state that serves as the fulcrum point around which incommensurable partial identities enter into a relation with each other, passing into the realm of perception while remaining nonetheless ultimately imperceptible since they are ever mobile, never taking on a form that could be seen or apprehended in its totality. It is according to such a mode that Grandrieux understands his own role here as a portraitist who cannot register the truth of the man as though he were somehow out of time, but only the ineffable quality in aesthetic form of that which arises out of the relation of the subject to time, which is to say of life itself. As he

says in voiceover as we contemplate Adachi's gnarled hands and deeply lined face,

> The portrait of a man, his hands, his face, shaped by time, by what he has lived. Does the beauty of the hands or the face express the truth with which life traverses us?

To put this another way, what Grandrieux's reflections on the cinema as a set of relations between images across time – either within a single film or across the history of the cinema – and on the possibility of representation point us towards is the way in which the work of the work of art consists in drawing the Real into a dance, making it move to a rhythm defined by a style[3] and, then, inscribing matter in time. Rhythm, indeed, is nothing but the spatialization of time and it is precisely these rhythmic qualities that pull lines of force and the flux of becoming around a semistable centre, into forms that are not one yet become nonetheless perceptible in their movement. It is this idea that Grandrieux will go on to explore in its most stripped back form in the triptych of works that he makes following *Masao Adachi*.

Unrest

Around the same time that he made *Masao Adachi*, Grandrieux commenced work on another series of works that, at first, could not seem further removed from this film essay, a triptych entitled *Unrest*. This title alone, however, should already indicate the extent to which these works would resonate strongly with *Masao Adachi*, for if the latter work ultimately springs from an aesthetic of accompaniment that instigates a resonant relation between various elements of the intra- and extra-cinematic universe on display, setting in train a rhythm across the individual images that pulls them beyond themselves and undoes any semblance or illusion of fixed form, then we might describe form here as being in a state of unrest.

More so than in any of Grandrieux's previous work, in the works that together comprise *Unrest* (of which only the first two have been made at the time of writing) what we are witness to, what

we are asked to accompany is nothing other than this, a principle of unrest expressed as rhythm, not so much matter *in* motion as matter *as* motion. Indeed, what we are presented with in both parts of the triptych produced thus far, namely *White Epilepsy* (2012) and *Meurtrière* (2015), takes Grandrieux's attempt to distance himself from indexical modes of representation and outcome-directed scenarios further than ever before. If we consider the film versions of these pieces to be the final form of these works, however, and to see an evolutionary process across the different stages of their genesis, then what we have here is not so much a semi-improvized response to a written text but a veritable metamorphosis that transmutes each iteration of the work.

Originally conceptualized as a diptych, *Unrest* – the collective title eventually given to this complete work as well as the individual title of the third and central piece – would become, once the first piece had been made, a triptych. As Grandrieux explains in his notes to *Meurtrière:*

Triptych
 Three rather than two. In the confrontation between two images the triptych imposes a third image, the central image. This image separates those on either side of it, holds them at a distance. Paradoxically, via this separation the third image in the centre achieves a kind of obscure resolution. It harbours an enigma that seems to emanate from what surrounds it, an enigma or perhaps a field of sensations produced by the interference coming from the adjacent images. *White Epilepsy* will be on the left, *Meurtrière* on the right. *Unrest*, which is also the name of the triptych, is in the centre. No narrative link unites the three parts of the triptych, what we have is rather three stages of bodily presence, three affective intensities, three events that we are able to access only via what they make us experience inside of us, our own disquiet.

Grandrieux's comments on the triptych here are not dissimilar to Deleuze's analysis of the non-narrative relation that flows across the individual canvases of Bacon's triptychs (and it should be noted that Grandrieux was deeply immersed in his research on Bacon at this time, these same notes telling us that he has just read Sylvester's interviews with Bacon and realized that his whole career

from *Sombre* onwards has been an attempt to put into effect what
Bacon describes as 'following this cloud of sensation in yourself'
without really knowing what this is, only that 'it's called instinct').
For Deleuze, in Bacon's triptychs, 'The three canvases remain
separated, but they are no longer isolated; and the frame or borders
of a painting no longer refer to the limitative unity of each, but to
the distributive unity of the three' (2003b, 70).

Even if it undoubtedly makes sense to think of there being a
linear and unidirectional evolution across the different iterations of
the works in Grandrieux's triptych, since the vast majority of people
will only ever see their filmic instantiation, much the same kind of
relation that separates yet unites the canvases of the triptych and
Unrest's individual works can be said to exist across and between
the different versions of each individual work, this relation being,
then, more of a metamorphosis than an evolution – a term I use
advisedly for reasons that will soon become clear. This is to say that
the difference between the various iterations is so great, both in
terms of content and form, that it becomes harder than ever before
to claim that there is here any indexical link from source text to
final product – or rather, in this case, subsequent iteration. Indeed,
both *White Epilepsy* and *Meurtrière* (and, one imagines, *Unrest* –
although to speculate about a work not yet made is a dangerous
enterprise indeed) originate in a text written by Grandrieux that
then becomes the ground upon which a semi-choreographed
performance with a dancer (in the case of *White Epilepsy*, four
dancers in the case of *Meurtrière*) is constructed through an intense
and intimate collaborative process during which other texts and
manifestos may be produced. This work leads to a live performance
and then, subsequently, a separate staging of the piece, this time
for the camera, there being (albeit in very different ways) marked
differences between the original performance and the film versions
of both *White Epilepsy* and *Meurtrière*.

White Epilepsy

The first work to be produced in this project (which was originally
to be called *White Epileptic Diptych*) was *White Epilepsy*. The text
that Grandrieux wrote as the originary ground out of which all
subsequent iterations would emerge is a long-form text containing

no dialogues that describes a series of set-ups and the kind of
camera movements and lighting conditions that will be employed
to create a specific kind of space in which these material elements
of the cinema become actors in the drama playing out as much as
the figures and environments described. The text begins as follows:

> Everything takes place in the forest. The trees and foliage in
> the foreground are violently lit. In the distance everything else
> recedes into blackness, into the dark of the night. The camera
> moves slowly. It *feels its way* through the dark space open before
> it. Sometimes the light from the neons used to illuminate the
> scene cut out suddenly and give way to a few seconds of total
> blackness, like a sudden fall, an unexplained collapse of the
> image. Then everything starts up again. The neons vibrate again,
> light up all around them and the camera continues its movement
> through this confusion of light and vegetation.

The text continues in a similar manner but each subsequent
paragraph adds into the scene a different figure or element.
We encounter a large black dog lying trembling on the ground
with a broken backbone, a gaping wound and blood-matted fur,
struggling to breathe and lift its head towards the camera, a look
of abject fear ablaze in its eyes. A clearing in the forest filled with
tall grasses and flowers that fall in and out of the light and create
the image in their own rhythm ['*rythment l'image*']. An elderly
man crouching in the clearing, naked, clutching at his stomach
wracked by violent spasms as he vomits out a thick, black, dense
substance. With a sudden acceleration and intensification of the
trembling of the entire image the camera starts to pursue a young
boy running as fast as he can through the forest, naked, looking
back over his shoulder with terror in his eyes at something beyond
the camera. As he runs 'the vibrations of the light [increase] such
that the child seems to be carried along in a kind of continuous
luminous palpitation that parts the darkness around him'. From
far away the muffled and barely audible voice of a young woman
is heard calling the boy's name, 'André', a call that only makes
the boy run faster and pull away from the camera until he is
swallowed up by the night, leaving the camera alone to slow its
chase, stop and pan to look towards the space whence they have
come and contemplate nothing but the white lines of brightly

lit trees in the night. Changing to a different kind of setting, the camera pivots towards the mud and grass of the ground underfoot. There is something hidden in the grass, something glistening in the mud, covered in a shiny, sticky mucus, burrowing the segments of its pulsing abdomen into the ground to lay its eggs. The seventh segment, we are told, does not have the anal appendages necessary for the male to grasp the female behind the head during coupling, this being the only way to distinguish between the different genders of this insect-like beast. The creature moves along with an 'infinite slowness turning in on itself' in a movement that can only be discerned by staring at the contractions of its brown musculature and the secretion of viscous mucus oozing from its main gland. The creature clutches in its claws a small mammal that it has paralysed and is keeping alive to feed its larvae when they hatch. The creature itself eats worms via an external digestive system that allows us to see its food dissolve in the digestive enzymes secreted into the cocoon-like casing it spins around its prey. The camera closes in on this scene and the ground beneath which teems with the seething life of millions of 'small translucent worms that writhe on the spot, turn in on themselves in the too bright light and transmit their chaotic frenzy to the ground and to the entire image'. Next is described a scene in a different part of the forest where we find ourselves in the midst of a pack of dogs tied to a tree, straining at their leashes, terribly agitated by something, one in particular, a big black dog held tightly on its leash by a naked adolescent boy who stares at something behind the camera, bumbling incomprehensibly and shifting his weight awkwardly from one foot to the other. 'The whole scene is caught up in the chaotic palpitations of this same white light. It seems as though a terrible force is about to be unleashed.' Another clearing. A young woman stands naked in the distance, waiting but not afraid. Cut to black. When the light returns the same young woman straddles a naked man, her pelvis thrashing frantically in the constantly changing light that creates 'a great sense of nervousness, a kind of luminous madness that lights up the scene intermittently'. Then suddenly the image changes, giving way to a shot of this same scene filmed now by a thermal camera that turns these figures into pure zones of intensity, white heat glows on black that 'devastate their faces' and strip them of any semblance of humanity as their movements become more and more animalistic in a Saint Vitus

dance at the climax of which the woman plunges her teeth into the man's flesh. Time is suspended in a brief moment of ecstasy that gives way to a terrible, blood-curdling scream. This scream seems to trigger something in the man and in a long paragraph marked out by italics Grandrieux describes how in this half-second an extraordinary inner light illuminates the man's soul, allows him to remember that very first moment of life, that very first scream. This sudden illumination, however, gives way almost immediately to total darkness as the man is gripped by a violent epileptic fit that possesses his entire body and gives birth to an even more terrible cry that eclipses all vestiges of the human. Cut to black. In the forest we see the young woman covered in blood, holding her head as though in pain. From her hand hangs a bloody, fur-covered chunk of flesh that swings against her thigh as she stumbles into the night, dazed. The camera follows but finds nothing other than a strobing light that alternately engenders then collapses the image.

While it may seem from this description that what we are dealing with here is the scenario for a supernatural horror film, the one-line summary of this work and Grandrieux's notes relating to this text indicate something very different. The summary reads, 'An ancient and archaic humanity in the depth of the forest performs the deranged scenes of a ceremony,' while the notes tell us that the figures inhabiting this film 'are subjected to subterranean forces that join them together' and that their actions 'answer to an injunction that we cannot understand but whose imperious sovereignty we sense' all the same. When thought about through this statement, rather than a horror film it would seem to be Grandrieux's intention here to present us once again with a space in which the petrified overcodings of subjectification are stripped back or, perhaps, in which they have never formed in the first place (John Jefferson Selve suggests the term 'anteform' (2013, 56)) and in which there exists, then, a liminal border between these figures and their environment that enables a communion to take place, a commonality between the text's various figures that extends across species boundaries – the descriptions of the dog and of the insectoid creature resonating as strongly with those of the screaming man and the young woman clutching a bloody lump of flesh, respectively, as do the images of the old man vomiting and the young boy running. This, then, is a space in which everything is in a state of unrest, where figures do not obey the axiomatics of an interiority that

would seek to shore up its own existence by defending itself against whatever lies beyond its border but, on the contrary, seek to escape via the spasmodic, ecstatic movement produced by an environment that engenders the dissolution of self. This, to put it another way, is a space in which everything throbs and pulses to the rhythm of an unknown and unseen power, a space that is transmitted (or to be transmitted, since we must not forget that we are still dealing here only with the originary text and not the eventual film of *White Epilepsy*) to the spectator through the ecstatic movement instigated by the scene of primal terror that (as with the children at the start of *Sombre*) places us outside of our self and quickens the systolic and diastolic contractions of our heart, preparing us for flight while simultaneously holding us captive in the spectacle, in the moment eviscerated of time where a second lasts an eternity. More than this, however, this movement comes to inhabit the spectator also through the slow strobing of the light that collapses the image and dilates our iris, and via the temporal contractions of time stripped of those punctual coordinates with which we would normally orient ourselves, coordinates so often signalled by specific sounds here absent and in whose stead sound plaintive drones seemingly out of time. Grandrieux writes in his notes:

The film should last about 25 minutes. That is the time necessary for the world of *White Epilepsie* to exist, the time required for the spectator to experience the film, for it to deposit itself in her. The time of the sequences is sometimes dilated, sometimes contracted, placing us in a kind of psychic deceleration, a form of numbness. The sound contributes greatly to these modifications of our perception of time. It is a distant sound, somehow muffled, as if exhausted.

While the sound is here stated to be of great importance, it is possible once again to suggest that the schema laid out in this text can be usefully conceptualized in terms of the sonic more broadly, for we are dealing with a space that is entirely immersive, constituted only by the resonant relations between its various elements and one which, what is more, exceeds all forms of boundaries, categories and taxonomies, just as the sonic bleeds into the spaces all around and operates according to a principle of propagation. Nowhere is this more apparent than with the insectoid creature that is

described in such a way as to be inseparable from the ground on which it lies and pulses and that is unclassifiable according to any prior taxonomic order. Indeed, if we remember the summary of this work that tells us that what we are witness to here are the rituals of an archaic humanity and recall the resonance that exists between this image and that of the young girl, then we must here admit the possibility that this creature is in fact human or, perhaps, expressive of the bare life of something that could eventually be called human.

It is by approaching this figure in this way that we are able to understand the link between this originary text and the next version of *White Epilepsy* to be created, a performance for a solo dancer. As Grandrieux explains in the notes that he writes to lay out the genesis of the second part of *Unrest*:

> I wish to continue here the work commenced with an actress and dancer, Hélène Rocheteau, more than one year ago. This work gave rise to a choreography, *Scène 4*, performed at the Pompidou Centre, Metz, and a film, *White Epilepsy*.
>
> With Hélène we ventured towards 'bare life', that life which imposes its pure and absolute necessity, above and beyond all forms of judgment, all values. Insects were our models. Insects are entirely taken over by the fulfilment of their needs. Nothing determines their actions other than this absolute and sovereign, instinctual imperative. They inscribed their convulsive movements, their awkwardness, their invincible obstinacy and their murderous voraciousness that occupies them so entirely in Hélène's body.[4]

Scène 4 was performed on 19 March 2011 at the Pompidou Centre, Metz, as part of an evening curated by Hubert Colas. The technical set-up (that would be replicated for *Meurtrière*) was both extremely simple yet extremely precise, requiring a square LED projector combined with a 210 colour gel to reduce the lighting level by two stops without discolouring the light at all and a 263 or 215 tough spun diffuser to reduce the light level by a further 1⅓ or 1½ stops and provide an even distribution of light, this whole rig being mounted horizontally, at a slight oblique angle above the stage, casting a very low level area of light down onto a precise area – this being the only part of the venue to be lit at all, the tech rider giving strict instructions to eliminate all other light sources including the

light from exit signs. Taking the idea of a ceremony very seriously, the soundtrack for the performance consisted of a loop of New Order's version of 'Ceremony' (1981) played at full volume, a song that – with its driving bass line jumping back and forth between Fs and Cs throughout the whole song and an incessant 4/4 rhythm that powers through the discordant rhythm guitar chords above and the syncopated thirds that split the fourth beat at various points – creates an almost trance-like state. In this space that pushed the limits of sensory perception to the extreme, audience members struggling to see anything at all while being subjected to an extreme sonic assault, a lone naked dancer, Hélène Rocheteau, performed a dance unlike any other, remaining at the very edge of the lighted zone, fading in and out of sight such that the audience could never be sure if they were seeing anything or not, nor, indeed, what they were seeing given the extreme unfamiliarity of the dancer's frenetic movements. As Grandrieux described the piece for the programme notes of this spectacle:

> The room is entirely plunged into darkness. A circle of light is projected onto the ground, an extremely weak light, on the verge of extinction. On the fringe of this circle, in the depths of darkness, something appears. A form incessantly metamorphoses, unstable, uncertain, both human and animal. Our pupils dilated, blinded by so much night, we search in the darkness. In the space of an instant what we desire and dread at one and the same time is made incarnate then falls away again, swallowed up once more in the folds of our soul, undone in the dark depths of the monad. (Grandrieux 2011)

Even though the film version of *White Epilepsy* that Grandrieux would go on to make after this performance is, in many respects, a very different work indeed, most notably because of the addition of a second figure for most of its duration and two further individual figures at the end, this description nonetheless remains, for the most part, entirely operational for a consideration of the film. Filmed in a vertical aspect, a choice Grandrieux ascribed to his desire to frame the image differently and in such a way that he could film the actors' hands and face at close quarters in the same frame (Grandrieux and Olivier 2012), we fade from black onto the back of a naked male figure, the head bowed such that it is swallowed

up in the darkness. Starting at the knees, this headless torso, lit in a dim grey green blue light that imbues this figure's skin with a hue both cyanotic and somehow non-organic, reinvents the form of classical Greek sculpture. This figure, indeed, seems to stand as still as a statue, yet we can discern in it a movement or, rather, a tension, as though it were trying not to move or to move so slowly as to not reveal itself in the process. The slowness of these movements seems to hold the figure in a state of suspension, both a suspension in time – as time is experienced as duration, generated from within the extension of time and not apprehended as a measure of discrete actions or relations to punctual external events or objects as is the case with a tracking shot of a figure walking down a street, for instance, or the gradual changes in light that cast shadows differently from and across a figure shot during the day – and a suspension in space as the male torso is the only solid form given to our vision, meaning that all movement here is generated within the flex and ripple of muscle and flesh and not from the position of the figure in relation to other objects in space or even the ground on which it (presumably) stands. The soundtrack is thick with different layers of noisescapes: we hear the regular chirp of the stridulations of crickets, the muffled, slow crack of branches breaking underfoot as this figure slowly shifts its weight from side to side or, perhaps, from another unseen entity making its way through the forest, the occasional heavy rhythmic rasping of close-miked breaths drawn in and out and a droning white noise roar that seems to pulse and throb like the sound of the diastolic and systolic contractions of an echocardiogram. The figure slowly bends forwards in a stoop, shifting its weight down through its legs which start to flex and bend at the knee. And then, suddenly yet slowly, one foot is raised slightly and stamped back to the ground, whether by accident as the figure stumbles or deliberately as part of a ceremonial dance or mating ritual we do not know. What strikes us most about the actions though is not the strangeness of the movement in and of itself but, rather, the movement that it produces in the flesh of the figure and the time of the image, for while the soundtrack and especially the stridulations of the crickets had led us to believe that this shot entertained a realistic relation to time – there being no discernible slurring or lowering of the sounds we hear as there would be if they had been slowed down – and while we have up until now laboured under the impression that the extreme slowness

of the movements here was produced solely within the body we observe, here, as this stomp sends a ripple up through the haunches of the figure, it becomes apparent that the image itself has been slowed down. The effect produced is somewhat uncanny as it creates an incommensurability of time between image and sound and within the figure and frame itself as the double slowness of the image is returned once again solely to the confines of the figure as the geometry of the image in time is drawn in the contractions of muscle, the stretch of sinew, the curvature of the spine, all of which render its movement in space as it lowers itself further into a crouch almost imperceptible.

The image fades to black inhabited only by the soundtrack and then back to a shot similar to the opening shot, although the figure is filmed this time from a slightly greater distance and at an oblique angle. Returned to an upright position, head still bowed in the darkness, the figure gradually collapses in on itself again, its back folding into a hunch as its arms are pulled into its stomach. The rasp of deep breaths returns to the soundtrack as the back rises and falls in time; in spite of this confluence of sound and image, it remains difficult to tie what we see and hear to an indexical relation in a recognizable reality, for what we witness resembles not so much the rhythmic contractions of respiration as a possession, the back appearing to swell and distend from within as if a creature producing the noises that we hear is trying to push its way out through the figure's ribcage.

We fade to black and back to, this time, a female figure shot at close range from the waist down. The figure walks slowly, gingerly over the forest floor then away from the camera until its entire torso from the knees up fills the frame. It comes alongside a male figure, perhaps the figure we have seen from the back before although we cannot know with any certainty since this figure appears now front-on, its face fully visible. The female figure walks slowly around the male figure, neither of them ever touching the other, the male's hand seeming nonetheless irresistibly drawn to the female figure as it passes close by.

We fade to black and back to these figures in a different pose. As before, the soundtrack continues across the break in the image, splitting the temporality of sound and image from each other, for if the soundtrack seems to create a temporal continuity, as the figures return to our vision we see that they have shifted their pose

considerably, the female figure now standing behind the male, digging her thumbs into his shoulders, pushing him down towards the ground and producing in his mouth a silent scream figured only in the gape and stretch of his jaw that echoes the lateral stretch of his limbs crumbling under the downward force exerted by the female form, pulling his body across the horizontal plane of the image and thus out of its primary verticality.

We fade to black and back to see the female figure stretched horizontally across the male figure now bent double, struggling to remain upright and to resist the weight of the female bearing down upon him with her forearm pushing into the back of his neck. Vanquished or exhausted, the male figure slowly slumps to lie motionless at the bottom of the screen, a headless carcass on the kill room floor. The female figure places her hand on the dark space where his head should be and pushes herself up, her body pivoting onto all fours and taking up a victorious, animalistic stance as a low, ominous roar issues forth. If it appears as though we have just witnessed the scene of a kill, however, the final moments of a familiar ballet performed by hunter and prey, what comes next confounds this impression entirely as the female mounts the male from the side, thrusting her pelvis into his flank, writhing on top of him with a motion whose purpose we cannot grasp and that is transmitted to us then only as a movement that is made stranger still and intensified by its slowness in time.

We fade to black and then back to a close-up of the two figures, one slumped on top of the other. We are at first unsure whether their positions have changed, whether the male has now assumed the upper position or whether he remains crushed under the weight of the female now collapsed on top of him. We soon realize that they are as before, with the female on top, but once again this taxonomic separation is confounded as the female digs her fingers into the male's shoulder, extending her arms and pushing herself upwards from the fulcrum point where her pelvis lies on the male figure's back, making it appear, once she is raised into the upright position, as though they form one body, as though the male figure is now her abdomen. The scene metamorphoses once more as she pulls her hands back gently over the male figure's back, in a movement that pulls the camera with it, reframing these bodies such that we see the male figure lying on the floor, his buttocks slightly raised, pressing back into the pelvis of the female figure whose hand movements

FIGURE 17 *Screenshot from* White Epilepsy. *Courtesy Epileptic.*

now seem to belong to a moment of post-coital tenderness as she remains inside him, still thrusting sporadically to assert her control (see Figure 17).

As should be clear from these descriptions, the figurations we are presented with here cannot be traced back to any prior form of identity, to any recognizable species, to any known patterns of behaviour, to any fixed gender boundary, to any identifiable motivation, to any specific outcome. The film continues in this vein for its first 49 minutes at which point the female leaves the male figure and walks off into the darkness, leaving the male lying on the forest floor. After a long pause the soundtrack shifts, being taken over by an almost machinic noisescape and then, a few seconds later, we cut (not fade) directly to an entirely different image.

We see a woman's face, brightly lit and overexposed, the strands of her white hair drawing brilliant white lines across her face and the blackness of the background as do the incandescent branches of the trees behind her. The image is almost entirely white, washed out in the glare of a light we have not seen before, a blinding flare shot into the midst of the darkness we have been inhabiting for the duration of the film. The effect is deeply unsettling and physiological as our fully dilated pupils contract violently. As we adjust to this new environment and are gradually able to see again, this assault on our senses is doubled by an attack on sense as we notice a bright red stain dripping from this woman's mouth. Perhaps, we imagine, this is the female figure from before who was indeed hunting her prey and who has now sated her appetite, yet this cannot be so since the female figure from the previous scenes had dark hair. Perhaps then this is the same figure some fifty years later, her hair silvered by age? This does not seem possible either, for the face we see is not that of an old woman and the cause-and-effect relation that we seek to establish would, in any case, be annulled by such a temporal split even if it were. We are given no further clues as to how this scene may be articulated to what has come before in relation to what little narrative content has been made available to us, since this sequence of the film continues in this vein for 12 minutes with only one cut, this taking us to a very similar shot in which this white-haired figure is seen crawling across the forest floor rather than swaying in an upright position, almost catatonic. Throughout this sequence, however, the light is in a constant state of flux and movement, the changing incidence of its reflection making the whole image pulse and throb, producing an impression of movement across and between the light lines drawn by tree branches and hair strands that makes the image itself seem to contract and expand to the jerky, stuttering rhythm created by the extreme slow-motion presentation of the digital image and that enters into a contrapuntal dance with the noisescape of the soundtrack that falls in and out of rhythmic patterns.

As has been the case with the dark sequences of the film up until this point, we are then able to engage this image only in its movement, to follow the lines of force that compose the image, pulling its forms up into the vertical plane of the frame or across and beyond the frame and the zones of contrast that make the forms before us bleed into each other or the ground of the image.

While these lines of force have been previously deployed primarily within the image frame, however, in the dynamic relations instigated between and across the figures on screen, here, in the absence of a second figure, the sudden luminescent glare of the image directs the full force of the image out from the screen towards us, pushing us out of the deep saturated hues of the film that have drawn us into their depths until this point and stripping us of our ability to see with this excess of light. As the sequence progresses, the red stain on the mouth becomes, in our quest for some kind of anchor point on which to fix our gaze, a kind of miraculating centre, drawing our eyes around the screen and dissolving the forms and lines in our peripheral vision into an abstract play of light that, in the final moments of this sequence, burns brighter and brighter, its white heat intensifying and building up to a flash point that eradicates all remnants of line and form, the image being composed of nothing but its own incandescent radiance.

We cut and the image goes black once again, or, rather, in the blackness of the screen we see an indistinct form that seems at first to be but the afterimage of the preceding frame, burnt into our retina. As this physiological effect gradually recedes, however, we see that there is indeed a new form in its place, but struggle at first to pin the geometric shapes that we see – a circle in the centre of the screen flanked by a thick vertical line to its left – to a referent. As our eyes adjust further and with time to study the image, we make out the form of the bowed head of an old man, his arm hanging down by his side, the composition of the image seeming to pull this figure downwards. Resisting this gravitational force, the old man struggles to lift his head, to raise himself up as the light starts to pulse slowly again, the visual corollary of the soundtrack which is now stripped back to a low level noisescape overlaid with the slowing rhythmic pulse of a heartbeat that stops for a long pause then returns as the image flickers and fades to black.

The original version of *White Epilepsy* that was in part financed from a fund requiring the end product to come in at under one hour did not contain these final two sequences which were added only when Grandrieux decided during the editing of the shorter version that he wanted to 'break its unity, and open it up to another perspective'. What is more, the original film comprising only the shots of the male and female figures engaged in some kind of

relational act were all taken from the very end of the four night shoot. Grandrieux explains:

> I only retained the last hours of the four nights of the shoot. The rest belongs to what will one day be the *White Epilepsy* installation. You have to be able to take great liberty with the rushes, it's a material which holds its own truth and necessity, rather like a block of marble contains a potential form, a hand or a foot. The final sequence to be shot was filmed very quickly, without rehearsing, with just some precise data given to the two dancers concerning the 'criminal' behaviour of the Languedoc Sphex towards the cricket, behaviour magnificently described by Jean-Henri Fabre in his book *Souvenirs entomologiques*. (Grandrieux and Olivier 2012)

Meurtrière

Meurtrière continues this exploration of insect life, yet the original text written to conceptualize this second part of the *Unrest* triptych differs markedly from the first. Recalling the work done for *White Epilepsy* in which an attempt was made to channel bare life via insect forms inhabiting the body of a dancer, Grandrieux explains in the introductory notes for this text that this quest to access bare life will here take place by observing subjects placed in a state of exception, exposed to the absolute and limitless violence of a sovereign power as well as, 'and this is the terrible intuition of Georges Bataille, to another form of sovereignty, that of an "inner experience," an ecstatic sovereignty', a form of bare life that emerges 'in the absolute subjectification arising in the sphere of the camps or via the ecstasy arising from the dispersion of Being'. Everything here, we are told in an elaborate explanation of the set-up for the story, will take place in the midst of a war, in a house on the very edge of the conflict zone with the sounds of war all around. In this house, 'She' – who or what precisely we do not know – 'will exercise the most absolute form of sovereignty', an 'ecstatic sovereignty that carries her beyond herself' to the point that she resembles nothing else. 'Her body', we are told, 'is obscene, stripped of all modesty [,] a body of flesh and nerves, shot through with intensities, waves, forces, sensations. Here everything bends to her law, the law of

her body.' We are told that a diary containing an account of her last five nights in this house was found much later in a nearby town, lying next to the dismembered and half-devoured corpse of a young woman. On the cover of the journal and on a cassette found next to it containing a recording of the journal entries read by, we suppose, their author, there figured one single word: 'Meurtrière'.[5] A video found in this same place, meanwhile, contained the silent images of the unspeakable acts taking place in this house over five nights, each of which is described in the journal and given the name of an insect: *Mantis religiosa*, *Sphex flavipennis*, *Carabus auratus*, *Calliphora vomitoria* and *Cicada atra*. At the end of this theoretical reflection and set-up, Grandrieux explains that the film to be made – that will take as its own title the word inscribed on the objects described in the scenario, namely *Meurtrière* – will consist only of the contents of the recording media described in the scenario, which is to say the diary entries read out by the man and recorded onto a cassette and the silent night-time images filmed in this house.

Before passing to the journal entries themselves, however, in his extensive preparatory text Grandrieux first reflects on the choice of a vertical frame for this film and *White Epilepsy*. Noting that the vertical loopholes of fortified buildings that allow you to see without being exposed to danger are called in French *meurtrières*, Grandrieux goes on to reflect that, 'Fear constitutes the prime material of the cinema, its most unshakable foundation. It is what holds us in suspense, captive, for the duration of the screening.' The cinema, he continues, shows us in its interstices, in its cuts, in the gap of 1/24 second what we both desire and dread seeing, what we peek at through the slits of our fingers as children, 'an image that we do not recognize, about which we know nothing, that threatens us'. This image, for Grandrieux, speaks to an originary event much older than psychoanalysis, bearing witness to the remnants of a foundational act, the last trace of the background noise of an ontological Big Bang lying dormant in each and every one of us. It is to this image that *Meurtrière* wishes to give us access, 'an image that we can confront head on only by risking our own annihilation'.

At this point begin the journal entries themselves that are, as written texts, genuinely terrifying, describing a creature both human and insect at the same time who makes her slave (the narrator) bring her fresh victims every night to be slaughtered in violent sexual acts

that send her into convulsive fits of ecstasy. The narrator comments on the war-ravaged landscape and acts of ethnic cleansing going on all around, explaining that the sheer brutality of this environment is what makes her actions possible. This is a brutality he wishes he could escape but knows he cannot, having the courage neither to run away nor to kill himself, and so he brings her fresh meat every evening until the final night when the conflict breaks its lines and encroaches upon their house, forcing them to flee to another town to begin the cycle over again.

If this text seems to lay out very specific indications as to precisely what the film to be produced might look like, the final product once again resembles the written text very little – although perhaps to a lesser extent than ever before in this particular case, there being in the final film no voiceover, no wartime setting, no backstory of a journal, videotape and cassette, no narrator figure bringing victims to a merciless sovereign female power and no explicit violence. The text, indeed, which is undoubtedly of interest for the light it shines retrospectively on *La Vie nouvelle*'s choice of setting, seems to serve merely as a device to advance Grandrieux's own reflections on the kind of life and forces that he wishes to bring into being and the conditions under which these might be enabled. Rather than serve as a script, indeed, this text served as the conceptual foundation for another collaborative piece of choreography with four female dancers – including Hélène Rocheteau who had already worked on *Scène 4* and *White Epilepsy*. Over a period of five days in September 2013, Grandrieux worked closely with these dancers, writing a new set of notes at the end of each evening that were then read to them the following day before starting work again. A short version of the work lasting around 30 minutes was subsequently staged for a small number of spectators in five consecutive performances at the Whitney Museum of American Art on 14 October 2013, and then in its full 3 hour version as part of the Pharenheit Festival at Le Phare, National Centre for Choreography in Le Havre on 29 January 2014.

The audience members for this latter performance were all given a very small booklet containing the preparatory notes that Grandrieux wrote during the rehearsals for this work and a couple of shots of the performance itself. Resonating somewhat strangely with the original written text, these notes are effectively like – and structured as – a journal in which Grandrieux explains to the dancers what it is that they are trying to access and reflects on what

happens as they gradually come to embody this. What it is that they are to incarnate is described simply as 'ça' [that] or 'la chose' [the thing], a pure state of desubjectified being, a form of absolute sovereignty such as that found in the original text where everything is under the sway of an absolute power. The notes begin by telling us that the object of *Meurtrière* is 'the thing', and that this thing is

> senseless, mad, untenable, hysterical, grotesque, phobic, dangerous, brutal, devouring, savage, sexual, unpredictable, stupefying, frenetic, atrocious, concerned, frightening, ecstatic, desirable, vulgar, perverse, embarrassing, immodest, nervous, obscene, sacred, sacrificed, furious, murderous. But above all, the thing is without intention.

This lack of intentionality is absolutely key to this work, for what becomes clear in these notes is that Grandrieux's desire is for these dancers to come to embody something akin to the insect life of Fabre (1879), an animal state that is purely instinctual, entirely attentive to and governed by changes in the ambient conditions. Grandrieux explicitly conceptualizes this state of being in terms of Rainer Maria Rilke's concept of the Open as expounded in his eighth Duino Elegy (2009, 49–54). For Rilke, the Open is what the creature sees and that we humans do not since from an early age our gaze is turned in on itself and trained to see only appearances; it is a fully chiasmic relation with the world that, unlike ours, is not bound up in and limited by knowledge of its own finitude. This gives the creature an entirely different relationship to time, for if in fixating always on our own death our relationship to time is always finite and outcome-directed, the creature, on the contrary, is immersed in eternity itself.

The openness of the mode of being described in Grandrieux's preparatory notes is expressed not only in the relation to time, however, but the very fleshy materiality of the dancers' bodies in their relation with each other and all that lies beyond them. In a kind of Deleuze-inspired riff on Merleau-Ponty's concept of the flesh of the world, Grandrieux writes in his address to the performers:

> On the lookout and ensnared in this stuff of the world [*cette pâte*], this common thickening, this wave renewed again which hollows itself out and swells up again and surges forth then

empties itself out again. On the lookout and taken up in one single mass, a molecular mass that lines up its possibilities slowly, from one thing to another in a sustained continuity. This continuity imposes its development. The body does not suddenly fall, it crumbles. The body does not shift regime all of a sudden, it passes from one thing to another via the passage of each particle of every molecule which is modified from within. This is an oceanic crossing, flesh. That's what flesh is, this molecular continuity, this darkness traversed, this silent obscurity.

The stuff of the world is here described as an undifferentiated mass, a 'pâte' (dough or thick paste) that takes on some consistency only through the establishment of certain rhythms that instigate a movement both within semi-individuated beings and beyond them, form being conceptualized here not as the contour of a clearly delineated entity separated from its ground, but only as the movement that renders visible something we might call a form. If this mode of being is described as oceanic, it is then precisely because its forms are like waves, defined only by the rhythm of the movement that carries them along in time. Or, as Grandrieux writes later in these notes:

> It is then this very movement, this swell that subtends *Meurtrière* completely, it [*ça*] empties itself out and swells up and falls away to empty itself out again and again and again, and then in different speeds, other directions, the same swell.
> ...
> It is this coelenterate[6] move, diastole and systole, this very movement of the heart that animates *Meurtrière*, of blood pumping through veins, dilation and ejection, a pulsing coming from the depths of time, the heart being the first organ of the body, of cell division, the first beat, the first movement.

Here as before the body can be conceptualized only through movement, only as a form that is undone via its inscription in time and then spatialized in time by a rhythmic principle that forms a perceptible event, a dynamic entity moving at speeds or vectors that generate sympathetic, contrapuntal or dissonant relations or resonance with the vibrant matter all around. It is when we are able to intuit this relation to another entity that we enter into the realm of affect, a relation that is transmitted not via the communicative

infrastructure of a cerebral or emotive network always already partially formed, preconditioned and thus at a point of remove from the Real, but, rather, in an immediacy both temporal and material, a kind of quantum entanglement that points to an originary, archaic common origin pre-subjectification, the realm not of form but the formless. Grandrieux writes, 'It is through this body ... that these affects out of which human matter is woven can return, freed from all trace of psychology and history'.

Grandrieux's notes provide some insight as to how this chiasmic relation is effected in the bodies of the dancers. In one of the entries, indeed, he describes how the rhythm or movement that is the object of *Meurtrière*, this thing that is not a thing, comes to inhabit one of them then the other in a 'mutual contamination' of bodies, a process via which one single gesture traverses these bodies differently, the rhythm of one body's movements infecting the others until they all pulse together on the floor then slow to a moment of respite, of apparent stillness, before the heavy rise and fall of one body's breathing starts the movement up again via different organs, different relations and to the beat of a different rhythm that remains nonetheless nothing other than the operational principle of *Meurtrière*'s 'unstable matter'. The challenge of the work of art, the challenge that Grandrieux has spent his artistic career investigating in one way or another up until this point, however, is how to transmit this movement to the spectator, how to generate affect from the formal operations of the work.

Once again and most obviously, this takes place here firstly via the removal of the actions or events staged from any narratival or psychological framework such that what we see is generated from within rather than in accordance with an external imperative towards which these events would be directed as a finality. As already discussed, this lack of intentionality is doubled here by the very nature of the insectoid life we are presented with, which, like Rilke's creature, remains entirely open to the world, in a state of constant tension, a kind of suspended animation attentive to anything in the surrounding environment that might help it satisfy its primal and instinctual desires. For the performance of *Meurtrière*, this abandonment of self to the environment is instilled in the members of the audience via the protocol required to enter into the performance space. Instructed to hold hands with the person next to them, the members of the audience are led as one,

like a gigantic centipede, into the pitch black of the performance
space's antechamber, relinquishing the intentionality of movement
to an other. From the antechamber the centipede formation is led
around the outer perimeter of the large square of the performance
space and left curled around its edge. At a standstill the members
of the audience separate again and settle in to this space which
is pitch black apart from a 1 metre square of light suspended in
mid-air in the middle of the space, a light so feeble that it seems to
cast almost no light into the space and thus draws the spectators'
attention to it, like moths to a flame. Gradually, however, growing
accustomed to the near total darkness, pupils dilate and contract
four shapes on the floor into the realm of visibility, forms that
have been there since before the audience entered but enter into
perception only once the spectator's body has taken up the rhythm
of this space, has been reshaped, literally, by the frequency of the
room. This light seems gradually to draw these figures towards
it also as they slowly stir, stretch, pulse, rise, throb, moan, groan,
cry, thrash, contort, twist, fall and rise and fall again to the beat
of a rhythm that is present nowhere except in the relation between
them and this space. As Manuela Morgaine has described this
scene wonderfully:

> You see convulsions, whirlwinds of hair, flashes of teeth,
> contortions, arcs, a tornado, skin, instability, combats, nothing,
> seismic quakes, canvases of the Grand Masters, reflections,
> gushes, waves, percussions, eruptions, sometimes all at once,
> orgasm and ocean.
> You hear pure breath then sighs, bellows, cries, a cough, a wail,
> hands hitting a body, like a rhythm that drives it, reanimates it,
> and then friction, flows, and, under it all, a swell. (Morgaine 2014)

The movements on display, movements unlike any other ever
witnessed, that push the dancers' bodies beyond the limits of what
we think a body can do, how it can move, seem impelled by a force
that remains entirely elusive and whose end cannot be known or
even guessed, and yet the extreme violence of the gestures does not
seem in the slightest arbitrary or random. Morgaine again:

> You soon understand that the choreography, this articulation
> of forms, is improvised, yet that there is a protocol here, codes

and movements that are deliberate and prescribed, pulsations, rhythms, but that time belongs only to the dance. That there is no single master directing the movements. But neither are there simply dancers doing as they want guided only by inspiration. Here the body is the sole sorcerer's apprentice of its own dance and soon of its trance.

Miraculated by a rhythm not entirely their own, abstracted from all of the psychological and social structures that constitute the architecture of our human self and identity, Grandrieux describes the state in which the dancers find themselves as, somewhat paradoxically, an 'immense solitude', a solitude expressed and generated out of the dancers' nakedness which is here removed from the overcoded realm of the erotic to become rather a statement of brute facticity, as well as from the gestures of their naked bodies that articulate them to a force that lies beyond their body. Grandrieux writes in one of his rehearsal addresses to the dancers:

> Hands grasp nothing, arms do not embrace. They are simply appendages, sometimes cumbersome, whose usage has been lost, bits of bodies removed from all social or cultural constituencies, beyond all knowledge. What *Meurtrière* requires is a body that does not know, entirely subjugated to the rhythm that drives it. It is this constant rhythm from which every act emerges. A fierce will that derives only from instinct.
>
> Your solitude is immense. All those of your species, entirely given over to acts of self-perpetuation experience the same solitude. Opposite you what we look at is what we once were, an ancient state of being, transmitted in infinity from man to man.
>
> The world of *Meurtrière* gradually begins to infiltrate us, to occupy us.

To make a claim such as this is perhaps easy when one is the creator of a piece, yet less easy to claim as a broader principle in relation to the experience of the piece by the members of the audience more generally. This strange experience of a crushing solitude that both undoes the self at the same time as it abandons the self to the absolute indifference of a force far greater than any individual is, however, remarkably close to the state of profound boredom as described by Heidegger in a series of lectures from 1929 to 1930

and published as *The Fundamental Concepts of Metaphysics* (1995). For Heidegger, the most interesting thing about boredom is precisely that it places us in a very specific kind of relation to time, an experience of time from within, as it were, or, perhaps better, of time as something beyond our control that is not governed by our own outcome-directed actions nor our own finitude as mortal beings – similar then to the open state of being of Rilke's creature – and the realization that this kind of time *is* in fact our time – or, rather, our Dasein (Heidegger 1995, 133). The suggestion here, let us be categorical about this, is *not* that *Meurtrière* is boring but that the state it induces in the spectator has much in common with Heidegger's account of profound boredom which is in fact not boredom at all as we would generally think of this state but which, first and foremost, brings about a very specific kind of attunement to *time* and thus ontological insights.

For Heidegger, philosophy is an enterprise of 'comprehensive questioning arising out of Dasein's being gripped in its essence' (132). He continues, 'Such being gripped however is possible only from out of and within a fundamental attunement of Dasein. This fundamental attunement itself cannot be some arbitrary one, but must permeate our Dasein in the ground of its essence' (132). Profound boredom is one of the means by which we can awaken this attunement, access a different relation to time and thus to the ground of the essence of Dasein such that we consequently gain an insight into the nature of existence that destabilizes the individual being's sense of coherence and autonomy – which explains why boredom for Heidegger is a mood that is intimately related to anxiety (or unrest, we might say here). As is the case with *Meurtrière* and its invocation of 'ça' – an unidentifiable, indeterminate, unfamiliar force that part conditions the movements and trajectories of all around it – profound boredom for Heidegger similarly puts the individual in a situation where all that can be said of this situation is that '*It is boring for me*' (134). This 'it', he explains, 'is the title for whatever is indeterminate, unfamiliar', and an encounter with this indeterminacy in the most absolute and profound form of boredom leaves the self behind such that in this experience we can no longer talk of our 'beloved ego of which we say that I *myself*, your yourself, we ourselves are bored' (134). Rather, this experience is such that the individual experience of this situation has no purchase on what is actually happening, with the result that we can only say, 'It is

boring for one. It – for one – not for me as me, not for you as you, not for us as us, but *for one*. Name, standing, vocation, role, age and fate as mine and yours disappear' (134–5). This identity is not replaced by a kind of 'universal ego', instead we become here an 'undifferentiated no one' (135), transported into 'a realm of power over which the individual person, the public individual subject, no longer has any power' (136).

This scenario resonates strongly with what has been said of *Meurtrière*'s performers who are carried along by a subterranean swell and, indeed, with what has been said of the audience's entry into this space. More than this, however, it seems to speak also to the experience of being in this space and with these bodies. In Morgaine's account of her experience upon entry into the performance space, indeed, she writes:

> You wish to get down off your feet, to eclipse yourself, like the light, you seek the half-light of yourself, to diminish your own shadow. You want to make yourself disappear, all but your eyes. If only you could bury yourself under the dance mat, or behind the black curtain you are leaning against. It's not that you're ashamed or want to hide yourself, it's that you want to abstract yourself. Your winter garments are heavy, if only you also could lie down naked in the darkness, you know no one would fall for it. You feel as though you have been stripped naked as soon as you enter into this radiographic space which unavoidably imposes itself on you. And so you fade into the darkness, you disappear from yourself as much as you can and, crouching like a beast, you watch… . (Morgaine 2014)

Another point of rapprochement here can be found, however, in relation to the experience of time in Heidegger's profound boredom and Morgaine's experience of *Meurtrière* – which, as she describes it, is uncannily similar to my own. For if Morgaine describes in her account how she 'quickly lost all sense of time', for Heidegger, rather than a sense of time dragging or of 'being set in place by standing time' (141) as is the case in the two lesser forms of boredom he discusses, here, 'in this "it is boring for one" one feels timeless, one feels removed from the flow of time' (141). If we feel removed from the flow of time, this is because the aspect of time now present to us, to 'one', is not clock time

or any form of time in which notions of anteriority, posteriority and presentness would have any purchase but, rather, 'the single and unitary universal horizon of time' (145) that is indifferent to any particular moment in time and furthers our sense of the absolute indifference of Dasein to individual beings. Heidegger writes, 'Time is that which, in this boredom, strikes Dasein into time's entrancement. Through such entrancement it gives beings as a whole the possibility of a telling refusal of themselves to the Dasein that entranced' (148).

It is here that we understand most clearly that the profound boredom Heidegger talks of has little to do with how we might normally think of boredom. While the lesser forms of boredom are related to profound boredom insofar as they are states in which the subject's relation to time is fundamentally altered, profound boredom is occasioned not by an external situation such that boredom can be attributed to a cause but, rather, from an acute realization of one's own relation to time. This particular attunement to time and sense of one's own being in time impels an insight into the true nature of existence, what Heidegger calls the 'moment of vision' [Augenblick] (149). What is revealed in this moment of vision is, as he writes, that 'Dasein is not something present at hand alongside other things, but is set in the midst of beings through the manifestness of the full temporal horizon' (149).

Even though there is here a refusal of self, a refusal of individual being similar to Grandrieux's idea of an immense solitude, it is through this refusal of self that, according to Heidegger, we are able to reconnect with a fundamental truth about that which unites us, a truth that is far more powerful than the illusory bonds proffered to man in the midst of what the Frankfurt School would term his alienation emerging from social atomization. Heidegger writes:

> The absence of an essential oppressiveness in Dasein is the emptiness as a whole, so that no one stands with anyone else and no community stands with any other in the rooted unity of essential action. Each and every one of us are servants of slogans, adherents to a program, but none is the custodian of the inner greatness of Dasein and its necessities. ... The mystery [Geheimnis] is lacking in our Dasein, and thereby the inner terror that every mystery carries with it and that gives Dasein its greatness remains absent. (163–4)

It is paradoxically then through the abandonment of self and identity, even communal identity, that an insight into the truth of existence can emerge that reveals to us the much deeper force that unites all existence. In Heidegger's terms, it is through beings' 'telling refusal of themselves as a whole' that takes place when 'boredom impels entranced Dasein into the moment of vision as the properly authentic possibility of its existence' that there arrives the realization that this is 'an existence only possible in the midst of being as a whole, and within the horizon of entrancement' (153).

If we now turn back to Morgaine's account of her experience of *Meurtrière*, what becomes apparent is that something incredibly similar is in operation, that a certain experience of time, of relation to self and other that is impelled both by temporality and also here by nakedness and the removal of the situation being played out from any possible hermeneutic or intentional framework engenders an earth-shattering, deeply disturbing yet ecstatic moment of vision. She writes:

This is now a unique time, unique for you, in which one of them, one of those naked female forms comes to wash up against you, on all fours, right up against you, its breath like a muzzle placed in your lap, breasts hanging like those of the Capitoline Wolf, against you, motionless, when this form comes close to you, rests there to inhale, breathe, with no odour after this convulsive and swelling flood, it must have been going on for 2 hours, you're breathless with tears in your eyes, you're submerged under a new emotion. Who knows why. This form, this 'Thing' built like a woman, does not move, does not caress you. It doesn't attract you. It doesn't provoke you. It doesn't seek you out. Doesn't attack you. It abandons you. Abandoned to itself it abandons you. It stays there for at least a quarter of an hour against you without the slightest movement. You are there with it 'without intention'. Finally 'without intention'. Could you have imagined that before? That it might be possible to get to this point, to be purely and simply 'without intention' and that this should be so transformational? You lack nothing. You have been made to act without manipulation. The other has enacted you by doing nothing, by doing nothing to you and without you doing anything. You desire to do nothing other than what you are doing here, what you are living here, except perhaps to prolong

the duration of this body to body relation without intention. We have not moved one iota, one nor the other, our hair, our breath are combined. Your heart is beating out of your chest. Inside you on the Richter scale it's the big bang, the initial instant. And in this the most moving moment comes as you touch the initial instant of vision. (Morgaine 2014)

As in Heidegger's state of profound boredom in which an insight into Dasein is awakened by a particular kind of relation to time that removes the experience of time from one that is governed by the perspective of the experiencing subject in such a way that individual being is articulated to and subjected under Dasein, so here a different kind of relation between beings is brought about. This relation is governed according to a rhythmic principle that miraculates the bodies of the dancers to its pulse at the same time as it removes the spectators from any external relation to time, placing them at the heart of its systolic and diastolic contractions that accelerate and slow from a frenzy in which bodies are blurred by speed to a new stillness that pulls everything towards them, distending time in the process. To put it in the simplest possible terms, what is staged in the performance of *Meurtrière* is a kind of ontological levelling produced out of a spatialization of time in which time itself is primary, action coming into being as a secondary effect of the contractions of time rather than time being extrapolated as the secondary effect of movements or actions in the world.

In the film version of *Meurtrière*, which combines many different techniques already seen in Grandrieux's earlier works, this principle is extended to the very matter of the moving image as filmic techniques are here used to bring about a flattening of both speed and scale that creates an incommensurability between discrete objects and bodies in the world and in time. The film consists of a series of long shots in portrait orientation (as in *White Epilepsy*) presented in extreme slow motion (similar to *L'Arrière-saison*). What we see in these shots are the bodies of *Meurtrière*'s dancers/ performers, sometimes standing extremely still, sometimes in the throes of the frenetic choreography of their St Vitus dance. In those shots approaching near total immobility that are stretched in time by slow motion, an incommensurability is instilled in the image as it becomes impossible to know whether we are dealing with a

still image or a still body. The first shot of the film, for instance, shows us a naked female torso leaning backwards, seeming almost to float in the darkness that engulfs its perimeter and contours. It remains still for almost 3 minutes at which point something seems to move inside of it, to pulse from within. This movement slowly coalesces into a new form and we realize that we are witnessing a dissolve transitioning us to a new shot. This technique is sustained for the transitions for the duration of the film, the geometry of the sets of juxtaposed images being such that the confluence between forms and contours in various zones of the image plane appears to create a movement within one shot before it is superseded by the subsequent shot – and this even when the scale and framing of the juxtaposed shots is very different (see Figure 18).

FIGURE 18 *Screenshot from* Meurtrière. *Courtesy Epileptic.*

This is not the only way in which movement is produced within the image, however, for many of the film's shots capture not near immobile bodies but, rather, the bodies of the dancers thrashing, convulsing, shuddering, pulsing in and out of time. If in the real time of the live performance the dancers' actions were already governed by a strange attractor and resolutely not outcome-directed, intentional, the extreme slow motion used here only intensifies this aspect of the work to produce an image that is not so much a representation of bodies engaged in a meaningful activity as a study of bodies in motion. To suggest this is not to say that we are dealing here with an abstract work, for, as was the case in *L'Arrière-saison*, there is something about these bodies as they are presented that inscribes them in the reality of an entropic universe. Indeed, while the four dancers here are all young women whose bodies would not under normal conditions reveal themselves as already subject to the forces of age and gravity, the extreme slow motion intensifies or rather makes visible in isolation movements of the flesh that would normally remain masked behind the movement of intentional action towards specific ends, each ripple, crease and wrinkle enfolded in the body's surface by its kinetic energy, staging the struggle of the body to endure and resist entropy. Even though the movements here are not movements that we recognize as human, the forms via which they are deployed remain indelibly human and, as such, inscribe *us* in this same relation to time, subject to it and not the master of it. This transference is doubled, what is more, by the geometry of the vertical frame which mirrors our own verticality, drawing us upwards, registering our own form, our body, at the same time as the agential capacity of the body before us is disavowed, its situation in space and time being regulated by the forces, rhythms and temporality of the film (as is ours). The impression produced is perhaps best described as an impression of floating, of being held in suspension and the verticality of the screen similarly alters our relation to time.[7] Indeed, if generally the widescreen aspect ratio of the cinema screen deploys time horizontally, directing action towards specific ends, outcomes or logics dictated by the lateral syntax of pans, tracking shots and reverse shots, here time seems also to be drawn upwards, distended and stretched towards something that remains beyond the frame.

If the title of *Meurtrière* is particularly apposite, it is in large part, then, because verticality plays such a vital role in the film,

pulling time and the bodies that would generally be contracted together in a linear, lateral and delimited logic to produce meanings or plots upwards into a different kind of relation. What is effectively murdered here, then, is the possibility of closure or fixed perspective, and this in turn must make us question which side of the *Meurtrière*, the loophole, we as spectators are situated on. For while it may appear, logically, that we are behind the loophole, observing the figures on screen as though from a distance, all-seeing yet unable to be touched and safe from threat, everything about the reading proposed here suggests that the opposite is in fact true. The rhythmic relation instigated, indeed, and the extension of the idea of the body and of flesh beyond the material and temporal constraints of embodied subjectivity place us on the other side of the loophole, in a place where those forms constituting what we take to be our existence are placed at risk of dissolution. And we, like Claire, willingly submit to this potential annihilation.

Conclusion

If profound boredom, according to Heidegger, is able to reveal ontological truths to us that take us beyond our subject-centred or even anthropocentric perspective, this is because, as we have seen in the previous chapter, it instigates a very particular kind of relation to time, one that is not governed by the finitude of our own mortality. In Grandrieux's last film to date, *Malgré la nuit* [*In Spite of the Night*] (2015), the main protagonists are similarly on a quest to escape their own situation, to find a connection to something greater than themselves and their personal histories through love, sex, music, drugs, violence or, in the most extreme case, by flirting with death itself. Human mortality or, rather, our consciousness of our own mortality, is here explicitly articulated as that which prevents man from accessing a more instinctual form of existence. Called in to talk to (one of) his girlfriend's father, Vitali (who wishes to pay his daughter's lover, Lenz, to leave the country and never return), Lenz admires the aquarium in Vitali's office. In a long monologue during which we watch extreme close-up shots of the tail, scales, eyes, gills and heads of Vitali's exotic fish collection overlaid with superimposed images of his head that fade in and out, seeming at times to be a reflection in the aquarium glass (see Figure 19), Vitali says:

> I see you like my fish. So do I. I too like them, my fish. I love their grace, I love the splendour of their movement. Even in captivity they express their nature fully. An entire world. They are animated by the very necessity of their instinct. They are absolutely present, in each instant, profoundly themselves, profoundly real. Alas, this is not possible for us. Such fulfilment, an unattainable fulfilment. If we could only, even for an instant, live such an experience, feel the absolute power of instinct, we would never be willing to return to our lives. They would have become unbearable for us. Do you know why we aren't like them, Lenz? We can't be. Because we know we're going to die, and they don't.

FIGURE 19 *Screenshot from* Malgré la nuit. *Courtesy Mandrake Films.*

We are here extremely close to *Unrest*'s insects – and one of *Malgré la nuit*'s subplots might be seen as a take on the found video footage of a scene of extreme cruelty and violence in the preparatory text for *Meurtrière*. There are, though, many resonances to be found between *Malgré la nuit* and the *Unrest* trilogy other than this (and much of Grandrieux's other prior work too, of course). This has been noted by Raymond Bellour who also connects *Malgré la nuit*'s fish and Vitali's monologue with the Rilke text examined during our own interrogation of the *Unrest* trilogy (2016, 14). The film's reflection on this question is, however, taken to a whole new level in a striking single, short, almost abstract shot that comes towards the end of *Malgré la nuit*. In the film's climactic scene that repeats a scenario already presented earlier in the film when Louis showed Lenz footage of an orchestrated murder, suggesting that the victim might be Madeleine, the person that Lenz attempts to track down throughout the film, we find Hélène and Lenz lying naked and unconscious on the floor of a dark room watched over by a German shepherd. Under orders barked out by Vitali, the man with the metallic voice (as he is credited) has beaten Lenz so severely and kissed Hélène so brutally through the latex bondage mask that covers her entire face with but one small opening for the mouth (see Figure 20) that both lie unconscious. As Vitali films their naked, lifeless bodies, the man with the metallic voice bends down and slips

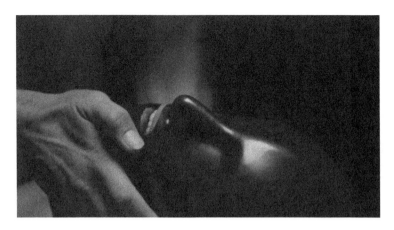

FIGURE 20 *Screenshot from* Malgré la nuit. *Courtesy Mandrake Films.*

a blue pill into Lenz's mouth. This, although we are never told so explicitly, is in all probability a dose of cannibal, a drug described to Lenz earlier by Vitali as 'a synthetic amphetamine that shuts down entire regions of your central nervous system, plunging you into a primal state in which you devour the first person you see'.

The light from the camera moves away, signalling the departure of Vitali and the man with the metallic voice and plunging Hélène and Lenz's bodies into darkness. Fade to black. We fade back to an extreme close-up shot of something entirely unrecognizable that seems to broach many different taxonomies. Its shiny, smoth white surface is covered with some kind of mucus that glistens and produces a sickening sound as the folds and pleats of this thing pulse and slide imperceptibly. Below one fold we see what appears to be a small mouth with some form of embryonic teeth, but a shift in the light as this thing seems to breathe in and swell from within from the force of pulmonary expansion make this opening seem more sphincter-like, what at first looked like teeth revealed to be puckered ridges of folded muscle. Physiological categories are confounded in more ways that this, however, since we are somewhat uncertain if we are looking at the internal organs of an animal of some kind via some kind of endoscopic shot or whether we are observing some form of monstrous being situated in an external reality. This is because, firstly, we are so close to this thing that it fills almost

the entire screen, allowing us no visual contextualization – just as we have no possibility of effecting any diegetic contextualization for this scene in relation to what has come before – and, secondly, because of the nature of the organic tissue itself which is in parts translucent, membrane-like, revealing a network of thin blue veins, and in others more opaque and fleshy, cephalopodic or umbilical in its twist.

We cut to a slightly different angle as this thing moves across the screen via a series of contractions, showing us the extremity of one of its folds which is formed into a single claw-like appendage made not of keratin but this same glistening white tissue. Underneath this fold, next to the sphincter, a different kind of flesh tinged pink is folded into forms that seem somehow recognizable as organs, even if their function remains entirely mysterious, never more so than when what may or may not be the thing's head comes into view, a monstrous, penis-like protrusion with some kind of eye or stamen emerging from the meatus. We fade to black for a long beat and back to a shot of the German shepherd on its side, its jowls gaping open, tongue limp between its teeth, blood pooling around its head, and we hear Hélène coughing and spitting. We cut to a shot of Hélène, still wearing the bondage mask, her naked body now covered in blood that may or may not be her own. Vitali roughly pulls Lenz up from the ground and we see that he also now has blood smeared across his torso, although less than Hélène. Vitali hands him a gun and instructs him to do what he has seen someone do before, to kill the naked, balaclava-clad female before him.

The puzzling sequence of the monstrous thing that we are presented with in the midst of this scene is undoubtedly based on the description of a monstrous, purely instinctual insectoid form of life described in detail in the preparatory text written for *White Epilepsy*[1] – and in this regard it is significant that in the journal written during the shooting of the film, Grandrieux refers to this only as 'the thing' (2016b), the very same word out of which *Meurtrière* is said to be born. Here, this thing is surely intended to figure the state of primal being brought about by the drug that Lenz has been forced to ingest, a state of being both unrecognizable as human yet nonetheless resonating uncannily with our own being on a deep and archaic level. As such, this thing can be thought of as being akin to those monstrous entities found in horror movies analysed by Dylan Trigg in his book *The Thing: A Phenomenology of Horror*, a volume

in which he attempts to formulate a phenomenology that avoids the subject-centred pitfalls of the common phenomenological position by arguing that the human is always defined in relation to and is then co-constitutive of the non-human. For Trigg,

> Another body needs to be accounted for in phenomenology. A creature that invades and encroaches upon the humanity of this thing we term 'the body', while at the same time retaining the centrality of the human body as its native host. (2014, 8)

The body that Trigg posits and that, for him, is figured in various horror films – and in most exemplary fashion in John Carpenter's *The Thing* (1982) – is, as he writes, 'not only anterior to humanity but in some sense opposed to human existence, at least insofar as it destabilises the experience of being a subject by establishing an unassimilated depth within the heart of familiar existence' (8). Similar to the way in which profound boredom, for Heidegger, connects individual human existence with a form of being that exceeds the limited significations and temporal sphere determined by human finitude, for Trigg, drawing on the work of Merleau-Ponty employed earlier in this study, the body horror contained in these films connects us to a different ontological (and consequently temporal, as in Heidegger) conception of life. Trigg writes:

> In contrast to the idea that life evolves as a gradual process of cephalisation, thus departing from the realm of nature, Merleau-Ponty instead advances the claim that the body is 'reflection in figural form'. Put another way, it is not the case that a human being begins at one point in the deep past and then proceeds to sublimate the rational unfolding of a corporeal history. Rather, that same history co-exists alongside the subject in the present, forming a double that both mirrors and distorts the emergence of human existence. (28)

For Merleau-Ponty, as Trigg goes on to argue, there exists then 'a kinship that invites the possibility of the animal and human living not merely alongside each other, but also *within* each other', 'an ontological continuity between different lifeforms' (28). Trigg continues: 'The kinship, he [Merleau-Ponty] goes on to say, is "strange," because in it, we confront the visibility of the

invisible: that is, the fossilized remains of a life that is beyond experience, but nevertheless constitutive of life' (28).

In Trigg's analysis, it is specifically the aesthetic image of the horror genre that enables us to 'move toward this underside [of experience] by clothing a nameless, formless thing with a discernible appearance' since it is precisely here that 'the alterity of subjectivity gains a counterpart in the experience of horror' (30). Even though the thing figured in *Malgré la nuit* might be said to have much in common with the creature in Carpenter's *The Thing* – described by Trigg as 'less a creature and more a composite of different lifeforms arbitrarily bound by being constituted from the same elemental stuff: *flesh*' (137) – what is remarkable is that this image appears not in the midst of a horror film but, rather, a film firmly situated in the reality of the everyday or, perhaps better, in a resolutely non-fantastical realm. *Malgré la nuit*, indeed, is perhaps the most conventional narrative- and dialogue-driven of Grandrieux's films to date, consciously situated in a recognizable Parisian setting in which figure heavily both the touristic clichés of Paris' monuments and the familiar sites of the everyday for the city's locals – including high-rise apartment blocks on the outskirts of the city, domestic interiors and the métro. Even though there are obviously extreme elements in the film's narrative that remove it from what we might normally consider to constitute the everyday, deep down this remains a recognizable tale of love, jealousy, loss and the complex web of intersubjective relations. To put this another way, this is resolutely not a horror film in the sense that Trigg apprehends this term. And yet the film *does*, as have all of Grandrieux's works examined herein, strive to connect us with an experience that exceeds the limited bounds of individual human experience, the banality and tragedy of our ageing mortal bodies, to articulate us to that which lays beyond and before (in both senses of the word) us, this is to say, to 'confront the visibility of the invisible' (Trigg 28).[2]

Grandrieux describes his own vision of the potential of the cinema in very similar terms in an article that he wrote for a special number of *Les Cahiers du cinéma* in November 2000 celebrating a century of cinema. Referencing Klossowski and in particular Artaud's delirious, ecstatic injunctions concerning the cinema, Grandrieux takes up the baton of Artaud's invectives against a cinema driven primarily by narrative and joins his defence of the deeper purpose of the cinema which is, for Artaud, 'to express the matter of

CONCLUSION 255

thought, the inside of consciousness, not so much via the interplay of images as via something imponderable that might reconnect us directly with their very materiality, without any interpolation or representation' (Artaud cited in Grandrieux 2000, 92). Referencing Artaud's highly corporeal understanding of the cinema, Grandrieux goes on to conclude his text as follows:

> Maybe bodies will then be the simulacra via which we will feel and experience the power of our desire, this 'voluptuous emotion'? Maybe fiction will be made incarnate, made flesh, made of blood and muscles? Perhaps that is *'the imponderable thing'* that Artaud dreamed of, via which we might reach the inside of consciousness directly, beyond representation, perhaps this is the transubstantiation of images in a body? Of course it's just a hallucination, but beyond the improbability of such a becoming, Artaud's delirium and Klossowski's fable seem to me to trace the trajectory of the destiny of the cinema, of the cinema that I love and that connects us to the most archaic of forces and to the most foundational and instinctive parts of us, that weaves together inextricably body and mind, that constitutes the very stuff of our affective relation to the world by placing us before the threat that is the staggering eruption of what can be neither seen nor heard. (2000, 92)

This, for Grandrieux, is what all of mankind's aesthetic images have attempted to access ever since the very first imprint of hands on cave walls, 'the body's night, its opaque mass, the flesh through which we think' in order to 'bring into the light, right in front of us, the enigma of our lives' (92). Conceived of in this way, the cinema becomes, as Grandrieux begins his article, that which admits into existence some of the chaos from which we attempt to shelter ourselves in our desire 'desperately to believe that the world is ordered and reasonable' (88).

In making these claims, Grandrieux articulates the cinema to a rich lineage of twentieth-century thought that sets out to expand human existence beyond the life of the individual. These include Deleuze, Merleau-Ponty and Heidegger, all of whom we have commented upon at length already. In addition, however, this idea of the body's night draws us close to Levinas when he figures – via the impersonal construction *il y a* [there is], a phrase proximate in

many ways to Heidegger's formulation 'it is boring for one' – this ontological question in optical terms. Levinas writes, 'Behind the luminosity of forms, by which beings already relate to our "inside," matter is the very fact of the *there is* ...' (2001, 51). Reduced or, rather, expanded to encompass all matter (or the flesh of the world as Merleau-Ponty would say), this impersonal figuration of being brings about the same kind of taxonomic erasure that we have seen figured in *Malgré la nuit*'s creature. As Levinas writes,

> *There is* transcends inwardness as well as exteriority; it does not even make it possible to distinguish these. The anonymous current of being invades, submerges every subject, person or thing. The subject-object distinction by which we approach existents is not the starting point for a meditation which broaches being in general. (52)

As Levinas continues his reflection, however, he connects this meditation on being in general to the night, suggesting that 'we could say that the night is the very experience of the *there is*, if the term experience were not inapplicable to a situation which involves the total exclusion of light' (52). He goes on,

> When the forms of things are dissolved in the night, the darkness of the night, which is neither an object nor the quality of an object, invades like a presence. In the night, where we are riveted to it, we are not dealing with anything. But this nothing is not that of pure nothingness. There is no longer *this* or *that*; there is not 'something'. But this universal absence is in its turn a presence, an absolutely unavoidable presence. It is not the dialectical counterpart of absence, and we do not grasp it through a thought. It is immediately there. (52)

If this is so important to our understanding of *Malgré la nuit*, it is because it allows us to intuit how the radical reconceptualization of life that is figured in *Malgré la nuit*'s thing/creature is extended into the very matter of the cinema via the radiant qualities of the image. In *Malgré la nuit*, indeed, especially in the early scenes, characters seem constantly to fade in and out of the darkness behind them and to seem somehow different from themselves when they reappear, a change of angle or point of entry constantly pushing at the logic

of continuity editing (although there is often when this happens here no actual cut) and making subjects seem somehow constantly interchangeable as they engage in a choreography that confounds expectation and keeps them constantly mobile (similar in many ways to what we have seen already in the *Unrest* works). For Bellour, it is precisely out of this interplay of different kinds of light and of figures in light that the film's greatest difficulty is produced, namely 'the impossibility of being able, from where we stand, to find an agreed order and coherence across the elements of the story recounted to us' (2016, 11). Just as in the paintings of Bacon, then, where the chromatic forces of the background exert a force upon the figure that releases in it a movement that carries it beyond the apparent limits of its visible form, effecting a similar movement in the spectator as the painting transmits itself to her not via understanding or representation but, rather, sensation, so here night, that space connected to a deep and primal fear of the unknown, of the absence of fixed coordinates and thus identity, becomes, via formal means, that which enacts the figural force on the subject on screen and then on us as we strain to see what cannot be seen.[3] To put this in Levinas' terms, if in the night the things of the day elude us, this is not only because darkness modifies their contours for vision, but also because 'it reduces them to undetermined, anonymous being, which they exude' (54). Mute witness to this spectacle, so it is that 'instead of serving as our means of access to being, nocturnal space delivers us over to being' (54).

The principle in operation here is one that we have seen again and again in Grandrieux's work via different means, namely an attempt to place us in a space devoid of the coordinates with which we might normally orient ourselves and understand what presents itself to us. To do precisely this, to struggle against common sense or opinion is, for Deleuze and Guattari, the very operation of art which thus strives to reconnect us with the chaos that lies beneath the secondary syntheses that we enact upon the world around us in order to '*make an opinion* for ourselves, like a sort of "umbrella," which protects us from chaos' (Deleuze and Guattari 1994, 202). In doing this, art prohibits us from making the reality before us conform always to a model located in the past and to remain, then, static, in place, petrified. Art, in turn, has the capacity fundamentally to alter our perception of the world, to retune our bodily, sensory and temporal relation to the outside in which we are situated

or – given this insight – with which we are but a co-constitutive element. As Deleuze and Guattari state in a formulation that is itself like a variation on Levinas' idea quoted above that 'nocturnal space delivers us over to being': 'The artist brings back from the chaos *varieties* that no longer constitute a reproduction of the sensory in the organ but set up a being of the sensory that is able to restore the infinite' (Deleuze and Guattari 1994, 202–3). This restoration of the infinite is at the same time, as it is in Heidegger, an act of violence against the unitary subject situated in time according to the measure of her own mortality. And this very operation is what we find in the transmission of affect which liberates a sensation from a form such that it can pass through other subjects, other times. Affect is, for Deleuze and Guattari, the latent capacity of art (or, at least, art that does not deal in clichés (204)) and they explicitly describe this in terms of a violent act. They write:

> In a violently poetic text, Lawrence describes what produces poetry: people are constantly putting up an umbrella that shelters them and on the underside of which they draw a firmament and write their conventions and opinion. But poets, artists, make a slit in the umbrella, they tear open the firmament itself, to let in a bit of free and windy chaos and to frame in a sudden light a vision that appears through the rent. (1994, 203)

Rather than a rent, Heidegger talks of a 'rupture' (1995, 170) that is enabled by this moment of vision. For Heidegger, this rupture is occasioned by an experience of profound boredom (or angst in *Being and Time* (1996)), but this very experience has much in common with the modes deployed by Grandrieux's work. Similar to what we have said of the fulcrum point in Merleau-Ponty, it is via this rupture that 'expanse' is related to 'extremity', and 'world' to 'individuation', and through an act of violence then that 'Dasein attains its existence proper precisely in this rupture' (Heidegger 1995, 170). It is, however, precisely because of this violence, precisely because – to return to Deleuze and Guattari via Lawrence's metaphor – art (or the experience of angst or profound boredom) rips through the very fabric that we hold up to protect ourselves from chaos, from the illusory order proffered by common sense and opinion when we take these to be truths, that it can be so difficult for some and ultimately rejected by those unwilling to open themselves

up to its attunement. For Artaud (in a text greatly admired by Grandrieux), the cinema is the art form best able to bring us close to the real stuff of life that lies behind those representational forms that pretend to bring reality to us while in actuality holding us at a distance from it since 'stupid order and customary clarity are its enemies' (2004, 258). Similarly, in a striking passage that resonates incredibly strongly with what we have heard Grandrieux say again and again throughout this study as he rails against a narrative and psychology-driven form of film-making in favour of a cinema that would enable a more direct access to the Real, to the flesh of the world, Heidegger writes:

> It is particularly dangerous to point out these connections today, because such reflections are immediately misused in the attempt to appropriate creative products and works of all kinds by analysing their provenance and their creative production in psychological terms. The life of spirit in our present day, with respect to itself and its history, is largely trapped in this blind alley and can move neither forward nor backward. For the false belief that something has been comprehended and appropriated once we have explained its provenance in psychological or anthropological terms is a blind alley. Because we can explain everything in this way, we seem to have acquired an objective position with respect to things. And we manage to persuade ourselves that this psychologically objective explanation and acceptance of anything and everything with regard to its psychological origin represents a form of superior freedom and tolerance. But in fact this approach fundamentally represents the most complacent and comfortable form of tyranny in which we risk nothing, not even our own viewpoint, since of course there is a psychological explanation for this too. (1995, 183)

To quote this passage and to suggest that it speaks forcefully to the problems that Grandrieux's work attempts to stare down is not by any means to accuse any who reject his vision of complacency or tyranny – which would be the worst kind of elitist cultural fascism. It is, however, allied to an attempt to understand why it is that his work remains so difficult for so many, including the programmers of major film festivals – including some not known to be reticent about pushing the envelope. Completed early in 2015, *Malgré*

la nuit would not be chosen for either Cannes or the Venice film festivals and would have to wait until the end of January 2016 for its world premiere at the Rotterdam Film Festival – soon after to be screened during the Berlin Film Festival's Critics' Week. Following the Rotterdam screening @daveyjenkins tweeted 'Malgré la nuit (Grandrieux) Makes Claire Denis' Bastards look like The Road Chip. Maybe most walkouts I've ever seen at a festival. V v good'. Grandrieux himself has said to me that the eternal return of this kind of hostile reception (those who walked out, not @daveyjenkins) is something that he finds tiring, but for those willing to submit to this 'radically sensual and physical film experience' – as *Malgré la nuit* was described in the Berlin Film Festival's Critics' Week synopsis – and to let his films slice through their cornea, it is undoubtedly a good thing (with the possible exception of the music video he directed for Marilyn Manson) that he has never compromised his vision but, on the contrary, arguably gone further and further into the night, away from the light, away from what we have already seen and, indeed, what *can* be seen.[4]

What we are presented with in Grandrieux's work is then the very opposite of mythic narratives that, as Elisabeth Bronfen writes, 'stand for a victory of the familiar over the unfamiliar', and that, 'since antiquity, … have produced narratives of how the world came to emerge from darkness'. 'The wager of all creation stories', she continues, 'is that the horror of a primordial night can be overcome by virtue of the light that the act of telling a story about it sheds on primordial darkness' (2013, 1). Rather than shed light on this primordial darkness, Grandrieux's work is forged out of this primordial darkness in the recognition that this darkness is always and ineluctably present behind the light, belief and reason that we attempt to shine onto and thereby sublimate or erase the mysterious, unbearable, horrifying or ineffable. More than this, for Grandrieux (as for Hegel) light and darkness are necessarily co-constitutive of each other, the relation between the two marking the point or threshold at which determinate form is contracted into being. Commenting on Hegel's *Logic of Being*, Bronfen explains this idea well, writing:

> Manifest appearance … requires that the two opposite terms, light and night, be brought together conceptually in relation to the distinction they are mutually able to bring forth. Light

is determined by darkness, as darkness is determined by light. Only in darkened light, only in illuminated darkness does the exchange occur that continually transforms pure being into a determinate and incessantly reborn existence. (2013, 83)

The particular achievement of Grandrieux's work is to enact this metaphysical question through the formal aesthetic operations of his work. In and of itself this is nothing new, nor something specific to the medium of film; indeed, as we have seen, Grandrieux started out his career by thinking through these questions in relation to different kinds of pictorial practice in *Via la vidéo* and *La peinture cubiste*. To posit an answer to one of the central questions that has driven this book throughout, then, this is why Grandrieux claims that Deleuze's book on Bacon is at heart a book about the cinema, because for Grandrieux it is through the formal and aesthetic qualities of the cinema when deployed in a certain manner that we are able to move beyond an individuated form of being and unitary perspective to apprehend the world as nothing other than the incessant interplay of different elements. Indeed, if, according to Deleuze in his study on Bacon, 'the painting exists by making present a very particular fact, which we will call the *pictorial fact*' – this 'fact' being 'first of all that several forms may actually be included in one and the same Figure' (2003b, 160) – for Grandrieux the cinema exists by making present a *cinematic fact* that rips the cinema away from the fixed forms of narratival and psychological coherence to return it instead to its origins and base ontological condition as nothing other than the interplay of light and sound in time and space. In doing this, the cinema returns us (or, rather, has the capacity to return us) to our own ontological base condition as sensory beings receptive to sensations that traverse us in their raw immediacy, prior to the imposition of a pre-emptive meaning, semblance of fixed form or metaphysical certainty. The cinema, this is to say, is like an echo from our own time past, returning to us nothing but an image of ourselves, albeit one that we may not recognize or wish we could forget. Grandrieux:

The question of Evil is the question of life itself. ... The cinema does not escape this question. ... My films leave each of us alone, faced with our drives, with an Evil that is our own. What happens in my films, the events that are deployed within them, what we

see and hear, remains confused, uncertain. They are like a surface
onto which each spectator projects her own human matter, her
own fantasies, worries, fears, a surface which ultimately returns
to her, then, nothing but her own image. This is undoubtedly why
for some people they remain unbearable to behold. (Grandrieux
and Selve 2016, 94)

AFTERWORD: SONIC CINEMA

The creature in *Malgré la nuit* constitutes an entirely new form of embodiment that thrusts us into a realm where the taxonomic orders that should separate the world out into distinct categories and thus enable it to be understood – or at least contained – fail and bleed into each other across these lines of containment or territorial delineations. In a very real way, then, this creature is the most literal embodiment of a strategy that we have seen again and again throughout Grandrieux's career which consists in placing us before forms of life that refuse to conform to our pre-existing codes and frameworks in relation to both their content – on a moral, diegetic or psychological level – and their formal operations – on an aesthetic and sensory level. This tendency to seep and bleed across boundaries is one of the qualities inherent to sound, which propagates itself by creating vibrations in any medium around it that has its own internal forces. One might be tempted to say, then, that sound co-opts the medium around it, yet this is not strictly speaking true since the medium through which it travels is actuated by the passage of the wave in such a way that the resultant sound carries qualities of both wave and medium. What the passage or expression of sound figures is, then, a truly chiasmic relation between elements, and it is for this reason that throughout this study I have invoked the spectre of a sonic conception of the cinema, since in so doing it is possible to avoid the pitfalls that beset much work in cinema studies that retains too much of the organism (or spectatorial subjectivity) in its original form.[1]

There are, of course, other theorists who have attempted to figure the relation between the cinema and the world or the cinema and its spectator in a similar manner, albeit via different kinds of vocabularies and architectures – and at this point I must again pay

homage to Philip Brophy's work on his own take on the idea of 'sonic cinema' (2004). Steven Shaviro, for instance, argues that

> the dematerialized images of film are the raw contents of sensation, without the forms, horizons and contexts that usually orient them. And this is how film crosses the threshold of a new kind of perception, one that is below or above the human. This new perception is multiple and anarchic, nonintentional and asubjective; it is no longer subordinated to the requirements of representation and idealization, recognition and designation. It is affirmed before the intervention of concepts, and without the limitations of the fixed human eye. ... Sitting in the dark, watching the play of images across a screen, any detachment from 'raw phenomena', from the immediacy of sensation or from the speeds and delays of temporal duration, is radically impossible. Cinema invites me, or forces me, to stay within the orbit of the senses. I am confronted and assaulted by a flux of sensations that I can neither attach to physical presences nor translate into systematized abstractions. I am violently, viscerally affected by *this* image and *this* sound, without being able to have recourse to any frame of reference, any form of transcendental reflection, or any Symbolic order. No longer does a signifying structure anticipate every possible perception; instead, the continual metamorphoses of sensation pre-empt, slip and slide beneath, and threaten to dislodge all the comforts and stabilities of meaning. (1993, 31–3)

The concept that provides Shaviro's very personal, idiosyncratic and joyous text with its guiding principle is that of fascination, and it is through a series of case studies that elicit this kind of desire in him that he elaborates his theoretical musings and mounts a scathing critique of the 'phobic construct' that is, for him, Lacanian film theory (16). As much as I am in agreement with Shaviro's sentiments expressed in the passage quoted above, however, to my mind the emphasis on fascination potentially limits the applicability of his argument since the same kinds of operations can be found in cinematic bodies in the thrall of powers other than fascination – as is made abundantly clear in many of the most affecting of passages of Grandrieux's films to which even my reaction (as an unashamed fan) can be far more ambivalent or complex than this.

If, as we have seen in Shaviro's claim, however, there is
something about the cinema that is inherently transgressive or
preconceptual (an idea that resonates forcefully with things we
have heard Grandrieux himself say), then the very idea of the
sonic may provide an ideal set of concepts and figures through
which to approach the cinema because of its inherent tendency
to seep, bleed and transgress fixed boundaries in its very
propagation or deployment. The sonic, what is more, brings with
it a whole host of familiar concepts and vocabularies about which
we have a shared understanding that is then problematized or,
rather, expanded when the idea of the sonic is used to talk of
phenomena that are not (or not simply) sonic. The sonic, this is
to say, provides us with the means and vocabulary to talk about
the operations found in the work of a film-maker like Grandrieux
that problematize the situatedness of the very many bodies that
together constitute this thing that we call the cinema. This is not
simply because sound both immerses us in an expansive field at
the same time as it traverses us and makes us then part of the
field created in the propagation of sonic expression but, more
fundamentally, because what the sonic enables is a figuration of
matter that reveals the extent to which matter is inscribed in time
and space, bound up in a matrix that is constitutive of it rather
than isolated in its apparent solidity and semblance of form. To
put this another way, the sonic disavows the very possibility of
containment, it is a figuration or deployment of matter that is
necessarily and irreducibly mobile. There is perhaps then no small
irony in the fact that what is called for here, what might keep the
moving image mobile and prevent it from being incessantly tied
down to stable forms, from being only ever a pale reflection of a
pre-existing world is, in fact, the sonic.[2]
 In saying this, I do not wish to invoke the spectre of synaesthesia
that has become a common trope in much recent work in cultural
analysis,[3] for what is at stake here is not simply (or not at all?) a
cross-modal sensory experience but, rather, a reconceptualization
of the cinema itself as a material and ideational form and hence of
our own bodies in the cinematic situation – and indeed beyond this
situation if we believe in the philosophical potential of the cinema
as a mode of thought. Rather, the sonic provides us with a possible
means to articulate a response to what we see before us when 'truth

and judgment crumble' and leave behind them only 'bodies which are ... nothing but forces' (Deleuze 1989, 139).[4]

Deleuze himself thought through the kind of body figured here via a musical diagram in a short text entitled 'Making Inaudible Forces Audible'. Taking part in a seminar at IRCAM organized by Pierre Boulez on the idea of time, Deleuze prepared a text responding to five pieces of music chosen by Boulez in which he found 'a kind of *non-pulsed* time emerging from a *pulsed* time, even though this non-pulsed time could become a new form of *pulsation*' (2007, 157). This reflection leads Deleuze into a series of musings on the biological body and what biologists refer to when they talk of rhythms. Similar to the complex temporal relations emerging across different semi-individuated musical expressions, according to Deleuze,

> biologists ... have also renounced the belief that heterogeneous rhythms are articulated under the domination of a unifying form. They do not seek to explain the articulations between vital rhythms, for example the 24-hour rhythm, in terms of a superior form that would unify them, or even in terms of a regular or irregular sequence of elementary processes. They seek an explanation somewhere entirely different, at a sub-vital, infra-vital level in what they call a population of molecular oscillators capable of passing through heterogeneous systems, in oscillating molecules coupled together that then pass through groups and disparate durations. The process of articulation does not depend on a unifiable or unifying form or a meter, cadence or any regular or irregular measure, but on the action of certain molecular couples released through different layers and different rhythmic layers. (1989, 157–8)

The point of this digression, as becomes clear when Deleuze turns his attention back to music, is to show that the body is not a pre-constituted entity that would hold dominion over or, perhaps, conduct (in the musical sense of the term) the rhythms taking place in it but is, rather, merely the material medium through which imperceptible heterogeneous forces and rhythms pass and become perceptible in this same process. Or, as Deleuze explains the same thing in relation to music:

> Music is ... no longer limited to musicians to the extent that
> sound is not its exclusive and fundamental element. Its element
> is all the non-sound forces that the sound material elaborated
> by the composer will make perceptible, in such a way that we
> can even perceive the differences between these forces, the entire
> differential play of these forces. (160)

This, for Deleuze, is resolutely not a phenomenon specific to music.
'We are all faced with somewhat similar tasks,' he writes (160).

> There is no absolute ear; the problem is to have an impossible
> one – making audible forces that are not audible in themselves.
> In philosophy, it is a question of an impossible thought, making
> thinkable through a very complex material of thought forces
> that are unthinkable. (160)

And so it is in the cinema, we might add, or at least the cinema
and associated work of Grandrieux which has consistently
presented us with a vision of bodies that serve to channel unknown
or unthinkable forces both internal and external to themselves and
to render them thinkable in the process. 'I want to make films with
bare life,' he says (Grandrieux 2004, 123). In doing this, however,
Grandrieux's cinema does not only present us with bodies on screen
that resonate and pulse with each other and to the rhythms of all
that surrounds them, but itself becomes the medium through which
the unthinkable force of life itself is amplified into perception, not
so much *camera obscura* as resonance chamber.

NOTES

Introduction

1 It should be noted that Martine Beugnet draws on Deleuze's book on Bacon to discuss the films of Grandrieux, but the use she makes of this text for her analysis is somewhat cursory and very different to the use made of it here. For Beugnet, Deleuze's analysis of the Figure in Bacon is of relevance in the context of her study on the 'cinema of sensation' because of this cinema's attraction towards the formless and because 'what is at stake is the passage from or, rather, the fluctuation between figuration and figure rendered possible by the elaboration of a haptic regime of the gaze, and the multi-sensory perception and understanding of the cinematic matter' (1997, 64–5).

2 Francis Bacon cited in Smith (2003, xi).

3 In conversation with the author.

4 It should be noted also that Brophy has himself written on the soundtrack of Grandrieux's film *La Vie nouvelle* [*A New Life*] (2013). For other excellent, detailed analyses of various aspects of Grandrieux's soundtracks specifically, see also Jordan 2016; Barnier 2005 and Villani 2005.

Chapter 1

1 This quotation is cited widely in every exhibition catalogue of the work of the Support(s)-Surface(s) group; its exact origin is, however, never cited.

2 In conversation with the author.

Chapter 2

1 It is important to note, having said this, that the TV stations or institutions that Grandrieux worked for or with for the most part, namely La Sept/ARTE and l'INA, are able, due to their funding models, to produce programmes with a much lesser chance of commercial success than many other channels, such as Pathé or France 2, the commercial entities that co-produced *The Century of Man*.

2 Note that Cyril Béghin (2004) has penned a very comprehensive description and analysis of *La Peinture cubiste* with psychoanalytic undertones that, in its second movement, is articulated to Grandrieux's first feature film, *Sombre*.

3 For a discussion of Kuntzel's use of this camera, see Bellour 2012a.

4 We see in this sequence the development of an idea that Grandrieux will develop further as his career progresses and that we will explore in the chapter on *La Vie nouvelle*.

5 The original German for this first proposition of the *Tractatus Logico-Philosophicus* reads 'Die Welt ist alles, was der Fall ist', which is generally translated into English as 'The world is everything that is the case'. In French, however, the translation is usually rendered as quoted by Grandrieux, which is to say 'le monde est tout ce qui arrive', the sense of which is retained far better by the translation used here, 'the world is everything that happens'. This would also accord with Bruce Fleming's preferred translation 'The world is everything that is' (2007, vi), a translation that has the advantage of not allowing the entire *Tractatus* to be read as an essay on language.

Chapter 5

1 For Haden Guest, this is in fact 'a bravura reinvention of *The Shining*'s opening' (2010, 43). Guest also comments on the intertextual nod to Truffaut's *Les 400 coups* to be commented on shortly.

2 Grandrieux himself makes the link to El Greco and Jean's pose here, remarking in his filming notes that he needs to show these paintings to Marc Barbé.

Chapter 6

1 My emphasis. Available online: www.lemonde.fr/archives/article/1998/08/18/palmares_3669809_1819218.html

2 For an example of the kind of vehement rejection that the film has elicited, see the Q&A with Philippe Grandrieux following a screening of *La Vie nouvelle* at the Tate Modern (Grandrieux and Tate 2008).

3 It should be noted that this analysis goes against that of Hélène Fleckinger for whom this man's brutality towards Mélania is the result of a madness that arises from 'the loss of self to which eroticism leads' (2005, 104).

4 The analysis also figures in Martin's book (2014, 119–23).

5 If we follow Randolph Jordan's analysis, a similar phenomenon can be found in *La Vie nouvelle*'s early club scene when Mélania sings to Seymour, spatially constructing a private space that he will attempt to regain for the remainder of the film (2016, 298–9).

6 In reading this scene in this way, I am reading it against Beugnet who suggests that 'even if we behold the aesthetic shock that such images create, it is difficult to equate them fully with the positive, life-expanding dimension of Deleuze and Guattari's concepts' (2007, 88).

7 While this probably does not need to be pointed out, it is worth mentioning that this is the opening line from Helen Reddy's feminist anthem 'I am woman'.

8 For more on this point, see Gorelick 2011, 265.

9 The term has been applied to Grandrieux in a beautifully written text by Serge Abiaad (2012, 41).

Chapter 7

1 'Unrest' is a term much discussed in the interviews with Gobille and one that Grandrieux will use as the collective title for the trilogy that he will commence in 2012 to be discussed in Chapter 9.

2 While it would undoubtedly be erroneous to attribute any kind of cause-and-effect relation to this fact or to imbue it with too much significance, it is nonetheless interesting to note that the soundtrack for *Met* was created by Marc Hurtado with whom Grandrieux had already worked on the soundtrack of *La Vie nouvelle* where Hurtado was credited alongside his brother and long-time collaborator as the group Étant donnés.

Chapter 8

1 In an interview published in the film's *Dossier de presse*, Grandrieux implies that it was especially during the editing of the film that the

stripping back of narrative and psychological elements took place (Grandrieux and Vassé 2009).

2 Accessed 1 June 2015, http://www.grandrieux.com/content/UnLac_DP.pdf.

3 Serre mentions all of these, but see also Walton (2016) and, in particular, Ramdas (2013) where the concept of haptic materiality becomes central.

4 Accessed 1 June 2015, http://www.mac-lyon.com/static/mac/contenu/fichiers/divers/2009/inattendus_verso.pdf.

5 The French word '*entendre*' has the double meaning of both 'to hear' and 'to understand' while being etymologically related to the concept of intentionality, a linguistic complexity unpacked well by Kane (2012).

6 See also Grandrieux and Vassé 2009.

7 Saige Walton offers an interesting alternative take on this idea via Wölfflin and Deleuze's 'philosophical concept of the baroque as fold [which] also signals an ontological joining or folding together of mind, body and world that articulates thinking itself as vibrational' (2016, 208). This link between the Baroque and Grandrieux's stylistic approach which 'in ontological terms seeks to render visible an immanent field of vibrant, dynamic life processes' is also commented upon by Ladegaard (2014, 156).

8 While the soundtrack is added in post-production and is not intended to generate a 'realistic' link between sound and image nor even a stylized reality effect – as is the case in classical Hollywood film-making's use of Foley effects, for instance – my claim is that all sound up until this point is diegetic since it is generated by the universe and formal geometry of the film and its operations.

9 For a slightly different take on this scene, see Jordan 2016.

Chapter 9

1 A second film in the series has since been completed, Oriane Brun-Moschetti's *Salut et fraternité. Les images selon René Vautier* [*Salvation and Fraternity. Images According to René Vautier*]. 70 minutes.

2 For an excellent discussion of Grandrieux's film that provides a great deal of information on Masao Adachi as well, see Ben C (2014).

3 My use of this term here is close to what Deleuze would call the diagram. See Deleuze 2003b, 83.

4 For an interview concentrating on Grandrieux's conception of the role of the choreographer and the relative merits of the art museum and the cinema, see Grandrieux and Copeland 2015.

5 The French word *meurtrière* designates both a murderess and the vertical slit or loophole found in medieval fortifications.

6 In the original French the term used is *méduse* which resonates with the idea of a deadly female figure in a way that the English cannot.

7 Raymond Bellour has said of the vertical image in *White Epilepsy* that 'the overriding feeling here has to do with the almost abstract implacability of time that the extreme physicality of the image imposes on the spectator to the point of vertigo' (2012, 93).

Conclusion

1 See *infra* pp. 251–2.

2 Grandrieux himself reflects on the difference between his films' treatment of evil and the spectacular nature of most horror films that are intended to entertain and distract us, leaving us ultimately 'indifferent'. See Grandrieux and Selve 2016, 94.

3 This very same principle united all of the works displayed in an exhibition of Grandrieux's photography organized by La Serial Galerie and displayed in the Galerie Bertrand Baraudou in 2014. Going under the name *Vanishing Twin*, the exhibition included photographic renderings of the bodies in *White Epilepsy* and the roses of *L'Arrière-saison* as well as photographs such as 'Midnight Blue' (2012) and the triptych 'Vanish' (2011).

4 Such is wonderfully illustrated by Marc van de Klashorst's comments on the film. He writes, 'in essence, *Malgré la nuit* is a film about connections, to others, to ourselves, and to life. Those willing to look past the style (even though it's part of the point) and the extremity, will find a deeply human, if very dark film' (2016).

Afterword

1 The formulation used here nods towards Deleuze and Guattari's *A Thousand Plateaus* when they write, 'You have to keep enough of the organism for it to reform each dawn. ... You don't reach the BwO, and its plane of consistency, by wildly destratifying' (1987, 160).

2 The ideas here resonate forcefully with a short, dense text by Lauro López-Sánchez (2015), which includes a short invocation of *La Vie nouvelle* and also ultimately turns around the phenomenon of the resonance chamber.

3 For an example of the application of the term to Grandrieux's work specifically, see Beugnet (2007, 72–5 and 88); for a more general work on synaesthesia, see Cretien van Campen (2007).

4 This idea found in Deleuze is central to Elena del Río's 2016 book *The Grace of Destruction: A Vital Ethology of Extreme Cinemas*, which could easily (although it does not) have included Grandrieux as one of its case studies.

REFERENCES

Works by Philippe Grandrieux

As Director

Via la vidéo. 1975. Video installation work on three screens. 3 × 45 minutes.

La Peinture cubiste [*Cubist Painting*]. 1981. Short film. Co-directed with Thierry Kuntzel. 49 minutes.

Petits écrans du Caire [*The Small Screens of Cairo*]. 1982. Short film. Made for *Juste une image* and screened in the 7th episode of this series. 10 minutes.

Une Génération. 1982. Short film.

Pleine lune [*Full Moon*]. 1983. Television program. 180 minutes.

Grandeur Nature [*Life-Sized*]. 1984. Television program. 52 minutes.

Long courrier [*Long Haul*]. 1985. Video work. 25 minutes.

Comédie/Comédiens [*Acting/Actors*]. 1986. Documentary. 50 minutes.

Berlin. 1987. Documentary. 30 minutes.

Berlin/Paris/Berlin. 1987. Documentary. 120 minutes.

Le monde est tout ce qui arrive [*The World is Everything that Happens*]. 30 part television news series. 30 × 15 minutes.

Azimut. 1989. 4 part television series: 1. *Le Monde est une image* [*The World is an Image*]; 2. *Le Trou noir* [*The Black Hole*]; 3. *Le labyrinthe: le temps, la mémoire, les images* [*The Labyrinth: Time, Memory, Images*]; 4. *La Taille de l'Homme* [*The Size of Man*]. 4 × 30–55 minutes.

Histoire parallèle [*Parallel History*]. 1989. Television series. 630 × 50 minutes (Grandrieux directed only the first few episodes).

Histoires [*Stories*]. 1990. Documentary made for the *Live* project. 60 minutes.

Cafés. 1992. Documentary. 210 minutes.

Gert-Jan Theunisse and *Brian Holm.* 1993. Two short documentary films made for the television series *La Roue.* 2 × 7 minutes.

La Chasse au Starck [*The Starck Hunt*]. 1993. Short documentary made for the television series *Atelier 256: Magazine de la création.* 56 minutes.

Les Enjeux militaires [*Military Stakes*]. 1994. Documentary. 45 minutes.

Jogo du bicho/Le Jeu des animaux [*The Animal Game*]. 1994. Documentary. 60 minutes.

Retour à Sarajevo [*Return to Sarajevo*]. 1996. Documentary. 75 minutes.

Le Siècle des hommes [*The Century of Man*]. 1996. 26 part television series. 26 × 45–55 minutes.

Balladur. 1995; *Jean-François Deniau à l'Assemblée Nationale*. 1995; *Dans la rue à Vitrolles* [*In the Streets of Vitrolles*]. 1995; *La Garde Républicaine*. 1995; *Nicole Notat*. 1996; *Place de la Bastille*. 1996; *La Vente aux enchères* [*The Auction House*]. 1996; *L'Ancien Premier Ministre* [*The Former Prime Minister*]. 1997. Documentaries made for the current affairs series *Brut*. 8 × 5–7 minutes.

Sombre. 1998. Film. 112 minutes.

La Vie nouvelle [*A New Life*]. 2002. Film. 102 minutes.

L'Arrière-saison [*Indian Summer*]. 2005. Video installation work. 9 minutes and 10 minutes (screened sequentially).

Grenoble. 2006. Video installation work on two screens. 38 minutes and 17 minutes (screened simultaneously).

Met. 2006. Video installation work. 5 minutes (loop).

Marilyn Manson – Putting Holes in Happiness. 2007. Music video. 4 minutes.

Un lac [*A Lake*]. 2008. Film. 90 minutes.

Il se peut que la beauté ait renforcé notre résolution – Masao Adachi [*It May be that Beauty has Strengthened our Resolve – Masao Adachi*] (2011). Film essay/documentary. 74 minutes.

Scène 4. 2011. Performance. 30 minutes.

White Epilepsy. 2012. Film. 68 minutes.

Meurtrière [*Murderess*]. 2013. Performance. 30 minutes.

Meurtrière. 2014. Performance. 180 minutes.

Meurtrière. 2015. Film. 60 minutes.

Malgré la nuit [*In Spite of the Night*]. 2015. Film. 156 minutes.

As Producer

Juste une image. 1982–3. 9 part television series. Co-produced by Philippe Grandrieux, Thierry Garell and Louisette Neil. 9 × 55 minutes.

Live. 1990. 14 part television series. 14 × 60 minutes.

Secondary sources

Abiaad, Serge. 2012. 'Philippe Grandrieux: la grâce déchue: rétrospective'. *24 Images* 159: 40–1.

Adachi, Masao. 2007. Interview with Masao Adachi. *Midnight Eye: Visions of Japanese Cinema*, 21 August. Accessed 15 November, 2015. http://www.midnighteye.com/interviews/masao-adachi.

Agamben, Giorgio. 1998 [1995]. *Homo Sacer: Sovereign Power and Bare Life*. Translated by Daniel Heller-Roazen. Stanford: Stanford University Press.

Andrew, Dudley. 2010. *What Cinema Is!* Oxford: Wiley-Blackwell.

Artaud, Antonin. 1958 [1938]. *The Theater and Its Double*. Translated by Mary Caroline Richard. New York: Grove Press.

Artaud, Antonin. 2004 [1927]. 'Sorcellerie et cinéma'. In *Œuvres*, edited by Évelyne Grossman, 256–8. Paris: Gallimard.

Barker, Jennifer. 2009. *The Tactile Eye: Touch and the Cinematic Experience*. Berkeley: University of California Press.

Barnier, Martin. 2005. 'Au bout du souffle'. In *La Vie nouvelle: nouvelle Vision: à propos d'un film de Philippe Grandrieux*, edited by Nicole Brenez, 150–2. Paris: Éditions Léo Scheer.

Bazin, André. 2005 [1961]. *What is Cinema?*, 2 vols. Berkeley: University of California Press.

Béghin, Cyril. 2001. 'La Chambre sombre'. *Balthazar* 4. Accessed 25 April 2006. http://cyrilbg.club.fr/chambresombre.html.

Bellour, Raymond. 1998. 'Pour Sombre'. *Trafic* 28: 5–8.

Bellour, Raymond. 2009a. *Le corps du cinéma: hypnoses, émotions, animalité*. Paris: P.O.L. Éditeur.

Bellour, Raymond. 2009b. '*Trafic* and the Films of Philippe Grandrieux'. Text written for the masterclass program of the Jeonju Film Festival in Korea. Translated by Adrian Martin.

Bellour, Raymond. 2012. *La Querelle des dispositifs: Cinéma – installations – expositions*. Paris: P.O.L. Éditeur.

Bellour, Raymond. 2013 [1990]. *Between-the-Images*. Zurich/Dijon: JRP Ringier Kunstverlag/Les Presses du réel.

Bellour, Raymond. 2013a [1990]. 'Thierry Kuntzel and the Return of Writing'. In *Between-the-Images*, 30–61. Zurich/Dijon: JRP Ringier Kunstverlag/Les Presses du réel.

Bellour, Raymond. 2013b [1990]. 'From In-Between the Bodies'. In *Between-the-Images*, 194–233. Zurich/Dijon: JRP Ringier Kunstverlag/Les Presses du réel.

Bellour, Raymond. 2016. 'États des corps (malgré la nuit)'. *Trafic* 98: 10–15.

Belting, Hans. 2010. *Looking Through Duchamp's Door: Art and Perspective in the Work of Duchamp, Sugimoto, Jeff Wall*. Köln: Walther König.

Benjamin, Andrew. 2004. *Disclosing Spaces: On Painting*. Manchester: Clinamen Press.

Bergson, Henri. 1912 [1903]. *An Introduction to Metaphysics*. Translated by T. E. Hulme. New York: G. P Putnam's Sons.

Beugnet, Martine. 2007. *Cinema and Sensation: French Film and the Art of Transgression*. Edinburgh: Edinburgh University Press.

Bioulès, Vincent and Louis Cane, Marc Devade, Daniel Dezeuze, Noël Dolla, Jean-Pierre Pincemin, Patrick Saytour, André Valensi, and Claude Viallat. 1969. *La Peinture en question*. Le Havre: Musée du Havre.

Birtwistle, Andy. 2010. *Cinesonica: Sounding Film and Video*. Manchester: Manchester University Press.

Blanchot, Maurice. 1962. *L'Attente l'oubli*. Paris: Gallimard.

Blümlinger, Christa. 2006. 'Philippe Grandrieux: The Real Beyond the Faces'. Translated by Mark Heffernan. *Parachute* 123: 71–9.

Bonino, Fabienne. 2013. 'La caméra haptique de Philippe Grandrieux: "le surgissement d'un autre monde"'. *Entrelacs* 10. Accessed 19 March 2015. http://entrelacs.revues.org/485.

Bordwell, David. 1980a. *French Impressionist Cinema: Film Culture, Film Theory, and Film Style*. New York: Arno Press.

Bordwell, David. 1980b. 'The Musical Analogy'. *Yale French Studies* 60: 141–56.

Bradburn, John. 2008. 'Nothing is True. Everything is Permissible'. *Vertigo* 18. Accessed 1 June 2016. http://www.closeupfilmcentre.com/vertigo_magazine/issue-18-june-2008/nothing-is-true-everything-is-permissible/.

Brenez, Nicole, ed. 2005. *La Vie nouvelle – nouvelle vision, à propos d'un film de Philippe Grandrieux*. Paris: Éditions Léo Scheer.

Brenez, Nicole, and Philippe Grandrieux. 2012. 'Cultural Guerrillas: The Fundamental Questions of a Cinema of Intervention'. *Museum of the Moving Image: Moving Image Source*. Accessed 16 January 2016. http://www.movingimagesource.us/articles/cultural-guerrillas-20120301.

Brinkema, Eugenie. 2014. *The Forms of the Affects*. Durham and London: Duke University Press.

Bronfen, Elisabeth. 2013 [2008]. *Night Passages: Philosophy, Literature, and Film*. Translated by the author with David Brenner. New York: Columbia University Press.

Brophy, Philip. 2004. *100 Modern Soundtracks*. London: British Film Institute.

Brophy, Philip. 2013. 'Parties in Your Head: From the Acoustic to the Psycho-Acoustic'. In *The Oxford Handbook of New Audiovisual Aesthetics*, edited by John Richardson, Claudia Gorbman and Carol Vernallis, 309–22. Oxford: Oxford University Press.

Brown, William. 2013. *Supercinema: Film-Philosophy for the Digital Age*. New York and Oxford: Berghahn.

C, Ben. 2014. 'Masao Adachi: Conceiving Urban Landscape'. *Film Antidote: a cinematic cure*, 5 February. Accessed 19 November 2015. http://www.filmantidote.com/masao-adachi/.

Campen, Cretien van. 2007 *The Hidden Sense: Synesthesia in Art and Science*. Cambridge, MA: MIT Press.

Castiel, Élie. 2003. '31e FCMM, Répérages: Philippe Grandrieux. L'altérité des sens'. *Séquences: la revue de cinema* 223: 25.

Chamarette, Jenny. 2011. 'Shadows of Being in *Sombre*: Archétypes, Wolfmen and Bare life'. In *The New Extremism in Cinema: From France to Europe*, edited by Tanya Horeck, and Tina Kendall, 69–81. Edinburgh: Edinburgh University Press.

Chamarette, Jenny. 2012. *Phenomenology and the Future of Film: Rethinking Subjectivity Beyond French Cinema*. Basingstoke: Palgrave Macmillan.

Chion, Michel. 2009 [2003]. *Film, A Sound Art*. Translated by Claudia Gorbman. New York: Columbia University Press.

Dante (Durante degli Alighieri). 2003 [1295]. *New Life*. Translated by J. G. Nichols. London: Hesperus Press.

Dante (Durante degli Alighieri). 2010 [1320]. *Inferno: The Divine Comedy I*. Translated and edited by Robin Kirkpatrick. London: Penguin Classics.

Deleuze, Gilles. 1986a [1962]. *Nietzsche and Philosophy*. Translated by Hugh Tomlinson. London: Continuum.

Deleuze, Gilles. 1986b [1983]. *Cinema 1: The Movement-Image*. Translated by Hugh Tomlinson and Barbara Habberjam. Minneapolis: University of Minnesota Press.

Deleuze, Gilles. 1989 [1985]. *Cinema 2: The Time-Image*. Translated by Hugh Tomlinson and Robert Galeta. Minneapolis: University of Minnesota Press.

Deleuze, Gilles. 1995 [1990]. 'On the Time-Image'. In *Negotiations*. Translated by Martin Joughin, 57–61. New York: Columbia University Press.

Deleuze, Gilles. 2003a [1981]. '*La Peinture enflamme l'écriture*'. In *Deux régimes de fous: textes et entretiens, 1975–1995,* edited by David Lapoujade, 167–72. Paris: Éditions de Minuit.

Deleuze, Gilles. 2003b [1981]. *Francis Bacon: The Logic of Sensation*. Translated and with an introduction by Daniel W. Smith. Minneapolis: University of Minnesota Press.

Deleuze, Gilles. 2007 [2001]. 'Making Inaudible Forces Audible'. In *Two Regimes of Madness: Texts and Interviews 1975-1995*. Translated by Ames Hodges and Mike Taormina, edited by David Lapoujade, 156–60. New York: Semiotext(e).

Deleuze, Gilles, and Félix Guattari. 1987 [1980]. *A Thousand Plateaus: Capitalism and Schizophrenia 2*. Translated by Brian Massumi. Minneapolis: University of Minnesota Press.

Deleuze, Gilles, and Félix Guattari. 1994 [1991]. *What is Philosophy?* Translated by Hugh Tomlinson and Graham Burchell. New York: Columbia University Press.

Delons, André. 1928. 'Cinéma pure et cinéma russe'. *Cinéa-Ciné pour tous* 105, 15 March: 11–12.

del Río, Elena. 2016. *The Grace of Destruction: A Vital Ethology of Extreme Cinemas.* New York: Bloomsbury Academic.

Eisenstein, Sergei. 1998. *The Eisenstein Reader.* Edited and Translated by Richard Taylor and William Powell. London: BFI Publishing, 1998.

Electronic Arts Intermix Catalogue, entry for La Peinture cubiste. Accessed 5 February 2015. http://www.eai.org/title.htm?id=2851.

Fabre, Jean-Henri. [1879]. *Souvenirs entolomologiques: Études sur l'instinct et les mœurs des insectes.* First series. Paris: Librairie Ch. Delagrave.

Faure, Élie. 1964. *Fonction du cinéma.* Paris: Gonthier.

Fleckinger, Hélène. 2005. 'Expérience érotique et transgression'. In *La Vie nouvelle: nouvelle Vision: à propos d'un film de Philippe Grandrieux,* edited by Nicole Brenez, 104–10. Paris: Éditions Léo Scheer.

Fleming, Bruce. 2007. *The New Tractatus: Summing Everything Up.* Lanham: University Press of America.

Foster, Hal, ed. 1988. *Vision and Visuality.* Seattle: Bay Press.

Gaffez, Fabien. 2005. 'Carnet de bord. Notes et contre-notes d'une incubation cinéphile'. In *La Vie nouvelle: nouvelle Vision: à propos d'un film de Philippe Grandrieux,* edited by Nicole Brenez, 26–34. Paris: Éditions Léo Scheer.

Gatens, Moira. 2004. 'Privacy and the Body: The Publicity of Affect'. In *Privacies: Philosophical Evaluations,* edited by Beate Rössler, 113–32. Stanford: Stanford University Press.

Gobille, Boris. 2007. 'L'Éblouissement, l'effroi' ['Glare, Dread']. Text written to accompany an installation of Grandrieux's *L'Arrière-saison.* Unpublished.

Gorelick, Nathan. 2011. 'Life in Excess: Insurrection and Expenditure in Antonin Artaud's Theatre of Cruelty'. *Discourse* 33 (2): 263–79.

Grandrieux, Philippe. 1995. 'Incendie'. *Trafic* 16: 14–22.

Grandrieux, Philippe. 1999. 'Notes d'intention'. Included in the extras of the DVD of *Sombre.* Paris: Diaphana.

Grandrieux, Philippe. 2000. 'Vivement le désordre: Sur l' "horizon insensé du cinéma"'. *Cahiers du cinéma, November, special issue on Le siècle du cinéma:* 88–92.

Grandrieux, Philippe. 2001. Interview with Philippe Grandrieux. *Balthazar: Revue d'analyse du cinéma contemporain* 4: 12–19.

Grandrieux, Philippe. 2002. Interview with Philippe Grandrieux. *Court-circuit.* ARTE France. 2 September, 2002. Television.

Grandrieux, Philippe. 2004. 'Troisième film'. *Trafic* 50: 122–3.
Grandrieux, Philippe. 2005. Visual storyline photographs. *Le Teaser 9*. Paris: Metronome Press.
Grandrieux, Philippe. 2010. 'Avenue Gabriel'. Photographs. *Edwarda* 1, January/February: 32–43.
Grandrieux, Philippe. 2011. *Program notes for Scène 4*. Accessed 14 January 2016. http://www.centrepompidou-metz.fr/node/535.
Grandrieux, Philippe, Antoine de Baecque, and Thierry Jousse. 1999. 'Le Monde à l'envers: entretien avec Philippe Grandrieux'. *Les Cahiers du cinéma* 532: 39–41.
Grandrieux, Philippe. 2012 [2008]. 'Congo'. *Trafic* 83: 138–42.
Grandrieux, Philippe. 2014. No title. *Les Cahiers du cinéma*, May, 700: 60.
Grandrieux, Philippe. 2016a. 'Journal de tournage'. *Trafic* 98: 1–7.
Grandrieux, Philippe. 2016b. 'Journal du tournage de Malgré la nuit'. *Mettray*, September 2016: [np].
Grandrieux, Philippe, and Lorenzo Baldassari. [n.d.]. 'Interview with Philippe Grandrieux'. *Lo Specchio Scuro*. Accessed 18 May 2016. http://specchioscuro.it/interview-philippe-grandrieux-intervista-grandrieux/.
Grandrieux, Philippe, and Sarah Bertrand. 2007. Interview with Philippe Grandrieux. *There is No Direction*. Documentary.
Grandrieux, Philippe, and Nicole Brenez. 2002. 'The Body's Night: An Interview with Philippe Grandrieux'. Translated by Adrian Martin. *Rouge*. Accessed 1 March 2013. http://www.rouge.com.au/1/grandrieux.html.
Grandrieux, Philippe, and Mathieu Copeland. 2015. 'Philippe Grandrieux in Conversation with Mathieu Copeland, Paris, 4 May 2014'. *In The Exhibition of a Film/L'Exposition d'un film*, edited by Mathieu Copeland, 116–22. Geneva/Paris: HEAD – Geneva University of Art and Design/Les Presses du Réel.
Grandrieux, Philippe, Anne Foti, and Sylvain Lécuyer. 2008. Interview with Philippe Grandrieux. Video. Accessed 1 June 2015. http://www.grandrieux.com/content/lac_QA_video_01.php?lang=fr.
Grandrieux, Philippe, and Boris Gobille. 2006–7. Interviews. Unpublished.
Grandrieux, Philippe, and Stéphane du Mesnildot. 2003. 'Philippe Grandrieux: Un cinéma visionnaire'. *Le Technicien du film* 530: 23–7.
Grandrieux, Philippe, and Olivier Pierre. 2012. 'White Epilepsy', interview with Philippe Grandrieux. *Journal Daily FID 2012*, 7 July. Accessed 4 January 2016. http://www.fidmarseille.org/pdf/070712.pdf.
Grandrieux, Philippe, and Alyosha Saari. 2009. '*Un lac*: Entretien avec Philippe Grandrieux'. *Stardust Memories: Magazine culturel et cinématographique*. Accessed 1 June 2015. http://www.stardust-memories.com/un-lac-entretien-avec-philippe-grandrieux/.

Grandrieux, Philippe, and Guillaume de Sardes. 2013. 'Grandrieux, dans le flou des corps'. *Prussian Blue* 4: 52–6.

Grandrieux, Philippe, and John Jefferson Selve. 2016. *'Malgré la nuit,* Philippe Grandrieux. Entretien'. *Possession immédiate* 5: 86–97.

Grandrieux, Philippe, and Tate. 2008. 'Q&A with Philippe Grandrieux'. 30 April 2008. Accessed 22 February 2009. http://www.tate.org.uk/ context-comment/audio/qaa-philippe-grandrieux.

Grandrieux, Philippe, and Claire Vassé. 2002. 'Entretien avec Philippe Grandrieux'. In *La Vie nouvelle: Dossier de Presse*. Paris: LPZ/Maïa Films/L Films.

Grandrieux, Philippe, and Claire Vassé. 2009. 'Entretien avec Philippe Grandrieux'. In *Un lac: Dossier de Presse*. Paris: Mandrake Films. Accessed 1 June 2015. http://www.grandrieux.com/content/UnLac_DP.pdf.

Grandrieux, Philippe, and Éric Vuillard. 2002. *'La Vie nouvelle*: correspondance'. *Trafic* 44: 25–38.

Grandrieux, Philippe, and Éric Vuillard. 2005. 'Contre-Culture Générale No. 1: Entretien collectif'. In *La Vie nouvelle: nouvelle Vision: à propos d'un film de Philippe Grandrieux*, edited by Nicole Brenez, 187–202. Paris: Éditions Léo Scheer.

Guest, Haden. 2003. 'Darkness Visible: The Act of Seeing with Philippe Grandrieux's Eyes'. *Film Comment* 46 (6): 42–5.

Hée, Arnaud. 2009. 'Liens Sacrés: *Un lac'*. *Critikat*, 17 March. Accessed 1 June 2015. http://www.critikat.com/actualite-cine/critique/un-lac.html.

Heidegger, Martin. 1971 [1950]. 'The Thing'. In *Poetry, Language, Thought*. Translated by Albert Hofstader, 163–80. New York: Harper and Row.

Heidegger, Martin. 1995 [1983]. *The Fundamental Concepts of Metaphysics: World, Finitude, Solitude*. Translated by William McNeill and Nicholas Walker. Bloomington: Indiana University Press.

Heidegger, Martin. 1996 [1953]. *Being and Time*. Translated by Joan Stambaugh. New York: State University of New York Press.

Iwamoto, Fumiwo. 2015. 'Keep on Walking, Keep on Relating: Masao Adachi and Landscape Theory Today'. *Real Estate/Landscape*, presented by Hotel Asia Project, 12 February. Accessed 15 November 2015. http:// www.hotelasia.cc/2015/artist/iwamoto.html.

Jay, Martin. 1988. 'Scopic Regimes of Modernity'. In *Vision and Visuality*, edited by Hal Foster, 3–27. Seattle: Bay Press.

Jordan, Randolph. 2016. 'Acoustical Properties: Practicing Contested Spaces in the Films of Philippe Grandrieux'. In *The Oxford Handboook of Sound and Image*, edited by Yael Kaduri, 289–314. Oxford: Oxford University Press.

Kane, Brian. 2012. 'Jean-Luc Nancy and the Listening Subject'. *Contemporary Music Review* 31 (5–6): 439–45.

Klashorst, Marc van de. 2016. 'IFFR Review: *Malgré la nuit* (Philippe Grandrieux)'. *International Cinephile Society*, 3 February. Accessed 28

June 2016. http://icsfilm.org/reviews/iffr-review-malgre-la-nuit-philippe-grandrieux/.

Ladegaard, Jakob. 2014. 'Spatial Affects: Body and Space in Philippe Grandrieux's *La Vie nouvelle*'. In *Exploring Text and Emotions*, edited by Lars Saetre, 151–75. Aarhus: Aarhus University Press.

Levinas, Emmanuel. 2001 [1978]. *Existence & Existents*. Translated by Alphonso Lingis. Pittsburgh: Duquesne University Press.

Lingis, Alphonso. 1968. 'Translator's Preface'. In Maurice Merleau-Ponty, *The Visible and the Invisible*. Translated by Alphonso Lingis, edited by Claude Lefort, xl–lvi. Evanston: Northwestern University Press.

López-Sánchez M., Lauro. 2015. 'Cavidad Resonante'. In *Excavaciones*, edited by Gabriel Berber, Lauro López-Sanchez M., and Raquel Solórzano Cataño, 45–51. Mexico City: Falso Raccord.

Lucca, Violet. 2013. 'Internal Affair: An Even Darker Side of Philippe Grandrieux'. *Film Comment* 49 (3): 16.

Marks, Laura. 1999. *The Skin of the Film: Intercultural Cinema, Embodiment, and the Senses*. Durham, NC: Duke University Press.

Martin, Adrian. 1999. 'Holy Terror: Philippe Grandrieux's *Sombre*'. *Senses of Cinema* 1. Accessed 3 October 2005. http://www.sensesofcinema.com/contents/00/1/sombre.html.

Martin, Adrian. 2004. 'Dance Girl Dance: Philippe Grandrieux's *La Vie nouvelle (The New Life*, 2002)'. *Kinoeye: New Perspectives on European Film* 4 (3). Accessed 8 August 2004. http://www.kinoeye.org/04/03/martin03.php.

Martin, Adrian. 2014. *Mise en scène and Film Style: From Classical Hollywood to New Media Art*. Basingstoke: Palgrave Macmillan.

Maurige, Jean-François. 2013. Interview with Jean-François Maurige on the occasion of an exhibition of the artist's work in the Galerie Jean Fournier, June 2013. *ouvretesyeux ARTV*. Accessed 4 April 2015. https://vimeo.com/68215323.

Mercier, Marc. 2005. 'Pour en finir avec l'art orthochromatique'. In *La Vie nouvelle: nouvelle Vision: à propos d'un film de Philippe Grandrieux*, edited by Nicole Brenez, 54–8. Paris: Éditions Léo Scheer.

Merleau-Ponty, Maurice. 1968 [1964]. *The Visible and the Invisible*. Translated by Alphonso Lingis. Edited by Claude Lefort. Evanston: Northwestern University Press.

Metz, Christian. 1982 [1977]. *The Imaginary Signifier: Psychoanalysis and the Cinema*. Translated by Celia Britton, Annwyl Williams, Ben Brewster and Alfred Guzzetti. Bloomington: Indiana University Press.

Morgaine, Manuela. 2014. '*Meurtrière*: une performance de Philippe Grandrieux'. *Médiapart*, 15 February. Accessed 1 March 2014. https://blogs.mediapart.fr/manuela-morgaine/blog/150214/meurtriere-une-performance-de-philippe-grandrieux (available in English at

http://24fpsverite.com/specials/meurtriere-philippe-grandrieux-performance/translated by Greg Hainge).

Nancy, Jean-Luc. 2007 [2002]. *Listening*. Translated by Charlotte Mandell. New York: Fordham University Press.

Palmer, Tim. 2011. *Brutal Intimacy: Analyzing Contemporary French Cinema*. Middletown, CT: Wesleyan.

Paulhan, Jean. 1990 [1971]. *La Peinture cubiste*. Paris: Gallimard (Folio Essais).

Proust, Marcel. 1987 [1908]. *Contre Sainte-Beuve*. Paris: Gallimard (Folio Essais).

Quandt, James. 2004. 'Flesh and Blood: Sex and Violence in Recent French Cinema'. *Artforum* 42 (6): 126–32.

Ramdas, Rodney. 2013. 'The Acinema of Philippe Grandrieux: On *Un lac*'. *Lumen* 1. Accessed 1 June 2016. http://lumenjournal.org/issues/issue-i/ramdas.

Rayner, John. 2012. 'This is a Love Song: The Physics of Music and the Music of Physics'. *The Conversation*, 11 July. Accessed 15 November 2015. https://theconversation.com/this-is-a-love-song-the-physics-of-music-and-the-music-of-physics-7799.

Renaud, Nicolas and Steve Rioux, and Nicolas L. Rutigliano. 1999. 'Au commencement était la nuit: Entretien avec Philippe Grandrieux'. *Hors Champ* (October). Accessed 3 October 2005. http://www.horschamp.qc.ca/Emulsions/grandrieux.html.

Rilke, Rainer Maria. 2009 [1923]. *Duino Elegies and the Sonnets to Orpheus*. Translated by Stephen Mitchell. New York: Vintage International.

Rosello, Mireille. 2016. 'Disorientation and Accompaniment: Paris, the Metro and the Migrant'. *Culture, Theory and Critique* 57 (1): 77–91.

Rushton, Richard. 2013 [2010]. *The Reality of Film: Theories of Filmic Reality*. Manchester: Manchester University Press.

Schneider, Rolf. 1998. 'The Sweet Poison of the White Swan: The Delicate Relationship with the Sister: Georg and Grete Trakl'. *Berliner Morgenpost*, 30 August 1998. Accessed 1 June, 2015. http://www.literaturnische.de/Trakl/english/material/t-schneider-e.htm.

Selve, John Jefferson. 2013. '*White Epilepsy*'. *Prussian Blue* 4: 56–7.

Serre, Stéphanie. 2009. 'Vision (re) prisée, à propos d'*Un lac* de Philippe Grandrieux'. *Lignes de fuite: la revue électronique du cinéma 5*. Accessed 1 June 2015. http://www.lignes-de-fuite.net/article.php3?id_article=121.

Shaviro, Steven. 1993. *The Cinematic Body*. Minneapolis: University of Minnesota Press.

Smith, Daniel W. 2003. Translator's Introduction to *Francis Bacon: The Logic of Sensation*, by Gilles Deleuze, vii–xxvii. Minneapolis: University of Minnesota Press.

Sobchack, Vivian. 2004. *Carnal Thoughts: Embodiment and Moving Image Culture*. Berkeley: University of California Press.

Sontag, Susan. 2003. *Regarding the Pain of Others*. New York: Farrar, Straus and Giroux.

Stifter, Adalbert. 2000 [1857]. *L'arrière-saison*. Translated by Martine Keyser. Paris: Gallimard.

Sylvester, David. 2000. *Looking Back at Francis Bacon*. New York: Thames & Hudson.

Trigg, Dylan. 2014. *The Thing: A Phenomenology of Horror*. Ropley: Zero Books.

Vesaas, Tarjei. 2013 [1957]. *The Birds*. Translated by Torbjørn Støverud and Michael Barnes. London: Peter Owen.

Villani, Vivien. 2005. 'Bande-son: modernité et archaïsme, tensions et chromatismes, structures obsessionnelles et organiques'. In *La Vie nouvelle: nouvelle Vision: à propos d'un film de Philippe Grandrieux*, edited by Nicole Brenez, 153–66. Paris: Éditions Léo Scheer.

Walton, Saige. 2016. '"Folds in the Soul": Deleuze's Baroque, Wölfflin and Grandrieux's *Un Lac* (2008)'. *Culture, Theory and Critique* 57 (2): 197–214.

Williams, Linda. 1999 [1989]. *Hard Core: Power, Pleasure, and the 'Frenzy of the Visible'*. Berkeley: University of California Press.

INDEX

Page numbers followed by *f* indicate figures. Numbers followed by "n" indicate endnotes.

292 INDEX